SLAVE CARRIER WITH A LOAD OF CORN
c. 1400–1500 A.D.
Aztec (Valley of Mexico)
Courtesy The Saint Louis Art Museum
Gift of Morton D. May

The Art of
Pre-Hispanic Mesoamerica

an annotated bibliography

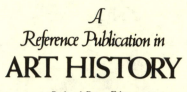

A
Reference Publication in
ART HISTORY
Richard Price, Editor
Non-Western Arts

The Art of
Pre-Hispanic Mesoamerica

an annotated bibliography

JANET CATHERINE BERLO

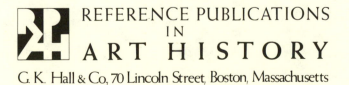

REFERENCE PUBLICATIONS
IN
ART HISTORY

G. K. Hall & Co, 70 Lincoln Street, Boston, Massachusetts

Library of Congress Cataloging in Publication Data

Berlo, Janet Catherine.
 The art of pre-Hispanic Mesoamerica.

 (Reference publication in art history/non-Western arts)

 Includes index.
 1. Indians of Mexico—Art—Bibliography.
 2. Indians of Central America—Art—Bibliography.
 I. Title. II. Series: Reference publication in art
 history. Non-Western arts.
 Z1209.2.M4B47 1985 [F1219.3.A7] 016.7'0972 85-21940
 ISBN 0-8161-8562-X

This publication is printed on permanent/durable acid-free paper
MANUFACTURED IN THE UNITED STATES OF AMERICA

Contents

The Author

Janet Catherine Berlo is associate professor of art at the University of Missouri-St. Louis. She received her doctorate in History of Art from Yale University in 1980. She has published essays on Teotihuacan art, Teotihuacan-Maya contact, modern Maya textiles, and North American Indian art. She is the author of <u>Teotihuacan Art Abroad:</u> <u>A Study of Metropolitan Style and Provincial Transformation in</u> <u>Incensario Workshops</u> (Oxford: British Archaeological Reports, 1984) and the editor of <u>Text and Image in Pre-Columbian Art:</u> <u>Essays on the</u> <u>Interrelationship of the Verbal and Visual Arts</u> (Oxford: British Archaeological Reports, 1983).

Editor's Preface

The past decade has witnessed a resurgence of academic and popular interest in the "Non-Western" arts--the arts of "the rest of the world" or what were once routinely and often pejoratively labeled "primitive arts." The recent opening of the monumental Rockefeller Wing at the Metropolitan Museum of Art for the art of Africa, the Pacific Islands and the Americas, the similarly lavish new installations at such places as the Dallas Museum of Fine Arts and the Baltimore Museum of Art, the impressive increase in traveling exhibitions and catalogues of non-Western art, and the recent establishment of several Indian-run museums on and near American Indian reservations all attest to the remarkable vigor and growth of the field. Yet, in part because both anthropologists and art historians have tended to approach these arts exclusively from their own disciplinary perspectives, there has been a paucity of general bibliographical and other research resources for the student of the non-Western arts. This series is intended to fill that gap.

Some twelve to fifteen volumes, each covering a broad geographical or cultural area and written by an authority in the field, will provide an annotated guide to the available literature in all relevant languages--books, periodical articles, dissertations, exhibition and sale catalogues, and so on. Each volume will include an introductory essay that reviews anthropological and art historical scholarship in the field, suggests areas for future research, and describes the scope and organization of the work. In addition, each volume will contain extensive indexes covering authors, titles, tribes or ethnic groups, media, and other subjects as appropriate.

The first volume in the series, which appeared in 1984, was Louise and Allan Hanson's rich reference source, The Art of Oceania. Forthcoming volumes include Daniel Biebuyck's The Arts of Central Africa, Ira Jacknis's Northwest Coast Indian Art, and Nelson Graburn's Eskimo Art. Other projected volumes will cover the arts of the Plains Indians, Southwest Indian arts, the arts of West Africa, and Southeast Asian arts. Still others are in the planning stage.

Janet Berlo's <u>The Art of Pre-Hispanic Mesoamerica</u>, the second volume in the series, opens with a panoramic overview of the history of Western studies of ancient Mesoamerican art. In this scholarly but lively historiographical survey, Berlo analyzes changing Western reactions to this art over a period of more than four and a half centuries, weaving together a complex archaeological and art historical tale. The body of the work is devoted to more than 1,500 annotated entries on the art made by the native inhabitants of Mesoamerica in the three thousand years before the Spanish conquest in 1521. Ranging from sculpture, painting, pottery, textiles, and jewelry to monumental architecture, the stunning works of art produced by the Aztec, Maya, Olmec, and scores of other peoples of the area become newly available, through Berlo's efforts, for undergraduate student and experienced scholar alike to confront, explore, and appreciate.

Richard Price
The John Hopkins University

Foreword

This bibliography includes some 1,500 annotated entries on the art made by native inhabitants of Mesoamerica in the three thousand years before the Spanish conquest in 1521. The geographical scope of the volume conforms to the generally recognized territorial limits of Meso-america: from north-central Mexico to the mouth of the Ulua river, encompassing the many complex civilizations that existed anciently in Mexico, Guatemala, Belize, El Salvador, and Honduras.

As discussed in the historiographic essay that follows, this area has been the focus of in-depth archaeology for over one hundred years; it was explored and discussed by a handful of individuals for 350 years before that. Yet only in this century, and only seriously in the past forty years, has the art of this region been appraised as a separate phenomenon, worthy of study in itself. This volume is a research tool to aid in that study. It consists of three parts:

An historiographic essay. My intention in the essay is to review the major trends since the colonial era in the study of pre-Hispanic art. Those early studies that approached Mesoamerican monuments and objects as art rather than as evidence are highlighted, and some significant contributions of the twentieth century are discussed in greater detail. The essay has an accompanying short bibliography of works not cited in the annotated bibliography. These are mainly items of anthropological or historical interest.

An annotated bibliography of fifteen hundred and thirty-three entries. These are in alphabetical order by author. Some of the annotations are evaluative; others simply report the contents of the work, mentioning the major contributions and unique features. The two scholarly extremes are most often evaluated critically: the most useful works as well as the least helpful ones. In annotations for collections of essays, I have noted which individual essays are annotated as well. Especially useful survey works, definitive contributions,

facsimile editions, and important photographic documentation are all noted.

I cannot claim that an exhaustive survey of the literature will be found in the 1,500 entries between these covers. Within the limitation of length I have aimed for a judicious mix of the most significant, the most recent, and the unusual, as well as those studies underrepresented in other reference works. In most instances I have not duplicated the efforts of those volumes that aim for detailed coverage of archaeological activity. I have omitted most site reports, except those that in some way are classic or standard works on architecture, sculpture, or painting at a particular site.

Many works omitted here can easily be located in other standard reference volumes. Several of these volumes are mentioned later in the foreword, and the most significant are cited in the historiographic essay. I have tried to focus on those works which have been slighted in the more general reference literature of achaeology and anthropology. For example, many articles published in art periodicals both here and in Europe have been ignored in anthropological bibliographies as well as in those reference works that purport to cover art. I have included many of them here.

In contrast, because of lack of space, I have omitted many works on pre-Hispanic manuscripts, except for the most recent. The literature on codices and documents has been ably covered by Glass, Robertson, and others in the multi-essay Guide to Ethnohistorical Sources which forms volumes 12-15 of the Handbook of Middle American Indians (1972-75).

A subject index to the bibliography. Each entry in the alphabetical list of annotations has its own number from 1-1533. The subject index lists these numbers, usually under more than one category. In addition to the customary indexing of site and monument names and artistic categories (jade; featherwork), major categories such as Maya or Aztec sculpture also contain entries for all works on individual sites and named monuments (Piedras Negras; Calendar Stone). This obviates the need to look up each site or monument individually when one needs an overview of Maya or Aztec sculpture, for example. Each site, however, is also listed separately.

Works on paper or skin are listed in one of two categories: Codices, or Maps and Documents. The Codex category lists manuscripts in alphabetical order and includes some post-conquest manuscripts that pertain to pre-Hispanic themes. Those entries providing facsimiles of the document are so noted in the index. As a guiding principle, I have been specific rather than general whenever possible (e.g., a work focused on Codex Laud will be listed under that name). Its reference

number is not repeated under the more general rubric of Borgia Group
Codices.

Iconographic studies are listed under individual topics (cauac
monster; skeletal imagery) or deity name (Tezcatlipoca; maize goddess;
God K). Painting, sculpture, and architecture are listed under indi-
vidual site and ethnic names (Maya painting; Tulum). Only those works
which are general in nature are listed under the all-encompassing
rubrics of Sculpture, Painting, or Architecture. Catalogues are listed
as such. Catalogues of individual collections are individually listed
within the catalogue designation (Land Collection; Museum für
Volkenkunde, Vienna). Names of individuals are listed in the index only
when they are the subject of a study (Sahagun; Teobert Maler) or when
they have written under more than one name (Merle Greene, see also Merle
Greene Robertson).

The user should keep in mind that some category distinctions are a
matter of personal interpretation on the part of the author of the work
in question, the bibliographer, or the user of this volume. For Zapotec
figural sculptures made of clay, for example, it would be prudent to
check the works listed under the subcategories of ceramics, urns,
figurines, and sculpture in order to insure that no reference has been
missed. Greenstones are listed with jades: architectural sculpture is
indexed both under architecture and sculpture; painted friezes both
with sculpture and painting. Works of a technical nature are indexed
both under Technical Studies and individual topics (stucco techniques;
paper).

* * *

There are a number of useful reference books, bibliographies, and
guides to the archaeology, ethnology, and ethnohistory of Mesoamerica.
As any scholar already working in the area knows, no reference text
focused on art can be used without recourse to these other volumes. Two
of the major resources are:

The Handbook of Middle American Indians (Austin: University of
Texas Press, Robert Wauchope, general editor, 1964-. In 16 volumes so
far, the Handbook has surveyed archaeology, ethnology, linguistics, and
documentary sources) and Bibliografía de arqueología y etnografía:
Mesoamérica y Norte de México, 1540-1960 (México: Instituto Nacional
de Antropología e Historia, Ignacio Bernal, editor, 1962. This lists
nearly 14,000 unannotated references.)

Pathways through the voluminous literature in Mesoamerican studies
can be forged with the help of two small but useful reference guides:

Middle American Anthropology: Directory, Bibliography and Guide to the
UCLA Library Collections, by Eileen A. McGlynn (Los Angeles: UCLA Latin
American Center, 1975) and Mesoamerican Archaeology: A Guide to the
Literature and other Information Sources by Susan F. Magee (Austin:
University of Texas Institute of Latin American Studies, 1981). Their
compendia of information will not be repeated here.

One final important reference tool is the Handbook of Latin Ameri-
can Studies (1935-, currently published by the University of Texas
Press). In alternating volumes on Humanities and Social Sciences, HLAS
provides useful annotated entries on recently published works.
Although far from comprehensive, it is particularly helpful in keeping
abreast of current literature.

Finally, my sincere apologies to those scholars whose favorite
works, or whose own works, I may have inadvertently slighted.

Acknowledgments

In the course of my research for this volume, a number of people gave generously of their time, their skill, or their moral support.

Professor Richard Price, general editor of the Non-Western Arts series, has been helpful and encouraging since 1980. I am grateful for his guidance. Similarly, Janice Meagher and Meghan Wander, editors at G.K. Hall, have been both patient and helpful.

A Summer Research Grant from the University of Missouri-St. Louis allowed me to work full-time on this project during the summer of 1982. George Kubler generously allowed me the use of his personal library in New Haven during that summer. Robert Godley offered hospitality and companionship in 1981 and 1982 during my research at Yale's Sterling Library.

As usual, Raymond E. Senuk gave unparalleled encouragement and praise, not to mention a lifetime supply of computer cards on which I indexed my entries. My colleagues Ronald Munson and Margaret Noonan at the University of Missouri gave advice and much-needed support. During the summer of 1984, my colleagues at Dumbarton Oaks, Elizabeth Boone, Ellen Taylor Baird, Richard Diehl and Jeff Kowalski provided comments and criticism of the historiographic essay. I am grateful for their help.

During the early stages of my work, I was aided by students Elaine Dempsey and Laura Hartog. They helped this project get off the ground. Sylvia Stevens, June Hilliard, and Joan Lorson, manuscript typists at the University of Missouri, have shown great fortitude in the face of my continual changes. To Kate Kane, my research assistant during 1983 and 1984, I owe a tremendous debt for her hard work, her discerning talent in editorial and stylistic matters, and her good cheer. She helped in every way to see this manuscript to completion.

The Art of Pre-Columbian
Art History:
An Historiographic Review

Introduction

During the summer of 1520, the great German artist Albrecht Dürer
began a tour of the Netherlands. In Brussels on August 27, he wrote
these words in his travel diary:

> I saw the things which have been brought to the King from the
> new land of gold, a sun all of gold a whole fathom broad, and
> a moon all of silver of the same size, and two rooms full of
> armour of the people there, and all manner of wondrous wea-
> pons of theirs, harness and darts, wonderful shields, strange
> clothing, bedspreads and all kinds of wonderful objects of
> various uses. . . . All the days of my life I have seen
> nothing that has gladdened my heart so much as these things
> for I saw amongst them wonderful works of art, and I marvelled
> at the subtle Ingenia of men in foreign lands. (Holt
> 1957:339)

These comments mark the first judgment of pre-Columbian art by the
standards of the European art community.[1] Nearly four centuries would
pass before such praise would again be accorded ancient Mesoamerican
art.

The history of the study and criticism of ancient Mesoamerican art
begins with Dürer's words and spans more than four hundred and fifty
years. A detailed intellectual history of the discipline remains to be
written; my intention in this essay is simply to highlight major trends,
focusing principally on the past century. Until recently, the history
of art historical inquiry in Mesoamerica has been subsumed by the his-
tory of archaeological endeavor, as my later comments will show. I
shall not recapitulate the work covered so ably by the surveys of
archaeological history (see, for example, Willey and Sabloff 1974;
Bernal 1980; Hammond 1983).[2] I shall, instead, highlight some pre-
twentieth-century studies that appraise Mesoamerican objects and monu-
ments as artistic manifestations. I shall also examine the issues

raised by early authors who either praised or disdained such works as art. For the period from 1913 to the present I shall provide more detailed coverage of major trends in pre-Columbian art history. The reader should by no means assume that every important study is mentioned, however. Even cursory perusal of some 1,500 entries in the annotated bibliography will demonstrate that the history of pre-Columbian art history can be discussed in only the most general terms in such a brief essay. Reference citations within this essay that appear in the annotated bibliography are marked with an asterisk (e.g., Pasztory 1979*). Citations not marked with an asterisk are listed in a short supplemental bibliography at the end of the essay.

1520-1840: Discovery and Early Writings

Dürer's remarks, as well as the narratives of the early conquerors and mendicant friars, are sometimes interpreted as evidence of early writers' regard for the alien arts of the New World. As an artist, Dürer sincerely appreciated the fine artistry in the objects he saw. But the conquerors' remarks, sometimes seen as adulatory, actually express typical Renaissance interest in exoticism and "curiosities" (see Greenhalgh 1978*, and de la Torre 1960*). For example, Duran recounts the feelings of the original conquerors upon viewing the Mexica capital:

> They assured me that the day they entered the City of Mexico, when they saw the height and grandeur of the temples, they thought them castellated fortresses, splendid monuments and defenses of the city, or castles or royal dwelling places, crowned with turrets and watchtowers. Such were the glorious heights which could be seen from afar! Thus the eight or nine temples in the city were all close to one another within a large enclosure. Within this compound they all stood together, though each had its own staircase, its special courtyard, its chambers, and its sleeping quarters for the priests of the temples. All of this took up much ground and space. How marvelous it was to gaze upon them--some taller than others, some more lavish than others, some with their entrances facing the east, others the west, others the north, others the south! All stuccoed, carved, and crowned with different types of merlons, painted with animals, (covered) with stone figures, strengthened by wide, great buttresses! How (the temples) gave luster to the city! How they gave it dignity, to the point that there was little else to see! (Duran 1971:76)

Although they were among the most adventuresome and outward-looking individuals of their era, these sixteenth-century soldiers and friars struggled (and failed) to reconcile the majesty of what they saw with the "savagery" they projected onto the creators of these monuments.

The sixteenth-century traveler saw ancient American art not only as exotic curiosity but also as material wealth. Kubler characterizes colonial documents as

> a literature of economic and political purpose. When monuments are mentioned, it is not for the sake of their form or expression, but to indicate that important centers of population were present, or that treasures might be latent. The notion of any artistic value beyond magnitude of enterprise, strangeness of form, and rarity of material was absent from sixteenth-century commentaries upon pre-conquest manufactures. (1962:8*)

In the seventeenth and eighteenth centuries, Mesoamerica figured only sporadically in European consciousness. Willey and Sabloff (1974:28-41), Hammond (1983:3-10), and Bernal (1980:49-102) have all discussed the pronouncements on antiquities made by settlers and "armchair speculators" (Willey and Sabloff 1974:28) of this period. During this time, most individuals who wrote on ancient America were preoccupied with the relationship between this civilization and the rest of the world. Were there ties, or did American civilization develop indigenously? Where in the developmental scheme of civilization did American antiquity fit? One of the most influential of these writers was W.R. Robertson, who published his <u>History of America</u> in 1778.

Robertson, a Scottish Presbyterian clergyman and a highly respected historian of his time, was writing before the age of the great travelers to Mexico--he relied totally on literary sources, especially those sources relating directly to the conquest. Robertson believed indigenous Americans to be "rude savages" in an early stage of development. Their arts, he says, "hardly merit any attention on their own account" (1778:1.369), but are important as historical monuments and records. He believed the Spaniards were too hasty in their enthusiastic praise of gold and feather work:

> (When) we survey the arts of nations comparatively rude, we are astonished at works executed under such manifest disadvantages . . . and are apt to represent them as products more finished than they really are . . . To this we may impute the exaggeration of some Spanish authors." (1778:2.285)

Robertson's contemporary, the Jesuit Francisco Clavijero (1721-1787), was more generous in his appraisal of pre-Hispanic America. Born in the New World, he had an unusual sympathy for its antiquities, and exhorted his peers to conserve them:

> I pray my fellow countrymen to guard what little is left of the military achitecture of the Mexica, so many fine antiquities have already been allowed to perish. (Bernal 1980:76)

3

During an age when those few objects deemed worthy of preservation survived merely as exotic trinkets in "curiosity cabinets," Clavijero advocated creating a museum for ancient Mexican sculpture, mosaics, and manuscripts.

Alexander von Humboldt, writing forty years after Robertson and Clavijero, did not accord the inhabitants of the New World much higher status of civilization than did Robertson. However, he evinced some understanding of how European notions of culture influenced judgments of non-Western civilizations:

> Nothing is more difficult than a comparison between nations, who have followed different roads in their progress toward social perfection. The Mexicans and Peruvians must not be judged according to the principles laid down in the history of those nations which are the unceasing objects of our studies. (1814:31)

Humbolt celebrated the fact that he lived at a time

> when we no longer deem unworthy of our attention whatever is not conformable to that style of which the Greeks have left such inimitable models. (ibid., p. 6)

Humboldt criticized earlier historians such as Robertson, saying,

> These writers consider every state of society as barbarous that did not bear that type of civilization which they, according to their systematic ideas, had formed. We cannot admit these abrupt distinctions into barbarous and civilized nations . . . Before we class nations, we should study them according to their specific characters, since external circumstances may give an infinite variety to the shades of civilization. (ibid., p. 409)

Despite his admonitions against cross-cultural comparisons, Humboldt's descriptions of Cholula, Teotihuacan, and Xochicalco deny that these monuments were, in fact, art. He claimed that their makers never reached the height of intellectual development at which they would have been "affected by the beauty of forms" (ibid., p. 36). Therefore, Humboldt believed, their monuments could be considered merely as historical documents. For European writers of the early to mid-nineteenth century, pre-Columbian society only approached the realm of the civilized. Recognition that its monuments were manifestations of an artistic impulse would not come until later in the century.

Guillaume Dupaix, an Austrian who led an expedition to Mexico in 1805, agreed with Humboldt's judgment that comparisons between cultures were difficult:

> In attempting to describe and explain these interesting monu-
> ments of antiquity, I must labor under great difficulty on
> account of that originality and peculiarity in the style of
> the Mexican school which superficial inquirers have spoken
> with ill-placed contempt. (Kingsborough 1831-48:432*)

Dupaix praised the ancient architecture of Mexico. Nevertheless, his
greatest compliments were reserved for Palenque, which he felt embodied
"the most exalted conceptions" of ancient American art, a view most of
his contemporaries shared.

Despite Humboldt's contention that European critics no longer
ignored those arts that did not conform to the models of Classical
Antiquity, nineteenth-century approbation <u>was</u> reserved for those
Mexican monuments most closely approaching European canons of
naturalism and veristic representation. To most critics, art at the
Maya site of Palenque alone approximated the refined proportions and
realistic depiction characteristic of Classical Mediterranean art. I
shall return to this issue of pre-Columbian art and European standards
of beauty in the following section.

In the period from the conquest to 1840, writings about the pre-
Columbian world reveal interest in art as artifact, as curiosity, as
material wealth, and as historical document. Nowhere is this art
appraised as art. Though writers like Humboldt and Dupaix sporadically
perceived that their Euro-centric yardstick of cultural comparison was
inappropriate for the New World, it was not until Stephens and
Catherwood (1841, 1843) that European explorers were able to abandon
their culture-bound standards.

1841-1913: Exploration and Documentation

Although the period from 1841 to 1913 still predates any study that
could truly be called art historical,[3] pioneering work in scientific
description of sites and monuments was the major achievement of the
age.[4] Increased archaeological exploration combined with advances in
the new technique of photography to facilitate the precise
documentation necessary for later art historical study. Publication of
accurate facsimiles made pre-Hispanic codices more accessible to
scholars. During this era, critical comparison between Mesoamerica and
the Classical world continued as well, as scholars grappled with the
meaning of this autochthonous civilization.

In 1841, John Lloyd Stephens and Frederick Catherwood inaugurated
a new era in Mesoamericanist studies with <u>Incidents of Travel in Central
America, Chiapas, and Yucatan</u>. It was an unusual work: both a best-
seller (eight editions in three years, and still in print today) and a
report that revolutionized its field. <u>Incidents of Travel in Yucatan</u>
followed two years later. In two trips to Mexico and Guatemala,
Stephens and Catherwood discovered scores of sites and accurately

described and mapped others already known. Using a <u>camera</u> <u>lucida</u> to project what he saw onto sketch paper, Catherwood completed the first detailed architectural drawings unhampered by distortion or fanciful interpretation. Stephens wrote the lengthy and detailed texts, combining personal anecdote and travel adventures with precise description and evaluation of the monuments. Stephens's unfettered appreciation of ancient American art is clear:

> It is the spectacle of a people skilled in architecture, sculpture, and drawing, and beyond doubt, other more perishable arts, and possessing the cultivation and refinement attendant upon these, not derived from the Old World, but originating and growing up here without models or masters, having a distinct, separate, independent existence; like the plants and fruits of the soil, indigenous. (1841:2, 442)

Although Catherwood's <u>camera</u> <u>lucida</u> allowed him to reproduce Maya monuments with a clarity heretofore unknown, advances in photographic processes in the generation after him afforded even greater precision. Desiré Charnay was the first successful archaeological photographer in Mesoamerica (I. Graham 1971:15*). <u>Cités et ruines américaines</u> (1863) and <u>Les anciennes villes du nouveau monde</u> (1885) chart Charnay's discoveries and theories. Both were popular successes, and were translated into English soon after their European publication (1887*).

Alfred Maudslay and Teobert Maler achieved even greater recognition for their painstaking photographic work in Mexico and Guatemala. Maudslay's superb photographs of Maya sculpture and architecture and the expert drawings done from his photos and casts by artist Annie Hunter are still important today for iconographic and epigraphic studies. They were published with Maudslay's careful descriptive text in large format in the series <u>Biologia Centrali-Americana</u> (1889-1902*). Following on the heels of Maudslay was the Austrian Teobert Maler, whose photos and reports of discoveries of Piedras Negras, Naranjo, and other Maya sites were published by the Peabody Museum at Harvard (1901-3*, 1908*, 1908*, 1910*, 1911*). His work on Maya architecture was posthumously published (1971*).

Exploration and documentation embraced more than the charting of ruins and monuments. Other contributions lay in the publication of manuscripts and the recording of murals. Kingsborough's ambitious nine-volume <u>Antiquities of Mexico</u> (1831-48*) was a landmark work for the mass of material it made available to scholars. The first three volumes contained hand-colored reproductions of major Mexican and Maya manuscripts, most of which had been previously unpublished. Though Viscount Kingsborough died penniless, his legacy of published manuscripts made possible some of the truly groundbreaking codex studies of this period (Seler 1887*, 1904-9*; Nuttall 1886*, 1902; Schellhas 1904*; Tozzer and Allen 1910*).

Between 1900 and 1907, the British artist Adela Catherine Breton made several trips to the Yucatan to record the disintegrating murals and stucco facades at Chichen Itza and Acanceh (see Carmichael 1973:30-32). Some of these were published early in the century (Seler 1915*; Breton 1917*); others remained unpublished until recently (A. Miller 1977*).

The systematic documentation of all major media (architecture, stone monuments, manuscripts, and murals) during this period laid the groundwork for the synthetic achievements of twentieth-century scholarship. Concurrently, speculation about and evaluation of pre-Columbian art and culture continued unabated. These discussions ranged from Kingsborough's thesis that ancient Mexicans were the Lost Tribes of Israel to continued debate over the relative position of ancient America in an evolutionary cultural sequence. For our purposes, one interesting discussion concerned evaluation of pre-Columbian art as art, and its relation to European canons of taste and beauty.

With the exception of Kugler (see note 3) and Viollet-le-Duc (in Charnay 1863), few art historians or critics engaged in this debate over the value of pre-Columbian art. Though art history as a discipline had originated with Johann Winckelmann in the mid-eighteenth century, until the twentieth century the discipline limited itself almost exclusively to European art from Greco-Roman times to the Renaissance. Darwinian evolutionary theory influenced art scholars like Gottfried Semper (1860-63) and Alois Riegl (1901), whose studies of the evolution of artistic forms were seminal contributions to the fledgling field (see Kleinbauer 1971:18-24). Darwinian theory also underlay the work of those anthropologists and explorers who sought in the cultures they studied an evolutionary development from "rude savagery" to civilization. Despite their interest in evolutionary models, no nineteenth-century art historians devoted themselves to the New World arts currently being excavated. Viollet's comments on Mesoamerican monuments, for example, did not arise from firsthand knowledge. His source materials were Desiré Charnay's photos, sketches, papier maché molds, and the earlier writings of other explorers. Viollet did not, in general, rank Mesoamerican architecture with the other great architectural achievements of the world, although he did single out the ruins at Mitla, Oaxaca for particular praise:

Les monuments de la Grèce et ceux de Rome, de la meilleure époque, égalent seuls la beauté de l'appareil de ce grand édifice. Les parements dressés avec une régularité parfaite, les joints bien coupés, les lits irréprochables, les arêtes d'une pureté sans égale indiquent, de la part des constructeurs, du savoir et une longue expérience. (in Charnay 1863:77)

In Ancient Cities of the New World, Desiré Charnay published contradictory evaluations of ancient American art. He judged that

American monuments, considered artistically, are but the rude
manifestations of a semi-barbarous race, which it were idle
to endow with intrinsic value. (1887:412*)

Yet his enthusiastic and detailed descriptions of Palenque, Uxmal, and
Yaxchilan belie this statement. He saw in the relief sculpture of
Yaxchilan the crowning achievement of New World art. Of Lintel 24 he
writes:

> It is by far the most wonderful monument which, up to the
> present time, has been found in America, and which we can
> boldly call a work of art. If we except the flat foreheads,
> everything is perfect in this monument. (ibid., p. 450)

Charnay reserved his praise for objects that mirrored nineteenth-
century European standards of realism and refinement--standards
stemming from the Greco-Roman tradition. Maya art, especially at
Palenque, comes closest to meeting these standards.[6]

Count de Waldeck interpreted Palenque through nineteenth-century
European eyes to an even greater extent than most of his contemporaries
(Monuments anciens du Mexique, 1866). Saying that he hoped to reproduce
the monuments with "the most scrupulous exactitude," and accusing the
artists who preceded him of having erred in both proportion and detail,
Waldeck published new drawings of the Palenque relief sculptures.
Waldeck's drawings emphatically reveal a Neo-Classical sensibility.
His renderings soften the reliefs and make them seem more fully three-
dimensional than they are. Perhaps a desire to make these strange and
curious arts accessible to Europeans moved Waldeck's hand to draw with a
Classical flourish.

Waldeck's contemporary, the Marquis de Nadaillac, also lauded
Palenque relief sculpture for "perfection of form (that) recalls Greek
art" (1884:324). In trying to convey to European readers the
excellence of Mesoamerican art, these authors understandably relied on
analogies with familiar European aesthetics. Yet this practice
obscured the need to understand ancient American art on its own terms
rather than subject it to an alien yardstick.

While some Maya monuments were celebrated for approaching Greek
aesthetic ideals, the nineteenth century saw no such praise for Aztec
sculpture. The history of the excavation and subsequent reburials of
the Coatlicue monument illustrates nineteenth-century attitudes toward
Aztec art. The giant stone sculpture of an Aztec earth goddess was
discovered in 1790. Soon after, it was moved to the Universidad Real y
Pontífica in Mexico City. Bernal reports that the professors there
judged it unfit company for the Greco-Roman casts on display; indeed,
some felt that this monument would incite revival of ancient pagan
religion (Bernal 1980:85). The monument was reburied, reexcavated for
Humboldt's viewing in 1803, and buried once again. In the 1820s it was
unearthed once more and relegated for many years to an unobtrusive spot

in the corridor of the University museum (Bernal 1980:85). Today it commands a major place in the National Museum in Mexico City and is considered a masterpiece of Aztec art (see Fernandez 1954; Pasztory 1979*; Bernal 1977*).

Despite this ambivalent attitude toward the monuments of the Aztec past, nineteenth-century Mexico often did exhibit keen interest in its antiquities. Bustamente reports an 1829 law that claimed governmental right of first refusal in purchasing sculptures unearthed during construction projects (1832 Part 2:88-89). During the nineteenth century, numerous ancient manuscripts and monuments were published for the first time in Mexico, as scholars endeavored to make sense of their cultural patrimony (see Bernal 1980:67-129).

By the turn of the century, Mesoamerican scholars had achieved deeper understanding of the meaning of pre-Hispanic art, and greater familiarity with its complex forms. As understanding grew, so did aesthetic appreciation. No longer did unfamiliarity breed distaste. We shall see, however, that Euro-centric aesthetic judgments persisted in some quarters of the general art historical community for more than another half century.

1913-1955: Gradual Acceptance and Popularization

The years 1913-55 produced a multitude of studies on pre-Columbian art and culture. Archaeology as an academic discipline came of age during this half century, and numerous ambitious excavation projects commenced in Mexico and Guatemala. Concurrently, popular interest in pre-Columbian art was piqued by reports of impressive archaeological finds throughout Mesoamerica. I shall divide the discussion of these crucial years in the development of the discipline into two parts: academic developments in Mesoamerican archaeology and art, and the growth of art-world interest in pre-Columbian objects. Though events within Mesoamerican circles and those in the greater art world are necessarily inter-related, by examining them separately we can more readily understand how pre-Columbian art studies have remained on the periphery of art history even to this day.

Two important events set the boundaries of the chronological segment from 1913 to 1955. I begin the period with the publication of Herbert Spinden's seminal work, A Study of Maya Art, and close it just before conferral of the first American Ph.D. in History of Art to a specialist in pre-Columbian art. The subsequent flowering of Mesoamerican art studies rests on the achievements of this period.

Pre-Columbian Art Studies and Their Archaeological Background. In 1913, Herbert Spinden's doctoral dissertation for the department of Anthropology at Harvard was published as Volume 6 of the Memoirs of the Peabody Museum. Spinden was the first Maya scholar to immerse himself in all aspects of ancient Maya art. Through careful stylistic and

iconographic analysis, Spinden elucidated the complex anthropomorphic
and zoomorphic imagery of Maya sculpture. He seriated Maya monuments
by their stylistic features, and surveyed architecture and minor arts
as well. Though written for an anthropology degree, the study was art
historical in its subject matter and method. Sensitivity to non-
European aesthetics distinguishes Spinden's work. He noted, for
example, that Classic Maya physiognomy differs from "accepted European
types of beauty" (1913:24*); and he approached such figural sculpture
on its own terms, something most of his predecessors had been unable to
do. Spinden provided later students with a sound example to follow.
His Study of Maya Art remains a major contribution to the field.

Spinden was not the first of his generation to examine pre-
Hispanic art as art. G.B. Gordon published brief essays on Maya art
(1902*, 1909*). German scholarship was particularly strong at the turn
of the century. Seler (1894*, 1895*, 1900-1901*, 1902*, 1902*, 1904*,
1904-1909*), Schellhas (1890*, 1904*), and Dieseldorf (1894*, 1894*)
all wrote on art-related themes. However, most of these studies grew
out of epigraphic or ethnohistorical interests; they do not focus as
specifically on the art object as did Spinden's work. Spinden was the
first to study art as an exclusive pursuit (until his later years when
he focused relentlessly on the calendrical correlation problem).

Spinden's contribution must be considered in the context of the
archaeological advances of his Harvard colleagues. Harvard supported
Maler's work, as mentioned in the previous section. G.B. Gordon (1896*,
1898*, 1902*) and Raymond Merwin (1913; Merwin and Vaillant 1932*) were
publishing the results of their research as well. Such explorations
provided the raw materials for Spinden's Study of Maya Art.

Both Harvard and, later, the Carnegie Institution of Washington
focused their research efforts on the Maya. Carnegie archaeologists
Sylvanus Morley and A.V. Kidder directed ambitious excavation projects
at Uaxactun, Chichen Itza, Kaminaljuyu, Quirigua, Copan, Tulum, Coba,
and Mayapan. Numerous reports on architectural sequences, glyphs,
pottery, and other arts ensued (Lothrop 1924*, 1952*; Morley 1920,
1935*, 1937-38; Pollock 1936*; Ruppert 1931*, 1935*, 1943*, 1952*;
Ruppert and Dennison 1943; Kidder, Jennings, and Shook 1946*; Morris,
Charlot and Morris 1931*; Ruppert, Thompson, and Proskouriakoff 1955*;
Thompson, Pollock, and Charlot 1932*). Several archaeologists
published popular reports of their adventures (E. Morris 1931*; A.A.
Morris 1931). The Carnegie staff also documented incidental finds from
the Maya highlands and lowlands (Kidder 1942*, 1943*, 1944*, 1949*; J.
Eric S. Thompson 1943*, 1943*, 1943*). Other North American institu-
tions focused on the Maya as well and continue to do so today: the
University Museum of the University of Pennsylvania excavated at
Piedras Negras (Satterthwaite 1937*, 1939*, 1940*, 1946-47*) and
Caracol (Satterthwaite 1954*); the Middle American Research Institute
at Tulane was active in Southern Mesoamerica (Blom and LaFarge 1926-
27*).

Although American archaeological attention during these years focused principally on the Maya, in 1939 Matthew Stirling began eight years of field research on the controversial Olmec culture of the Gulf Coast. The Olmec excavations, cosponsored by the Smithsonian and the National Geographic Society, brought to light dramatic evidence of a pre-Maya culture of stunning artistic sophistication—a discovery that proponents of Maya pre-eminence found hard to accept.[8] From its modest inception at Stirling's Tres Zapotes field camp, Olmec archaeology unfolded as a flourishing subbranch of Mesoamerican research. From the beginning, an integral part of this research involved careful discussion of art objects and their stylistic and technical features (Stirling 1941*, 1943*, 1955*, 1961*; Drucker and Heizer 1956*; Covarrubias 1942, 1977*).

Concurrent with North American endeavors in the Maya and Olmec areas, intensive work by Mexicans and Europeans in Central Mexico and Oaxaca provided more new materials for study and a richer context in which to place them. Only a few of these projects will be mentioned here. Eighteen field seasons at Monte Alban under the stewardship of Alfonso Caso (Bernal 1980:178) resulted in numerous publications on sculpture (Caso 1928*), pottery (Caso and Bernal 1952*; Caso, Bernal, and Acosta 1967*) and other arts (Caso 1932*, 1967*). The Swede Sigvald Linné excavated at Teotihuacan (1934, 1942*), while the Mexican Jorge Acosta excavated at Tula (1940*, 1944*, 1945*). A brief sample of the myriad studies of the arts of those successor civilizations in the Valley of Mexico includes: Acosta 1943*, 1961*; Hasso Von Winning 1947*, 1947*, 1949* 1955*; Linné 1941*.[9]

Out of the rich mine of sustained archaeological activity by these American, Mexican, and European scholars came not only important archaeological syntheses, but also some valuable art historical syntheses. Marquina's works on pre-Hispanic architecture (1928*, 1951) and Totten's (1926*) stand out, as do Caso's and Bernal's monumental tomes on Monte Alban already mentioned. Tatiana Proskouriakoff's unsurpassed Study of Classic Maya Sculpture (1950*), her album of renderings of Maya architectural reconstructions (1946*) and her briefer, but no less important articles (1951*, 1953*, 1958*) grew from her engagement as staff artist for Carnegie excavations. Her later pivotal contributions to Maya epigraphy (1960, 1963, 1964) had their genesis here too.

By the end of this period, anthropological archaeology in the Americas began to turn toward a scientific model of cultural development (see Willey and Sabloff 1974:178-211). Cecelia Klein has suggested that as "New Archaeology" became the mode of the future, a vacuum was left in the study of "unique and elitist" objects:

New Archaeology's enthronement of objective science thus placed the "old" archaeology first on the defensive, and, finally, in partial exile. Study of the precious and symbolic aspects of Mesoamerican culture in particular were

ripe for relocation in another, more congenial discipline.
(1982:3*)

She suggests that pre-Columbian art history "came into being in this
country in part specifically to carry on what archaeology had ceased to
do" (ibid., p. 4). This is partly true, yet the groundswell of interest
in pre-Columbian art during this era actually predates the widespread
acceptance of New Archaeology. Furthermore, it is closely bound to
events within the world of fine arts as well as the larger world of
inter-American cultural affairs. It is to these trends that we shall
turn next.

Pre-Columbian Art and the Art World. In 1918 the British art
critic Roger Fry wrote in the Burlington Magazine:

> Recently we have come to recognize the beauty of Aztec and
> Maya sculpture, and some of our modern artists have even gone
> to them for inspiration. This is, of course, one result of
> the general aesthetic awakening which has followed on the
> revolt against the tyranny of the Graeco-Roman tradition.
> (1918:156*)

He wrote these words at a time when the art world was just becoming
aware of the power and expressive beauty of pre-Columbian art. Popular
interest in accounts of Latin American archaeological exploration had
grown steadily since publication of Stephens and Catherwood's volumes
(1841, 1843). The World's Fairs in Chicago (1893) and St. Louis (1904)
both had sizable ethnographic exhibits, including displays of Mexican
and Central American archaeology. Interest in pre-Columbian art as art
is strictly a twentieth-century phenomenon, however. Robert Woods
Bliss bought his first pre-Columbian piece (an Olmec jade figurine) in
1914, making him almost certainly the first art collector to buy a pre-
Columbian object solely for its aesthetic appeal (Elizabeth Boone,
personal communication, 1984). From this initial purchase grew the
renowned collection that bears his name at Dumbarton Oaks in
Washington, D.C. Inclusion of pre-Columbian topics in art magazines
and world art surveys began in the second decade of this century,
followed shortly thereafter by major exhibits of pre-Columbian art. I
will discuss these signs of interest in American antiquity, and suggest
some relationship with cultural and political events of the first half
of the twentieth century.

In 1914, William Henry Holmes became an editor of the journal Art
and Archaeology. His six-part series of articles, "Masterpieces of
aboriginal American art," began in the premiere issue and appeared
regularly for several years (see all his 1915-19 entries in the
bibliography). The use of the word "masterpieces" suggests that the art
world of the second decade of the twentieth century respected pre-
Columbian art as art. Perusal of the popular journal Art and
Archaeology during its two decades of publication (1915-34) reveals an
appreciation of the arts of diverse cultures. From Pompeii to Pueblo

pottery, from Corinth to Chichen Itza, the ancient arts of the world were presented in serious fashion.

At the same time, the encyclopedic surveys of art history began to include "non-Western" arts within their pages as well. This trend started in Europe. Eli Faure's Histoire de l'art (1909-21) includes Africa, Oceania, and the Americas. The German Orbis Pictus series published Lehman's Mexikanische Kunst (1921*), while the highly respected Propylaen Kunstgeschichte included von Sydow's expert Die Kunst der Natur-Volker und der Vorzeit (1923) in its series. The Spanish Summa Artis included pre-Columbian art by 1927 (Pijoan, 1927), later giving the subject its own first-rate volume (Cossio-Pijoan 1931; Pijoan 1946*).

Though von Sydow and Pijoan treated the subject successfully, the other authors were not prepared to discuss ancient America in art historical terms. Faure's prose reveals his ignorance of Aztec art:

> Like a tropical vegetation swollen with spongy bulbs, with spines and blotches and warts, the Mexican culture has its own continuity, as it continues sending forth its blood, from the torpid depths where the heart beats, to the fat projections--heads and other parts of reptiles, bare skulls, human fingers, and breastbones of birds that, at first view, seem to be caught there by chance. (1948:200)

Lehman's book is not a history of art at all; its author, the director of the Ethnological Institute of Berlin's Ethnographic Museum, discusses ancient American ethnic groups and their chronology in his brief introduction, but leaves the art works to speak for themselves.

By 1926 the American Helen Gardner had joined the movement toward including "non-Western" art in art history survey texts.[10] Her influential Art through the Ages (1926) not only includes a chapter on "aboriginal American art," but declares in the first sentence of the preface her commitment to a global approach to art history:

> The purpose of this book is to introduce the reader to certain phases of art--architecture, painting, sculpture, and the minor arts--from the remote days of the glacial age in Europe, through the successive civilizations of the Near East, Europe, America, and the Orient to the twentieth century. (1926:iii)

Concurrent with textbook coverage of pre-Hispanic art, we find museum exhibits as well. Kelemen recalls that both the Cleveland Museum of Art and the Fogg Museum at Harvard exhibited pre-Columbian objects in the 1920s, and in 1930 an exhibit of textiles, metallurgy, and ceramics opened at the Metropolitan Museum (Kelemen 1946:152*). Numerous exhibits followed throughout the country. Two of the most influential were "American Sources of Modern Art" (1933) and "Twenty Centuries of Mexican Art" (1940), both at the Museum of Modern Art.[11]

Close on the heels of these museum exhibits came the first compre-
hensive yet popular survey of pre-Columbian art published in this
country, Pal Kelemen's Medieval American Art (1943*). Lauded for its
encyclopedic range, profuse illustrations, and accessible text, it is
still in print today. At the same time, George Kubler, the single most
influential historian of pre-Columbian art, began writing on ancient
topics (1943*, 1944*), though until the late 1950s his main interest
would be Iberian art and its colonial manifestations.

Mexican scholars, too, evinced an interest in art as a separate
category of ancient endeavor. The Instituto de Investigaciones
Estéticas of the Universidad Nacional Autónoma de México began to
publish its Anales in 1937. Toscano's Arte Precolombino de México y de
la América Central appeared in 1944*. Miguel Covarrubias was writing on
Olmec art (1946; published in English in 1977*) and other topics (1948*,
1957*). Justino Fernández's influential study Coatlicue came out in
1954*.

The 1930s and 1940s were indisputably a period of great flowering
of interest in pre-Columbian art, yet the books and articles I have
cited for the previous two decades indicate that such interest had been
taking hold here and in Europe by the second decade of this century.
The exhibits of the 1930s both influenced and reflected the great
popular appeal of Latin American culture. The Mexican muralist
movement was well known in the U.S.A. by the 1920s. Orozco painted
murals at Pomona College, the New School, and Dartmouth College from
1927-33. Diego Rivera and Frida Kahlo arrived in 1930, and Rivera had a
major show at the Museum of Modern Art in 1931; indeed his exhibit broke
all attendance records. Modern-day Medicis' political and economic
interests in Latin America played no small part in these exhibits. John
D. Rockefeller was a force behind many Mexican shows at the Museum of
Modern Art. Rockefeller and his brother-in-law Winthrop Aldrich
founded the Mexican American Arts Association "to promote friendship
between the people of Mexico and the United States by encouraging
cultural relations and the interchange of fine and applied arts." Both
men had sizeable investments in Mexico (Herrera 1983:127-30).

Writing in 1944, Kubler attributed the increased professional
interest in pre-Columbian art history to "the many agencies of the Good
Neighbor Policy (which) provided generous facilities and rewards for
study" (1944:148*).[12] Recently, Bailey (1978*) and Klein (1982*)[13] have
forcefully analyzed the pivotal role of U.S. government agencies in
turning both public and scholarly attention to Latin America in the
1930s and 1940s.

Still unexplained, however, is the scholarly art world's
subsequent repudiation of pre-Columbian studies. Only a few years
after acceptance finally seemed likely--with the flurry of exhibits and
articles, both scholarly and popular--the art world's interest in the
serious side of pre-Columbian art history abruptly waned. On the verge
of joining the mainstream, the field seemed destined for eclipse. In

1941, Elizabeth Wilder pointed out in the College Art Journal that only
4 of 400 colleges surveyed taught courses on Latin American art. In her
"Call for Pioneers" she exhorts her professional colleagues to embrace
Latin American studies or else "art will lag behind the intellectual
enthusiasms of our time" (1941:9).

Thirty years later, two studies prove that indeed, in some ways the
scholarly art community has lagged behind the intellectual enthusiasms
of the twentieth century. Both Bailey and Boone have documented the
decline in recognition of Latin American art history in professional
art historical publications and organizations from 1938 to the present.
Using the publications of the leading professional journal as a
barometer, Bailey records seven articles on Latin American topics in
the Art Bulletin from 1941-53 alone (1978:1*). Boone records but two
from 1957-77 (1978:4). None have been published since. The vigorous
blossoming of the field (documented in the next section) has coincided
with the art establishment's refusal to recognize its legitimacy.[14]

1956 to the Present: The Coming of Age of Mesoamerican Art History

I follow Klein in marking 1956 as a pivotal date in pre-Columbian
art studies (Klein 1982:40*). It was the year in which Donald Robertson
earned a Ph.D. from Yale University for his research on early colonial
Mexican manuscript painting, a topic that bridged the chasm between
pre-Hispanic and European arts.[15] Robertson's intellectual genealogy
actually extends back to Herbert Spinden, whose Harvard dissertation
marked the opening of the previous era of pre-Columbian art studies (see
pp. 9-10). As Klein has pointed out, Spinden taught pre-Columbian art
history in the Art History Department of New York University in the
1930s:

> The position was pivotal, for between 1936 and 1938 Spinden
> served as "mentor in pre-Columbian archaeology" to Yale
> graduate student George Kubler, soon to go on to teach the
> subject himself for Yale's Department of the History of Art
> while writing the first detailed but comprehensive text on
> the subject, The Art and Archaeology of Ancient America,
> published in 1962. In 1956, moreover, with the award of a
> Yale doctorate to his student Donald Robertson, Kubler
> . . . produced the first U.S. art historian whose disserta-
> tion dealt with pre-Hispanic material. Spinden must be
> recognized, therefore, as the man who both first introduced
> courses on pre-Columbian art under the rubric of art history
> rather than anthropology and helped to train the founder of
> the academic discipline of pre-Columbian art history in the
> U.S. (1982:40*)

In the next quarter century, more than thirty Ph.D. degrees would be
conferred upon historians of pre-Columbian art at American
universities.[16] Yet the course of pre-Columbian art history is not
predicated on the careers of these individuals alone. Many

anthropologists, museum curators, artists, self-trained aficionados, and others continue to make advances in the field. The rest of this essay will be devoted to highlighting a variety of scholarly contributions from this era.

I cannot stress too emphatically that exclusion from this list does not constitute critical censure. My aim here is twofold: to highlight some areas of major concern within the past quarter century, and to stress the richness and variety of scholarship by citing a few examples in each category. Exhaustive cataloging of all contributions is beyond the aims of this essay.

Landmark accomplishments. Miguel Covarrubias's Indian Art of Mexico and Central America (1957*), with its mix of archaeological data leavened by the author's artistic discernment, stands as a classic in the field. George Kubler's major compendium, The Art and Architecture of Ancient America (1962*), ranks as the definitive survey volume on both Mesoamerican and Andean art. It has since been updated twice. Anderson and Dibble's monumental work of translation of the Florentine Codex (1950-69*) has made this key Nahuatl document available to scholars.

In 1966, Dumbarton Oaks inaugurated its Studies in Pre-Columbian Art and Archaeology series, of which more than 27 volumes have been published. It serves as a major outlet for scholarly studies. Publications based on Dumbarton Oaks's annual conferences have appeared since 1968 (see many entries under Benson and Boone). The Handbook of Middle American Indians, while not focused on art, is a major source book for all aspects of Mesoamerican research. Beginning publication in 1964 (Wauchope 1964-), its most recent addition is a supplementary update on archaeology (Sabloff 1981).

Catalogues of major collections and exhibits. In this period, a number of important scholarly catalogues have appeared as welcome additions to the literature. An early example, Lothrop, Foshag, and Mahler's catalogue of the Robert Woods Bliss Collection at Dumbarton Oaks (1957*), was updated in part by Benson (1963*, 1969*). Noteworthy examples of the relatively complete publication of museum collections include Bolz (1975*), Nicholson and Cordy-Collins (1979*), and Parsons (1980*). Easby and Scott (1974*), and Nicholson (1983*) have catalogued exhibits assembled from diverse sources.

Several catalogues that focus on one region or ethnic tradition have become standard references. West Mexican ceramic sculpture has been featured in Kan, Meighan, and Nicholson (1970*), Von Winning and Hammer (1972*), and Eisleb (1971*). Kidder and Samayoa Chinchilla wrote a catalogue of Maya art (1958*). Frierman (1969*) documented the Natalie Wood collection of Chupicuaro ceramics. Ceramics of Veracruz and Oaxaca, respectively, have been catalogued by Nicholson, et. al. (1971*), and Schuler-Schömig (1970*).

Documentation of data: monuments, murals, and manuscripts. The late twentieth century has produced several heirs to the nineteenth-century practice of careful record-keeping for posterity. Merle Greene Robertson's rubbings of Maya sculpture have proved important for the detailed study of iconography, style, and epigraphy (Greene 1966*, 1967*; Greene, Rands, and Graham 1972*). Arthur Miller's cataloging and contextual documentation of Mesoamerican murals (Teotihuacan: 1969*, 1970*, 1973*; Chichen Itza: 1977*, 1979*; Tulum-Tancah 1982*) and Villagra-Caleti's work on Teotihuacan murals (1951*, 1952*, 1965*) have made them the intellectual descendants of Adela Breton.

Ian Graham's long-term project of recording all Maya texts found on stone monuments, jade, shell, bone, wood, stucco, and painted walls (1975-*) has already produced nearly a dozen volumes. Art scholars especially appreciate his clear line drawings of monumental sculpture and associated texts. On a related topic, Karl Mayer's catalogues of displaced Maya sculpture are useful compilations (1978*, 1980*).

Late twentieth-century graphic technology has made it possible to print fine color photographic facsimiles of native pictorial manuscripts.[17] The Sociedad Mexicana de Antropología has published several (see, for example, Caso 1960*, 1964*; Caso and Smith 1966*). European publishers, however, have led the field. Reproductions of the Selden Roll (Burland 1955*) and the Dresden Codex (Lips and Deckert 1962*) were published in Berlin; more recently, Akademische Druck -u. Verlagsanstalt in Graz, Austria, has published numerous facsimiles of the highest quality. See, for example, Anders 1967*, 1968*, 1970*, 1976*; Burland 1965*, 1966*; Nowotny 1961*, 1968*.

Documentation of codices also includes the monumental bibliographic task of cataloging and annotating manuscript works. John Glass's catalogue to the collection of manuscripts in the Museo Nacional in Mexico (1964*) is an important reference. His work, along with that of many colleagues, has continued in the "Guide to Ethnohistorical Sources" which comprises volumes 12-15 of the Handbook of Middle American Indians (Wauchope 1964-). I have not annotated the individual essays in these volumes in the bibliography. All are essential reference works, but particularly noteworthy for the student of pre-Columbian art are Robertson (1972) and Glass (1975). Glass also provides an exhaustive annotated bibliography of manuscript studies (1975).

Pictorial manuscripts. The study of native pictorial documents moved into the forefront of scholarly activity concurrently with publication of first-rate facsimiles. Within the past thirty years, an international group of scholars has turned[18] to examination of manuscripts from Central and Southern Mexico. These screenfolds, lienzos, and other pictorial documents of both preconquest and colonial date, comprise a rich stratum of information that is finally being mined successfully.

In the decades just prior to this period, few scholars investigated manuscripts. But since the 1950s, a steadily growing stream of contributions has modified and deepened our knowledge of Central Mexican and Mixtec ethnohistory, economics, art, genealogy, and religion. Two important review articles illuminate the history of manuscript studies (Nicholson 1960*; Troike 1978*). Writing in 1960, Nicholson discussed history of research and publication, and present state of knowledge. While announcing plans for the Handbook of Middle American Indians bibliographic project, he nevertheless laments the fact that "research into the Mesoamerican pictorials is today hardly riding the crest of a wave" (1960:214*). Less than twenty years later, Troike was able to assert that "since mid-1974 very significant progress has been made in understanding and interpreting the Mixtec codices . . . This time of almost explosive growth has radically altered the foundations of the field" (1978:553*).

Alfonso Caso's many important contributions to codex studies span two decades (1951*, 1955*, 1959*, 1960*, 1960*, 1964*, 1964*, 1967*; Caso and Smith 1966*), although his chronological contributions have been superseded by more recent scholarship, as Troike indicates. Other scholars working early in this period include Dibble (1951*) and D. Robertson (1959*) on early postconquest pictorials, Dark (1958*) and M.E. Smith (1963*) on Mixtec manuscripts, and Nowotny (1961*) and Spranz (1964*) on iconographic issues. More recently, manuscript specialists have studied technical and physical aspects of the materials (Troike 1969*, 1970*; Robertson 1982*) as well as stylistic questions (Robertson 1963*, 1966*; Troike 1970*, 1979*, 1982*; Boone and Nuttall 1983*). Iconographical, historical, and linguistic research has been conducted by M.E. Smith (1973*, 1973*, 1979*), J. Furst (1977*, 1978*, 1978*, 1978*, 1982*), Rabin (1979*), Chadwick (1982*), and Durand-Forest (1982*), among others. Anawalt has demonstrated that costume analysis is a fruitful technique for solving some problems in provenience, attribution, and meaning (1979*, 1981*, 1981*).

Olmec studies. Although Olmec archaeology and discussion of the "Olmec problem" began two decades before the start of this period (see remarks, page 11), studies of Olmec art have only come of age in recent years. Beginning with the influential works of Covarrubias (1957*, 1977*), Olmec art in every medium--from architecture (Diehl 1981*; Heizer and Drucker 1968*) to colossal heads (de la Fuente 1975*; Kubler 1977*; Clewlow, et. al. 1967*) to jade (Stirling 1961*)--has been the topic of lively scholarly investigation.

Starting with P. Furst's landmark article on the Olmec were-jaguar motif (1968*), numerous experts have considered problems in Olmec iconography (Coe 1972*, 1973*; Joralemon 1971*, 1976* 1981*; Pohorilenko 1975*, 1977*; Gay 1972*, 1972*; Grove 1970*, 1972*, 1973*, 1981*; de la Fuente 1977*). Indeed, the 1970s might be considered the "decade of the Olmec" in Mesoamerican studies. Sculpture has been examined in detail by Stirling (1965*) and de la Fuente (1973*, 1977*).

De la Fuente (1975*, 1981*), Kubler (1977*) and Millbrath (1979*) have tackled the problem of stylistic analysis of Olmec art. Remarks on Olmec historiography appear in Stirling (1968*).

Synthesizing knowledge of Olmec art and culture has been under- taken with admirable result by Bernal (1969*), Wicke (1971*), and Coe (1965*, 1965*, 1968*). The explosion of research in the past fifteen years warrants some updating of these general works, however. The publication of the Dumbarton Oaks conference volume The Olmec and Their Neighbors (Benson 1981) has begun this process.

Maya art. North American scholars have long expressed keen interest in the Maya, as discussed on pages 9-11. Art historical studies are no exception. While Proskouriakoff (1946*, 1950*, 1964*, 1965*), Rands (1952*, 1953*, 1954*); and Thompson (1961*, 1963*, 1972*, 1973*, 1975*) have studied the Maya for many years, interest in the topic has bloomed since 1969, in part because of increased excavation at Maya sites such as Tikal. Kubler's influential iconographic studies (1969*, 1974*, 1976*, 1977*), Coggins's work on Tikal (1975*), and the several volumes on Palenque edited by Merle Greene Robertson (1974*, 1976*, 1980*) represent major strides in understanding Maya art. Kubler, Coggins, and many participants in the Palenque conferences demonstrate the efficacy of the combined epigraphic/iconographic approach, which has taken hold in this period. See, for example, Schele (1974*, 1976*, 1977*, 1979*), Cohodas (1974*, 1976*), Baudez and Mathews (1979*), and M.G. Robertson (1974*, 1979*).

The 1970s have also witnessed a great blossoming of scholarly interest in Maya polychrome pottery. Michael Coe has been the leader in this field, with his groundbreaking The Maya Scribe and His World (1973*). Coe's later works continue investigation of the imagery and texts on Maya vases (1975*, 1977*, 1978*, 1982*); again, a combined epigraphic and iconographic inquiry has proven most fruitful. Iconographic and stylistic investigations of Maya pottery have also been undertaken by Quirarte (1977*, 1979*, 1979*, 1979*) and Robicsek (1981*; Robicsek and Hales 1982*). D. Taylor's study of restoration and overpainting on Maya vases provides an important caveat to such inquiries (1982*).

The demand for Maya art objects, in particular, in the international art market, has led to increased looting of many archaeological sites. Several scholars have served as the art world's conscience, advocating both legislation and greater public recognition of the moral and legal aspects of this issue. (See Coggins 1969*, 1972*, 1972*; M.G. Robertson 1972*; Meyer 1972*, 1977*). For discussion of related issues of repatriation and falsification see Braun (1982*) and Boone (1982*, ed.).

Teotihuacan art. As in the study of Maya art, recent excavation at Teotihuacan has precipitated interest in the art of that Central Mexican metropolis. Several scholars, however, have been looking at

Teotihuacan art for many years (Caso 1942*, 1959*, 1966*; Von Winning 1947*, 1947*, 1947*, 1949*, 1961*, 1976*). Sejourné has published numerous useful photos and line drawings of Teotihuacan finds (1966*, 1966*, 1966*, 1969*), while Villagra Caleti (1951*, 1952*, 1965*, 1971*) and A. Miller (1969*, 1973*, 1974*) have documented wall painting. Teotihuacan murals have been the topic of other studies as well, some dealing predominantly with chronology (Hall 1962*), others with iconography (Pasztory 1976*). Kubler's essay on Teotihuacan iconography remains the best short statement on that topic (1967*); individual themes are elucidated by others. See Millon (1973*), Pasztory (1973*, 1974*), Von Winning (1961*, 1968*, 1977*, 1979*), Heyden (1975*, 1981*), Kubler (1972*, 1973*) and Berlo (1982*, 1983*). Von Winning's forthcoming La iconografía de Teotihuacan: Los dioses y los signos should prove a valuable summary statement of his encyclopedic knowledge of Teotihuacan art. Recently, a small body of literature has considered the subject of Teotihuacan artistic influence on the Maya area and elsewhere (Quirarte 1973*, 1979*; Pasztory, ed. 1978*; Hellmuth 1975*, 1978*; A. Miller 1978*; Berlo 1980*, 1983*; and Von Winning 1948*, 1967* and 1977).

Aztec art. Aztec art history has recently emerged as a topic of importance to North American scholars. In this country it had long been overshadowed by interest in the Maya and the Olmec. Scholars working in Europe and Mexico have always been interested in late Central Mexican peoples (Fernandez 1954*, 1959*, 1963*, 1966*; Garcia Payon 1946*, 1974*; Hvidtfeldt 1958*; Heyden 1971*, 1972*, 1972*, 1974*; Solis Olguin 1982*; Sullivan 1976*, 1982*; Van Zantwijk 1981*), but until the 1970s, UCLA anthropologist H.B. Nicholson was one of few U.S. scholars to focus chiefly on the Aztec. He remains the most influential writer in English on Aztec art and religion (1954*, 1955*, 1958*, 1961*, 1961*, 1963*, 1967*, 1971*, 1971*, 1973*, 1983*). In the last decade, a younger generation has launched Aztec studies into new realms of social history of art, as well as rigorous art historical studies of style and meaning (Klein 1975*, 1976*, 1977*, 1980*, 1982*; Townsend 1979*, 1982*, 1982*; Pasztory 1983*). Moreover, Aztec art history has provided the point of departure for art historical examinations of acculturation and social change (D. Robertson 1974*; Baird 1979*, 1983*; B. Brown 1977*, 1982*, 1983*).

Architecture and city planning. Detailed excavation reports have always considered architectural sequences and site layouts. General treatments of architecture (Marquina 1928*, 1951*; Totten 1926*) as well as some monographs on individual structures (for example, Morris, Charlot and Morris 1931*; Ruppert 1931*) appeared in the preceding period. In the last thirty years, many more detailed architectural studies have been published. A number survey Mesoamerica as a whole (D. Robertson 1963*; Hardoy 1964*; Heyden and Gendrop 1973*), but the Maya area has received the major share of attention in architectural history. Maya architectural studies range from broad regional surveys (Rivet 1960*; Andrews 1975*; Hartung 1971*; Maler 1971*; Pollock 1965*) to analyses of subregions (Foncerrada de Molina 1962*; Potter 1977*) to

studies of individual structures (Bolles 1972*; Cohodas 1978*; Kowalski 1981).

Burgeoning interest in archaeoastronomy and astronomical siting of structures is an offshoot of recent architectural endeavor (Broda 1982*; Aveni and Gibbs 1976*; Aveni and Hartung 1979*; Aveni and Linsley 1972*), as is the interest in architecture as reflective of world-view and cosmological order (Schele 1981*; Townsend 1982*, 1982*; Coggins 1982*).

<u>Minor arts</u>. In pre-Columbian art history, the distinction between "fine art" and "minor art" or "craft" is not as pronounced as in European art. So-called "minor arts"--small-scale, portable objects of jade, metal, clay, fabric, and so forth--have routinely been included in the literature (see for example Gann 1924*, 1930*; Saville 1922*, 1925*; Lothrop 1952*). Yet, as in many other areas, interest in such topics has intensified in recent years. Reasons for increased publications in this area are threefold. The rise of pre-Columbian art publications in general has led to greater investigation of objects that are rare, unusual in medium or use, or that can shed light on cultural practices (miniature stelae: Hammond, Kelley, and Mathews 1975*; textiles: Johnson, all entries*; Pang, 1975*; d'Harcourt 1958*; incense burners: Goldstein 1977*; Berlo 1980*, 1982*). The rise of international commerce in pre-Columbian antiquities has also sparked increased scholarly interest in small-scale objects such[19] as Jaina figurines and jades that are the mainstays of the art market[19] (jades: E. Easby 1961*; Digby 1964*; Proskouriakoff 1974*; Jaina figurines: Groth-Kimball 1961*; Piña-Chan 1968*; Corson 1973*, 1975*, 1976*; Goldstein 1974*, 1980*; turquoise mosaics: Carmichael 1970*). Thirdly, scholars increasingly realize that study of non-elite objects provides insight into questions of social meaning and artistic style (Pasztory 1983*:78-79, 281-91; Ramsey 1982*).

<u>Stylistic and formal analysis</u>. In addition to the area and media studies mentioned thus far, several scholars have conducted traditional art historical analyses of stylistic and formal problems. Again, the Maya have received the most attention, perhaps because the relative naturalism of Maya sculpture and painting lends itself more easily to a methodology derived from the study of European art. De la Fuente (1965*), D. Robertson (1974*), and Clancy (1977*) have considered Maya sculpture, while Grieder (1964*), Coggins (1975*), and Lombardo de Ruiz (1976*, 1979*) have described Maya painting.

Olmec sculpture has been the subject of several stylistic analyses (de la Fuente 1975*, 1981*; Kubler 1977*). Aztec and Mixtec painting styles have been discussed by D. Robertson (1963*, 1966*) and Boone (1982*). Proskouriakoff has delineated Classic Veracruz sculptural style (1960*). The stylistic convergence of different traditions has been outlined by D. Robertson 1959*, 1970*), Bailey (1972*), and Baird (1979*).

Connoisseurship studies. Another area fundamental to European art history is the study of individual artists and masterpieces. Such topics have played only a minor role in pre-Columbian art history. It is not surprising that, along with the stylistic analyses just mentioned, connoisseurship studies have been conducted primarily by scholars who are art historians rather than anthropologists. Studies of individual hands and workshops have focused on the Maya (Trebbi del Trevigiano 1958*; Griffin 1976*; M.G. Robertson 1975*, 1977*; Cohodas 1979*). Scott has considered Zapotec ceramic workshops (1977*). Pasztory has examined the notion of "the masterpiece," focusing her remarks on Aztec sculpture (1979*).

Chronological problems and regional boundaries. Although many studies, both art historical and archaeological, have addressed problems of chronology, a few deserve special mention. All use art objects as the primary basis for chronological or regional realignment. In 1960 H.B. Nicholson reformulated Vaillant's Mixteca-Puebla concept, characterizing it primarily as a horizon style (1960*). This has proved useful for subsequent studies of this period and region (see Nicholson 1982* for an update). Artistic manifestations of Mixteca-Puebla style on the Caribbean coast were outlined by D. Robertson in his essay, "The Tulum Murals: The International Style of the Late Post-Classic" (1970*).

The concept of horizon style, first put forth in Andean studies, was also adopted by Lee Parsons in his radical reordering of Mesoamerican Classic-period chronology and history (1969*; first sketched out in a 1957 article). Parsons posits a Middle Classic horizon in Mesoamerica from 400-700 A.D., based on the overriding influence of Teotihuacan during this era. Pasztory's art historical reconstruction of Middle Classic Mesoamerica (Pasztory, ed. 1978*) builds on Parsons's earlier achievements. Other scholars, too, have argued for a reordering of Mesoamerican chronologies, arguing that the lowland Maya-based divisions of Early and Late Classic do not fit the data from other regions (see Andrews 1965; Price 1976). Kubler's remarks on periodization and the variability of chronological boundaries are germane here as well (1970*).

Intellectual trends. The last few pages have documented an explosion of scholarly publications in the last quarter-century. During this period, pre-Columbian art history has reflected the intellectual fashions of the successive decades, from the shamanistic and psychopharmacological focus of the late 1960s and early 1970s (P. Furst 1968*, 1974*, 1974*; Wasson 1973*), to the materialist and cultural evolutionist interpretations emerging today (Pasztory 1984). But as the discipline of pre-Columbian art history has matured, its practitioners have assumed an increasingly articulate, self-critical stance. The growing literature on methodology, theory, and historiography attests to this.

This most widespread methodological controversy of recent years concerns the use of nonart sources. The proper place of ethonohistoric texts, ethnographic analogy, and "upstreaming" in art historical interpretation has been vigorously debated. Peter Furst's article analyzing Olmec were-jaguar imagery by means of South American ethnographic parallels (1968*) sparked this controversy. Various partisan positions have been set forth by P. Furst (1973*, 1974*), Willey (1973*), Nicholson (1976*) and Kubler (1970*, 1972*, 1972*, 1973*, 1973*). (See Berlo 1983:2-7 for further discussion of the main features of the debate.) Kubler has been the main opponent of ethnohistory and ethnography as art historical evidence. The generation of art historians succeeding Kubler has mediated the disciplinary dispute; Grieder (1975*) and Pasztory (1973*) have both advocated an approach that draws from all disciplines and sources while mandating rigorous methodological standards.

Pasztory's "synthetic approach" (1973*) and her comparative intra-cultural analysis of Mesoamerican systems during the Middle Classic period (ed. 1978:3-22, 108-42*) stand as models for modern scholarship. Such cross-disciplinary or cross-cultural methodologies are characteristic of the best recent work in the field. For example, the epigraphic/iconographic approach to Maya art already discussed (p. 19) combines linguistic and artistic data for more holistic understanding of the Maya. Marcus has used this method profitably to elucidate early Zapotec art (1980*); most current Mixtec scholars follow it as well (see p. 17-18).

Recently several individuals have emerged as critics of the discipline, repudiating the narrowly defined purview of traditional art history. Coggins eschews

> the specialized and historically limited pursuits of pure connoisseurship. The study of isolated objects that have been torn from their context serves but the narrowest purposes of scholarship while at the same time feeding the international art market which finances the looting of archaeological sites. (1979:319*)

She advocates studies that answer historical questions.

Klein, too, criticizes the ahistorical bent of most art historical investigations. Using recent dissertation topics as examples, she finds them to be almost exclusively

> descriptive, stylistic or iconographic analyses of select classes of objects . . . Symbolic studies, moreover, are still notably restricted to the ideological sphere. Images are typically "explained' by pre-Columbian art historians in terms of mythic, astronomical and/or religious concepts . . . And while there is some sparring within the discipline as to whether stylistic analysis or iconography is more

informative, there traditionally has been general agreement on both sides that history as such is at best a secondary goal. When historical reconstructions do surface, they are as particularistic, as preoccupied with the unique, as were those of Boas, and are usually confined to the narrow typologies and seriations that absorbed the attention of archaeologists prior to 1940. This practice conforms to Kubler's dictum (1975:758*) that art operates according to its own principles, independent of "history" on a grander scale, a dictum still accepted by most art historians in the field. (1982:4*)

Assessing the current state of the field, Klein concludes that in defining itself by its methodologies (stylistic and iconographic analyses, etc.), pre-Columbian art history has retarded its own intellectual development. She advocates a "redefinition of the discipline in terms of its contribution to our common fund of knowledge about human behavior in general" (1982:5*).

The widespread refusal to see Mesoamerican art as political propaganda that can provide information about the state has been criticized both by Pasztory (1984) and Klein (1982:5*). Pasztory further notes that exhibits and catalogues continue to "perpetuate the notion that the art and ideology of the elite is the art and ideology of an entire nation" (1983:393). The issue of elite versus popular art must be addressed in order to understand the socially stratified world of pre-Columbian peoples.

This recent concern with historical issues and social process could signal a new era for Mesoamerican art studies. Yet it remains to be seen whether such criticisms will significantly alter the course of a rapidly growing field. In 1983 the National Gallery of Art in Washington, D.C. mounted an exhibit of elite Aztec art entitled "Treasures of Tenochtitlan." While applauding this event as "another step in the struggle to give non-Western art a legitimate place in our cultural life," one scholar decried the "presentation of objects for our aesthetic contemplation or even delectation when their original intention was not primarily aesthetic or contemplative" (Pasztory 1983:391). In effect, she pleads that we treat the art of pre-Hispanic Mesoamerica with all the depth and nuance and intellectual sophistication that we muster for other human achievements, and not simply marvel, as Albrecht Dürer did that summer day in 1520, at the artistry of men in foreign lands.

Notes

1. The items that Dürer saw were sent by Cortes to Charles V of Spain with his first letter to the monarch in the summer of 1519 (see J. Bayard Morris, ed. 1928:381-82). In this first letter, Cortes describes the inhabitants of the Yucatan and Gulf Coast, as well as their ornaments and architecture (ibid., p. 22), but without the sense of wonder and appreciation apparent in the later letters from Central Mexico (e.g., see ibid., pp. 83-88).

2. On the history of European intellectual involvement with the New World see also Brotherston 1979, and Turner 1980.

3. George Kubler has pointed out that the first art historian to comment upon ancient Mesoamerican art was Franz Kugler, whose Handbuch der Kunstgeschichte (1842) was the first history of world art. Kugler's comments on Mesoamerica were based on his readings of Humboldt, Dupaix, Kingsborough, and others. Like his predecessors, he favored the art of Palenque (see Kubler 1962:13-14*).

4. My categorization and periodization in this section derive loosely from that of Willey and Sabloff, who refer to the period from 1840 to 1914 as the Classificatory-Descriptive Period (1974:42-87). Stephens's and Catherwood's work marks the beginning of the period both for me and for Willey and Sabloff. They, however, close the era with the implementation of the stratigraphic method in Mexico and Peru (1974:8). In an art historical context, I find the pivotal date for the close of one period and the opening of the next to be Spinden's influential Study of Maya Art (1913*).

5. Kingsborough's fourth volume illustrated monuments and sculpture. Volumes five through nine contained extracts of Humboldt's and Dupaix's writings, as well as Kingsborough's own voluminous notes and outlandish theories.

6. See Griffin 1974* for a discussion of travellers to Palenque before 1900 and their verbal and visual impressions of the site. See also Baddeley 1982* for discussion of nineteenth-century response to Mesoamerican art.

7. Spinden's interest in seriation and chronology reflects archaeological issues of his day. The first twenty years of the twentieth century witnessed the first stratigraphic work in the Valley of Mexico. Gamio's studies (1913) and subsequently those of Vaillant (1938) made clearer the sequential nature of the major pre-Hispanic cultures.

8. See Michael Coe's remarks on this topic in his memorial tribute to Matthew Stirling in American Antiquity 41, no. 1:67-70.

9. See Bernal (1980:160-89), Willey and Sabloff (1974:88-177) and Hammond (1983:15-25) for a fuller archaeological historiography of this period. See Bernal (1962*) for an exhaustive directory of publications resulting from this field work.

10. Gardner's several editions serve as a barometer for the art world's interest in pre-Columbian art. Her first and second editions devote one chapter to "aboriginal art" (1926:388-403; 1936:534-63). Gardner's third edition (1948) includes coverage of Asia and ancient America in each of her Ancient, Medieval, and Renaissance sections. The fourth edition (1959) continues the practice. The fifth edition (1970), edited by De la Croix and Tansey, omits non-Western arts, offering the explanation that such topics are now covered in their own courses and textbooks. The sixth edition (1975) restores, in a highly abbreviated fashion, discussion of non-Western art. The cursory overview (eleven pages) of pre-Columbian art includes nine illustrations of Mesoamerican objects as compared with sixteen in the 1948 edition; nineteen in the 1936 edition, and seventeen in 1926.

11. See Kelemen (1946:152-53*) for a full listing of the other exhibits. See Cahill's catalogue of the first Museum of Modern Art show (1933*) and Charlot's review of the second (1940*). In addition, Bernal's bibliography (1962:53-64*) lists numerous catalogues, articles, and reviews published during this period.

12. He adds that the outbreak of World War II forced some scholars to abandon European research and embrace Latin American topics instead.

13. Klein's remarks are amplified, and bibliographic references provided in an unpublished English version.
 Recently, Aldona Jonaitis, an historian of American Indian art, has documented a parallel pattern in acceptance of North American Indian art by the art world. She suggests that "major exhibits which scholars agree had profound effects on the public perception of Indian art were as much motivated by the political concerns of the United States government during the thirties and forties as they were by a sudden awareness of an intrinsic esthetic merit in the art itself" (1981:6).

14. A distinction should be made here between the scholarly community and the art-loving public. In the popular world of exhibits, sales catalogues, and general-interest articles in magazines like Apollo and Connoisseur, the level of interest has increased greatly. However, to judge by many art historians, professional meetings, and prestigious art historical publications, pre-Columbian art still lacks intellectual "respectability."

15. This dissertation was later published by Yale University Press (1959*). Robertson's own remarks on his intellectual history also shed light on this era (1970).

16. See Klein's unpublished English version of her 1982 article for an appendix listing twenty-five of these individuals from 1956 to 1979.

17. See Nicholson (1960:208-10*) for discussion of the history of earlier reproduction and publication of manuscripts.

18. The study of Maya codices is subsumed under Maya studies, and will not be discussed here. While Troike has rightly stressed the necessity for studying Mixtec manuscripts separately from Central Mexican ones, advances in both areas are treated together here. The reader should keep in mind that Mixtec studies is a subarea with its own patterns of analysis and interpretation (see Troike 1978:553-54*).

19. Although I have already discussed Maya polychrome ceramics, these studies, too, are both product of and spur to the illegal international art market.

Supplemental Bibliography

(Works cited in the essay that are not
included in the annotated bibliography)

Andrews, E. Wyllys
 1965 Archaeology and prehistory in the northern Maya lowlands:
 an introduction. Handbook of Middle American Indians. Ed.
 R. Wauchope. 2:288-330. Austin: University of Texas
 Press.

Basler, Adolphe, and Ernest Brummer
 1928 L'art précolumbien. Paris: Librairie de France.

Benson, Elizabeth (ed.)
 1981 The Olmec and Their Neighbors. Washington, D.C.:
 Dumbarton Oaks.

Bernal, Ignacio
 1980 A History of Mexican Archaeology: The Vanished Civiliza-
 tions of Middle America. London: Thames and Hudson.

Boone, Elizabeth
 1978 The C.A.A. and Iberian and Interamerican art. Research
 Center for the Arts Review 1, No. 1:4-5. San Antonio.

Bustamente, Carlos Maria de (ed.)
 1832 Descripción histórica y cronológica de las dos piedras que
 conocasión del nuevo empedrana que es esta formando en la
 plaza principal de México, por Don Antonio de León y Gama.
 Mexico: Alejandro Valdés.

Brotherston, Gordon
 1979 Image of the New World. London: Thames and Hudson.

Carmichael, Elizabeth
 1973 The British and the Maya. London: The British Museum.

Charnay, Desiré
 1863 Cités et ruines américaines. Paris: Gide.

 1885 Les anciennes villes du nouveau monde. Paris.

Cossio-Pijoan, José
 1931 Summa Artis. Madrid.

Covarrubias, Miguel
 1942 Origen y desarrollo del estilo artístic "olmeca." Mayas y
 Olmecas. Mexico: Sociedad Mexicana de Antropología. 46-
 49.

Durán, Fray Diego
 1971 Book of the Gods and Rites and the Ancient Calendar. Trans.
 and ed. F. Horcasitas and D. Heyden. Norman: University of
 Oklahoma Press.

Faure, Eli
 1901-21 Histoire de l'art. Paris. Translated as History of Art in
 Two Volumes. New York: Dover Publications, 1948.

Gamio, Manuel
 1913 Arqueología de Atzcapotzalco, D.F., Mexico. Proceedings of
 the 18th International Congress of Americanists. 180-87.
 London.

Gardner, Helen
 1926 Art through the Ages. New York: Harcourt, Brace and Co.

 1936 Art through the Ages. Revised (second) edition.

 1948 Art through the Ages. Third edition.

 1959 Art through the Ages. Fourth edition.

 1970 Art through the Ages. Fifth edition.

 1975 Art through the Ages. Sixth edition.

Glass, John B.
 1975 A survey of Native Middle American pictorial manuscripts.
 Handbook of Middle American Indians 14:3-80. Austin:
 University of Texas Press.

 1975 Annotated references. Handbook of Middle American Indians
 15:537-724. Austin: University of Texas Press.

Hammond, Norman
 1983 Lords of the jungle: a prosopography of Maya archaeology.
 Civilization in the Ancient Americas: Essays in Honor of
 Gordon R. Willey. Ed. R.M. Leventhal and A.L. Kolata.
 Albuquerque: University of New Mexico Press.

Herrera, Hayden
 1983 Frida: A Biography of Frida Kahlo. New York: Harper and
 Row.

Holt, Elizabeth Gilmore, ed.
 1957 A Documentary History of Art, Vol. 1. Garden City, N.Y.:
 Doubleday, Anchor Books.

Humboldt, Alexander von
 1814 Researches Concerning the Institutions and Monuments of the
 Ancient Inhabitants of America. London.

Jonaitis, Aldona
 1981 Creations of mystics and philosophers: the white man's
 perceptions of Northwest Coast Indian art from the 1930s to
 the Present. American Indian Culture and Research Journal
 5, no. 1:1-45.

Kleinbauer, W. Eugene
 1971 Modern Perspectives in Western Art History. New York:
 Holt, Rinehart and Winston.

Kowalski, Jeff Karl
 1981 The House of the Governor, A Maya Palace at Uxmal, Yucatan,
 Mexico. Doctoral Dissertation, Department of History of
 Art, Yale University. Ann Arbor: University Microfilms.

Kugler, Franz
 1842 Handbuch der Kunstgeschichte. Stuttgart.

Linné, Sigvald
 1934 Archaeological Researches at Teotihuacan, Mexico. Ethno-
 graphic Museum of Sweden Publication no. 1. Stockholm.

Marquina, Ignacio
 1951 Arquitectura prehispánica. Mexico: Instituto Nacional de
 Antropologia e Historia.

Merwin, Raymond
 1913 The Ruins of the Southern Part of the Peninsula of Yucatan
 with Special Reference to Their Place in Maya Culture.
 Ph.D. dissertation, Department of Anthropology, Harvard
 University.

Morley, Sylvanus
 1920 The Inscriptions of Copan. Carnegie Institution of
 Washington Publication no. 219. Washington, D.C.:
 Carnegie Institution of Washington.

 1937-8 The Inscriptions of Peten. 5 vols. Carnegie Institution of
 Washington Publication no. 437. Washington,D.C.: Carnegie
 Institution of Washington.

Morris, Ann Axtell
 1931 Digging in the Yucatan. New York: Doubleday, Doran, and
 Co.

Morris, J. Bayard, ed.
 1928 Five Letters of Cortés to the Emperor. New York: W.W.
 Norton Co.

Nadaillac, Marquis de
 1884 Prehistoric America. New York and London: G.P. Putnam's
 Sons.

Nuttall, Zelia
 1902 Codex Nuttall: Fascimile of an Ancient Mexican Codex
 Belonging to Lord Zouche of Harynworth England. Cambridge:
 Peabody Museum of Harvard University.

Parsons, Lee
 1957 The nature of horizon markers in Middle American archae-
 ology. Anthropology Tomorrow 5, no. 2:98-121. Chicago:
 University of Chicago Press.

Pasztory, Esther
 1983 Review: The Art of Aztec Mexico. Art Journal 43, no.
 4:390-93.

 1984 The function of art in Mesoamerica. Archaeology 37, no.
 1:18-25.

Pijoan, José
 1927 History of Art. New York: Harper and Brothers.

Price, B.J.
 1976 A chronological framework for cultural development in Meso-
 america. The Valley of Mexico Ed. Eric Wolf. 13-21.
 Albuquerque: University of New Mexico Press.

Proskouriakoff, Tatiana
 1960 Historical implications of a pattern of dates at Piedras
 Negras, Guatemala. American Antiquity 25:454-75.

 1963 Historical data in the inscriptions of Yaxchilan. Estudios
 de Cultura Maya 3:149-67.

 1964 Historical data in the inscriptions of Yaxchilan (part II).
 Estudios de Cultura Maya 4:177 202.

Riegl, Alois
 1901 Die spätrömische Kunst-Industrie. Vienna.

Robertson, Donald
 1970 Clio in the New World. The Historian's Workshop Ed. L.P.
 Curtis, Jr. New York: Knopf.

 1972 The pinturas (maps) of the Relaciones Geográficas, with a
 catalog. Handbook of Middle American Indians 12:243-78.
 Austin: University of Texas Press.

Robertson, W.R.
 1778 The History of America. London.

Ruppert, Karl, and J.H. Dennison
 1943 Archaeological Reconnaissance in Campeche, Quintana Roo and Peten. Carnegie Institution of Washington Publication no. 543. Washington, D.C.: Carnegie Institution of Washington.

Sabloff, Jeremy (ed.)
 1981 Supplement to the Handbook of Middle American Indians: Archaeology. Austin: University of Texas Press.

Semper, Gottfried
 1860-63 Der Stil in den technischen und tektonischen Künsten oder Praktische Aesthetik. Munich: F. Bruckmann.

Stephens, John Lloyd, and Frederick Catherwood
 1841 Incidents of Travel in Central America, Chiapas, and Yucatan. New York.

 1843 Incident of Travel in Yucatan. New York.

Turner, Frederick
 1980 Beyond Geography. New York: Viking Press.

Vaillant, George
 1938 A correlation of archaeological and historical sequences in the Valley of Mexico. American Anthropologist n.s. 40:535-73.

Von Sydow, Eckart
 1923 Die Kunst der Natur-Völker und der Vorzeit. Berlin: Propyläen Kunstgeschichte.

Von Winning, Hasso
 1977 Los incensarios teotihuacanos y los del Litoral Pacífico de Guatemala: su iconografia y función ritual. Los Procesos de Cambio 2:327-34. Mexico: Sociedad Mexicana de Antropología.

 forthcoming
 La iconografía de Teotihuacan: Los dioses y los signos. Mexico: Universidad Nacional Autonoma de Mexico.

Waldeck, F.M.
 1866 Monuments anciens du Mexique. Paris.

Wauchope, Robert (ed.)
 1964- Handbook of Middle American Indians. Austin: University of Texas Press.

Wilder, Elizabeth
 1941 Call for pioneers. College Art Journal 1, no. 1:6-8.

Willey, Gordon R., and Jeremy A. Sabloff
 1974 <u>A History of American Archaeology</u>. San Francisco: W.H.
 Freeman and Company.

The Art of Pre-Hispanic Mesoamerica: An Annotated Bibliography

Abrams, H. Leon, Jr.
1 1973. Comentario sobre la sección colonial del codice Telleriano-Remensis. Anales (Ser. 7) 3:139-76. 14 plates.
 Study of both pictorial and textual aspects of this postconquest manuscript. Useful concordance of chronological correspondences among numerous manuscripts.

2 1977. Justin Kerr's innovative contribution to Maya archaeology. Katunob: A Newsletter-Bulletin on Meso-american Anthropology 10, no. 2:19-22. 1 fig. Greeley, Colorado: University of Northern Colorado.
 Description of the development of roll-out photography of cylindrical vessels.

Acosta, Jorge R.
3 1940. Exploraciones en Tula, Hidalgo, 1940. Revista Mexicana de Estudios Antropológicos 4, no. 3:172-94. 8 figs., 5 plates, 4 tables, 4 maps.
 Important for early site plans and architectural plans.

4 1943. Los colosos de Tula. Cuadernos Americanos 12, no. 6: 138-46. 2 figs., 8 plates.
 Description and illustration of the figural pillars and columns discovered at Tula, Hidalgo in recent excavations. Identification of warrior attributes in costume.

5 1944. La tercera temporada de exploraciones arqueológicas en Tula, Hidalgo, 1942. Revista Mexicana de Estudios Antropológicos 6, no. 3:125-60. 31 figs., 3 maps.
 Many useful architectural plans, drawings of stone monuments, and architectural reliefs.

6 1945. La quarta y quinta temporadas de exploraciones arqueológicos en Tula, Hidalgo, 1943-1944. Revista Mexicana de Estudios Antropológicos 7, nos. 1-3:23-64. 34 figs., 4 maps.

Although a report on field seasons, is useful for drawings and photos of monuments and relief sculpture. Color plates of polychrome relief frieze in the vestibule of Mound B.

7 1949. El pectoral de jade de Monte Alban. Anales 3:17-25. 6 figs., 1 color plate. Mexico: Instituto Nacional de Antropología e Historia.
Discussion of the excavation and reconstruction of the famous jade Murciélago pectoral mask of Monte Alban II date. Comparison with bat iconography on pottery urns.

8 1961. La indumentaria de las cariatides de Tula. Homenaje a Pablo Martínez del Río. 221-28. 22 figs. Mexico: Instituto Nacional de Antropología e Historia.
Inventory of costume elements on the large warrior columns of Pyramid B at Tula.

9 1964. El Palacio del Quetzalpapalotl. 85 pp., 114 figs., 7 color plates. Mexico: Instituto Nacional de Antropología e Historia.
In-depth study of the excavation and rebuilding of one structure at Teotihuacan.

10 1965. Preclassic and classic architecture of Oaxaca. Handbook of Middle American Indians 3. Ed. Gordon R. Willey. 814-36. 29 figs. Austin: University of Texas Press.
Focuses almost exclusively on Monte Alban.

11 1966. Un brasero excepcional de Teotihuacan. Boletín del Instituto Nacional de Antropologia e Historia 23:23-24. 1 fig. Mexico.
Unusual two-part spiked censer found in La Ventilla excavations.

Adams, R. E. W.
12 1963. A polychrome vessel from Altar de Sacrificios, Guatemala. Archaeology 16, no. 2:90-92. 5 figs.
Illustration of a ceramic masterpiece excavated at this Maya site in 1962. Detailed discussion of figural iconography and dating to 754 A.D.

13 1973. Fine orange pottery as a source of ethnological information. Contributions of the University of California Archaeological Research Facility 18:1-9. Berkeley.
Balancan and Altar Fine Orange ceramics analyzed in terms of the light they shed on the Classic Maya collapse.

Adams, R. E. W., and Robert C. Aldrich.
14 1980. A reevaluation of the Bonampak murals: a preliminary statement on the paintings and texts. Third

Palenque Round Table, 1978. Part 2. Ed. M.G. Robertson.
45-59. 10 figs. Austin: University of Texas Press.
 Principally concerned with textual analysis and glyphic
passages in the wall paintings. Identification of historical
personages.

Adelhofer, Otto.
15 1963. Codex Vindobonensis Mexicanus. 37 pp., 8 figs. with
 separate screenfold facsimile between boards, 55 pp. on
 obverse, 13 pp. on reverse. Graz, Austria: Akademische
 Druck- und Verlagsanstalt.
 Color facsimile of Codex Vienna. Detailed commentary by
 the author. Good bibliography.

Agrinier, L.
16 1960. The Carved Human Femurs from Tomb 1, Chiapa de Corzo.
 Papers of the New World Archaeological Foundation 6. 42
 pp. 17 figs., 28 plates. Provo, Utah.
 Thorough analysis of the bones discovered in this early
 Proto-Classic tomb. The two carved bones (nos. 1 and 3) are well
 illustrated and their symbolism is discussed.

Aguilera, Carmen.
17 1971. Una posible deidad negroide en el panteón azteca.
 Estudios de Cultura Nahuatl 9:47-56, 4 figs.
 Unconvincing case made for negroid deities in ceramic
 art of pre-Hispanic Mexico based on the facial features of some
 Tlatilco figurines and one figure in the Codex Matritense.

18 1977. El arte oficial Tenochca: Su significación social.
 Cuadernos de historia del arte, 5. 168 pp., 18 plates.
 Mexico: Universidad Nacional Autónoma de Mexico.
 Aztec art considered in its social and historical con-
 texts, and in respect to its function. Most useful for its
 analysis of the arts under each Aztec ruler. Few illustrations.

Ainsworth, Maryan.
19 1975. A flute in the Olsen collection: its place in pre-
 Columbian music and art. Yale University Art Gallery
 Bulletin 35, no. 2:26-33. 7 figs.
 A possible Post-Classic Gulf Coast provenance for this
 polychrome ceramic flute.

Albers, Anni.
20 1970. Pre-Columbian Mexican Miniatures. unpaginated. 84
 plates. New York: Praeger Publishers.
 Catalog of Josef and Anni Albers's collection of small-
 scale pre-Columbian figurines. Emphasis on the Pre-Classic
 period.

Alcina Franch, José.
21 1955. Fuentes indígenas de Méjico: ensayo de
 sistematización bibliográfica. Revista de Indias 15, no.
 62: 421-521.
 Systematic classification of codices according to ethnic
 affiliation. Subcategories according to type.

Alsberg, John L.
22 1968. Ancient Sculpture from Western Mexico. 135 pp., 60
 black-and-white plates. Berkeley: Nicole Gallery.
 Illustrations of figural sculpture, mostly in clay.
 Text less useful.

Alvarez Heydenreich, Laurencia.
23 1976. Indumentaria en el Códice Nuttall. Boletín (ser. 2)
 18:39-48. 21 figs. Mexico: Instituto Nacional de
 Antropología e Historia.
 Superficial discussion of clothing styles in a Mixtec
 codex.

Anawalt, Patricia.
24 1976. The Xicolli: "godly jackets" of the Aztecs.
 Archaeology 29, no. 4:258-65. 7 figs.
 Analysis of the sleeveless fringed jacket tied at the
 neck that was worn by Aztec men in particular rituals. Examples
 drawn from sculpture and codices.

25 1976. The Xicolli: an analysis of a ritual garment.
 Proceedings of the 41st International Congress of
 Americanists 2:223-35. 18 figs.
 The sleeveless jacket worn by males is discussed as a
 garment worn by priests and other participants in religious
 observances, based principally on its depictions in codices and
 discussion in ethnohistoric documents.

26 1977. What price Aztec pageantry? Archaeology 30, no. 4:
 226-33. 7 figs.
 Aztec military attire analyzed for clues to the meaning
 of ritual pomp and display.

27 1979. The Mixtec-Aztec Xicolli: a comparative analysis.
 Proceedings of the 42nd International Congress of
 Americanists 7:147-60. 11 figs. Paris.
 Use of the Xicolli among the Mixtec relates to the
 wearer's social class, unlike the Aztec situation where it
 relates to particular ritual events. The author uses a produc-
 tive methodological approach for comparing differences and
 similarities in the material culture of two societies.

28 1980. Costume and control: Aztec sumptuary laws.
 Archaeology 33, no. 1:33-43. 9 figs.

Through use of codex illustrations and ethnohistory, the author sets forth the basic features of clothing proscriptions in a highly stratified society. Emphasis on the use of costume and emblem among nobles and warriors.

29 1981. Costume analysis and the provenience of the Borgia Group codices. <u>American Antiquity</u> 46, no. 4:837-52. 30 figs.
 Author points out that, based on costume analysis, Borgia-group manuscripts probably did not originate in the Mixteca because they do not display Mixtec ritual clothing patterns. Diverse origins suggested for codices of this group.

30 1981. <u>Indian Clothing before Cortés: Mesoamerican Costumes from the Codices</u>. 232 pp., 64 figs., 23 charts, 16 color plates and numerous text figures. Norman: University of Oklahoma Press.
 Important, exhaustive study of clothing styles of the Aztecs, Tlaxcalans, Tarascans, Mixtecs, Lowland Maya, and Borgia-group area and their meanings. Invaluable for the wealth of data collected.

31 1982. Analysis of the Aztec quechquemitl: an exercise in inference. <u>The Art and Iconography of Late Post-Classic Central Mexico</u>. Ed. Elizabeth Boone. 37-72. 17 figs. Washington, D.C.: Dumbarton Oaks.
 Further studies in costume analysis as cultural information.

Anders, Ferdinand.
32 1967. <u>Codex Tro-Cortesianus (Codex Madrid)</u>. 54 pp. and separate screenfold facsimile in two sections, 35 and 21 leaves. Graz, Austria: Akademische Druck- und Verlagsanstalt.
 Color facsimile of the Maya Madrid Codex. Commentary in German with English summary.

33 1968. <u>Codex Peresianus (Codex Paris)</u>. 41 pp. and separate screenfold facsimile, 11 leaves. Graz, Austria: Akademische Druck-und Verlagsanstalt.
 Color facsimile of the Maya Paris Codex. Commentary in German with English summary.

34 1970. <u>Codex Magliabecchiano CL. XIII. 3 (B.R. 232)</u>. 77 pp. with separate facsimile, 1 plus 92 leaves. Graz, Austria: Akademische Druck-und Verlagsanstalt.
 Color facsimile of a Mexican codex. Commentary in German with English summary.

35 1976. <u>Codex Ixtlilxochitl</u>. 36 pp. text, 30 color facsimile plates, 20 black-and-white facsimile pages of text. Graz, Austria: Akademische Druck-und Verlagsanstalt.

A facsimile of the manuscript. Fine color plates. Brief commentary on style and content in French; summaries in Spanish, English, German.

Anderson, A. J. O.
36 1963. Materiales colorantes prehispánicos. Estudios de Cultura Nahuatl 4:73-83.
 Sources for dyes and paint as described by sixteenth-century texts are identified.

Anderson, A. J. O., and Charles Dibble.
37 1950-69. Florentine Codex: General History of the Things of New Spain by Fray Bernardino de Sahagún. 11 vols. Santa Fe: School of American Research and the University of Utah.
 Nahuatl text and English translation of Sahagun's manu-script about Aztec life.

Anderson, Edgar, and R. H. Barlow.
38 1943. The maize tribute of Moctezuma's empire. Annals of the Missouri Botanical Garden 30:413-20. 1 plate. St. Louis.
 Pictures in Codex Mendoza and Matrícula de Tributos analyzed for information about provinces paying tribute in corn.

Anderson, Edgar, R. H. Barlow, and J. J. Finan.
39 1945. Maize in the Yanhuitlan Codex. Annals of the Missouri Botanical Garden 32:361-66. 3 figs., 2 plates. St. Louis.
 Yanhuitlan Codex discussed in terms of the drawings of maize and their botanical identification.

Andrews, E. Wyllys.
40 1939. A group of related sculptures from Yucatan. Contributions to American Anthropology and History 5, no. 26:67-79. 3 figs., 2 plates. Washington, D.C.: Carnegie Institution of Washington.
 Several unusual figural sculptures, some with pronounced phallic emphasis, from west-central Quintana Roo illustrated and discussed.

41 1968. Dzibilchaltun: a northern Maya metropolis. Archaeology 21:36-47. 16 figs.
 Good brief introduction to recent excavations at this northern Maya site and to the periodization and architectural plan of the ancient city.

42 1974. Some architectural similarities between Dzibilchaltun and Palenque. Primera Mesa Redonda de Palenque Part I. Ed. M. G. Robertson. 137-47. 7 figs., 1 table. Pebble Beach, California: Robert Louis Stevenson School.

A relationship is posited between the western Maya lowlands and northern Yucatan based on numerous architectural similarities.

43 1979. Early Central Mexican architectural traits at Dzibilchaltun, Yucatan. Proceedings of the 42nd International Congress of Americanists 8:237-49. 4 figs. Paris.
 Teotihuacan-style talud-tablero at this northern Yucatan site.

Andrews, George F.
44 1967. Comalcalco, Tabasco, Mexico: An Architectonic Survey. 105 pp., 59 plates, 13 maps, 24 architectural drawings. Eugene: University of Oregon.
 Mapping and architectural survey of a Maya site. Useful site map and plans of all buildings.

45 1969. Edzna, Campeche, Mexico: Settlement Patterns and Monumental Architecture. 149 pp., 71 figs., 17 drawings. Eugene: University of Oregon.
 Mapping and architectural survey of this Maya site. Stelae are illustrated and described.

46 1975. Maya Cities: Placemaking and Urbanization. 468 pp., 350 figs. Norman: University of Oklahoma Press.
 Important study of Maya architecture, its basic elements and groupings, with descriptions of twenty Maya sites.

Angulo, Jorge.
47 1970. Un posible códice de El Mirador, Chiapas. 22 pp., 7 figs. Mexico: Instituto Nacional de Antropología e Historia.
 Report on a layered stucco block, badly decomposed, discovered in excavation at this site in Chiapas. The author argues convincingly that it is an ancient manuscript.

Animal Sculpture in Pre-Columbian Art.
48 1957. 48 pp., 72 figs. Chicago: Art Institute of Chicago.
 Catalog of zoomorphic sculpture, principally in clay, from Mexico and South America.

Anton, Ferdinand.
49 1969. Ancient Mexican Art. 309 pp., 215 illustrations. New York: G. P. Putnam's sons.
 Translated from Alt-Mexiko und seine Kunst. Divides Mesoamerican history into "Archaic Cultures," "Classic Theocracies," and "Toltec and Aztec Militarism." Excludes the Maya. Text focuses on general culture history rather than art.

50 1970. Art of the Maya. 351 pp., 66 figs., 299 plates. New
 York: G. P. Putnam's Sons.
 Translation of his 1968 Kunst der Maya (Leipzig).
 Lavishly illustrated survey of Maya art from early Classic to
 Late Post-Classic times. Text is not detailed.

51 1973. La mujer en la América antigua. 86 pp., 112 photos
 plus unnumbered text figures. Mexico.
 Translated from 1973 German original "Die Frau im alten
 Amerika" (Leipzig). Introduction to female deity figures, prin-
 cipally in stone, pottery, and manuscripts, and their icono-
 graphy. Both Middle and South America are considered.

Armillas, Pedro.
52 1944. Los dioses de Teotihuacán. Anales del Instituto de
 Etnología Americana 6:35-61. 16 figs., 2 plates. Mendoza,
 Argentina: Universidad Nacional de Cuyu.
 Important early classificatory study of gods in the Teo-
 tihuacan iconographic system.

Arnold, Dean Edward.
53 1967. "Sak lu'um" in Maya Culture: and Its Possible
 Relation to Maya Blue. Department of Anthropology Research
 Reports, 2. 53 pp., 9 tables. Urbana: University of
 Illinois.
 Ethnographic study of potters' materials in the Yucatan,
 especially the clay mineral attapulgite, for the light that they
 shed on the question of the makeup of the ancient "Maya blue"
 pigment.

Arsandaux, H., and Paul Rivet.
54 1921. Contribution à l'étude de la métallurgie mexicaine.
 Journal de la Société des Américanistes de Paris n.s.
 13:261-80. 2 plates. Paris.
 Brief technological survey of metallurgical techniques,
 illustrated by objects from the Trocadero Museum and private
 collections. Particular interest in copper and tin alloys.

55 1923. Nouvelle note sur la métallurgie mexicaine.
 L'Anthropologie 33:63-85. 1 plate.
 Further technological study of metallurgical techniques
 in Mexican metal objects in Trocadero Museum.

Art de Mésoamerique/Meso-Amerikaanse kunst.
56 1976. Société Générale de Banque. Bruxelles. 197 plates,
 some in color.
 Brief introductory statement accompanies illustration
 of ancient objects, principally small-scale, in stone and
 ceramic.

Ashton, Dore and Lee Bolton.
57 1957. Abstract Art before Columbus. André Emmerich
 Gallery. 48 pp., 28 figs. New York.
 Mostly Mexican objects.

Aveleyra Arroyo de Anda, Luis.
58 1963. La estela teotihuacana de La Ventilla. Cuadernos
 del Museo Nacional de Antropología, 1. 26pp., 12 figs.
 Mexico.
 Useful study of the four-part low-relief sculpture found
 at Teotihuacan thought to be a ballcourt marker.

59 1963. An extraordinary composite stela from Teotihuacan.
 American Antiquity 29, no. 2:235-37. 2 figs.
 Report on the discovery at the La Ventilla ranch of a
 unique four-part sectional stone sculpture. A Classic period
 date and a function as a ball courtmarker are suggested.

Aveleyra Arroyo de Anda, Luis, and Gordon F. Ekholm.
60 1971. Clay scupture from Jaina. Anthropology and Art. Ed.
 C. M. Otten. 311-17. 1 fig. Garden City, N.Y.: The
 Natural History Press.
 Brief article on Jaina figurines and their archaeologi-
 cal context.

Aveni, Anthony, and Sharon L. Gibbs.
61 1976. On the orientation of Precolumbian buildings in
 Central Mexico. American Antiquity 41, no. 4:510-17. 5
 figs.
 Architectural alignments east of north determined for a
 number of pre-Hispanic structures. The exact orientations of a
 number of Central American structures are listed.

Aveni, Anthony, and Horst Hartung.
62 1979. Some suggestions about the arrangement of buildings
 at Palenque. Tercera Mesa Redonda de Palenque. Ed. M. G.
 Robertson and D. C. Jeffers. 173-77. 3 figs. Monterey,
 California.
 Brief discussion of the solstitial nature of the astro-
 nomical orientation of the Cross Group. Cosmic symbolism relat-
 ing to Palenque's rulers and their individual buildings is
 suggested.

63 1980. The cross petroglyph: an ancient Mesoamerican
 astronomical and calendrical symbol. Indiana 6:37-54. 5
 figs. Berlin: Ibero-Amerikanisches Institut Preussischer
 Kulturbesitz.
 Pecked crosses at Teotihuacan and Alta Vista and their
 astronomical importances.

Aveni, Anthony, Horst Hartung, and Beth Buckingham.
64 1978. The pecked cross symbol in ancient Mesoamerica.
 <u>Science</u> 202, no. 4365:267-79.
 Reports twenty-nine locations where quartered circle
 figures occur. Multileveled iconography of the symbol is pre-
 sented.

Aveni, Anthony, and Robert M. Linsley.
65 1972. Mound J, Monte Alban: possible astronomical
 orientation. <u>American Antiquity</u> 37, no. 4:528-40. 2
 figs., 3 tables.
 It has been determined that at the time of the construc-
 tion of Mound J at this Zapotec capital, a line perpendicular to
 the base of the steps would have pointed to the heliacal rising
 of the star Capella. A possible zenith sighting tube was built
 into the steps.

Azcue y Mancera, Luis.
66 1967. <u>Codice Peresiano</u>. 135 pp., 20 plates. Mexico:
 Editorial Orion.
 Mediocre study of the Maya Paris Codex. Useful for
 black-and-white illustrations of the pages of the manuscript.

Aztec sculpture.
67 1933. <u>American Magazine of Art</u> 26:485-94. 13 figs. New
 York.
 Brief essay and photos of Aztec sculpture in the Museum
 of Anthropology in Mexico City.

<u>Aztlan, terre des Aztèques: Images d'un nouveau monde.</u>
68 1976. 113 pp., 39 illustrations. Paris: Bibliothèque
 Nationale.
 Well-illustrated catalog of an exhibition mounted in
 honor of the centenary anniversary of the Société des
 Américanistes. Objects and manuscripts from the holdings of the
 Bibliothèque Nationale. Post-Classic Central Mexican
 manuscripts are the predominant illustrations.

Baddeley, Oriana.
69 1982. Changing conceptions of Mesoamerican art. <u>The Other
 America</u>. Ed. Valerie Fraser and Gordon Brotherston. 69-
 76. England: University of Essex.
 Brief historiographic essay on the changing appreciation
 by Europeans of Mesoamerican art.

70 1983. The relationship of ancient American writing systems
 to the visual arts. <u>Text and Image in Pre-Columbian Art</u>.
 Ed. J. C. Berlo. 55-77. 8 figs. Oxford: British
 Archaeological Reports.

Historical background underlying the study of pre-Columbian art is considered. Maya and Central Mexican systems of conveying meaning are compared, with particular attention paid to their convergence at Cacaxtla.

Badner, Mino.
71 1972. A Possible Focus of Andean Artistic Influence in Mesoamerica. Dumbarton Oaks Studies in Pre-Columbian Art and Archaeology, 9. 56 pp., 53 figs. Washington, D.C.
Based on formal and thematic similarities in Chavin and Moche art in Peru and Izapan art, the author posits contact between Andean civilizations and the Late Pre-Classic cultures of the Pacific coast of Guatemala and Chiapas.

Baer, Gerhard.
72 1972. Figuren und Gefässe aus Alt-Mexico. unpaginated, 14 figs. Basel: Museum für Völkerkunde.
Catalog of an exhibit of figural ceramics. Checklist of 134 objects. Brief introductory essay.

Bailey, Joyce W.
73 1972. Map of Texupa (Oaxaca, 1579): a study in form and meaning. The Art Bulletin 54, no. 4:452-72. 23 figs.
Formal and iconographic study of a postconquest map reveals a blending of indigenous and European conventions.

74 1978. The study of Latin American art history in the United States: the past forty years. Research Center for the Arts Review 1, no. 2:1-3. San Antonio: University of Texas.
Interesting inquiry into the reasons behind the rise and fall of art world interest in Latin America.

Baird, Ellen Taylor.
75 1979. Sahagun's "Primeros Memoriales": A Structural and Stylistic Analysis of the Drawings. Ph.D. dissertation. Department of Art History, University of New Mexico. 348 pp., 113 figs. Ann Arbor: University Microfilms.
Sahagun's early work on the Aztec placed in its sixteenth-century context. Identification of European and indigenous elements of style and form.

76 1983. Text and image in Sahagun's Primeros Memoriales. Text and Image in Pre-Columbian Art. Ed. J. C. Berlo. 155-79. 11 figs. Oxford: British Archaeological Reports.
Pictorial structure of this sixteenth-century manuscript and the function of the illustrations are considered. This illuminates Sahagun's methodology and suggests what sorts of preconquest manuscripts were the source materials for the visual images.

Baker, Robert George.
77 1962. The recarving and alteration of Maya monuments.
 American Antiquity 27, no. 3:281-302. 23 figs.
 Important discussion of the stylistic and calendrical
inconsistencies found on Classic Maya monuments. These are
explained by the established Maya practice of altering,
resetting, and recarving such monuments.

Ball, Joseph W.
78 1974. A Teotihuacan-style cache from the Maya lowlands.
 Archaeology 21, no. 1:2-9. Reprinted in Pre-Columbian Art
 History. Ed. Alana Cordy-Collins and Jean Stern. 71-80.
 8 figs. Palo Alto: Peek Publications, 1977.
 Analysis of a cache of Teotihuacan ceramics, including a
cylindrical tripod, hollow figure, and miniature mold-made
figurine inserts. The martial iconography of the figures is
stressed, as well as its alien context at Becan in the Yucatan.

79 1975. Cui orange polychrome: a Late Classic funerary type
 from central Campeche, Mexico. Contributions of the
 University of California Archaeological Research Facility
 27, no. 4:32-39. 3 figs., 1 plate. Berkeley.
 Discussion of the geographical distribution, age, and
iconography of one ceramic type. Three complete plates
illustrated.

Ballesteros-Gaibrois, Manuel.
80 1964. Codices Matritenses de la Historia General de las
 Cosas de la Nueva España de Fr. Bernadino de Sahagún. 2
 vols. 342 pp., 52 color folio photographs. Madrid:
 Ediciones José Porrúa Toranzas.
 Study of early postconquest manuscript. Especially
useful for its fifty-two pages of color plates of the original
manuscript, although they are in small scale.

Balser, Carlos.
81 1959. Los "Baby Faces" olmecas de Costa Rica. Proceedings
 of the 33rd International Congress of Americanists 2:280-
 85. 1 fig. San Jose.
 Discussion of Olmec-style figural jades found in Costa
Rica.

82 1968. A new style of Olmec jade with string sawing from
 Costa Rica. Proceedings of the 38th International Congress
 of Americanists, 243-47. 5 figs. Stuttgart and Munich.
 Stirrup-shaped Olmec jade effigy head and its technique
of manufacture.

Barbachano Ponce Mayan Art Collection.
83 1976. 32 pp. 22 plates. Corpus Cristi, Texas: Golden
 Banner.

Catalog of an exhibit of 148 pieces of Maya art.

Bardawil, Lawrence W.
84 1976. The principal bird deity in Maya art: an
 iconographic study of form and meaning. Segunda Mesa
 Redonda de Palenque. Ed. M.G. Robertson. 195-209. 25
 figs. Pebble Beach, Calif.: Robert Louis Stevenson
 School.
 Avian forms, their genesis in Izapa sculpture, and their
 representations in Maya monumental arts are considered. The
 principal bird deity is considered as a member of the long-
 lipped complex, possibly an avian manifestation of Itzamna.

Barlow, R. H.
85 1946. The Malinche of Acacingo, Estado de Mexico. Notes on
 Middle American Archaeology and Ethnology 3, no. 65:31-33.
 1 fig. Washington, D.C.: Carnegie Institution of
 Washington.
 Notes on an Aztec rock carving of late preconquest date.

86 1946. The Tamiahua Codices. Notes on Middle American
 Archaeology and Ethnology 3, no. 64:26-30. 3 figs.
 Washington, D.C.: Carnegie Institution of Washington.
 Notes on three maps of areas in Veracruz. Maps show no
 trace of European influence.

87 1947. The Codex of Tonayan. Notes on Middle American
 Archaeology and Ethnology 3, no. 84:178-81. 6 figs.
 Washington, D.C.: Carnegie Institution of Washington.
 Postconquest map from Veracruz (also known as the Plano
 de San Juan Chapultepec) is discussed.

88 1947. Stone objects from Cocula and Chilacachapa,
 Guerrero. Notes on Middle American Archaeology and
 Ethnology 3, no. 80:151-55. 4 figs. Washington, D.C.:
 Carnegie Institution of Washington.
 Additions to the known corpus of small-scale Mezcala
 style sculptures.

Barnett, Mme.
89 1912. Quelques observations sur les petites tetes de
 Teotihuacán. Proceedings of the 18th International
 Congress of Americanists. 203-5. London.
 Questions raised about the function of small clay heads
 found in great numbers at Teotihuacan. Hypothesis that
 miniature heads are small-scale emblems of actual human
 sacrifices to the gods.

Barrera Rubio, Alfredo.
90 1980. Mural paintings of the Puuc region in Yucatan. Third
 Palenque Round Table, 1978. Part 2. Ed. M. G. Robertson.
 173-82. 15 figs. Austin: University of Texas Press.

Review and illustration of vestiges of mural paintings at Mulchic, Chacmultun, Chacbolay, Dzulá, Xkichmol, and Kom.

91 1980. La obra fotográfica de Teobert Maler en la Peninsula de Yucatan. Indiana 6:107-24. 5 figs. Berlin: Ibero-Amerikanisches Institut Preussischer Kulturbesitz.
Report on 189 early photographs now in Merida, taken by Maler, mainly at Puuc and Chenes sites. All sites and number of photos of each are listed.

Barrera Vasquez, Alfredo.
92 1975. La ceiba-cocodrilo. Anales (ser. 7a) 5:187-208. 37 figs. Mexico: Instituto Nacional de Antropología e Historia.
Relationships of earth monsters to trees in Mesoamerican thought. Examples from glyphs, codices, and monumental art.

Barthel, Thomas.
93 1963. Die Stele 31 von Tikal. Tribus 12:159-241, 4 figs. Stuttgart.
Although principally a study of the lengthy hieroglyphic text on the back of the Early Classic Stela 31, Barthel also considers the iconography of the figural relief.

94 1972. Asiatische Systeme im Codex Laud. Tribus 21:97-128. Stuttgart.
Trans-Pacific parallels in planetary information in this Mexican codex.

95 1975. Weiteres zu den hinduistischen Äquivalenzen im Codex Laud. Tribus 24:113-36. 3 figs. Stuttgart.
An attempt at correlating the planetary aspects of principal Hindu deities with figures depicted in Mexican codices.

96 1979. Enigmatisches in Codex Vaticanus 3773: Kosmogramm und Eschatologie. Tribus 28:83-122. 5 figs. Stuttgart.
Another of his Indo-Mexican studies. Hindu mythology and epigraphy used to unlock meaning of Mexican codices.

97 1980. Methods and results of Indo-Mexican studies. Indiana 6:13-21. 2 tables. Berlin: Ibero-Amerikanisches Institut Preussischer Kulturbesitz.
A preliminary report on research on trans-Pacific influences in Mesoamerica, focusing on religious aspects of the Codex Borgia group.

98 1980. Mourning and consolation: themes of the Palenque sarcophagus. Third Palenque Round Table, 1978. Part 2. Ed. M. G. Robertson. 81-90. 1 fig. Austin: University of Texas Press.

Iconography of sarcophagus lid and sides shown to encode messages based on verbal and visual punning and the use of multiple metaphors.

99 1981. Veritable "texts" in Teotihuacan art. The Masterkey 56, no. 1:4-12. 3 figs.
 Preliminary remarks on the need for a systematic study of Teotihuacan iconography to determine the existence and meaning of "texts" in the visual symbolic vocabulary.

Basler, A., and E. Brummer.
100 1928. L'art précolumbien. 64 pp., 8 color plates, 190 black-and-white plates. Paris.
 Middle and South America are covered. The focus is almost solely on sculpture and pottery from the Trocadero.

Bastian, A.
101 1876. Die Monumente in Santa Lucia Cotzumalguapa. Zeitschrift für Ethnologie 8:322-26. 2 plates. Berlin.
 Description of several of the sculptured stone monuments at this southern Guatemalan site. Early discussions, but not well illustrated.

Bastien, Rémy.
102 1951. The pyramid of the Sun in Teotihuacán, a new interpretation. Selected Papers of the 29th International Congress of Americanists 62-67. 4 figs. Chicago.
 Disputes Batres's early reconstruction of the pyramid as a five-bodied structure. Suggests a four-level pyramid is more accurate. Figure 1 presents a tentative reconstruction model.

Batres, Leopoldo.
103 n.d. Civilización de algunas de las diferentes tribus que habitaron el territorio hoy mexicano, en la antiquedad. 92 pp., 30 plates. Mexico.
 Early study of small-scale archaeological materials from various sites. Focus on ceramic, stone, and metal objects. Beautifully rendered drawings of the objects.

104 1905. La lápida arqueológica de Tepaxtlaco-Orizaba. 18 pp., 26 plates. Mexico: Tipografia de Fidencio Soria.
 Stone monuments from one region in Mexico are briefly described, with reference to other, better-known reliefs. Useful only for early photographs of several objects.

105 1912. Descubrimientos y consolidación de los monumentos arqueológicos de Teotihuacán. Proceedings of the 18th International Congress of Americanists. 188-93. London.
 Description of the current work of the author at Teotihuacan and problems of reconstruction.

Baudez, Claude, and Peter Mathews.
106 1979. Capture and sacrifice at Palenque. Tercera Mesa
 Redonda de Palenque. Ed. M. G. Robertson and D. C.
 Jeffers. 31-40. 13 figs. Monterey, California.
 Iconography of captive and bound figures in Classic Maya
 sculpture is briefly surveyed, followed by an examination of the
 captive figures from Houses A and C and elsewhere at Palenque.
 Brief discussion of related hieroglyphic texts.

Becker-Donner, Etta.
107 1962. Präkolumbische Malerei. 64 pp., 24 figs. Vienna:
 Verlag Brüder Rosenbaum.
 Brief discussion of painting in both Meso- and South
 America. Pottery painting, wall painting, and other media are
 considered. Most useful for color figures.

108 1965. Die mekikanischen Sammlungen des Museums für
 Völkerkunde, Wien. 56 pp., 64 figs., 8 color plates.
 Vienna: Museum für Völkerkunde.
 Introductory essay on the regional manifestations of
 ancient Mexican culture, followed by a catalog of the objects in
 the museum's collection.

Becquelin, Pierre, and Claude F. Baudez.
109 1975. Architecture et sculpture à Tonina, Chiapas,
 Mexique. Proceedings of the 41st International Congress of
 Americanists 1:433-36. Mexico.
 Brief report on types of structures and monuments dis-
 covered in recent excavations at this Maya site.

Beetz, Carl P., and Linton Satterthwaite.
110 1981. The Monuments and Inscriptions of Caracol, Belize.
 132 pp., 43 figs. Philadelphia: The University Museum.
 Epigraphic and stylistic study of stelae and associated
 monuments. First dynastic history of the rulers here. Fine line
 drawings of all monuments.

Beidler, Paul.
111 1952. An architect in Mayaland. Natural History 61:440-
 45, 473-74. 9 figs.
 Popular account of adventures in Belize while doing
 architectural rendering for the University of Pennsylvania
 Museum. Description of process of accurately rendering a stucco
 frieze at Xunan Tunich.

Benson, Elizabeth P.
112 1963. Handbook of the Robert Woods Bliss Collection of
 Pre-Columbian Art. 78 pp., 145 black-and-white plates.
 Washington, D.C.: Dumbarton Oaks.
 Checklist of 425 pieces in the Dumbarton Oaks
 collection; 159 objects illustrated.

113 1969. Supplement to the Handbook of the Robert Woods Bliss
 Collection of Pre-Columbian Art. unpaginated, 13 black-
 and-white plates. Washington, D.C.: Dumbarton Oaks.
 Thirty-six additional objects in the Bliss collection,
 thirteen of which are illustrated.

114 1970. The Maya World. 176 pp., 60 figs. New York:
 Crowell.
 Survey of Maya culture, with particular attention to
 art, architecture, and religion.

115 1971. An Olmec Figure at Dumbarton Oaks. Dumbarton Oaks
 Studies in Pre-Columbian Art and Archaeology, 8. 39 pp.,
 46 figs. Washington, D.C.
 An analysis of a small-scale diopside human figure said
 to have come from Arroyo Pesquero. The meaning of its elaborate
 incised designs is discussed. Briefer analysis of a previously
 unpublished broken half-figure also in the Dumbarton Oaks
 collection.

116 1974. Gestures and offerings. Primera Mesa Redonda de
 Palenque Part I. Ed. M.G. Robertson. 109-20, 18 figs.
 Pebble Beach, California: Robert Louis Stevenson School.
 The author outlines a topic worthy of further
 examination: the importance of pose and figural gestures for an
 understanding of the meaning of monumental sculpture and vase
 painting.

117 1976. Ritual cloth and Palenque kings. Segunda Mesa
 Redonda de Palenque. Ed. M.G. Robertson. 45-58. 16 figs.
 Pebble Beach, California: Robert Louis Stevenson School.
 Cloth bundles and draped fabrics as seen in monumental
 sculpture at Palenque. Supporting evidence from other sites and
 from Maya ceramics.

118 1979. Observations on certain visual elements in late
 classic Maya sculpture. Tercera Mesa Redonda de Palenque.
 Ed. M. G. Robertson and D. C. Jeffers. 91-97. 5 figs.
 Monterey, California.
 The use of the shield, manikin scepter, windsock, and
 other ceremonial objects at Palenque, especially in the Temple
 of the Sun, is compared to the use of such ritual paraphernalia
 at other sites. Palenque is shown to be unique in certain
 conventions pertaining to the use and display of such objects.

119 1981. Some Olmec objects in the Robert Woods Bliss
 collection at Dumbarton Oaks. The Olmec and Their
 Neighbors. 95-108. 11 figs. Washington, D.C.: Dumbarton
 Oaks.
 Assessment of eight of the most significant small-scale
 Olmec pieces at Dumbarton Oaks. Discussion of their stylistic

and iconographic relationship to other significant works of Olmec style.

Benson, Elizabeth P. (ed.)
120 1968. Dumbarton Oaks Conference on the Olmec. Washington
 D.C.: Dumbarton Oaks.
 Proceedings of the 1967 conference. Contributions by
 Stirling, M. Coe, Proskouriakoff, and Furst are annotated here.

121 1972. The Cult of the Feline: A Conference in Pre-
 Columbian Iconography. 166 pp. Washington, D.C.:
 Dumbarton Oaks.
 Proceedings of the 1970 conference. Mesoamerican
 contributions by M. Coe, Kubler, and Grove are annotated here.

122 1975. Death and the Afterlife in Pre-Columbian America.
 Washington, D.C.: Dumbarton Oaks.
 Proceedings of the 1973 conference. Mesoamerican
 contributions by Furst, Klein, and M. Coe are annotated here.

123 1977. The Sea in the Pre-Columbian World. 188 pp., 35
 figs., 3 tables. Washington, D.C.: Dumbarton Oaks.
 Proceedings of the 1974 conference at Dumbarton Oaks.
 Mesoamerican contributions by J. Sabloff and A. Miller are
 annotated here.

124 1981. Mesoamerican Sites and World Views. Washington,
 D.C.: Dumbarton Oaks.
 Proceedings of the 1976 conference at Dumbarton Oaks.
 Articles by Heyden, Hartung, Van Zantwijk, Schele and Carlson
 annotated here.

Beecher, Graciela, and Robert Beecher.
125 1974. Danzantes engraved on two jade plaques. Archaeology
 27, no. 2:130-32. 4 figs.
 First publication of unusual jade breast plaques said to
 be in a private collection for nearly a century.

Berlin, Heinrich.
126 1970. Miscelánea palencana. Journal de la Société des
 Américanistes 59:107-28. 6 figs. Paris.
 Report on early exploration and illustrations of the
 Maya site of Palenque, and epigraphic notes on some
 inscriptions. Article in Spanish.

Berlo, Janet Catherine.
127 1976. Punning in the Madrid Codex: an interaction of text
 and image. New Mexico Studies in the Fine Arts 1:26-8.
 Albuquerque.
 An examination of pages 38, 42, and 43 of the Maya Madrid
 Codex reveals that so-called scribal errors were really glyphic

puns, the understanding of which depends on both illustration and glyphic passages.

128 1980. Teotihuacan Art Abroad: A Study of Metropolitan Style and Provincial Transformation in Incensario Workshops. Doctoral dissertation, Dept. of History of Art, Yale University. 387 pp., 297 figures. Ann Arbor: University Microfilms International.
 Analysis of Classic period incense burners in the Valley of Mexico, Escuintla, Guatemala, and Lake Amatitlan, Guatemala. Style, iconography, and cultural context considered.

129 1982. Artistic specialization at Teotihuacan: the ceramic incense burner. Pre-Columbian Art History: Selected Readings. Second edition. Ed. A. Cordy-Collins. 83–100. 12 figs. Palo Alto: Peek Publications.
 An in-depth analysis of one art form, the clay incensario, suggests certain deductions about Teotihuacan workshop practices and craft specialization. Context, iconography, and ritual use considered as well.

130 1983. Conceptual categories for the study of texts and images in Mesoamerica. Text and Image in Pre-Columbian Art. Ed. J.C. Berlo. 1–40. 8 figs. Oxford: British Archaeological Reports.
 Surveying how twentieth-century scholars have handled the relationship of textual sources to visual imagery, the author suggests that Mesoamerican texts can be divided into 1) discrete texts, 2) conjoined texts, and 3) embedded texts. Methodological issues in the study of pre-Columbian art are discussed.

131 1983. The warrior and the butterfly: Central Mexican ideologies of sacred warfare and Teotihuacan iconography. Text and Image in Pre-Columbian Art. Ed. J. C. Berlo. 79–117. 9 figs. Oxford: British Archaeological Reports.
 Evidence for Teotihuacan military and religious beliefs about a martial butterfly goddess who is a precursor of the Aztec goddesses Itzpapalotl and Xochiquetzal, based on analysis of metropolitan Teotihuacan art as well as Teotihuacan-style art in Escuintla, Guatemala.

Berlo, Janet Catherine (ed.).
132 1983. Text and Image in Pre-Columbian Art: Essays on the Interrelationship of the Verbal and Visual Arts. 212 pp. Oxford: British Archaeological Reports.
 Collection of essays that examine the relationship of art to writing in Mesoamerica and the Andes. Contributions by Berlo (2), A. Miller, Baddeley, Baird, and B. Brown annotated here.

Bernal, Ignacio.
133 1962. Bibliografía de arqueología y etnografía,
 Mesoamerica y norte de México, 1514-1960. 634 pp. Mexico:
 Instituto Nacional de Antropología e Historia.
 Nearly 14,000 entries on archaeology, art, calendrics,
 and anthropology, divided by geographical and cultural areas.
 Extremely useful.

134 1965. Architecture in Oaxaca after the end of Monte Alban.
 Handbook of Middle American Indians 3. Ed. Gordon R.
 Willey. 837-48. 17 figs. Austin: University of Texas
 Press.
 Mitla and Yagul are discussed almost exclusively.

135 1968. The ball players of Dainzu. Archaeology 21, no.
 4:246-51. 11 figs.
 Introductory article on the formative period relief
 sculptures from a site in Oaxaca.

136 1968. The Olmec presence in Oaxaca. Mexico Quarterly
 Review 3:5-22. 14 figs.
 Reliefs of danzantes at Monte Alban and ballplayers at
 Dainzu and what they reveal of Olmec influence.

137 1969. The Olmec World. 273 pp., 103 plates, 43 figs.
 Berkeley: University of California Press.
 Important and detailed survey of Olmec art and culture.
 Profusely illustrated. Useful bibliography of works before
 1967.

138 1969. 100 Great Masterpieces of the Mexican National
 Museum of Anthropology. 100 color illustrations. New
 York: Harry N. Abrams.
 Large-scale picturebook of well-known pre-Columbian
 objects. Brief remarks at end of book on each object.

139 1973. Stone reliefs in the Dainzu area. The Iconography of
 Middle American Sculpture. 13-23. 17 figs. New York:
 Metropolitan Museum of Art.
 A sculptural substyle of long duration (Monte Alban 1-
 5), centered on the site of Dainzu is examined.

140 1976. The jaguar facade tomb at Dainzú. To Illustrate the
 Monuments: Essays on Archaeology Presented to Stuart
 Piggott. Ed. J. V. S. Megaw. 296-300. 11 figs. London:
 Thames and Hudson.
 Contents and structure of Tomb 7 at this Oaxacan site,
 including illustration and discussion of unusual lintel and
 jambs carved in jaguar form.

141 1977. La historia póstuma de Coatlicue. <u>Del arte:</u>
 <u>Homenaje a Justino Fernández</u>. 31-34. Mexico: Universidad
 Nacional Autónoma de México.
 Traces the history of the large Aztec sculpture of
 Coatlicue from its discovery in 1790 to its placement in the
 Museo Nacional in 1964.

142 1981. The Dainzú Preclassic Figurines. <u>The Olmec and</u>
 <u>Their Neighbors</u>. Ed. Elizabeth Benson. 223-29. 9 figs.
 Washington, D.C.: Dumbarton Oaks.
 Very brief consideration of the types of figurines found
 in Pre-Classic contexts at this Oaxacan site. Suggestion of a
 highland style extending from central Mexico to Guatemala during
 this period.

Bernal, Ignacio, Pedro Ramirez Vazquez, and Otto Schöndube.
143 1971. <u>Colección arqueológica mexicana de Licio Lagos</u>.
 unpaginated, 101 plates. Mexico: Ediciones Lito Offset
 Fersa, S.A.
 Catalog of a private collection of Pre-Columbian art,
 principally small-scale ceramic objects. Brief notes on each
 piece.

Bernal, Ignacio, and Andy Seuffert.
144 1970. <u>Yugos de la colección del Museo Nacional de</u>
 <u>Antropología</u>. Corpus Antiquitatum Americanensium Mexico,
 4. 51 pp., 42 plates. Mexico: Union Académique
 Internationale, Instituto Nacional de Antropología e
 Historia.
 Illustrations drawn of all yokes in Mexico City's
 Anthropology Museum. Individual descriptive catalog entries on
 each piece. Text in Spanish and English.

145 1973. <u>Esculturas asociadas del Valle de Oaxaca</u>. Corpus
 Antiquitatum Americanensium Mexico, 6. 29 pp., 19 plates.
 Mexico: Union Académique Internationale, Institute
 Nacional de Antropología e Historia, Mexico.
 Illustration and description of thirty-six stone
 sculptures, twenty-five from Macuilxochitl, eleven from
 Tlacochahuaya in the eastern branch of the Valley of Oaxaca.
 Text in Spanish and English.

Bettelheim, Judith.
146 1975. Two Nayarit house groups in the Olsen Collection.
 <u>Yale University Art Gallery Bulletin</u> 35, no. 2:34-42. 4
 figs.
 These ceramic assemblages discussed in relation to Peter
 Furst's work on ethnographic analogy and West Mexican art.

Beuchat, Henri.
147 1912. <u>Manuel d' archéologie américaine</u>. 773 pp., 262
 figs. Paris: Picard et Fils.

Important early survey of North, Middle, and South American archaeology. Mesoamerican objects considered in detail.

Beyer, Hermann.
148 1910. Sobre algunas representaciones del dios Huitzilopochtli. Proceedings of the 17th International Congress of Americanists 2:364-72. 20 figs. Buenos Aires. Images, emblems, and iconography of one Aztec deity.

149 1919. ¿Guerrero o Dios? Nota arqueológica acerca de una estatua mexicana del Museo de Historia Natural de Nueva York. El México Antiguo 1, no. 2:72-81. Mexico. Presentation of evidence that a ceramic figure previously thought to be a warrior is actually an effigy of Xipe Totec.

150 1919. Objectos de forma amigdaloide existentes en representaciones mexicanas de la tierra. El Mexico Antiguo 1, no. 2:83-89. 25 figs. Iconographic examination of drop-shaped emblems that appear in contexts pertaining to earth or ground.

151 1930. A deity common to Teotihuacan and Totonac cultures. Proceedings of the 23rd International Congress of Americanists. 82-84. 3 figs. New York. Fat-faced deity with puffy eyes seen in small-scale clay images in Vera Cruz and in the central highlands of Mexico.

152 1933. Shell Ornament Sets from the Huaxteca, Mexico. 154- 215. Middle American Research Series 5, no. 4. 8 plates, 88 figs. New Orleans: Tulane University. In-depth study of gorgets and eardisks incised with Mesoamerican gods.

153 1946. La controversia Mena-Gamio. El México Antiguo 1:283-88. 4 figs. Remarks on a controversy between Ramon Mena and Manuel Gamio over the reconstruction of a Teotihuacan-style incense burner from Azcapotzalco.

154 1945. An incised Maya inscription in the Metropolitan Museum of Art, New York. Middle American Research Records 1, no. 7:85-88. 6 figs. New Orleans: Tulane University. Maya head pendant with Late Classic date incised on the reverse.

155 1955. La "Piedra del Sacrificio Gladiatorio" del Museo Nacional de Arqueología. E México Antiguo 8:87-94. 8 figs.

Through study of its occurences in painted manuscripts, the author identifies a circular stone sculpture as a "gladitorial stone" to which prisoners were bound.

156 1955. La "procesión de los señores," decoración del primer teocalli de pieda en México-Tenochtitlan. El México Antiguo 8:1-42. 38 figs.
Posthumous publication of a 1917 study by Beyer of a series of stone slabs forming a bench. The scene, depicting a group of warriors in procession, is similar to those found at Tula and Chichen Itza.

157 1965. Mito y simbología del México antiguo. Special issue of El México Antiguo 10. 516 pp.
A posthumous collection of forty-nine brief papers by Beyer on symbolism and iconography of ancient Mexican art. Concentration on Aztec subject matter. Most previously published elsewhere.

158 1965. La gigantesca diosa de Teotihuacan. El México Antiguo 10:419-23. 4 figs.
Remarks on the history of a large-scale volcanic stone monument of Teotihuacan manufacture.

159 1965. La mariposa en el simbolismo azteca. El México Antiguo 10:465-68. 11 figs.
Brief remarks on butterfly iconography and its relation to flowers, flames, and several Aztec deities.

160 1966. Estudio interpretativo de algunas grandes esculturas. El México Antiguo 11:297-309. 22 figs.
Study of large-scale stone sculptures at Teotihuacan emblematic of Tlaloc, serpents, a skeletal figure, and a masked god.

Bittmann Simons, Bente.
161 1968. Los mapas de Cuauhtinchan y la historia Tolteca-Chichimeca. Investigaciones, 15. 96 pp., 7 figs., 9 plates. Mexico: Instituto Nacional de Antropología e Historia.
Study of postconquest pictorial maps in indigenous style.

162 1974. Further notes on the map of Tepecoacuilco, a pictorial manuscript from the state of Guerrero, Mexico. Indiana 2:97-131. 10 figs. Berlin: Ibero-Amerikanisches Institut Preussischer Kulturbesitz.
Discussion of three fragments that form one colonial Mexican codex in native style.

Blom, Franz.
163 1930. Preliminary notes on two important Maya finds.
 Proceedings of the 23rd International Congress of
 Americanists. 165-71. 3 figs. New York.
 Find of pre-Hispanic textiles in a Chiapas cave, and new
 data on some ballcourts in Chiapas and elsewhere.

164 1932. The Maya ball-game Pok-ta-Pok. Middle American
 Research Series Publication 4:485-530. New Orleans:
 Tulane University.
 Early survey of ballgame iconography, incorporating
 information from architecture, codices, pottery, sculpture, and
 ethnohistory.

165 1935. A checklist of falsified Maya codices. Maya
 Research 2:251-52.
 List of ten of the more prominent spurious codices in
 circulation at the time that the author was writing.

166 1935. The "Gomesta Manuscript," a falsification. Maya
 Research 2:233-48.
 Refutation of the claim that the Gomesta manuscript is a
 new Maya codex. Its spuriousness is proven through both
 linguistic and iconographic evidence.

167 1950. A polychrome Maya plate from Quintana Roo. Notes on
 Middle American Archaeology and Ethnology 4, no. 98:81-84.
 2 figs. Washington, D.C.: Carnegie Institution of
 Washington.
 Large Classic period plate depicting the Principal Bird
 Deity is discussed and illustrated.

168 1959. Historical notes relating to the pre-Columbian amber
 trade from Chiapas. Mitteilungen aus dem Museum für
 Völkerkunde 25:24-27. 2 figs. Hamburg.
 Discussion of amber deposits, pre-Columbian use of
 amber, and ethnohistoric accounts of amber traders.

Blom, Franz, and Oliver La Farge.
169 1926-7. Tribes and Temples. 2 vols. vol. 1: 237 pp., 194
 figs.
 Important for early discussion of architecture and stone
 sculpture at Maya sites.

Boggs, Stanley H.
170 1944. A human-effigy pottery figure from Chalchuapa, El
 Salvador. Notes on Middle American Archaeology and
 Ethnology 2, no. 31:1-7. 2 figs. Washington, D.C.:
 Carnegie Institution of Washington.
 Hollow, tall (143 cm.) human figure discussed and
 illustrated. Figure is similar to an effigy from Coatlinchan,
 Mexico.

171 1963. Apuntes sobre varios objetos de barro procedentes de
 Los Guapotes, en el Lago de Güija. Antropología e Historia
 de Guatemala 15, no. 1:15-21. 3 figs. Guatemala.
 Brief comments on various ceramic objects, mainly
 figural with skeletal imagery, cast as offerings into a lake on
 the Guatemala-El Salvador border.

172 1971. An Olmec mask-pendant from Ahuachapan, El Salvador.
 Archaeology 24, no. 4:356-58. 6 figs.
 Incised mask of Olmec style discovered in El Salvador.
 Report on its condition and iconography. Late Olmec date
 suggested.

Bolles, John S.
173 1977. Las Monjas: A Major Pre-Mexican Architectural
 Complex at Chichén Itzá. 304 pp., numerous unnumbered text
 illustrations. Norman: University of Oklahoma Press.
 Thorough study of one structural complex at Chichen
 Itza: its architecture, burials, paintings, sculpture, arti-
 facts, and hieroglyphs--by one of the early excavators at the
 site.

Bolz, Ingeborg.
174 1975. Sammlung Ludwig: Altamerika. unpaginated, 228
 plates, numerous text figures. Cologne, Germany:
 Rautenstrauch-Joest-Museum der Stadt Köln.
 Catalog of the Ludwig Collection at the Cologne Museum.
 Half of the catalog concerns Middle America, for which there are
 110 plates. Introduction, glossaries, and maps for each
 geographic area. Text in German.

Bolz-Augenstein, Ingeborg, and Hans D. Disselhoff.
175 1970. Werke Präkolumbischer Kunst. Ibero-Amerikanisches
 Institut Preussischer Kulturbesitz. Monumenta Americana
 VI. 327 pp., 169 figs., Berlin.
 One hundred and sixty-nine objects illustrated with mul-
 tiple photographs and drawings, both black and white and color.
 Scholarly catalog entries for each. Both Middle and South
 America represented. Thirty-three Mesoamerican pieces, 136
 Peruvian pieces.

Bond, Margaret N.
176 1978. Archaeological evidence of Mesoamerican folk
 religion in the Lake Chapala basin, Jalisco, Mexico. Codex
 Wauchope: A Tribute Roll. Ed. M. Giardino, et al. 131-44.
 5 figs. New Orleans: Tulane University.
 Discussion of miniature pottery cast as offerings into
 Lake Chapala during the Late Classic to Early Post-Classic
 periods.

Boone, Elizabeth Hill.
177 1980. How efficient are early colonial Mexican manuscripts
 as iconographic tools? Research Center for the Arts Review
 3, no 4:1-5. 3 figs. San Antonio: University of Texas.
 Provocative comments on the pitfalls and proper uses of
 manuscripts as art historical documents.

178 1982. Towards a more precise definition of the Aztec
 painting style. Pre-Columbian Art History: Selected
 Readings. Second edition. Ed. A. Cordy-Collins. 153-68.
 15 figs. Palo Alto: Peek Publications.
 Concise review of what is known about Aztec painting
 styles. Early postconquest Codex Borbonicus and Codex
 Magliabechiano examined for stylistic attributes that separate
 Aztec painting from both the Borgia-group manuscripts and from
 Spanish-influenced manuscripts.

Boone, Elizabeth H. (ed.).
179 1982. The Art and Iconography of Late Post-Classic Central
 Mexico. 254 pp. Washington, D.C.: Dumbarton Oaks.
 Proceedings of a 1977 conference. All essays, by
 Sullivan, Anawalt, Solis Olguín, Townsend, Offner, Spranz,
 Troike, J. Furst, and Nicholson are annotated here.

180 1982. Falsifications and Misreconstructions of Pre-
 Columbian Art. 142 pp. Washington, D.C.: Dumbarton Oaks.
 Proceedings of a 1978 conference concerned with both
 Mesoamerica and the Andes. Contributions by Pasztory, Taylor,
 and Molina-Montes are annotated here.

Boone, Elizabeth, and Zelia Nuttall.
181 1983. The Codex Magliabechiano. 2 vols. Vol. 1: 250 pp.,
 28 figs. Vol. 2: 19 pp. and codex facsimile. Berkeley:
 University of California Press.
 Reproduction of Zelia Nuttall's 1903 essay and facsimile
 of this Mexican codex, its lost prototype, the group of
 manuscripts of which it is a part, and translation of the
 sixteenth-century text of the manuscript. An important work.

Boos, Frank H.
182 1962. Una nueva categoria de urnas "Acompañantes." Anales
 14:129-35. 3 plates. Mexico: Instituto Nacional de
 Antropología e Historia.
 Monte Alban figural urns with "glyph L" in the headdress
 suggested as a new class of urns.

183 1964. El dios mariposa en la cultura de Oaxaca: una
 revisión del estado actual del conocimiento. Anales 16:77-
 97. 13 plates. Mexico: Instituto Nacional de
 Antropología e Historia.
 Butterfly imagery in Zapotec urns and its linkage to
 other iconographic categories.

184 1964. Las urnas zapotecas en el Real Museo de Ontario.
 Corpus Antiquitatum Americanensium Mexico, 1. unpaginated,
 32 plates. Mexico: Union Académique Internationale,
 Instituto Nacional de Antropología e Historia.
 Catalog of the large collection of urns in the Royal
 Ontario Museum in Toronto. Text in Spanish and English. Entries
 on each object are more extensive than in his later 1966 volume
 in this series.

185 1966. Colecciones Leigh y Museo Frissell de Arte Zapoteca.
 Corpus Antiquitatum Americanensium Mexico, 2. 121 pp., 103
 plates. Mexico: Union Académique Internationale,
 Instituto Nacional de Antropología e Historia.
 Predominantly Classic period figural urns and brasiers
 from this important Oaxacan collection. Brief entries on each
 item, in Spanish and English.

186 1966. The Ceramic Sculptures of Ancient Oaxaca. 488 pp.,
 458 black-and-white figs. New York: A.S. Barnes.
 Monumental survey of Zapotec figural urns from 600 B.C.
 to 1350. Urns subdivided into forty-four icongraphic
 categories.

187 1968. Colecciones Leigh, Museo Frissell de Arte Zapoteca,
 Smithsonian Institution y otras. Corpus Antiquitatum
 Americanensium Mexico, 3. 45 pp., 45 plates. Mexico:
 Union Académique Internationale, Institute Nacional de
 Antropología e Historia.
 Predominantly figural ceramic urns from two museums.
 Text in English and Spanish.

188 1968. The Xantil tradition in the Oaxacan culture: report
 of the present state of our knowledge. Baessler-Archiv
 n.f. 16, no. 2:323-30. 4 figs.
 Brief discussion of four large hollow ceramic figurines
 with open bases, the apparent function of which was to be placed
 over smoking fires.

189 1968. Two Zapotec urns with identical unclassified figures
 display an unique maize fertility concept. Baessler-Archiv
 n.f. 16, no. 1:1-8. 2 figs.
 Two figural urns in British Museum and Museum für
 Völkerkunde, Berlin, depicting both male and female genitals,
 are discussed. Vulva is starshaped; penis is an ear of corn.
 Author stresses the rarity of sexual imagery in Oaxacan pottery.

190 1969. Conservatismo en el simbolismo de Oaxaca. Anales
 (Ser. 7a) 1:95-111. 9 plates. Mexico: Instituto Nacional
 de Antropología e Historia.
 Extreme conservatism in elements and iconography found
 in Zapotec urns spanning many centuries.

191 1969. The ceremonial paw vase in Greece and Oaxaca.
 <u>Proceedings of the 38th International Congress of
 Americanists</u> 1:133-38. 6 figs. Munich.
 Figural urns in which humans carry jaguar-paw vessels;
 the vessels themselves are illustrated and discussed.

Boos, Frank H., and Philippa D. Shaplin.
 192 1969. A Classic Zapotec tile frieze in St. Louis.
 <u>Archaeology</u> 22, no. 1:36-43. 13 figs.
 Terracotta frieze of unknown provenience depicts Zapotec
 deities and glyphs. Iconography and correct sequence of tiles
 is discussed. Date of IIIb assigned.

Borhegyi, Stephan F.
 193 1950. A group of jointed figurines in the Guatemala
 National Museum. <u>Notes on Middle American Archaeology and
 Ethnology</u> 4, no. 100:93-99. 3 figs. Washington, D.C.:
 Carnegie Institution of Washington.
 One unusual figurine type is discussed and illustrated.

 194 1952. Travertine vase in the Guatemala National Museum.
 <u>American Antiquity</u> 17, no. 3:254-56. 3 figs.
 Description and photographs of a previously unpublished
 stone vase in the Diesseldorf Collection of the Guatemala
 Museum. The object represents a kneeling monkey bearing the
 vase on his back.

 195 1954. Jointed figurines in Mesoamerica and their cultural
 implication. <u>Southwest Journal of Anthropology</u> 10:268-77.
 3 figs.
 Distribution and archaeological contexts of this unusual
 type of figure. Typology constructed. Author suggests they may
 have been used as puppet or ventriloquist figures.

 196 1955. Pottery mask tradition in Mesoamerica. <u>Southwest
 Journal of Anthropology</u> 11:205-13. 2 figs.
 Review of the archaeological context of ceramic masks
 and of their continued use in ethnographic settings. Author
 suggests there are four types: true masks, effigy masks, death
 masks, and pendant masks.

 197 1961. Miniature mushroom stones from Guatemala. <u>American
 Antiquity</u> 26, no. 4:498-502.
 Pre-Classic cache of nine mushroom stones at Kaminaljúyu
 seen as evidence for extreme activity for its associated cult. A
 connection with nine lords of the night and other series of nine
 is suggested.

 198 1961. Ball-game handstones and ball-game gloves. <u>Essays
 in Pre-Columbian Art and Archaeology</u>. Ed. S. K. Lothrop,
 et al. 126-51. 9 figs. Cambridge, Mass.: Harvard
 University Press.

Use and distribution of stone objects associated with the ballgame. Use of looped handstones as ball deflectors is suggested. Charts of known handstones and instances of handpadding are included.

199 1963. Pre-Columbian pottery mushrooms from Mesoamerica. American Antiquity 28:328-38.
 Previously classified as jars, hollow ceramic "mushrooms" are diagnostic of the Pre- and Proto-Classic periods in southern Mesoamerica. Possible ceremonial use in hallucinogenic mushroom rituals.

200 1966. A miniature ceremonial ballgame yoke from Mexico. American Antiquity 31, no. 5:742-44. 3 figs.
 An unusual horseshoe-shaped stone yoke from Papantla, Veracruz is described. The religious nature of such miniatures is stressed.

201 1967. Miniature "Thin Stone Heads" and other Pre-Columbian miniature stone objects from Mesoamerica. American Antiquity 32, no. 4:543-47. 2 figs.
 Miniature anthropomorphic hacha and other small scale stone objects are related to ballgame rituals.

202 1971. Pre-Columbian contacts--the dryland approach: the impact and influence of Teotihuacan culture on the pre-Columbian civilizations of Mesoamerica. Man Across the Sea. Ed. C. Riley. 79-105. Austin: University of Texas Press.
 Provocative article on Teotihuacan and its influence. Analogies made with Hellenism and Greek mystery religions.

203 1980. The Pre-Columbian Ballgames, a Pan-Mesoamerican Tradition. Contributions in Anthropology and History, 1. 30 pp., 25 figs. Milwaukee: Milwaukee Public Museum.
 Posthumously published survey of ballcourt, playing gear, architecture, and iconography. Author divides Mesoamerica into ten ballgame zones, based on differences in courts and playing gear.

Borhegyi, Stephan F., and Lee A. Parsons.
204 1963. Pares de vasijas gemelas policromadas con figuras pintadas, del area Maya. Estudios de Cultura Maya 3:107-12. 3 figs.
 Discussion of "twin vases" with polychrome figural painting in the collection of the Milwaukee Public Museum. Suggests a specifically funerary or offertory use for such specimens.

Bosch-Gimpera, P.
205 1977. Posible art rupestre paleolítico en México. Del
 arte: Homenaje a Justino Fernández. 27-29. 2 figs.
 Mexico: Universidad Nacional Autónoma de Mexico.
 Brief article suggesting a relationship between paleoli-
 thic rock art in Mexico and the rest of the hemisphere.

Bowditch, Charles P.
206 1900. The Lords of the Night and the Tonalamatl of the
 Codex Borbonicus. American Anthropologist n.s. 2, no.
 1:145-54.
 Calendrical matters and associated deities in an Aztec
 manuscript.

Bowles, John H.
207 1974. Notes on a floral form represented in Maya art and
 its iconographic implications. Primera Mesa Redonda de
 Palenque, Part I. Ed. M.G. Robertson. 121-27. 17 figs.
 Pebble Beach, California: Robert Louis Stevenson School.
 A plant previously identified as a water lily in Maya
 art is considered to be a forest perennial called Dorstenia
 contrajerva, known by the Maya to be an effective antidote to
 many poisons.

Brack-Bernsen, Lis.
208 1977. Die Basler Mayatafeln. Verhandlungen der
 Naturforschenden Gesellschaft in Basel, Band 86, Heft 1 and
 2. 76 pp., 23 figs.
 Investigation of the two wooden lintels originally from
 Tikal temple IV, now in the Museum für Völkerkunde in Basel.
 Principally a glyphic and astronomical study.

Brainerd, George M.
209 1947. A pottery figurine head from Tres Zapotes, Veracruz,
 Mexico. The Masterkey 21:127-30.
 An early attempt to correlate pottery figurines with the
 then-mysterious colossal stone heads from the same region.
 Outdated.

210 1953. On the design of the Fine Orange pottery found at
 Chichén Itzá, Yucatán. Revista Mexicana de Estudios
 Antropológicos 13:463-73. 2 figs.
 X Fine Orange ware originating in central Veracruz is
 briefly examined. Design analysis as a key to cultural dynamics
 is proposed.

Braun, Barbara.
211 1976. Southern sources of Cotzumalhuapa, Guatemala.
 Proceedings of the 41st International Congress of
 Americanists 2:279-308. 24 figs.

Suggests that Izapan art and early horizon northern Andes art are the sources for the motifs and styles found in the art of the Cotzumalhuapa area of southern Guatemala.

212 1977. Ball-game paraphernalia in the Cotzumalhuapa style. Baessler-Archiv n.f. 25, no. 2:421-57. 39 figs.
Iconography and ritual function of carved yokes, hachas, and handstones are considered. The author suggests multiple functions for such carved stone objects.

213 1978. Sources of the Cotzumalhuapa style. Baessler-Archiv n.f. 26, no. 1:159-232. 40 figs. Berlin.
The author theorizes that the Cotzumalhuapa art style on the south coast of Guatemala has its genesis both in Olmec art and in northern Andean three-dimensional art. She disputes the often-repeated contention that the sources of this art style are to be found in Central Mexico.

214 1982. The mysterious murals at Cacaxtla. Connoisseur (April): 66-73. 17 illustrations, many in color.
Preliminary discussion of the unusual murals in Maya style recently found at a central Mexican site. Excellent illustrations.

215 1982. The serpent at Cotzumalhuapa. Pre-Columbian Art History: Selected Readings. Second edition. Ed. A. Cordy-Collins. 55-82. 27 figs. Palo Alto: Peek Publications.
Serpent imagery on large scale and portable stone sculptures principally from the Middle to Late Classic period at El Baul and Bilbao, Guatemala. Relationship of this imagery to the ballgame and modes of status transformation.

216 1982. Subtle diplomacy solves a custody case. Art News 81, no. 6:100-103. 5 figs.
Account of negotiations between the de Young Museum in San Francisco and the Institute of Anthropology and History in Mexico concerning the repatriation of a large group of Teotihuacan murals.

Bray, Warwick.
217 1977. Maya metalwork and its external connections. Social Process in Maya Prehistory. Ed. Norman Hammond. 365-403. 16 figs. London: Academic Press.
An examination of Maya metallurgy in the wider context of trade relationships with Mexico and the Isthmus of Central Mexico.

Breton, Adela.
218 1906. The wall paintings at Chichen Itza. Proceedings of the 15th International Congress of Americanists. 165-69. Québec.

Discussion of her work of copying all murals at Chichen Itza. Mention of the variation in coloration, artists hands, and imagery depicted.

219 1908. Archaeology in Mexico. Man 8, no. 17:34-37. 3 black-and-white figs.
 Remarks on recent discoveries. Illustrates and discusses Acanceh reliefs.

220 1910. Painting and sculpture in Mexico and Central-America. Proceedings of the 17th International Congress of Americanists 1:245-47. Buenos Aires.
 Very brief remarks on the quality of art found in Meso-america, with comparisons to other great art styles of the world.

221 1915. Preliminary study of the north building (chamber "C"), Great ball court, Chich'en Itzá, Yucatán. Proceedings of the 19th International Congress of Americanists. 187-94. 4 plates, 7 figs. Washington, D.C.
 Concerned principally with careful description and reproduction of the imagery on the columns and walls at one building. Author's linedrawings superimposed on photos.

222 1919. Some Mexican picture names. Man 19:118-21. London. Codex Kingsborough and its place signs.

Brettell, Richard A.
223 1974. Mezcala stone sculpture in the Olsen Collection. Yale University Art Gallery Bulletin 35, no. 1:14-19. 6 figs.
 Discussion of six of the twelve small-scale stone figures from Guerrero in the collection of the Yale University Art Gallery.

Brinton, Daniel G.
224 1885. The sculptures of Cosumalhualpa. Science 6:42.
 A letter to the editor, discussing ethnic affiliations of the sculptures of Cotzumalhuapa. Discussion of Maya, Xinca, and Pipil inhabitants of surrounding area.

British Museum Guide to the Maudslay Collection of Maya Sculptures.
225 1938. British Museum, London, England. 93 pp., 10 plates, 20 figs. Second, revised edition.
 Using the casts and original Classic Maya sculptures (mainly from the southern lowlands) that Maudslay brought back to the British Museum, the book serves as an introduction to Maya art and culture. First edition was 1922.

Brockington, Donald L.
226 1982. Spatial and temporal variations of the Mixtec-style
 ceramics in southern Oaxaca. Aspects of the Mixteca-Puebla
 style and Mixtec and Central Mexican Culture in Southern
 Mesoamerica. 7-13. Middle American Research Institute
 Occasional Paper no. 4. 4 figs. New Orleans: Tulane
 University.
 Specific ceramic provinces on the Oaxaca coast and their
 implications for culture history.

Broda, Johanna.
227 1982. Astronomy, cosmovisíon, and ideology in pre-Hispanic
 Mesoamerica. Ethnoastronomy and Archaeoastronomy in the
 American Tropics. Ed. A. Aveni and G. Urton. Annals of the
 New York Academy of Sciences 385:81-110. 9 figs., 1 table.
 Aztec calendar rituals, astronomy, and cult practices as
 clues to the ideological aims of the Aztec empire.

Brotherston, Gordon.
228 1974. Sacred sand in Mexican picture-writing and later
 literature. Estudios de Cultura Nahuatl 11:303-9.
 Suggests a ritual function for sand brought to temple
 precincts. Images of hills of sand in codices as well as verbal
 images in literature lend support to his contention.

229 1975. Time and script in ancient Mesoamerica. Indiana
 3:9-40. 13 figs. Berlin: Ibero-Amerikanisches Institut
 Preussischer Kulturbesitz.
 Discussion of temporal counts and the genesis of glyphic
 writing. Maya and Mexican codices, as well as Maya monuments,
 used as evidence.

Brown, Betty Ann.
230 1977. European Influences in Early Colonial Descriptions
 and Illustrations of the Mexica Monthly Calendar. Ph.D.
 dissertation, Department of Art History, University of New
 Mexico. 369 pp., 52 figs. Ann Arbor: University
 Microfilms.
 Variations and inconsistencies in colonial texts and
 images of monthly calendar lead the author to suggest that the
 development of such a calendar was stimulated by contact with
 Europeans. Colonial authors structured the information the
 Mexica gave them according to European calendrical standards.

231 1982. Early colonial representations of the Aztec monthly
 calendar. Pre-Columbian Art History: Selected Readings.
 Second edition. Ed. A. Cordy-Collins. 169-91. 21 figs.
 Palo Alto: Peek Publications.
 Author stresses that both European and pre-Hispanic
 pictorial traditions are evident in composition and content of
 many early colonial chronicle illustrations.

232 1983. Seen but not heard: women in Aztec ritual--the
 Sahagun texts. Text and Image in Pre-Columbian Art. Ed. J.
 C. Berlo. 119-53. 14 figs. Oxford: British
 Archaeological Reports.
 Examination of the discrepancies between indigenous
 imagery of Aztec rituals and the accompanying European-penned
 texts. Author endeavors to determine women's role in Aztec
 rituals.

Bullard, William R., Jr.
233 1963. A unique Maya shrine site on the Mountain Pine Ridge
 of British Honduras. American Antiquity 29:98-99. 4 figs.
 Small ruin of prehistoric date is unique in this region.
 Platform structure described and illustrated.

Bunker, Frank F.
234 1927. The art of the Maya as revealed by excavations at the
 Temple of the Warriors, Chichén Itza, Yucatan. Art and
 Archaeology 23, no. 1:3-10. 5 figs., 1 color plate.
 Mural painting and relief sculpture of one building
 described for a general audience.

Burkitt, Robert.
235 1933. Two stones in Guatemala. Anthropos 28:9-26, 781-82.
 15 black-and-white figs. Vienna.
 Description and illustration of Cotzumalhuapa
 sculptures. Focus on glyphs and numerals.

Burland, Cottie A.
236 1947. Einige Bemerkungen über den Codex Vindobonensis
 Mexic. 1. Archiv für Völkerkunde 2:101-7. Vienna.
 Genealogical links between figures in Codex Vienna and
 Toltec dynasties.

237 1951. The picture books of ancient Mexico. Natural
 History 30, no. 4:177-81. New York.
 Popular article on Mexican codices, focusing especially
 on Mixtec manuscripts.

238 1951. The tree of the Mixteca: a short study of the
 historical codices of Mexico. Selected Papers of the 29th
 International Congress of Americanists. 68-71. Chicago.
 Brief and rather vague discussion of unanswered
 questions about some Mixtec codices.

239 1952. In the house of flowers: Xochicalco and its
 sculptures. Ethnos 17, nos. 1-4:119-29. 4 figs.
 Stockholm.
 Discussion of feathered serpent and related symbolism on
 the pyramid at Xochicalco. Maya, Cotzumalhuapan, Teotihuacan,
 Toltec, and Gulf coast relationship noted.

240 1955. The Selden Roll: An Ancient Mexican Picture
 Manuscript in the Bodleian Library at Oxford. Monumenta
 Americana. 2. 51 pp. and fold-out manuscript. Berlin.
 Photographic facsimile and iconographic and
 ethnohistoric study of this manuscript. In English with German
 pamphlet.

241 1957. Codex Borbonicus, pages 21 and 22: A critical
 assessment. Journal de la Société des Américanistes 46:
 157-63.
 Discussion of structure and meaning of two key pages of
 this Aztec manuscript. Author presents these pages as blessings
 of the year beginnings, with emphasis placed on Lords of the
 Night.

242 1958. Ethnographic notes on Codex Selden in the Bodleian
 Library of the University of Oxford. Proceedings of the
 31st International Congress of Americanists 1:361-72.
 Mexico.
 Codex Selden is approached as an ethnohistoric document
 revealing information on Mixtec culture at the time of the
 conquest. Discussion of clothing and equipment, architecture,
 place glyphs, etc. Brief section on technique and overpainting.

243 1965. Codex Egerton 2895, British Museum, London. 23 pp.
 with screenfold facsimile, 16 leaves. Graz, Austria:
 Akademische Druck- und Verlaganstalt.
 Color facsimile. The author's text focuses on physical
 and material aspects of the codex.

244 1966. Codex Laud. 34 pp. with separate screenfold
 facsimile, 24 leaves. Graz, Austria: Akademische Druck-
 und Verlaganstalt.
 Color facsimile. Descriptive notes by author.

245 1967. The Gods of Mexico. 219 pp., 7 plates. New York:
 G. P. Putnam's Sons.
 Introductions to Aztec gods and religion with
 comparative information from other cultures. Useful for the
 nonspecialist.

246 1967. Reflection on Toltec social and material culture as
 seen in Codex Vindobonensis Mexic 1. Folk (Dansk
 Etnografisk Tidsskrift) 8/9:55-62. 5 figs. Copenhagen.
 Author posits that recto of this manuscript provides an
 account of Toltec rulers, although in Mixtec style and
 iconography. Essentially a brief descriptive account of
 implements and material culture depicted in the manuscript.

Bushnell, Geoffrey H. S.
247 1964. An Olmec jade formerly belonging to Alfred Maudslay. Proceedings of the 35th International Congress of Americanists 1:541-42. 4 figs.
 Description and illustration of a jade in the Cambridge University Museum of Archaeology that depicts two jaguar masks in relief.

Bushnell, G. H. S., and Adrian Digby.
248 1955. Ancient American Pottery. 51 pp., 80 black-and-white plates. London: Faber and Faber.
 Survey of pre-Columbian pottery of the Western Hemisphere. Most illustrated pieces are from the British Museum or Cambridge University collections. Almost half of the pieces illustrated are Mesoamerican.

Butler, Mary.
249 1931. Dress and decoration of the Maya Old Empire. Museum Journal 22:155-83. 30 figs. Philadelphia: University of Pennsylvania.
 Important early article on lowland Maya clothing styles as depicted in stone monuments of the Classic period.

250 1935. A study of Maya mouldmade figurines. American Anthropologist 37:636-72. 6 figs.
 Useful early typology of figurines and their regional styles.

251 1937. Gods and heroes on Maya monuments. Publications of the Philadelphia Anthropological Society 1:13-26. 8 figs.
 Noteworthy for being an early realization that Maya monuments depicted historical figures rather than mythical ones. Author suggests that stylistic analysis coupled with costume analysis is an important approach to the study of Maya art.

Cahill, Holger.
252 1933. American Sources of Modern Art. 50 pp., 56 figs. New York: Museum of Modern Art.
 Brief essay (17 pp.) outlining the debt modern art owes to ancient American art. Briefer discussion of the cultural context of these works. Fifty-six of the more than 200 ancient objects in show are illustrated in black-and-white photos. Predominance of stone and ceramic sculpture illustrated.

Callegari, G. V.
253 1922-23. Scultura, lapidaria, oreficeria nel Messico precolombino. Dedalo: Rassegna d'Arte Diretta da Ugo Ojetti 3:541-66. 27 figs. Rome and Milan.
 Brief text, many photos of varieties of Mexican sculpture in stone, wood, and metal.

254 1934. Un nuevo precioso "Atlatl" mexicano antiguo.
 <u>Proceedings of the 25th International Congress of
 Americanists</u> 2:7-10. 3 figs. Buenos Aires.
 Brief note on the recent discovery of a wooden and metal
atlatl in the Rome Ethnographic Museum.

Calnek, Edward E.
255 1972. The internal structure of cities in America. Pre-
 Columbian cities: the case of Tenochtitlan. <u>Proceedings
 of the 39th International Congress of Americanists</u> 2:347-
 58. 2 figs. Lima.
 Urbanism and residence localities in the Aztec capital.
Comparisons with Teotihuacan residential compounds.

256 1973. The historical validity of the Codex Xolotl.
 <u>American Antiquity</u> 38:423-27.
 Summary of historical evidence that attests to the truth
of this Aztec codex's historical references. Refutes many
claims made by J. Parsons (1970) about the inaccuracies in the
codex.

Capitan, Dr.
257 1908. Les grands anneaux de poitrine des anciens
 Mexicains. Comparaison avec les anneaux similaires
 japonais, océaniens et préhistoriques de la Gaule.
 <u>Proceedings of the 16th International Congress of
 Americanists.</u> 103-6. 4 figs. Vienna.
 Brief discussion of circular stone breast plaques and
their similarities to ones found elsewhere in the world. An
historic connection is discussed but not definitely affirmed.

258 1912. Quelques caractéristiques de l'architecture maya.
 <u>Proceedings of 18th International Congress of Americanists.</u>
 216-19. 5 figs. London.
 Focuses on architecture in the Yucatan, with particular
reference to raised platforms and facade ornamentation.
Analogies to the art of other great civilizations.

Cardos de Mendez, Amalia.
259 1976. Estudio preliminar de representaciones de hombre-
 pájaro. Los hombres-pájaro de Chichén Itzá. <u>XIV Mesa
 Redonda</u> 191-201. 14 figs. Mexico: Sociedad Mexicana de
 Antropología.
 Comparative study of anthropomorphic bird figures from
Izapa, Teotihuacan, El Tajin, and Chichen Itza.

Carlson, John B.
260 1976. Astronomical investigations and site orientation
 influences at Palenque. <u>Segunda Mesa Redonda de Palenque.</u>
 Ed. M.G. Robertson. 107-22. 2 figs., 9 tables. Pebble
 Beach, California: Robert Louis Stevenson School.

71

Although primarily a paper on archaeoastronomy, the author presents information about a number of possible considerations influencing the layout of the site of Palenque.

261 1981. Olmec concave iron-ore mirrors: the aesthetics of a lithic technology and the Lord of the Mirror. The Olmec and Their Neighbors. Ed. Elizabeth Benson. 117-47. 40 figs. Washington, D.C.: Dumbarton Oaks.
Analysis of Olmec mirror lapidary technology, catalog of all known examples of Olmec mirrors, and hypotheses on the use and purpose of mirrors in ancient Mesoamerica based on linguistic, archaeological, and ethnohistoric data.

262 1981. A geomantic model for the interpretation of Mesoamerican sites: an essay in cross-cultural comparison. Mesoamerican Sites and World Views. Ed. E. P. Benson. 143-215. 19 figs. Washington, D.C.: Dumbarton Oaks.
Provocative article on geomancy--divination using topographic features for proper orientation of human structures--as possibly used in Mesoamerica. Insightful analogies with Chinese geomancy and cosmology.

Carmack, Robert, and Lynn Larmer.
263 1969. Quichean art: a Mixteca-Puebla variant. Katunob 7, no. 3:12-35. 13 figs.
A variant of the Mixteca-Puebla art style found in the Guatemalan highlands during the Late Post-Classic period.

Carmichael, Elizabeth.
264 1970. Turquoise Mosaics from Mexico. 40 pp., 8 color plates, numerous text illustrations. London: The British Museum.
Group of nine turquoise mosaics in the British Museum are discussed and placed in cultural context.

Carrera Stampa, Manuel.
265 1965. Códices, mapas y lienzos acerca de la cultura nahuatl. Estudios de Cultura Nahuatl 5:165-220. Mexico.
Descriptive list of pictorial manuscripts of Nahuatl origin.

Carver, Norman F.
266 1966. Silent Cities. 246 pp., 234 illustrations. Tokyo: Shokokusha Publishing Company.
Survey of twenty important Mesoamerican sites, with maps and photos of architectural details. Text for the non-specialist. In English and Japanese.

Carynnyk, Deborah B.
267 1982. An exploration of the Nahua netherworld. Estudios de Cultura Nahuatl 15:219-36. 6 figs. Universidad Nacional Antonoma de México.

Florentine codex and other ethnohistoric accounts of calendar feasts used as evidence for Aztec beliefs about the afterlife.

Caso, Alfonso.
268 1927. Las ruinas de Tizatlan, Tlaxcala. Revista Mexicana de Estudios Históricos 1, no. 4:139-72. 19 figs., 4 plates.
 Study of the painted altars at this Aztec site, and iconographical relationships with gods known from the codices. Important for color reproductions of the painted altars.

269 1927. El vaso de jade de la Colección Plancarte. Revista Mexicana de Estudios Históricos 1, no. 1:7-18. 9 figs. Mexico.
 Study of a stone vessel with Tlaloc iconography. Comparison with iconography on some Zapotec urns.

270 1928. Las estelas zapotecas. 204 pp., 95 figs. Mexico: Museo Nacional de Arqueología, Historia y Etnografía.
 Useful early study of Zapotec monuments, their iconography, epigraphy, and calendrics.

271 1930. Un codice en Otomí. Proceedings of the 23rd International Congress of Americanists. 130-35. 4 plates, 3 figs. New York.
 Preliminary study of a codex rendered in Spanish, Otomi, and pictographics. Calendrical data suggests concordance with Aztec system.

272 1932. Reading the riddle of ancient jewels. Natural History 32, no. 5:464-80. New York: American Museum of Natural History. Reprinted in Ancient Mesoamerica: Selected Readings. Ed. John A. Graham. 236-52. 28 figs. Palo Alto: Peek Publications, 1966.
 First analysis of the objects in Tomb 7 at Monte Alban, by its excavator. Study of ceramics, carved bones, jewels, and glyphs shows that tomb was used twice, first by Zapotes, later by Mixtecs.

273 1932. Monte Alban, richest archaeological find in America. National Geographic 62, no. 4:487-512.
 Semipopular account of the discovery of Tomb 7 at Monte Alban in Oaxaca. Ceramics, carved bones, mosaics, and metal objects discussed. Zapotec tomb reused by Mixtecs.

274 1938. Thirteen Masterpieces of Mexican Archaeology. Trans. E. Mackie and J. R. Acosta. 131 pp., 13 plates. Mexico: Editoriales Cultura y Polis.
 Thirteen objects on display at Mexico's Museo Nacional are illustrated and described. Most are from central and southern Mexico.

275 1942. El paraíso terrenal en Teotihuacán. Cuadernos
 Americanos 6, no. 6:127-36. 1 fig.
 Using Aztec analogy, the author suggests that the famous
mural at Tepantitla represents Tlalocan, the rain god's
paradise. See Pasztory (1976) for a revised interpretation.

276 1949. Una urna con el dios mariposa. El México Antiguo
 7:78-95. 20 figs.
 Iconography of a Zapotec urn with butterfly headgear.
Examination of butterfly iconography elsewhere in Mesoamerica.

277 1951. Explicación del reverso del Codex Vindobonesis.
 Memorias del Colegio Nacional 5, no. 5:9-46. Mexico.
 Interpretations of the Codex Vienna's reverse side.

278 1955. Vida y aventuras de 4 Vientos, "Serpiente de Fuego."
 Miscelánea de Estudios Dedicados al Dr. Fernando Ortíz por
 sus Discípulos, Colegas y Amigos con Ocasión de Cumplirse
 Sesenta Años de la Publicación de su Primer Impreso en 1895
 1:293-98. Havana.
 Warfare and intermarriage as expressed in Mixtec
codices.

279 1958. The Aztecs: People of the Sun. 125 pp., unnumbered
 text illustrations, 16 plates. Norman: University of
 Oklahoma Press.
 Useful introductory survey of Aztec art, culture, and
religion.

280 1956. El mapa de Xochitepec. Proceedings of the 32nd
 International Congress of Americanists. 458-66. 1 fig.
 Copenhagen.
 An indigenous amate paper document of post-Columbian
date but exhibiting native toponymic and genealogical
characteristics. Map is in the collection of the Copenhagen
Museum.

281 1958. Fragmento de genealogía de los príncipes mexicanos.
 Journal de la Société des Américanistes de Paris n.s.
 47:21-31. 1 plate.
 Postconquest pictorial document pertaining to Central
Mexican royal families and their genealogies.

282 1959. El dios 1. Muerte. Mitteilungen aus dem Museum für
 Völkerkunde 25:40-43. 11 figs. Hamburg.
 Brief study of one god in the Mixtec codices.

283 1959. Glifos Teotihuacanos. Revista Mexicana de Estudios
 Antropológicos 15:51-70. 9 figs., 1 color plate.
 Important early study of Teotihuacan iconography.

284 1960. Interpretación del Códice Bodley 2858. 85 pp., 8
 figs., separate color facsimile. Mexico: Sociedad
 Mexicana de Antropología.
 Photographic facsimile of the codex with scholarly com-
 mentary. English edition published as well.

285 1960. The historical value of the Mixtec codices. Boletín
 de Estudios Oaxaqueños 16. Reprinted in Ancient
 Mesoamerica: Selected Readings. Ed. John A. Graham. 253-
 57. Palo Alto: Peek Publications, 1966. See also
 Cuadernos Americanos 19:2 (1960) for same article in
 Spanish.
 Brief discussion, for the introductory student, of
 writing, calendar, and historical information in codices.

286 1961. El glifo ojo de reptil. Ethnos 26, no. 4:167-71. 1
 fig.
 Response to von Winning (1961) clarifies certain details
 in the use of the reptile eye symbol.

287 1962. Calendario y escritura en Xochicalco. Revista
 Mexicana de Estudios Antropológicos 18:49-79. 20 figs.
 Iconography and calendrics on the monumental sculpture
 at this Mexican site and their relationships to other cultures.

288 1963. Representaciones de hongos en los codices. Estudios
 de Cultura Nahuatl 4:27-35. 6 figs.
 Identifications of scenes in codices in which
 hallucinogenic mushrooms are used.

289 1964. Interpretación del Códice Selden 3135 (A.2). 100
 pp., 17 figs., tables, with separate color facsimile of the
 manuscript. Mexico: Sociedad Mexicana de Antropología.
 Photographic facsimile of manuscript. Detailed
 scholarly commentary.

290 1964. Relations between the Old and New Worlds: a note on
 methodology. Proceedings of the 35th International
 Congress of Americanists 1:55-71. 10 figs., 2 maps.
 Mexico.
 Careful dating seen as a check to claims of trans-
 oceanic contact. Author presents useful illustrations showing
 that specious claims for "relationships" can be made based on
 geometric patterns occuring in contemporary New Guinea canoes,
 nineteenth-century Benin boxes, an Aztec relief, and a Louis XVI
 table.

291 1964. Los señores de Yanhiutlán. Proceedings of the 35th
 International Congress of Americanists 1:437-38. 11 figs.
 Mexico.

Dynastic relationships principally in Codex Bodley and other Mixtec manuscripts.

292 1965. Lapidary work, goldwork, and copperwork from Oaxaca. Handbook of Middle American Indians 3. Ed. Gordon R. Willey. 896-930. 63 figs. Austin: University of Texas Press.
 Useful survey of the minor arts, drawn principally from tomb finds at Monte Alban.

293 1965. Sculpture and mural painting of Oaxaca. Handbook of Middle American Indians 3. Ed. Gordon R. Willey. 849-70. 33 figs. Austin: University of Texas Press.
 Survey of major forms focuses principally on Monte Alban.

294 1966. The Lords of Yanhuitlán. Ancient Oaxaca. Ed. J. Paddock. 313-15. 35 figs., 2 tables. Stanford.
 Documentary, pictographic, and archaeological evidence of Mixtec geneological history.

295 1966. Dioses y signos teotihuacanos. Teotihuacan, Onceava Mesa Redonda 1:249-79. 42 figs. Mexico: Sociedad Mexicana de Antropología.
 Study of Teotihuacan iconography. Aztec deity names are suggested for Teotihuacan configurations.

296 1967. Los calendarios prehispánicos. 266 pp., numerous text figures. Mexico: Universidad Nacional Autónoma de México, Instituto de Investigaciones Históricas.
 Republication, and in some cases revision, of the author's previous articles on diverse topics having to do with manuscripts, dating and calendrics, and glyphs. Provides a wealth of pictorial information.

Caso, Alfonso, and Ignacio Bernal.
297 1952. Urnas de Oaxaca. Memorias del Instituto del Antropología e Historia, 2. 389 pp., 527 figs. Mexico: Instituto Nacional de Antropología e Historia.
 Classic study of figural urns excavated at Monte Alban and elsewhere. Focus is primarily iconographic.

298 1965. Ceramics of Oaxaca. Handbook of Middle American Indians 3. Ed. Gordon R. Willey. 871-95. 25 figs. Austin: University of Texas Press.
 Chronological survey considers both plain and decorated wares.

Caso, Alfonso, Ignacio Bernal, and Jorge R. Acosta.
299 1967. La ceramica de Monte Alban. Memorias del Instituto Nacional de Antropología e Historia, 13. 493 pp., 401 figs., 32 plates. Mexico.

Definite study of the ceramics of this Zapotec site written by Mexico's principal excavators there. Both fine and plain wares considered. Urns studied separately in Caso and Bernal's 1952 work.

Caso, Alfonso, and Mary Elizabeth Smith.
300 1966. Interpretación del Códice Colombino; las glosas del Códice Colombino. 189 pp., with separate screenfold facsimile, 24 leaves. Mexico: Sociedad Mexicana de Antropología.
 Caso's commentary on codex, Smith's commentary on the glosses, and photographic facsimile of this Mixtec Codex. Text in English and Spanish.

Castillo Tejero, Noemi.
301 1968. Algunas tecnicas decorativas de la cerámica arqueológica de México. Investigaciones, 16. 134 pp., 5 plates, 2 figs. Mexico: Instituto Nacional de Antropología e Historia.
 Scientific study of one type of ceramic ware ornamented with postfiring decoration. Appendices on technological, mineralogical, and petrographic analyses.

Cervantes, María Antonieta.
302 1969. Dos elementos de uso ritual en el arte olmeca. Anales (ser. 7a) 1:37-51. 15 figs., 4 plates. Mexico: Instituto Nacional de Antropología e Historia.
 Study of two hand-held implements in Olmec art that are often found in association with each other.

303 1976. La estela de Alvarado. Proceedings of the 41st International Congress of Americanists 2:309-22. 14 figs., 2 photos. Mexico.
 Although this stela has been called Olmec in style, the author suggests that it is Early Classic in date, with stylistic relationship to the relief sculpture from El Tajin.

304 1976. Olmec materials in the National Museum of Anthropology, Mexico. Origins of Religious Art and Iconography in Preclassic Mesoamerica. Ed. H. B. Nicholson. 9-25. 30 figs. Los Angeles.
 Explanation of the five-part organization of the Olmec halls in the Mexican Museum.

Chadwick, Robert.
305 1966. The tombs of Monte Albán I style at Yagul. Ancient Oaxaca. Ed. J. Paddock. 244-55. 11 figs. Stanford, California.
 Descriptive report on the architecture and artifacts of four early tombs at Yagul. Tombs are structurally similar to coeval ones at Monte Alban, though made of adobe rather than

stone. Interred objects relate stylistically to Monte Alban I, phase C (circa 650 B.C.).

306 1971. Postclassic pottery of the central valleys. Handbook of Middle American Indians 10. Ed. Gorden F. Ekholm and Ignacio Bernal. 228-57. 26 figs. Austin: University of Texas Press.
Review of the literature and definition of major decorated types.

307 1982. An explanation of the textual changes in Codex Nuttall. Aspects of the Mixteca-Puebla Style and Mixtec and Central Mexican Culture in Southern Mesoamerica. 27-32. Middle American Research Institute Occasional Paper no. 4. New Orleans: Tulane University.
Textual changes as a rewriting of 8 Deer Tiger Claw's life to give him a more central role in Mixtec history.

Charlot, Jean.
308 1935. Mayan art. American Magazine of Art 38, no. 7:418-23. 6 figs.
Thoughtful but dated essay on the style and meaning of Maya sculpture. Of interest chiefly for the light it throws on the art world of the 1930s.

309 1938. A XII century Mayan mural. American Magazine of Art 31, no. 11:624-29, 670. 8 figs.
Black-and-white drawings of murals from the Temple of the Jaguars at Chichen Itza. Drawings traced from original by author and Ann Axtell Morris. Discussion of artistic technique and subject matter.

310 1940. Twenty centuries of Mexican art. American Magazine of Art 33:398-404, 440-43. 12 figs. New York.
Review of Mexican exhibit at Museum of Modern Art in New York. Approximately half of review and photos devoted to pre-Hispanic art (emphasis on Aztec). Author comments on pre-Columbian and colonial Mexican aesthetics.

Charnay, Desiré.
311 1887. The Ancient Cities of the New World. 514 pp., numerous text illustrations. London: Chapman and Hall.
Description of the author's travels throughout Mexico and Central America between 1857 and 1882. Many illustrations of sites and monuments.

Chefs-d'oeuvre de l'art mexicain.
312 1962. Petit Palais, Paris.
Catalog of show of 2,100 objects from antiquity to present. Fewer than 100 illustrated, chiefly pre-Columbian.

Chefs-d'oeuvre de l'art mexicain.
313 1968. Palais des Beaux-Arts, Bruxelles. 77 pp., 30 black-
 and-white figs.
 Catalog of Mexican art from Pre-Classic to contemporary
 period. Chiefly pre-Hispanic objects. Brief introductory
 comments. Different from the 1962 Paris exhibit.

Chomel de Coelho, Martine.
314 1976. Recapitulación y precisión sobre la identificación
 de la lechuza en Teotihuacan. Proceedings of the 41st
 International Congress of Americanists 2:323-33. 14 figs.
 Mexico.
 Bird imagery formerly thought of as depicting quetzals
 or eagles in Teotihuacan murals is reinterpreted on the basis of
 ornithological information as depicting owls.

Clancy, Flora.
315 1977. Maya pedestal stones. New Mexico Studies in the Fine
 Arts 1:10-19. Albuquerque.
 Stylistic and compositional analysis of motifs on
 "altars" (here renamed pedestal stones) at Tikal and other
 lowland sites.

Clark, James Cooper.
316 1938. Codex Mendoza. 3 vols. London: Waterlow and Sons.
 Photographic facsimile of Aztec codex, detailed descrip-
 tion, commentary, and identification of place glyphs.

Clark, John L., and William F. Parady.
317 1975. Stone Monuments of the Guatemalan Piedmont and
 Chiapas. unpaginated, 32 plates. Privately printed.
 Documentation of numerous non-Maya sculpture of the
 southern coastal lowlands. Text in English and Spanish.

Clarkson, Persis B.
318 1978. Classic Maya pictorial ceramics: a survey of
 content and theme. Papers on the Economy and Architecture
 of the Ancient Maya. Ed. Raymond Sidrys. 86-141. 18 figs.
 Los Angeles: UCLA Institute of Archaeology Monograph VIII.
 Some of the numerous pictorial themes on 231 Maya vases
 are briefly discussed. Includes valuable roll-out drawings of
 eighteen vessels.

Clewlow, C. William Jr.
319 1970. Comparison of two unusual Olmec monuments.
 Contributions of the University of California
 Archaeological Research Facility 8, no. 3:35-40. 3 figs.,
 1 plate. Berkeley.
 Monument 44 at La Venta and the similar "Idolo de San
 Martin Pajapan" compared in terms of size, manner of execution,
 subject matter, and iconography.

320 1974. <u>A Stylistic and Chronological Study of Olmec
Monumental Sculpture</u>. Contributions of the University of
California Archaeological Research Facility 19, no. 1. 299
pp., 53 figs., 20 tables, 6 plates. Berkeley.
 Useful analysis of the various subcategories of Olmec
sculpture, their chronology, and place in Olmec culture.

Clewlow, C. William, <u>et al</u>.
321 1967. <u>Colossal Heads of the Olmec Culture</u>. Contributions
 of the University of California Archaeological Research
 Facility 4. 170 pp., 29 figs., 36 plates. Berkeley.
 Detailed description and stylistic comparison of these
large-scale sculptures. Review of previous literature and
theories. Useful study.

Clouse, G. W.
322 1976. The Gomesta falsification. <u>The Masterkey</u> 50, no.
 1:19-24. 1 fig.
 Further background to Blom's 1935 article on this
specious Maya manuscript.

<u>Codex Mexicanus</u>.
323 1952. 102 plates. Paris: Bibliothèque Nationale Société
 des Américanistes.
 Black-and-white facsimile of this Mexican manuscript.
No commentary.

Coe, Michael.
324 1956. The funerary temple among the Classic Maya.
 <u>Southwestern Journal of Anthropology</u> 12:387-94.
 Important early article on the use of pyramids and
palaces as burial places for Maya elite. Interesting for its
prophetic suggestion that Maya society was governed by a series
of hereditary rulers.

325 1962. An Olmec design on an early Peruvian vessel.
 <u>American Antiquity</u> 27, no. 4:579-80. 2 figs.
 An inscribed maize motif on a pre-Chavin bottle from
Kotosh, Peru is seen as evidence for Olmec influence in South
America.

326 1965. <u>The Jaguar's Children: Pre-Classic Central Mexico</u>.
 126 pp., 208 figs. New York: The Museum of Primitive Art.
 Monograph based on an exhibit of Olmec material, princi
pally ceramic, held at the Museum. Concentration on Las Bocas
figurines and vessels.

327 1965. The Olmec style and its distributions. <u>Handbook of
 Middle American Indians</u> 3. Ed. Gordon R. Willey. 739-75.
 58 figs. Austin: University of Texas Press.
 Important survey of the Olmec art style and its temporal
and geograhic diffusion.

328 1966. The Maya. 180 pp., 141 figs. New York: Praeger
 Publishers. Revised and enlarged edition. London: Thames
 and Hudson, 1980.
 Although not focused solely on art, this introduction to
 the Maya is useful for its discussion of Maya life, art, and
 thought.

329 1966. An Early Stone Pectoral from Southeastern Mexico.
 Dumbarton Oaks Studies in Pre-Columbian Art and
 Archaeology, 1. 18 pp., 11 figs. Washington, D.C.
 Discussion of an Olmec greenstone pectoral incised with
 a Proto-Classic style Maya figure and unusual glyphs. Argues
 for use of writing among the Late Pre-Classic Maya of the
 lowlands.

330 1967. An Olmec serpentine figurine at Dumbarton Oaks.
 American Antiquity 32, no. 1:111-13. 4 figs.
 Description of a small figurine with an engraved mosaic
 pavement design on the upper arm. Object said to have come from
 La Venta.

331 1968. America's First Civilization: Discovering the
 Olmec. 160 pp., numerous unnumbered text illustrations.
 New York: American Heritage Publishing Co., Inc.
 Basic popular book on the discovery of the Olmec, their
 art style, and their cultural expansion.

332 1968. San Lorenzo and the Olmec civilization. Dumbarton
 Oaks Conference on the Olmec. Ed. E. P. Benson. 41-78. 13
 figs. Washington, D.C.: Dumbarton Oaks.
 Discussion of recent excavation at San Lorenzo and the
 light it sheds on the heartland and genesis of Olmec
 civilization. Sculpture and topography are discussed. Olmec
 state in operation here by 1200 B.C.

333 1971. The shadow of the Olmecs. Horizon 13, no. 4:67-76.
 9 figs.
 Brief history of Olmec countries, discussion of the
 author's excavations at San Lorenzo, and rudiments of Olmec art
 and civilization.

334 1972. Olmec jaguars and Olmec kings. The Cult of the
 Feline. Ed. Elizabeth P. Benson. 1-18. 8 figs.
 Washington, D.C.: Dumbarton Oaks.
 Aztec ethnohistory combines with zoological information
 to provide a picture of Olmec religion in which sacred jaguars
 are closely associated with divine rulers and the royal lineage.

335 1973. Death and the ancient Maya. Death and the Afterlife
 in Pre-Columbian America. Ed. E. P. Benson. 87-103. 11
 figs. Washington, D.C.: Dumbarton Oaks.

Important article on Maya concepts of death and the underworld. The Popul Vuh as a crucial source of information on this topic. Death symbolism in Maya art (principally codices and vase painting) is discussed. Death and apotheosis as one of main ritual concerns of the Maya.

336 1973. The iconology of Olmec art. The Iconography of Middle American Sculpture. 1-12. 7 figs. New York: The Metropolitan Museum of Art.
 Based on the work of Joralemon (1971) and on analogy with the Aztec, the author suggests at least eight gods in the Olmec pantheon.

337 1973. The Maya Scribe and His World. 160 pp. New York: The Grolier Club.
 Important catalog of eighty-eight objects displayed at the Grolier Club in New York. Most are polychrome ceramic objects, but paper and carved stone are included as well. This volume was the first publication of the "Grolier Codex," a recently discovered Maya manuscript. First publication of Coe's theories about repeating texts on Maya vases, and the underworld symbolism of most Maya vase painting.

338 1974. A carved wooden box from the Classic Maya civilization. Primera Mesa Redonda de Palenque Part II. Ed. M.G. Robertson. 51-58. 8 figs. Pebble Beach, California: Robert Louis Stevenson School.
 Examination of a rectangular hardwood box dating from the seventh century A.D. and ascribed to the Tortuguero region of Chiapas. Glyphic inscription and low relief human figure ornament the box.

339 1975. Classic Maya Pottery at Dumbarton Oaks. Folio and 30-pp. pamphlet, 17 black-and-white figs., 17 color folio leaves. Washington, D.C.: Dumbarton Oaks.
 Catalog of an important collection of Maya vessels. Both polychrome and incised pieces are included. Brief entries of the iconography and epigraphy of each piece. Seventeen full color roll-out watercolors of the vessels.

340 1975. Three Maya figurines from Jaina Island. Yale University Art Gallery Bulletin 35, no. 2:24-25. 2 figs. New Haven.
 Discussion of a female figurine and two small clay flowers with emergent aged faces.

341 1977. Mexico. Second edition. 216 pp., 75 plates, 41 figs. New York: Praeger.
 An updated version of his 1962 survey of northern Mesoamerican cultures. Excludes Maya area, which is treated in a separate volume.

342 1977. Supernatural patrons of Maya scribes and artists.
 Social Process in Maya Prehistory. Ed. Norman Hammond.
 327-47. 17 figs. London: Academic Press.
 Aztec and Yucatec Maya information on scribes and
 artists used in conjunction with the Popul Vuh and vase painting
 from the Classic lowlands in order to reveal the status and
 sacred patronage of Classic Maya scribes.

343 1978. Lords of the Underworld: Masterpieces of Classic
 Maya Ceramics. 142 pp., 20 black-and-white figs., 3 line
 drawings, 20 roll-out color plates. Princeton: The Art
 Museum, Princeton University.
 Catalog of an important exhibit of Maya polychrome
 pottery. All twenty objects are illustrated, both in roll-out
 and conventional photography. The iconography and epigraphy of
 each object is considered in a catalog entry for each piece.
 Appendix by Justin Kerr on his technique of roll-out
 photography.

344 1982. Old Gods and Young Heroes: The Pearlman Collection
 of Maya Ceramics. 128 pp., 64 color and black-and-white
 plates, numerous figures. Jerusalem: The Israel Museum.
 Important pictorial record of one collection of Maya
 vases. Brief notes on iconography and glyphs.

Coe, Michael, and Elizabeth P. Benson.
345 1966. Three Maya Relief Panels at Dumbarton Oaks.
 Dumbarton Oaks Studies in Pre-Columbian Art and
 Archaeology, 2. 36 pp., 12 figs. Washington, D.C.
 Descriptive, epigraphic, and iconographic study of three
 Classic Maya figural reliefs from the Piedras Negras area,
 Palenque, and Kuna-Lacanha.

Coe, William R.
346 1958. Two carved lintels from Tikal. Archaeology 11, no.
 2:75-80. 8 figs.
 Zapote wood lintels from Temples I and III, still in
 situ at the time of writing, are discussed. Cleaning and photo-
 graphic techniques of documentation are described, drawings of
 figural reliefs and a discussion of their meaning are included.

347 1972. Cultural contact between the Lowland Maya and
 Teotihuacan as seen from Tikal, Peten, Guatemala.
 Teotihuacan, Onceava Mesa Redonda 2:257-72. Mexico:
 Sociedad Mexicana de Antropología.
 Archaeological evidence, mainly sculptural and ceramic,
 for evidence of contact between these two sites. Obsidian trade
 and architecture considered as well.

Coe, William, and John J. McGinn.
348 1963. Tikal: the north acropolis and an early tomb.
 Expedition 5, no. 2:25-32. 12 figs.
 Pre-Classic Burial 85 and its associated jade and
ceramic artifacts.

Coe, W. R., E. M. Shook, and L. Satterthwaite.
349 1958. The carved wooden lintels of Tikal. *Tikal Reports*
 6:17-111. 37 figs. Philadelphia: University Museum,
 University of Pennsylvania.
 Detailed study of all aspects of these Maya lintels.
Covers not only those *in situ*, but those in Basel as well.

Coggins, Clemency.
350 1969. Illicit traffic of pre-Columbian antiquities. *Art
 Journal* 29:94-98, 114.
 Brief essay on the plundering of Mesoamerican sites.
Includes partial list of stone monuments recently stolen from
Mexico and Guatemala.

351 1972. Archaeology and the art market. *Science* 175, no.
 4019:263-66.
 Discussion of the crisis in the looting of Maya antiqui-
ties. Comments on the questionable role of scholars in the
valuation of objects for the art market.

352 1972. Displaced Mayan sculpture. *Estudios de Cultura Maya*
 8:15-24.
 Listing of present location of numerous Maya sculptures
that were illegally plundered from their sites.

353 1975. *Painting and Drawing Styles at Tikal: An Historical
 and Iconographic Reconstruction.* Unpublished doctoral
 dissertation, Department of Fine Arts, Harvard University.
 Ground-breaking study, not only of stylistic and icono-
graphic features of art at this Maya site, but also of possible
historical synthesis drawn from context, style, iconography, and
epigraphy.

354 1979. A new order and the role of the calendar: some
 characteristics of the Middle Classic period at Tikal.
 Maya Archaeology and Ethnohistory. 38-50. 4 figs. Ed. N.
 Hammond and G. Willey. Austin: University of Texas Press.
 Evidence of intrusive elite of Central Mexicans found in
stelae, inscriptions, and tomb furniture at Tikal, as well as in
what the author sees as a Maya accommodation to Central Mexican
ideology.

355 1979. A role for the art historian in an era of new
 archaeology. *Proceedings of the 42nd International
 Congress of Americanists* 7:315-20. Paris.

Thought-provoking essay on the gaps and overlaps between two disciplines. Prescriptive suggestions for avenues for future methodologies for art historians.

356 1979. Teotihuacan at Tikal in the Early Classic period. Proceedings of the 42nd International Congress of Americanists 8:251-69. 6 figs. Paris.
Evidence for Teotihuacan-Maya contact in the Peten based on sculptural, ceramic, and glyphic evidence at Tikal. Abstracted from the author's doctoral dissertation.

357 1980. The shape of time: some political implications of a four-part figure. American Antiquity 44, no. 4:727-39. 7 figs.
The quadrupartite imagery in Maya katun celebrations is linked to Teotihuacan influence in the Peten during the Early Classic period.

358 1982. The zenith, the mountain, the center, and the sea. Ethnoastronomy and Archaeoastronomy in the American Tropics. Ed. A. Aveni and G. Urton. Annals of the New York Academy of Sciences 285:111-24. 7 figs.
Idea of a central cosmic axis governed both the site orientation and the sculptural program at Izapa.

Cohodas, Marvin.
359 1974. The iconography of the Panels of the Sun, Cross, and Foliated Cross at Palenque: Part II. Primera Mesa Redonda de Palenque Part I. Ed. M.G. Robertson. 95-107, 7 figs. Pebble Beach, California: Robert Louis Stevenson School.
Low-relief sculptural program as a sort of noninscriptional agricultural calendar, reinforcing the symbolism and activities of the sun and moon deities.

360 1975. The symbolism and ritual function of the Middle Classic ball game in Mesoamerica. American Indian Quarterly 2, no. 2:99-130. 8 figs.
Meaning of Middle Classic ballgame elucidated through an understanding of Late Post-Classic versions of the game. Middle Classic evidence drawn principally from Tajin, Copan, and Chichen Itza.

361 1976. The iconography of the Panels of the Sun, Cross, and the Foliated Cross at Palenque: part III. Segunda Mesa Redonda de Palenque. Ed. M.G. Robertson. 155-76. 12 figs. Pebble Beach, California: Robert Louis Stevenson School.
Iconography of the Cross Group mirrors Mesoamerican cosmological structure. This structure, in turn, shapes Maya dynastic symbolism.

362 1978. Diverse architectural styles and the ball game cult:
the late Middle Classic period in Yucatan. Middle Classic
Mesoamerica: AD 400-700. Ed. E. Pasztory. 86-107. 16
figs. New York: Columbia University Press.
 Controversial but convincing new chronology for Chichén
Itza based on close parallels between Puuc and Chichén-Toltec
architectural styles.

363 1978. The Great Ball Court at Chichen Itza, Yucatan,
Mexico. 302 pp., 122 figs. New York: Garland Publishing,
Inc.
 Publication of the author's doctoral dissertation in the
department of art and archaeology, Columbia University, 1974.
Controversial study of the style and iconography of this one
monument. A new earlier temporal sequence for Chichen Itza is
proposed.

364 1979. The identification of workshops, schools, and hands
at Yaxchilan. Proceedings of the 42nd International
Congress of Americanists 7:301-13. 4 figs. Paris.
 Attributions of sculptural works to particular artists
at this Maya site. One Yaxchilan carver during Bird-Jaguar's
reign, designated as "the Master of Structure 13," is discussed.

365 1979. Some unusual aspects of Cross Group symbolism.
Tercera Mesa Redonda de Palenque. Ed. M. G. Robertson and
D. C. Jeffers. 215-32. 6 figs. Monterey, California.
 Cross-group architecture at Palenque as the synthesis of
divergent trends in Maya art: dynastic and public architecture,
symbolism of death, transformation and rebirth, and monumental
vs. funerary arts. Temple of Inscriptions as a precursor for
some of these themes.

Cook de Leonard, Carmen.
366 1954. Dos extraordinarias vasijas del Museo de
Villahermosa. Yan 3:83-104. 13 figs.
 Iconographic and stylistic examination of a large
figural urn from Ixtapanjoya, Teapa, Tabasco and a fragmentary
polychrome Maya vase with a palace scene.

367 1955. Una "Maqueta" prehispanica. El México Antiguo 8:
169-91. 17 figs.
 A rock carving that had been presumed to be an
architectural mock-up is reassessed as a ceremonial spot for
bloodletting by pilgrims. The models and building-planning
methods of ancient American architects are discussed.

368 1967. Sculptures and rock carvings at Chalcatzingo,
Morelos. Contributions of the University of California
Archaeological Research Facility 3, no. 3:57-84. 13 figs.,
8 plates. Berkeley.

Olmec reliefs at Chalcatzingo are analyzed in terms of Aztec deity representations.

369 1971. Ceramics of the Classic period in Central Mexico. Handbook of Middle American Indians 10. Ed. Gordon F. Ekholm and Ignacio Bernal. 179-205. 12 figs., 3 tables. Austin: University of Texas Press.
 Figurines and vessels, principally at Teotihuacan.

370 1971. Minor arts of the Classic period in Central Mexico. Handbook of Middle American Indians 10. Ed. Gordon F. Ekholm and Ignacio Bernal. 206-26. 18 figs. Austin: University of Texas Press.
 Survey focuses on materials: stone, clay, pigments, leathers, shell, bone, feathers, and plant products, and their apparent use at Teotihuacan.

Cooper-Clark, J.
371 1912. The story of 8 Deer in Codex Colombino. Proceedings of the 18th International Congress of Americanists. 135-36. 1 plate. London.
 Abstract of a longer presentation. Discusses the appearance of the personage 8 Deer in several Mixtec codices, and the events in which he participates.

Corona Núñez, José.
372 1952. Cual es verdadero significado del Chac Mool? Tlatoani 1, nos. 5-6:57-62. 9 figs.
 Survey of reclining figures in Aztec, Toltec, and Toltec-Maya sculpture. Chac Mool as messenger or transmitter of offerings.

Corson, Christopher.
373 1973. Iconographic survey of some principal figurine subjects from the mortuary complex of Jaina, Campeche. Contributions of the University of California Archaeological Research Facility 18, no. 5:51-75. 3 plates. Berkeley.
 Female figurine types, dwarfs, humpbacks, and ball players in Jaina figures.

374 1975. Stylistic evolution of Jaina figurines. The Masterkey 49, no. 4:130-38. 4 figs. Reprinted in Pre-Columbian Art History. Ed. Alana Cordy-Collins and Jean Stern. 63-69. 4 figs. Palo Alto: Peek Publications, 1977.
 Tri-partite periodization of Jaina-style figurines from 600-1200 A.D. The differing stylistic and technological features of each period are briefly outlined.

375 1976. Anthropomorphic Maya Figurines from Jaina Island, Campeche. 218 pp., 34 figs. Ramona, Calif.: Ballena Press.

Typological and stylistic study.

Covarrubias, Miguel.
376 1948. Tipología de la industria de piedra tallada y pulida
de la cuenca del Río Mezcala. El Occidente de México. 87-
90. 6 figs. Mexico: Sociedad Mexicana de Antropología.
 Brief stylistic typology of Mezcala stone sculpture.
Author divides the corpus into Olmec, Olmecoid, Teotihuacan,
Olmec-Teotihuacan, and local styles.

377 1957. Indian Art of Mexico and Central America. 360 pp.,
146 figs., 64 black-and-white plates, 12 color plates. New
York: Alfred A. Knopf.
 Influential survey of the field by one of its foremost
students. Noteworthy for its early, thorough coverage of "The
Olmec Problem."

378 1977. Olmec Art or the art of La Venta. Pre-Columbian Art
History. Ed. Alana Cordy-Collins and Jean Stern. 1-34. 24
figs., 5 plates. Palo Alto, California: Peek
Publications.Translated from Cuadernos Americanos 28, no. 4
(1946).
 An introduction to the art of the Olmec written soon
after the great discoveries at La Venta and elsewhere.
Attention paid both to stylistic and iconographic features of
Olmec art.

Cresson, F. M.
379 1938. Maya and Mexican sweat houses. American
Anthropologist n.s. 40:88-104.
 The function of sweathouses and the custom of ceremonial
bathing in Mesoamerica.

Cubas, Antonio García.
380 1910. Estudio comparativo de dos documentos históricos.
Proceedings of the 17th International Congress of
Americanists 2:411-26. 2 plates. Buenos Aires.
 Discussion of the "Tira del Museo" and "Pintura del
Museo," two maguey paper manuscripts concerning the Aztec
migrations. The two are discussed as a continuous narrative.

Dark, Philip.
381 1958. Mixtec Ethnohistory: A Method of Analysis of The
Codical Art. 61 pp., 7 figs. Oxford: Oxford University
Press.
 Puts forth an "ideographic-iconographic" method of codex
decipherment. Also reviews previous approaches to codex
analysis. Especially interested in genealogies in Codex Selden
and Codex Bodley.

Dark, Philip, and J. Plesters.
382 1959. The palimpsests of Codex Selden: recent attempts to
 reveal the covered pictographs. Proceedings of the 33rd
 International Congress of Americanists 2:530-39. Costa
 Rica.
 Report on underlying paintings in one manuscript. No
 clear details were successfully revealed. Technical analysis of
 pigments.

Dávalos Hurtado, Eusebio, and J. M. Ortiz de Zárate.
383 1952-53. La plástica indígena y la patología. Revista
 Mexicana de Estudios Antropológicos 13, nos. 2 and 3:95-
 104. 13 figs.
 Physical deformities as exhibited in pre-Columbian art.
 Principally Olmec and Classic Veracruz examples used.

Davis, Whitney.
384 1978. So-called jaguar-human copulation scenes in Olmec
 art. American Antiquity 43, no. 3:453-56.
 Criticisms of earlier interpretation of themes in Olmec
 iconography. Evidence for so-called copulation scenes is seen
 as inconclusive. A nonsexual theme of aggression is proposed
 for these monuments.

Del arte: Homenaje a Justino Fernández.
385 1977. Mexico: Universidad Nacional Autónoma de México.
 312 pp.
 Festschrift volume consisting of a number of essays on
 pre-Hispanic and colonial arts, letters, and history, and the
 life and work of Justino Fernández. Individual annotations
 given here for Robertson, Scott, Bosch-Gimpera, Bernal, de la
 Fuente and Foncerrada de Molina.

de la Fuente, Beatriz.
386 1965. La escultura de Palenque. Estudios y fuentes del
 arte en México, 20. 214 pp., 72 plates. Universidad
 Nacional Autónoma de México.
 A study of Palenque sculpture with background and
 historiographic material and information on Maya sculpture in
 general. Author charts an evolutionary sequence for Palenque
 sculpture.

387 1973. Escultura monumental olmeca: Catálogo. 309 pp.,
 245 plates. Mexico: Universidad Nacional Autónoma de
 México.
 Catalog of 248 pieces of large-scale Olmec stone
 sculpture, listing provenience, context, history, formal
 description and citing published references to each piece.

388 1974. Arte prehispánico funerario. Collección de arte 27.
 61 pp., 12 color plates, 90 figs. Mexico: Universidad
 Nacional Autónoma de México.

Study of the ceramic figures of Colima, Jalisco, and Nayarit. Pieces illustrated drawn mainly from collections of Museo Nacional de Antropología.

389 1975. Las cabezas colosales olmecas. 64 pp., 33 plates. Mexico.
Stylistic study of all known colossal heads in Olmec style.

390 1976. La cabeza colosal de Cobata. Proceedings of the 41st International Congress of Americanists 2:348-57. 8 figs. Mexico.
Based on stylistic analysis, recently discovered "Olmec" head is assessed as being not Olmec but a later reinterpretation of the Olmec colossal head theme.

391 1977. Los hombres de piedra: Escultura olmeca. 385 pp., 24 color plates, 91 figs. Mexico: Universidad Nacional Autónoma de México.
Full-length study of large-scale Olmec stone sculpture. Objects from each major site considered separately. Iconographic and proportional study, historiographic section. As in her other short article (1977), she defines iconographic categories of mythic images, supernatural beings, human figures.

392 1977. La iconografía de la escultura olmeca monumental. Del arte: Homenaje a Justino Fernández. 35-43. 16 black-and-white figs. Mexico: Universidad Nacional Autónoma de Mexico.
Breaks Olmec monumental figural sculpture into groups: mythical images, supernatural beings, and human figures.

393 1981. Toward a conception of monumental Olmec art. The Olmec and Their Neighbors. Ed. Elizabeth Benson. 83-94. 13 figs. Washington, D.C.: Dumbarton Oaks.
An inquiry into the criteria used in defining Olmec "style" in monumental figural sculpture. Discussion of the proportional canon ("golden mean") used by Olmec artists in representing the human figure.

Delgado, Agustín.
394 1961. Polychrome Zapotec tomb paintings. Current Anthropology 2:269.
Announcement of the discovery of historic period murals in Mixtec style near San Pedro Yolox.

395 1965. Infantile and jaguar traits in Olmec sculpture. Archaeology 18, no. 1:55-62. 17 figs.
Figurines and large-scale sculpture analyzed for feline and childlike facial qualities. No persuasive reason given for the conflation of such traits.

Delgado, Hilda S.
396 1969. Figurines of backstrap loom weavers from the Maya
 area. Proceedings of the 38th International Congress of
 Americanists 1:139-49. 13 figs. Munich.
 Jaina figurines and the information they reveal about
 the correspondences between ancient and modern weaving practices
 in the Maya area.

Dertig Eeuwen Mexicaanse kunst.
397 1959. 52 pp., 36 plates, 3 text figs. Hague:
 Gemeentemuseum.
 Catalog of exhibit. Mostly stone, clay, and mosaic
 objects, most of pre-Hispanic Mexican origin. Several pieces
 from lower Central America and from recent times.

d'Harcourt, Raoul.
398 1958. Représentation de textiles dans la statuaire Maya.
 Proceedings of the 32nd International Congress of
 Americanists. 415-21. 9 figs. Copenhagen.
 The author suggests that with few actual textile
 fragments from the Classic Maya, we must turn to sculptural
 reliefs to glean information about weaving. Examples drawn
 principally from Palenque, Piedras Negras, and Yaxchilan.
 Similarities with known examples of open work gauze from ancient
 Peru discussed.

Dibble, Charles E.
399 1947. Codex Hall: An Ancient Mexican Hieroglyphic Picture
 Manuscript. Monographs of the School of American Research,
 11. 16 pp., 2 folding pls. Santa Fe.
 Color silk-screen facsimile of a falsified pictorial
 manuscript.

400 1951. Códice Xolotl. 166 pp., plates. Mexico:
 Universidad Nacional Autónoma de México and the University
 of Utah.
 Photographic facsimile and commentary on the codex.

401 1955. The Aztec writing system. Readings in Anthropology.
 Ed. E. Adamson Hoebel, J. D. Jennings, and E. Smith. 296-
 302. New York: McGraw Hill.
 Good but brief introduction to the principles of Aztec
 pictographic writing.

402 1965. Apuntes sobre le plancha X del Códice Xólotl.
 Estudios de Cultura Nahuatl 5:103-6. 1 fig.
 Brief notes on a reinterpretation of one page in a
 Mexican codex.

403 1981. Codice en Cruz. 2 vols. vol. 1:68 pp., 73 figs.
 vol. 2:44 plates. Salt Lake City: University of Utah
 Press.

Study of an early postconquest Aztec historical manu-
script. Volume two is facsimile of the original and three later
copies.

Diehl, Richard.
404 1981. Olmec architecture: a comparison of San Lorenzo and
 La Venta. The Olmec and Their Neighbors. Ed. Elizabeth
 Benson. 69-81. 2 figs. Washington, D.C.: Dumbarton Oaks.
 Descriptive and comparative study of the major features
of Early and Middle Formative architecture at two major sites.
Points up major important differences that have previously been
underemphasized.

Diehl, Richard A., Roger Lomas, and Jack T. Wynn.
405 1974. Toltec trade with Central America. Archaeology 27,
 no. 3:182-87. 9 figs.
 A cache discovered in excavations at Tula revealed
Papagayo polychrome pottery from southern Central America and
plumbate from Guatemala.

Dieseldorff, Erwin P.
406 1894. Ein Thongefäss mit Darstellung einer vampyrköpfigen
 Gottheit. Zeitschrift für Ethnologie 26:576-77. 1 fig.
 Translated as "A clay vessel with a picture of a vampire-
 headed deity." Bureau of American Ethnology Bulletin
 28:665-66. 1 fig. 1904.
 Brief essay on famous Chama vase excavated by the
author. Vase depicts leaf-nosed bat.

407 1894. Ein bemaltes Thongefäss mit figürlichen
 Darstellungen aus einem Grabe von Chama. Zeitschrift für
 Ethnologie 26:372-77. 2 figs. Translated as "A pottery
 vase with figure painting from a grave in Chama." Bureau of
 American Ethnology Bulletin 28:639-44. 2 figs. 1904.
 Description of famous Chama vase depicting black-painted
warrior lords. Author discusses excavation and iconography of
the vessel.

408 1922. Welchen Got stellen die Steinidolen der Mayavölker
 dar? Festschrift Eduard Seler. Ed. W. Lehmann. 47-58. 1
 plate, 11 figs. Stuttgart.
 Brief discussion of several categories of Classic Maya
gods found in clay figures and vase painting, with reference to
Maya ethnology.

409 1926. Kunst und Religion der Mayavölker im alten und
 heutigen Mittelamerika. 45 pp., 53 plates. Berlin:
 Julius Springer.
 Early study of Maya art and religion, based principally
on materials in German museum collections.

410 1930. The Aztec calendar stone and its significance.
 Proceedings of the 23rd International Congress of
 Americanists. 211-22. 12 figs. New York.
 Brings Maya information to bear on the question of the
 meaning of the Aztec calendar stone, but no new interpretation
 is forthcoming.

Dietschy H.
411 1948. La coiffure de plumes mexicaines du Musée de Vienne:
 critique iconographique et notes ethno-psychologiques.
 Proceedings of the 28th International Congress of
 Americanists. 381-92. Paris.
 Discussion of the famous Aztec plumed headdress studied
 earlier by Nuttall (1892) and others.

Digby, Adrian.
412 1951-52. A jade earplug and a carved shell pectoral from
 Pomona, British Honduras. British Museum Quarterly 16:29-
 30. 2 figs. London.
 Brief remarks on two Classic Maya objects in the collec-
 tions of the British Museum.

413 1952. The Maize God and the crossed band glyph.
 Proceedings of the 30th International Congress of
 Amricanists. 41-44. 4 figs. London.
 Jade plaque in the British Museum depicting a human face
 with crossed-bands head ornament said to represent the maize god
 based on comparison with Copan sculpture and other Maya imagery.

414 1953. The Olmec jades in the exhibition of Mexican Art.
 Burlington Magazine 95, no. 602:162-65. 8 figs. London.
 Brief remarks on objects concurrently on exhibit in
 London. Perceptive comments on style and technique. Fine
 illustrations.

415 1964. Maya Jades. 32 pp., 16 figs. London: The British
 Museum.
 Good concise introduction to the technique of jade
 working and Maya jade objects, based principally on objects in
 the British Museum.

Disselhoff, Hans-Dietrich, and Sigvald Linné.
416 1961. The Art of Ancient America. 274 pp., 148 figs., and
 numerous unnumbered color plates. New York: Crown
 Publishers, Inc.
 Survey of the art of Mesoamerica, Central America, and
 the Andes. Mesoamerican section written by Linné. Emphasis on
 small-scale portable items. Little discussion of architecture.

Dixon, K. A.
417 1958. Two masterpieces of Middle American bone sculpture,
 American Antiquity 24, no. 1:53-62. 3 figs.

Preliminary report on carved human femurs from Chiapa de Corzo, Mexico. Carving style and iconography combine elements of early Monte Alban, Olmec, and Izapa traditions. Proto-Classic date suggested.

Dockstader, Frederick J.
418 1964. Indian Art in Middle America. 221 pp. 248 plates, many in color. Greenwich, Conn.: New York Graphic Society.
 Profusely illustrated survey of Middle American art from the Pre-Classic to contemporary folk arts of the region. Many of the pieces illustrated are from the Museum of the American Indian, New York.

419 1968. Miniature ball-game objects from Mesoamerica. American Antiquity 33, no. 2:251-53. 7 figs.
 Miniature replicas of ballgame paraphernalia from central Mexico, Guerrero, Oaxaca, Veracruz, and Guatemala are illustrated and described. All are from the Museum of the American Indian.

Dow, James W.
420 1967. Astronomical orientations at Teotihuacán, a case study in astro-archaeology. American Antiquity 32, no. 3:326-34. 7 figs.
 Pleiades, Sirius and sun as orientation points for Teotihuacan architecture and city planning.

Drucker, Philip.
421 1952. La Venta, Tabasco: A Study of Olmec Ceramics and Art. Bureau of American Ethnology Bulletin no. 153. 248 pp., 64 figs., 66 plates. Washington, D.C.
 Important early study of art style and iconography of objects excavated from this Olmec site. Explores relationship of La Venta's art to other Mesoamerican styles.

422 1955. The Cerro de las Mesas Offering of Jade and Other Materials. 29-68. Bureau of American Ethnology Bulletin no. 157. 13 plates. Washington, D.C.
 Detailed study of several hundred jades and jadelike materials unearthed by Sterling in 1941. Figurines, plaques, earspools, celts, beads, and miscellaneous items are discussed.

423 1968. The El Mesón monument at Angel R. Cabada, Veracruz. Contributions of the University of California Archaeological Research Facility 5, no. 3:41-57. 4 figs., 1 plate. Berkeley.
 Description and photograph of an unusual basalt monument. Author suggests affinities with Early Classic Teotihuacan and Cerro de las Mesas.

424 1981. On the nature of Olmec polity. The Olmec and Their
 Neighbors. Ed. Elizabeth Benson. 29-47. Washington,
 D.C.: Dumbarton Oaks.
 Suggests that Olmec political organization was that of a
 "primitive state." Monumental sculpture and tomb finds examined
 as evidence for this claim. Important study.

Drucker, Philip, and Robert F. Heizer.
 425 1956. Gifts for the Jaguar God. National Geographic
 Magazine 110:366-75. 8 figs.
 Popular article on some of the underground jades and
 other cache objects at La Venta.

Dunn, Mary Eubanks.
 426 1975. Ceramic evidence for the prehistoric distribution of
 maize in Mexico. American Antiquity 40, no. 3:305-14. 8
 figs.
 Ceramic corncobs on Zapotec funerary urns used to
 determine types of maize and their distribution in ancient
 Mesoamerica.

Durand-Forest, Jacqueline de.
 427 1982. Les neuf seigneurs de la nuit. Indiana 7:103-29. 9
 plates, 4 tables. Berlin: Ibero-Amerikanisches Institut
 Preussischer Kulturbesitz.
 The Nine Night Lords in Mexican and Mixtec codices and
 their characteristic elements and directions.

Durbin, Marshall.
 428 1980. Some aspects of symbolism in Classic Maya stelae
 texts. Symbol as Sense: New Approaches to the Analysis of
 Meaning. Ed. M. L. Foster and S. H. Brandes. 103-21. 8
 figs. New York: Academic Press.
 Comments on the meaning of monumental art, the
 relationship of text to image, and the content of texts on Maya
 stelae.

du Solier, Wilfrido.
 429 1943. A reconnaissance on Isla de Sacrificios, Veracruz,
 Mexico. Notes on Middle American Archaeology and Ethnology
 1, no. 14:63-80. 9 figs. Washington, D.C.: Carnegie
 Institution of Washington.
 Archaeological context of certain pottery figures.

Dütting, Dieter.
 430 1979. Sustina gracia: an inquiry into the Farmer's
 Almanacs of the Codex Dresden. Indiana 5:145-70. 16 figs.
 Berlin: Ibero-Amerikanisches Institut Preussischer
 Kulturbesitz.
 Textual and iconographic study of pages in one Maya
 Codex. Mainly epigraphic.

Dwyer, Jane Powell, and Edward B. Dwyer.
431 1973. Traditional Art of Africa, Oceania, and the
 Americas. 165 pp., numerous text figures. San Francisco:
 The Fine Arts Museums.
 Catalog of the collection at the de Young Museum in San
 Francisco. One quarter of the book devoted to Middle and South
 America.

Easby, Dudley T., Jr.
432 1961. Fine metalwork in pre-conquest Mexico. Essays in
 Pre-Columbian Art and Archaeology. Ed. S. K. Lothrop, et
 al. 35-42. 3 figs. Cambridge: Harvard University Press.
 Brief discussion of various methods of working precious
 metals, with well-known pieces used as examples.

433 1962. Two "South American" metal techniques found recently
 in western Mexico. American Antiquity 28, no. 1:19-24. 4
 figs.
 High-status burial at Uruapan, Michoacan yielded
 evidence of metal techniques previously unknown in Mesoamerica.
 Gold frogs formed by pressing sheet metal over a model and tech-
 niques of drawing gold wire are discussed.

434 1971. Ancient American goldsmiths. Anthropology and Art.
 Ed. C. M. Otten. 298-310. 3 figs. Garden City, N.Y.:
 The Natural History Press.
 Brief survey article on gold working technology in
 Middle and South America.

Easby, Dudley T., Jr., and Frederick J. Dockstader.
435 1964. Requiem for Tizoc. Archaeology 17, no. 2:85-90. 9
 figs.
 Technical and stylistic analysis of a gold figurine of
 an Aztec ruler reveals it as a fake.

Easby, Dudley T., Jr., and Elizabeth Kennedy Easby.
436 1962. A Zapotec get-together. Archaeology 15, no. 2:94-
 98. 8 figs.
 The reuniting of two halves of a Zapotec greenstone
 figural plaque, one half of which was in a private collection,
 the other half in the Museum of the American Indian. Object
 dates from Period IIIb.

Easby, Elizabeth K.
437 1961. The Squier Jades from Toniná, Chiapas. Essays in
 Pre-Columbian Art and Archaeology. Ed. S. K. Lothrop, et
 al. 60-80. 10 figs. Cambridge: Harvard University Press.
 Stylistic, iconographic, and epigraphic discussion of a
 group of worked jades excavated in the nineteenth century, now
 in the Amerian Museum of Natural History. These pieces, also

known as the "Ocosingo jades" are discussed in relation to other
Maya jadework of the Classic period. Important article.

438 1963. Un "Dios Hacha" de las tierras altas mayas. Estudios
 de Cultura Maya 3:97-106. 4 figs.
 Discussion of small jade figure from Tzajalob, Chiapas
 which Easby assesses as an Early Classic Maya replica of a Costa
 Rican jade form.

439 1966. Ancient Art of Latin America from the Collection of
 Jay C. Leff. 139 pp. Brooklyn: The Brooklyn Museum.
 Catalog of an exhibit of a major private collection of
 pre-Columbian art. Five hundred fifty-seven objects cataloged,
 almost half of which are illustrated. Strongest in Mesoamerican
 objects.

Easby, Elizabeth K., and John F. Scott.
440 1970. Before Cortés: Sculpture of Middle America. 322
 pp., 27 color plates, 39 text figs., 308 illustrations.
 New York: The Metropolitan Museum of Art.
 Important scholarly catalog of a major exhibit of pre-
 Columbian art. Lower Central America and the Antilles
 considered as well as Mesoamerica.

Edwards, Emily.
441 1966. Painted Walls of Mexico: From Prehistoric Times
 until Today. 306 pp., 267 figs. Austin: University of
 Texas Press.
 Survey of wall painting. First fifty-eight pages and
 thirty-three figures are concerned with ancient Mexico.

Eisleb, Dieter.
442 1968. Eine skulptierte olmekische Steinschale aus dem
 Besitz des Berliner Museums für Völkerkunde. Tribus 17:27-
 30. 2 figs.
 Bird-form sculptured vessel from the Middle Pre-Classic
 is briefly discussed.

443 1968. Westmexikanische Steinplastiken aus den Sammlungen
 des Berliner Museums für Völkerkunde. Baessler-Archiv n.f.
 16, no. 1:9-30. 51 figs. Berlin.
 Typological study of small-scale stone objects from
 Mezcala area.

444 1969. Töpferkunst der Maya. 26 pp., 35 black-and-white
 plates. Berlin: Gebr. Mann Verlag.
 Slim volume on Maya incised, modeled, and painted
 pottery. Detailed remarks on each illustrated item.

445 1971. Westmexikanische Keramik. 75 pp., 261 figs., 4
 color plates. Berlin: Museum für Völkerkunde.

Catalog of the museum's collection of West Mexican pottery and figurines.

Ekholm, Gordon.
446 1940. Prehistoric lacquer from Sinaloa. Revista Mexicana de Estudios Antropológicos 4, nos. 1-2:10-15. 2 figs. Mexico.
 Excavations at Guasave reveal lacquer technique on gourdlike objects. First finds of prehistoric lacquer technique on perishable vessels. Technique also called pseudocloisonné.

447 1945. A pyrite mirror from Queretaro, Mexico. Notes on Middle American Archaeology and Ethnology 2, no. 53:178-81. 1 fig. Washington, D.C.: Carnegie Institution of Washington.
 Technique of manufacture and Totonac-style figural motifs on a mirror of uncertain provenience.

448 1946. The probable use of Mexican stone yokes. American Anthropologist 48, no. 4:593-606. 4 figs.
 Evidence that stone yokes were ballgame belts is derived from figurines, Copan sculpture, and stone sculpture from Cotzumalhuapa.

449 1946. Wheeled toys in Mexico. American Antiquity 11, no. 4:222-28. 1 plate.
 Survey of use and geographical range of wheeled toys and their general implications. See Linné 1951 for additions to the corpus.

450 1949. Palmate stones and thin stone heads: suggestions on their possible use. American Antiquity 15, no. 1:1-9. 7 figs.
 Palmas and hachas, principally from the Gulf Coast, are discussed in terms of their possible use as ceremonial objects based on wooden or other lightweight prototypes that were worn as ballgame costume.

451 1953. A possible focus of Asiatic influence in the Late Classic cultures of Mesoamerica. Asia and North America: Transpacific Contacts. Ed. M. W. Smith. Memoirs of the Society for American Archaeology 9:72-89. 23 figs.
 Examination of analogous traits in the art and architecture of southeast Asia and the Maya area. Transpacific contact is proposed.

452 1959. Stone Sculpture from Mexico. 31 pp., 31 figs. New York: Museum of Primitive Art.
 Catalog of a small exhibit of diverse objects. Very little text.

453 1961. Some collar-shaped shell pendants from Mesoamerica.
 Homenaje a Pablo Martínez del Río. 287-93. 4 figs.
 Mexico.
 Discussion and illustration of four pendants from
 Central Mexican sites made from Patella mexicana shells.
 Toltec-era figural designs adorn two of the shells.

454 1964. A Maya Sculpture in Wood. Museum of Primitive Art
 Studies, 4. 12 pp., 9 figs. New York.
 Descriptive study of a remarkable kneeling wooden figure
 of Classic Maya date.

455 1964. The possible Chinese origin of Teotihuacán
 cylindrical tripod pottery and certain related traits.
 Proceedings of the 35th International Congress of
 Americanists 1:39-45. Mexico.
 Comparison of Teotihuacan vessels and pottery of the Han
 dynasty (206 B.C. to 220 A.D.) in China.

456 1966. Pre-Columbian Art. 22 figs., unpaginated. Houston:
 The Museum of Fine Arts.
 Catalog of a gift of two hundred twenty objects to the
 Houston Museum. Virtually no text.

457 1970. Ancient Mexico and Central America. 127 pp.,
 numerous unnumbered black-and-white and color text
 illustrations. New York: The American Museum of Natural
 History.
 Partial catalog of the museum's most significant
 holdings in this area. Many important pieces illustrated.

458 1973. The eastern Gulf coast. The Iconography of Middle
 American Sculpture. 40-51. 10 figs. New York: The
 Metropolitan Museum of Art.
 Identification of subregional style groups of ceramics
 and stone sculptures of this poorly understood area.

Ekholm, Suzanna M.
 459 1968. A three-sided figurine from Izapa, Chiapas, Mexico.
 American Antiquity 33, no. 3:376-79. 4 figs.
 Suggested reconstruction of a three-sided figurine
 fragment from Pre-Classic Izapa, and comparison with other such
 figurines from the Gulf coast.

460 1979. The Lagartero figurines. Maya Archaeology and
 Ethnohistory. Ed. N. Hammond and G. Willey. 172-86. 5
 figs. Austin: University of Texas Press.
 Late Classic Maya mold-made figurines excavated in
 Chiapas.

Ekholm-Miller, Suzanna M.
461 1973. The Olmec Rock Carving at Xoc, Chiapas, Mexico.
 Papers of the New World Archaeological Foundation, 32. 28
 pp., 18 figs. Provo, Utah: Brigham Young University.
 Report on a site where large-scale figural rock carving
 in Olmec style was discovered. Discussion of ceramic
 associations and iconography. Well illustrated.

Emmerich, André.
462 1959. Savages never carved these stones. American
 Heritage 10, no. 2:46-57. 22 figs.
 Brief, well-illustrated survey of the various types of
 sculpture made in ancient Mesoamerica.

463 1963. Art before Columbus. 256 pp. New York.
 Survey text of the artistic production and cultural
 heritage of ancient Mesoamerican societies. Includes several
 hundred unnumbered photos.

Enciso, Jorge.
464 1947. Sellos del antiguo Mexico. 155 pp., all
 illustrations. Mexico.
 Picturebook of designs and motifs on pre-Columbian
 ceramic stamps. Little text.

Ernst, A.
465 1892. Notes on some stone yokes from Mexico.
 International Archiv für Ethnographie 5:71-76. 1 plate.
 Leiden.
 Description and illustration on three stone yokes from
 Veracruz deposited in the museum in Caracas.

Exposición de escultura mexicana antigua.
466 1934. 139 black-and-white plates. Mexico: Palacio de
 Bellas Artes.
 Catalog of an early Mexican exhibit on stone and ceramic
 sculpture of diverse regions. No text.

Farris, Nancy M., Arthur G. Miller, and Arlen F. Chase.
467 1975. Late Maya mural paintings from Quintana Roo, Mexico.
 Journal of Field Archaeology 2, no. 1-2:5-10. 3 figs.
 Discovery of previously unknown murals at Xelha. Rela-
 tionship to Tulum and Tancah is evident. No murals illustrated.

Feest, Christian.
468 1975. Maya: Keramik und Skulptur aus Mexiko.
 unpaginated, 21 figs. Vienna: Museum für Völkerkunde.
 Catalog of an exhibit of Maya art from the Barbachano
 Ponce collection and that of several museums.

Feldman, Lawrence.
469 1965. Bearded gods in Mesoamerica and Peru. The Masterkey
 39, no. 4:135-40. 2 figs.
 Examination of the iconographic evidence for bearded
 figures in pre-Columbian America. Discussion of the pre-
 conceptions of the colonial Spaniards about the indigenous
 peoples.

Fernández Barrera, Josefina.
470 1960. Las cabecitas sonrientes de la Mixtequilla
 veracruzana. Homenaje a Rafael García Granados. 179-83.
 4 figs. Mexico: Instituto Nacional de Antropología e
 Historia.
 Brief descriptive article on the "smiling face"
 figurines of the Gulf coast.

471 1965. El arte textil entre los Nahuas. Estudios de Cultura
 Nahuatl 5:143-52. 5 figs.
 Brief but good exploration of sixteenth-century
 ethnohistorical accounts of Aztec textile manufacture.

Fernández, Justino.
472 n.d. Mexico's Pre-Hispanic Sculpture. unpaginated, 36
 figs. Mexico: Editorial Mexico, S. A.
 Color plates of Mesoamerican objects, principally small-
 scale ceramics, most from the collection of the National Museum
 in Mexico. Brief catalog entries for each piece.

473 1954. Coatlicue: Estética del arte indígena antiguo. 285
 pp., 220 illustrations. Universidad Nacional Autónoma de
 Mexico. Reprinted in Estética del arte mexicano, 1972.
 Mexico.
 Originally the author's thesis. Looks at famous Aztec
 sculpture of the goddess Coatlicue in order to understand the
 pre-Hispanic aesthetic system. Analysis of formal and symbolic
 elements, discussion of the history of criticism of indigenous
 art and its meaning for modern Mexican artists.

474 1958. Arte mexicano de sus origenes a nuestras días. 208
 pp., 224 black-and-white illustrations. Mexico.
 Guide to Mexican arts from ancient to modern times.
 Brief section entitled "Arte indigena antiguo" begins the book.
 Includes fifty-two black-and-white illustrations of pre-
 Hispanic art, 1 in color.

475 1959. Una aproximación a Xochipilli. Estudios de Cultura
 Nahuatl 1:31-41. 6 figs.
 Study of the famous stone statue Xochipilli found at
 Tlelmanalco, D. F., now in Museo Nacional. Use of Nahuatl
 poetry and ethnohistory to elucidate the meaning of the work.

476 1963. Una aproximación a Coyolxauhqui. Estudios de
 Cultura Nahuatl 4:37-48. 4 figs.
 Famous head of the Aztec goddess is analyzed in terms of
 its iconography.

477 1966. El Mictlan de Coatlicue. Estudios de Cultura
 Nahuatl 6:47-53. 8 figs.
 Photographic documentation of the relief on the base of
 the giant sculpture of the Aztec goddess when it was moved in
 1964. Geometric sectioning of the image to elucidate its
 composition and structure. Date of 1454 suggested for its
 execution.

Fernández, Miguel Angel.
 478 1940. Exploración y reconstrucción del Templo del Sol,
 Palenque, Chiapas. Revista Mexicana de Estudios
 Antropológicos 4, nos. 1-2:57-64. 7 figs., 2 plates.
 Notes on early exploration at Palenque and recent
 excavation. Reconstruction of mansard roof and roof comb with
 figural sculpture is suggested.

 479 1946. Los adoratorios de la Isla de Jaina. Revista
 Mexicana de Estudios Antropológicos 8:243-60. 8 figs., 12
 plates.
 Architectural remains on this Maya island.

Ferree, Lisa.
 480 1972. The Pottery Censers of Tikal, Guatemala. 265 pp., 36
 figs. Ann Arbor: University Microfilms.
 Archaeological analysis of this one ceramic type.

Feuchtwanger, Franz.
 481 1951. Olmekische Kunst, neue archäologische Funde zu einer
 bisher unerforschten mittleamerikanischen Kultur.
 Atlantis 23:265-71. 14 figs.
 Discussion of the Olmec art style and newly discovered
 facts about Olmec civilization illustrated by photos of a number
 of famous pieces.

 482 1978. Ikonographische Ursprünge Einiger Mesoameri-
 kanischer Gottheiten. Baessler-Archiv n.f. 26, no. 2:241-
 80. 42 figs. Berlin.
 Examination of Pre-Classic ceramic material from
 Tlatilco, Tlapacoya, Las Bocas, and elsewhere.

Fewkes, J. Walter.
 483 1894. A study of certain figures in a Maya codex. American
 Anthropologist 7, no. 3:260-74. 4 plates.
 Long-nosed god in the Madrid Codex and his symbolism.

484 1895. The god "D" in the Codex Cortesianus. <u>American Anthropologist</u> 8:205-22. 4 plates.
 Identification of the depictions of "God D" in Madrid Codex, his iconographic and glyphic associations, as well as discussion of opinions of earlier scholars. Gods B and G discussed in relation to D.

485 1906. An ancient megalith in Jalapa, Veracruz. <u>American Anthropologist</u> n.s. 8:633-39. 1 plate.
 Description and illustration of a stela depicting a low relief of a bloodletting ritual.

Field, Frederick V.
486 1967. <u>Thoughts on the Meaning and Use of Pre-Hispanic Mexican Sellos</u>. Dumbarton Oaks Studies in Pre-Columbian Art and Archaeology, 3. 48 pp., 58 figs. Washington, D.C.
 The function of clay seals, both cylindrical and flat, is discussed. Hypotheses about their use in body decoration and textile and pottery imprinting are examined. Pre-Classic sellos from Tlatilco and Las Bocas as well as Post-Classic ones from Colima and Guerrero are analysed and illustrated.

Fitzer, P. M.
487 1981. Symbolic "one-leggedness": Pacal as Tezcatlipoca. <u>American Antiquity</u> 46, no. 1:163-66.
 The Palenque ruler, his relationship to the Maya "God K" of the maniken scepter, and the Aztec serpent-footed deity Tezcatlipoca.

Flannery, Kent V., and Joyce Marcus.
488 1976. Formative Oaxaca and the Zapotec cosmos. <u>American Scientist</u> 64, no. 4:374-83. 9 figs.
 New discoveries in Zapotec ritual, cosmology, agriculture, and the evolution of village ceremonials explained in a concise article.

Flannery, Kent, and Joyce Marcus (eds.).
489 1983. <u>The Cloud People: Divergent Evolution of the Zapotec and Mixtec Civilizations</u>. 391 pp., numerous figures and tables. New York: Academic Press.
 Important synthesis of archaeological and ethno-historic information on the ancient civilizations of Oaxaca. Includes valuable, though brief reports on art, writing, and manuscripts by Marcus, Smith, Robertson, and others.

<u>Flor y canto del arte prehispánico de Mexico</u>.
490 1964. unpaginated, 411 color plates. Mexico: Fondo Editorial de la Plástica Mexicana.
 Very little text. Extraordinarily fine plates, principally of sculpture, pottery, and painting.

Florescano, Enrique.
491 1964. La serpiente emplumada, Tláloc y Quetzalcoatl.
 Cuadernos Americanos 133, no. 2:121-66. 10 figs., 6
 plates.
 Late Post-Classic deity figures manifested in art at
 Teotihuacan and Xochicalco.

Folan, William J.
492 1967. El Chichan Chob y la Casa del Venado, Chichen Itza,
 Yucatan. Anales 19:49-61. 2 figs., 8 plates. Mexico:
 Instituto Nacional de Antropología e Historia.
 Comparison of two similar structures at Chichen Itza.

Follett, Prescott H. F.
493 1932. War and Weapons of the Maya. 375-410. Middle
 American Research Series, 4. 56 figs. New Orleans: Tulane
 University.
 Maya murals and sculpture combined with ethnohistoric
 analogy from the Aztec reveal Maya ideas about warfare and
 armaments.

Foncerrada de Molina, Marta.
494 1962. La arquitectura Puuc dentro de los estilos de
 Yucatan. Estudios de Cultura Maya 2:225-38.
 Discussion of the relationship of Rio Bec, Chenes, and
 Puuc architecture styles with those elsewhere in the Maya area.
 Focuses on dating and stylistic definition of Puuc style.

495 1965. La escultura arquitectónica de Uxmal. Estudios y
 fuentes del arte en México, 20. 207 pp., 17 plates, 59
 figs. Mexico: Universidad Nacional Autónoma de Mexico.
 Discussion of architectural sculpture includes
 consideration of historiography, placement of Puuc style within
 styles of Yucatan ethnohistoric accounts and art, decorative
 elements, and stylistic evolution in the Pyramid of the
 Magician.

496 1974. Reflexiones en torno a Palenque como necrópolis.
 Primera Mesa Redonda de Palenque, Part II. Ed. M.G.
 Robertson. 77-79. Pebble Beach, California: Robert Louis
 Stevenson School.
 Brief article on the notion of Palenque as a city of the
 dead. Comparison with Jaina which the author sees as a true
 necropolis.

497 1976. El sacrificio por decapitación en Palenque. Segunda
 Mesa Redonda de Palenque. Ed. M.G. Robertson. 177-80. 2
 figs. Pebble Beach, California: Robert Louis Stevenson
 School.
 Brief look at decapitation imagery in House D and the
 Temple of the Foliated Cross.

498 1976. El ritual maya en un vaso del Museo Reitberg de
 Zürich. Proceedings of the 41st International Congress of
 Americanists 2:334-47. 14 figs. Mexico.
 Discussion of the mythological characters depicted on
one Maya polychrome vase from the lowlands. Distinction drawn
between this sort of "popular art" and large scale, public
"official art."

499 1977. El comerciante en la cerámica pintada del clásico
 tardio maya. Del arte: Homenaje a Justino Fernández. 45-
 52. 24 black and white figures. Mexico: Universidad
 Nacional Autónoma de Mexico.
 Discussion of secular imagery in classic Maya
vasepainting. Merchant/warrior themes and scenes of daily life
as a reflection of social and commercial organization of the
classic Maya.

500 1979. La pintura mural de Cacaxtla. Proceedings of the
 42nd International Congress of Americanists 7:321-35. 8
 figs. Paris.
 Early discussion of Maya-style murals in Tlaxcala. Good
line drawings.

501 1980. Mural painting in Cacaxtla and Teotihuacán
 cosmopolitism. Third Palenque Round Table, 1978. Part 2.
 Ed. M. G. Robertson. 183-98. 38 figs. Austin:
 University of Texas Press.
 Teotihuacan traits in Maya style murals from central
Mexico.

Ford, James.
502 1968. A stela at El Baul, Guatemala. Archaeology 21, no.
 4:298-300. 1 fig.
 Publication of the so-called Herrera Stela of a
ballplayer in Cotzumalhuapa style found in 1964.

Foshag, William.
503 1957. Mineralogical Studies on Guatemalan Jade.
 Smithsonian Miscellaneous Collections, 135, no. 5. 60 pp.,
 5 plates. Washington, D.C.: Smithsonian Institution.
 Technical study of jade and its uses. Primarily based
on collections in the Guatemala National Museum.

Found: America's greatest sculpture.
504 1948. Art News 46, no. 11:32-33. 4 figs.
 Announcement of two large pre-Columbian sculptures put
on display at the National Museum in Mexico. One is the famous
Olmec "wrestler," the other a Huaxtec deity.

Franco, José Luis.
505 1954. Snares and traps in Codex Madrid. Notes on Middle
 American Archaeology and Ethnology 5, no. 121:53-58. 1
 fig. Washington, D.C.: Carnegie Institute of Washington.
 Depictions of animal traps in a Maya Codex.

506 1955. Trampas en el Código Madrid y discusión de glifos
 relacionados. El México Antiguo 8:193-218. 29 figs.
 Expansion and translation of the author's article in
 English in Carnegie Notes, No. 121 (1954). Comparison of snares
 in the Madrid Codex with ethnologically known traps. Discussion
 of glyphs found in association with trapping scenes.

507 1961. Representaciones de la mariposa en Mesoamérica. El
 México Antiguo 9:195-244. 20 plates. Mexico.
 Short survey of butterfly imagery in ancient Mexican
 art. Brief article, but numerous figures in each plate.

508 1966. Sculpture maya. 35 black-and-white plates. Paris:
 Galerie Jeanne Bucher.
 Exhibit catalog, principally of stone and stucco
 sculpture. Brief descriptive text.

509 1967. La decoración del huipilli de Chilapa, Guerrero.
 Revista Mexicana de Estudios Antropológicos 21:173-89. 4
 figs., 2 color plates.
 Study of a finely woven fragmentary huipil of pre-
 Hispanic date. This report goes with I. Johnson (1967), to
 comprise a complete study of the textile.

Fraser, Valerie, and Gordon Brotherston (eds.).
510 1982. The Other America. 80 pp. England: University of
 Essex.
 A booklet of brief essays written to accompany an
 exhibit at the Museum of Mankind in London. Essays concern North
 and South America as well as Middle America. Interesting
 historiographic essay by Baddeley on "Changing Conceptions of
 Mesoamerican Art" is annotated here.

Frías, Martha A.
511 1968. Catálogo de las características de los personajes en
 los códices de Dresden y Madrid. Estudios de Cultura Maya
 7:195-239. 21 figs.
 Systematic analysis of iconographic elements in the
 pictorial portions of the Maya codices.

Friedel, David.
512 1977. A late Preclassic monumental Mayan mask at Cerros,
 northern Belize. Journal of Field Archaeology 4, no. 4:
 488-91. 2 figs.

Polychrome mask on a well-preserved stucco facade of structure 5C is discussed. Iconographic similarities with Late Pre-Classic art from the Peten and Izapa are evident.

Frierman, J. D. (ed.)
513 1969. The Natalie Wood Collection of Pre-Columbian ceramics from Chupicuaro, Guanajuato, Mexico at UCLA. Occasional Papers of the Museum and Laboratories of Ethnic Arts and Technology, 1. 92 pp., numerous text illustrations. Los Angeles: UCLA.
Catalog of an extensive collection of Pre-Classic figurines, hundreds of which are illustrated. Brief chapters by several scholars on Chupicuaro reappraised, radiocarbon dates, and the extent of the Chupicuaro tradition.

Fry, Roger.
514 1918. American archaeology. Burlington Magazine 33, no. 188:155-57. 1 fig., 1 plate.
In a review of T. A. Joyce's archaeological handbooks, this British art critic comments on the nature of pre-Columbian art.

515 1939. American Art. Last Lectures, 85-96. 35 figs. London: Cambridge University Press.
Formalist and psychological remarks on pre-Columbian art.

Furst, Jill Leslie.
516 1977. The tree birth tradition in the Mixteca, Mexico. Journal of Latin American Lore 3, no. 2:183-226. Los Angeles: UCLA Latin American Center.
Trees as birthplaces of gods, kings, and lineage ancestors in contemporary Mixtec oral traditions and in ancient codices.

517 1978. Codex Vindobonensis Mexicanus: A Commentary. Institute for Mesoamerican Studies, 4. 366 pp., 103 figs., 14 plates. Albany: State University of New York.
Contextual study of this Mixtec manuscript with particular emphasis placed on the gods and their rituals and the unusual use of metaphoric dates.

518 1978. The year 1 Reed, day 1 Alligator: a Mixtec metaphor. Journal of Latin American Lore 4, no. 1:93-128. 3 figs. Los Angeles: UCLA.
Dates on obverse of Codex Vienna are not historical time indicators but metaphors of particular qualities. Discussion of one date and its associated meanings, not only in this Codex, but in Nuttall, Borgia, and Bodley as well.

519 1978. The life and times of ♂ 8 Wind "Flinted Eagle."
 <u>Alcheringa: Ethnopoetics</u> 4, no. 1:2-37. 16 figs., 7
 plates. Boston: Boston University.
 Good introduction to the meaning and conventions of
Mixtec codices. First seven pages of Codex Zouche-Nuttall
obverse are illustrated with useful explanation and commentary
on activities depicted.

520 1982. Skeletonization in Mixtec art: a re-evaluation.
 <u>The Art and Iconography of Late Post-Classic Central</u>
 <u>Mexico</u>. Ed. Elizabeth Boone. 207-25. 13 figs.
 Washington, D.C.: Dumbarton Oaks.
 Skeletal imagery in Mixtec codices pertains to
generative and life-sustaining functions, and chthonic
fertility.

Furst, Peter T.
521 1966. <u>Shaft Tombs, Shell Trumpets and Shamanism</u>. Ph. D.
 dissertation. 443 pp., 88 plates. Los Angeles:
 University of California.
 Important study of West Mexican pottery figures, their
mortuary and cultural context, and their meaning, based
principally on ethnographic analogy.

522 1968. The Olmec were-jaguar motif in the light of
 ethnographic reality. <u>Dumbarton Oaks Conference on the</u>
 <u>Olmec</u>. Ed. Elizabeth P. Benson. 143-78. 3 figs.
 Washington, D.C.: Dumbarton Oaks.
 Ground-breaking article on the meaning of Olmec icono-
graphy. Jaguar imagery is revealed as primarily shamanistic,
based on intrinsic evidence as well as ethnographic analogy.

523 1973. West Mexican art: secular or sacred? <u>The</u>
 <u>Iconography of Middle American Sculpture</u>. 98-133. 22
 figs. New York: The Metropolitan Museum of Art.
 Ethnographic analogy provides iconographic
interpretation of mortuary ceramics. Important article.

524 1974. Ethnographic analogy in the interpretation of West
 Mexican art. <u>The Archaeology of West Mexico</u>. Ed. Betty
 Bell. 132-46. 6 figs. Ajijic, Jalisco, Mexico: West
 Mexican Society for Advanced Study.
 Study of iconography and meaning of mortuary ceramics,
using the contemporary Cora and Huichol as a source for
ethnographic information.

525 1974. Hallucinogens in Precolumbian art. <u>Art and</u>
 <u>Environment in Native America</u>. Ed. M.E. King and I.R.
 Traylor, Jr. 55-101. 23 figs. Lubbock: The Museum Texas
 Tech. University.

Survey of objects from both Mesoamerica and South
America that depict preoccupation with ritual drugs. Emphasis
on West Mexico.

526 1974. Morning glory and mother goddess at Tepantitla,
 Teotihuacan: iconography and analogy in pre-Columbian art.
 Mesoamerican Archaeology: New Approaches. Ed. N. Hammond.
 187-215. 4 figs. Austin: University of Texas Press.
 The central image of the so-called Tlalocan mural at
 Tepantitla is reinterpreted as an earth goddess surrounded by
 hallucinogenic plants. Discussion of the importance of
 ololiuhqui and other psychoactive plants among the Aztecs.

527 1975. House of Darkness and House of Light: sacred
 functions of West Mexican funerary art. Death and the
 Afterlife in Pre-Columbian America. Ed. E. P. Benson. 33-
 68. 13 figs. Washington, D.C.: Dumbarton Oaks.
 The West Mexican artistic tradition is seen as part of
 both Mesoamerica and the "Greater Southwest." Exploration of
 the ideology informing shaft-tomb art based on ethnographic
 analogy and homology. An important article.

528 1976. Fertility, vision quest and auto-sacrifice: some
 thoughts on ritual blood-letting among the Maya. Segunda
 Mesa Redonda de Palenque. Ed. M.G. Robertson. 181-93. 5
 figs. Pebble Beach, California: Robert Louis Stevenson
 School.
 Anthropological and ethnohistoric analogies help
 elucidate the bloodletting and visionary events in the lintels
 of Yaxchilan.

529 1978. The Ninth Level: Funerary Art from Ancient
 Mesoamerica. 125 pp., 201 figs. Iowa City: University of
 Iowa Museum of Art.
 Excellent catalog, principally of ceramic material in
 the Solomon collection. Useful catalog entries and lengthy
 essay by the author on funerary art, shamanism, and symbolism of
 these objects.

530 1981. Jaguar baby or toad mother: a new look at an old
 problem in Olmec iconography. The Olmec and Their
 Neighbors. Ed. Elizabeth Benson. 149-62. 18 figs.
 Washington, D.C.: Dumbarton Oaks.
 V-shaped cleft head imagery and toothless mouths in
 Olmec art are reconsidered here. Furst, using ethnographic
 analogy and natural history as supporting evidence, suggests
 that such imagery represents an early representation of
 Tlaltecuhtli, the earth mother, in her jaguar-toad
 manifestation. Important article.

Furst, Peter T., and Michael D. Coe.
 531 1977. Ritual enemas. <u>Natural History</u> 86, no. 3:88-91.
 Hallucinogenic substances administered by enema are dis-
 cussed with reference to an unusual Maya painted vessel
 depicting the practice.

Gaines, Mary E.
 532 1980. A pre-Columbian ceremonial vase from Teotihuacán.
 <u>Bulletin of the Museum of Fine Arts</u> 7, no. 2:3-14. 12 figs.
 Houston.
 Discussion of a stuccoed cylindrical tripod with special
 attention paid to the plant motifs painted on it.

Galarza, Joaquim.
 533 1968. Révélés par l'art du Mexique: les jeux
 précolombiens. <u>Plaisir de France</u> 34, no. 10:53-60. 15
 figs.
 Popular discussion of ballplayers and other sporting
 figures in sculpture of ancient Mexico. Some color plates.

Gamboa, Fernando.
 534 n.d. <u>Das Portrait Mexikos</u>. 26 pp., 31 figs. Vienna:
 Museum für Völkerkunde.
 Catalog of an exhibit, principally of figural ceramics,
 many from the Museum of Anthropology in Mexico City. Some
 colonial and modern objects included as well.

Gann, Thomas.
 535 1924. Maya jades. <u>Proceedings of the 21st International
 Congress of Americanists</u> 2:274-82. 12 figs. Göteborg.
 Fine early article describing some of the most famous
 Maya jade carvings.

 536 1930. Changes in the Maya censor, from the earliest to the
 latest times. <u>Proceedings of the 24th International
 Congress of Americanists</u>. 51-54. 13 figs. Hamburg.
 "Old Empire" incense burners and "New Empire" ones com-
 pared; notes on eccentric flints.

 537 1943. Painted stucco heads from Louisville, British
 Honduras. <u>Middle American Research Records</u> 1, no. 4:13-16.
 1 fig. New Orleans: Tulane University.
 Architectural contexts of stucco heads, which the author
 believes to be portraits or death masks.

Garces Contrera, Guillermo.
 538 1972. <u>Bonampak: Una visión sincrónica</u>. 146 pp., 20
 plates. Mexico: Editorial Arana.
 Study of Bonampak and its murals by a nonspecialist.
 Comparisons are made with fresco painting traditions of Egypt,
 Crete, and India. No color reproductions of the murals.

García Cisneros, Florencio.
539 1970. <u>Maternity in Pre-Columbian Art</u>. 147 pp., 95 black-
 and-white photos. New York: Cisneros Gallery.
 Brief essay for the nonspecialist. Bilingual English
 and Spanish text not very informative. Photo examples, drawn
 from both Middle and South America, are principally of small-
 scale ceramic objects. Poor photographs.

García Cook, Angel, and Raul M. Arana.
540 1978. <u>Rescate arqueológico del monolito Coyolxauhqui:
 Informe preliminar</u>. 94 pp., 66 figs. Instituto Nacional
 de Antropología e Historia.
 Documentation of the discovery, excavation, associated
 offerings, conservation, and meaning of the recently discovered
 sculpture of this Aztec goddess.

García Moll, Roberto.
541 1979. Un relieve olmeca en Tenosique, Tabasco. <u>Estudios
 de Cultura Maya</u> 12:53-59. 5 figs.
 Discussion of a large Olmec relief on stone (94 x 88
 cm.). Its principal iconographic feature is the characteri-
 stically Olmec cleft human head. Iconographic connections to
 the Choapas, Veracruz relief is posited.

García Payón, José.
542 1939. El edificio megalítico de Malinalco es de cultura
 azteca. <u>Proceedings of the 27th International Congress of
 Americanists</u> 2:222-28. 4 figs. Mexico.
 Discussion of the architecture and interior stone
 sculpture of the round, rock-cut temple.

543 1946. Los monumentos arqueológicos de Malinalco, estado de
 Mexico. <u>Revista Mexicana de Estudios Antropológicos</u> 8:5-
 63. 39 figs., 1 color plate, 1 map.
 Important early study of the sculpture, painting, and
 architecture of this Aztec site. Full-color watercolor recon-
 struction of the warrior fresco there.

544 1949. Una "palma" in situ. <u>Revista Mexicana de Estudios
 Antropológicos</u> 10:121-24. 7 figs. Mexico.
 Discussion of the Aparicio stela from Veracruz and other
 monuments that show yokes and palmas being worn.

545 1961. Ensayo de interpretación de los bajorrelieves de los
 cuatro tableros del juego de pelota sur del Tajin,
 Veracruz. <u>El México Antiguo</u> 9:445-60. 4 figs.
 Iconographic analysis of an interrelated series of low
 relief panels depicting historicomythic scenes of a game between
 the sun and the planet Venus.

546 1973. El tablero del Montículo IV de El Tajín. <u>Boletín</u>
 (ser. 2) 7:31-34. 3 figs. México: Instituto Nacional de
 Antropología e Historia.
 Excavation of Mound 4 at El Tajín revealed a 1-x-2-meter
 tablet with a complex figural relief comparable to those in the
 ballcourts.

547 1974. <u>Los monumentos arqueológicos de Malinalco</u>. 63 pp.,
 39 figs. Biblioteca Enciclopédica del Estado de México.
 Discussion of buildings, stone monuments, and mural
 painting at this Aztec site.

Gay, Carlo T.
548 1967. Oldest paintings of the New World. <u>Natural History</u>
 76, no. 4:28-35. 12 figs.
 Important preliminary article on the Olmec paintings in
 Juxtlahuaca Cave, Guerrero.

549 1967. <u>Mezcala Stone Sculpture: The Human Figure</u>. 39 pp.,
 60 figs. New York: The Museum of Primitive Art.
 Important introduction to small-scale stone sculpture
 from Guerrero, its style and subject matter. Most objects
 illustrated are from private collections.

550 1972. <u>Chalcacingo</u>. 119 pp., 24 plates, 47 figs. Graz,
 Austria: Akademische Druck- u. Verlagsanstalt.
 Monograph on Olmec rock art and sculpture at a site in
 Morelos. Fine quality stippled line drawings of each rock-cut
 relief.

551 1972. <u>Xochipala: The Beginnings of Olmec Art</u>. 63 pp., 41
 figs. Princeton, N.J.: Princeton University Press.
 First major catalog of an exhibit of unusual Olmec-
 related figural ceramics from Guerrero.

552 1973. Olmec hieroglyphic writing: the probable background
 and meaning of an inscribed stone tablet from Ahuelicán,
 Guerrero, Mexico. <u>Archaeology</u> 26, no. 4:278-88. 35 figs.
 A tablet in the Dallas Museum of Fine Arts and other
 early Mexican texts used to outline a system of Olmec
 pictographs.

Gendrop, Paul.
553 1974. Consideraciones sobre la arquitectura de Palenque.
 <u>Primera Mesa Redonda de Palenque, Part II</u>. Ed. M.G.
 Robertson. 81-88. 6 figs. Pebble Beach, California:
 Robert Louis Stevenson School.
 Discussion of some of the unique aspects of the
 Palencano temples that distinguish them from those at Tikal and
 elsewhere.

554 1980. Dragon-mouth entrances: zoomorphic portals in the
 architecture of central Yucatan. Third Palenque Round
 Table, 1978. Part 2. Ed. M. G. Robertson. 138-50. 13
 figs. Austin: University of Texas Press.
 Itzamná theme in the architectural facade sculpture of
 Chenes and Río Bec buildings.

Gerhard, Peter.
 555 1964. Shellfish dye in America. Proceedings of the 35th
 International Congress of Americanists 3:177-91. Mexico.
 Use of murex and purpura dyes from pre-Hispanic times to
 the present.

Gettens, Rutherford J.
 556 1962. Maya Blue: an unresolved problem in ancient
 pigments. American Antiquity 27, no. 4:557-64. 2 tables.
 The properties of the blue coloring material used in
 Maya vase and wall painting are discussed. X-ray diffraction
 studies revealed the pigment to be the clay mineral attapulgite.

Getze, E. Bioren.
 557 1932. Two sculptures of the Maya Old Empire. Art and
 Archaeology 33:213-17. 5 figs.
 Description of lintel 3 and stela 12 from Piedras
 Negras, Guatemala.

Girard, Rafael.
 558 1969. Descubrimiento reciente de esculturas "pre-Olmecas"
 en Guatemala. Proceedings of the 38th International
 Congress of Americanists 1:203-13. 12 figs. Munich.
 "Monte-Alto" style heads from various sites are analyzed
 and their position in Pre-Classic culture sequence discussed.

 559 1972. Nuevas esculturas líticas en el area Maya.
 Proceedings of the 40th International Congress of
 Americanists 1:195-202. 12 figs. Rome.
 Discussion of a miscellaneous group of non-Maya stone
 monuments from the piedmont and highland area of Guatemala.

 560 1975. Esculturas monumentales olmecoides en los altos de
 Guatemala. Proceedings of the 41st International Congress
 of Americanists 1:436-41. 8 figs. Mexico.
 Description of various monuments from the piedmont and
 highlands of Guatemala. Some previously unpublished. Several
 tenoned heads.

Glass, John B.
 561 1964. Catálogo de la colección de códices. 237 pp., 139
 plates. Mexico: Museo Nacional de Antropología.
 A guide to the collection of indigenous manuscripts (of
 both pre- and post-Columbian date) in the Mexican National

Museum. Each entry includes a description, classification,
history, and bibliography. There are black-and-white
illustrations from many of the codices, maps, lienzas, and
genealogical records.

Goldstein, Marilyn.
562 1974. Maya jointed figurines. Ethnos 39, nos. 1-4:135-58,
 10 figs.
 Survey of articulated figurines in the Maya area; their
 distribution, dates, style, function, and meaning are discussed.

563 1977. The ceremonial role of the Maya flanged censer. Man
 n.s. 12:402-20. 5 figs. London.
 Traces the development of the Maya tubular flanged
 incense burner from Pre-Classic times through the ethnographic
 present, focusing on Late Classic censers of the Palenque region
 and their iconography.

564 1980. Relationships between the figurines of Jaina and
 Palenque. Third Palenque Round Table, 1978. Part 2. Ed.
 M. G. Robertson. 91-98. 7 figs. Austin: University of
 Texas Press.
 Categorization of six distinct figurine styles found on
 Jaina island. Comparison of style and iconography with those
 found at Palenque.

Goncalves de Lima, Oswaldo.
565 1956. El maguey y el pulque en los códices mexicanos. 278
 pp., 72 figs., 1 color plate. Mexico: Fondo de Cultura
 Económica.
 Study of the representations of fermented maguey beer
 and its associated rituals in the Mexican and Mixtec codices,
 supplemented with information from ethnohistoric accounts.

Gordon, G. B.
566 1896. Prehistoric ruins of Copan, Honduras. Memoirs of
 the Peabody Museum 1, no. 1. 48 pp., 1 map, 8 plates.
 Cambridge: Harvard University.
 General remarks on field work and detailed description
 of the ruins and stone monuments.

567 1898. Researches in the Uloa Valley. Memoirs of the
 Peabody Museum 1, no. 4. 44 pp., 12 plates, 1 map.
 Cambridge: Harvard University.
 Especially important for Maya pottery found in this area
 of Honduras.

568 1902. On the interpretation of a certain group of
 sculptures at Copan. American Anthropologist n.s. 4:130-
 43.
 Sculptures X and Y at this Maya site depicting knotted
 bundles stand for the literal "binding up of the years."

569 1902. The Hieroglyphic Stairway, Ruins of Copan. Memoirs
 of the Peabody Museum 1, no. 6. 38 pp., 26 figs., 18
 plates. Cambridge: Harvard Univeristy.
 Architecture, epigraphy, and stone sculpture.

570 1909. Conventionalism and realism in Maya art at Copan,
 with special reference to the treatment of the macaw.
 Putnam Anniversary Volume. 191-95. 2 figs. New York.
 Discusses Maya tendency toward exaggeration in the
artistic representation of animals. Brief discussion of Late
Classic Maya art as showing a balance between early tendencies
toward conventionalism and later striving for realism.

571 1912. An unpublished inscription from Quirigua, Guatemala.
 Proceedings of the 18th International Congress of
 Americanists. 238-40. 2 figs. London.
 Stela 1 at Quirigua similar to stone monuments at
Piedras Negras.

Gordon, George B., and Mason, John A.
 572 1925-43. Examples of Maya Pottery in the Museum and Other
 Collections. 66 folio plates. Philadelphia: University
 Museum, University of Pennsylvania.
 Important (and now rare) early pictorial survey of Maya
vase painting. Folio plates of hand-drawn and watercolor
reproductions of Maya polychrome and modeled vessels from
important institutional collections.

Gosner, Kenneth.
 573 1952. Maya metropolis. Natural History 61, no. 3:104-10.
 10 figs.
 Report on a visit to Uaxactun and Tikal before the
advent of the University of Pennsylvania excavations at Tikal.
Photos of unrestored monuments.

Graham, Ian.
 574 1970. The ruins of La Florida, Peten, Guatemala. Peabody
 Museum Papers 61:425-55. 12 figs. Cambridge: Harvard
 University.
 Site plan and drawing of sculptural monuments at this
Maya site.

575 1971. The Art of Maya Hieroglyphic Writing. 63 pp., 40
 figs. Cambridge: Peabody Museum of Harvard University.
 Catalog of an exhibit held both at Harvard and at the
Center for Inter-American Relations. Maya writing as manifested
in artistic objects in all media. Brief discussion of the
history of decipherment of Maya texts.

576 1975--. Corpus of Maya Hieroglyphic Inscriptions.
 Cambridge: Peabody Museum of Harvard University.

Ongoing series of reports that record in photos and line drawings the monumental sculptures and inscriptions of lowland Maya sites. Very useful for clear, accurate line drawings of Maya monuments.

Graham, J. A.
577 1973. Aspects of non-Classic presences in the inscriptions and sculptural art of Seibal. The Classic Maya Collapse. Ed. T.P. Culbert. 207-19. 2 figs. Albuquerque: University of New Mexico Press.
Puuc-style dating and distinctly nonlowland Maya elements in Late Classic stelae at Seibal. Relationship of these cycle 10 monuments with others in the Maya world is briefly discussed.

578 1977. Discoveries of Abaj Takalik, Guatemala. Archaeology 30, no. 3:196-97. 2 figs.
Brief description of recent work at this Pacific coast site. Illustration of Stela 5 (A.D. 126) and earlier Olmec monument.

579 1979. Maya, Olmecs, and Izapans at Abaj Takalik. Proceedings of the 42nd International Congress of Americanists 8:79-88. 2 figs.
Remarks on the newly discovered stela 5 and altar 13 and the light they shed on early cultural relationships.

580 1981. Abaj Takalik: the Olmec style and its antecedents in Pacific Guatemala. Ancient Mesoamerica: Selected Readings. Second edition. Ed. John A. Graham. 163-76. 15 figs. Palo Alto: Peek Publications.
Diversity of sculptural styles in this area during the formative period is stressed. Discussion of reuse of Olmec-style monuments.

581 1982. Antecedents of Olmec sculpture at Abaj Takalik. Pre-Columbian Art History: Selected Readings. Second edition. Ed. A. Cordy-Collins. 7-22. 15 figs. Palo Alto: Peek Publications.
Controversial article on boulder sculptures in southwestern Guatemala alleged to be pre-Olmec in date.

Graham, John A., and Steven R. Fitch.
582 1972. The recording of Maya sculpture. Contributions of the University of California Archaeological Research Facility 16, no. 4:41-51. 1 fig. Berkeley.
Remarks on the history of recording Maya monuments, and an explanation of the process of photogrammetry.

Graham, John, and Mark Johnson.
583 1971. The great mound of La Venta. Contributions of the
 University of California Archaeological Research Facility
 41:1-6. 1 fig. Berkeley.
 Reconstruction of the La Venta pyramid with four levels
 and inset corners. Takes issue with Heizer's "fluted cone"
 theory.

Greene, Merle.
584 1966. Classic Maya rubbings. Expedition 9, no. 1:30-39.
 15 figs.
 Oil and paper rubbings used to record relief sculpture
 and glyphic texts on Maya monuments are explained by the best-
 known practitioner of this technique.

585 1967. Ancient Maya Relief Sculpture. unpaginated, 60
 figs. New York: The Museum of Primitive Art.
 First collection of rubbings by Greene. Brief
 description of each relief sculpture by J. Eric Thompson.

Greene, Merle, Robert L. Rands, and John A. Graham.
586 1972. Maya Sculpture. 432 pp., 202 plates. Berkeley:
 Lederer, Street and Zeus.
 Useful collection of rubbings of many monuments. Brief
 description of each relief sculpture illustrated. Some Izapa
 and Cotzumalhuapa monuments illustrated along with the Classic
 Maya items.

Greenhalgh, Michael.
587 1978. European interest in the non-European: the
 sixteenth century and pre-Columbian art and architecture.
 Art in Society. Ed. M. Greenhalgh and V. Megaw. 89-103.
 5 figs.
 The Renaissance view of pre-Columbian art and culture is
 examined in historical context. Interest in exoticism is seen
 to exist at the same time as ethnocentric view of culture.

Grieder, Terence.
588 1964. Representation of space and form in Maya painting on
 pottery. American Antiquity 29, no. 4:442-48. 8 figs.
 Conventions for the representation of three dimensions
 on flat surfaces used by the Maya vase painter are discussed.
 Overlapping and variation in height seen to be the most
 prominent means of suggesting space.

589 1975. The interpretation of ancient symbols. American
 Anthropologist 77:849-55.
 Important article on the methodology of interpreting
 ancient pictorial material. Advocates both configurational
 analysis and ethnological analogy to determine meaning.

Griffin, Gillett G.
590 1974. Early travelers to Palenque. <u>Primera Mesa Redonda</u>
<u>de Palenque. Part I</u>. Ed. M.G. Robertson. 9-33. 22 figs.
Pebble Beach, California: Robert Louis Stevenson School.
 An examination of the history of discovery of the site
and some of the visual impressions of the site drawn by travelers
before 1900.

591 1976. Portraiture in Palenque. <u>Segunda Mesa Redonda de</u>
<u>Palenque</u>. Ed. M.G. Robertson. 137-47. 12 figs. Pebble
Beach, California: Robert Louis Stevenson School.
 Stucco heads at Palenque considered as true portraits.
Cross cultural comparisons are made.

592 1979. Cresterías of Palenque. <u>Tercera Mesa Redonda de</u>
<u>Palenque</u>. Ed. M. G. Robertson and D. C. Jeffers. 139-46.
19 figs. Monterey, California.
 Survey of Mesoamerican roof combs, wih particular
emphasis on Palenque. Suggests that the iconographic program of
each temple roof comb served as an easily understood emblem of
the function of the building. Cross-cultural analogy supports
thesis.

593 1981. Olmec forms and materials found in central Guerrero.
<u>The Olmec and Their Neighbors</u>. Ed. Elizabeth Benson. 209-
22. 23 figs. Washington, D.C.: Dumbarton Oaks.
 Discussion of the range of Olmec styles and forms
originating in the state of Guerrero, far from the so-called
Olmec heartland. Important because of the lack of firm
archaeological contexts for most pieces from this region.
Suggests a more crucial role for the highland than previously
thought.

Grosscup, G. L.
594 1961. A sequence of figurines from West Mexico. <u>American</u>
<u>Antiquity</u> 26:390-406. 7 figs.
 Seriation and typological classification of figurines
from Amapa, Nayarit.

Groth-Kimball, Irmgard.
595 1961. <u>Maya Terrakotten</u>. 96 pp., 44 figs. Zurich.
 Catalog of forty-four Jaina figurines with descriptive
paragraph on each piece in German, English, French, and Spanish.

Groth-Kimball, Irmgard, and Franz Feuchtwanger.
596 1954. <u>The Art of Ancient Mexico</u>. 125 pp., 4 color plates,
105 black-and-white plates. London and New York: Thames
and Hudson.
 Introductory picturebook with brief entries on each
plate.

Grove, David C.
597 1968. Chalcatzingo, Morelos, Mexico: a re-appraisal of
 the Olmec rock carvings. American Antiquity 33, no. 4:486-
 91. 7 figs.
 The author disputes the alleged phallic representation
 usually seen in relief II, and presents information and drawing
 of a new relief, now in a private collection.

598 1970. The Olmec Paintings of Oxtotitlan Cave, Guerrero,
 Mexico. Dumbarton Oaks Studies in Pre-Columbian Art and
 Archaeology, 6. 36 pp., 36 figs., 1 color plate.
 Washington, D.C.
 Report on the Olmec-style rock paintings in southwestern
 Mexico. Major paintings in both grottos illustrated, described,
 and related to other known examples of Olmec art.

599 1970. Los murales de la cueva de Oxtotitlán, Acatlán,
 Guerrero. Investigaciones, 23. 95 pp., 28 plates, 25
 figs. Mexico: Instituto Nacional de Antropología e
 Historia.
 Report on Olmec-style paintings in a cave in
 southwestern Mexico. Same as his 1970 Dumbarton Oaks report.

600 1972. Olmec felines in highland Central Mexico. The Cult
 of the Feline. Ed. E. P. Benson. 153-64. 4 figs.
 Washington, D.C.: Dumbarton Oaks. Reprinted in Pre-
 Columbian Art History. Ed. Alana Cordy-Collins and Jean
 Stern. 43-52. 4 figs. Palo Alto: Peek Publications, 1977.
 Jaguar imagery in rock art at Chalcatcingo and in cave
 painting at Oxtotitlan and Juxtlahuaca, Guerrero. A number of
 mythical concepts appear to be represented in these images, but
 most link jaguars, caves, and underworld themes.

601 1973. Olmec altars and myths. Archaeology 26, no. 2:129-
 35. 5 figs.
 An important reevaluation of La Venta altars 4 and 5 as
 thrones, the iconography of which depicts the confirmation of
 divine rulership. Oxtotitlan cave paintings used as supporting
 evidence.

602 1981. Olmec monuments: mutilation as a clue to meaning.
 The Olmec and Their Neighbors. Ed. Elizabeth Benson. 48-
 68. 13 figs. Washington, D.C.: Dumbarton Oaks.
 Analysis of various types of mutilation of public large-
 scale sculpture. Suggests ritual defacement as a means of
 controlling the supernatural powers of a deceased ruler.

Grove, David C., and L. I. Paradis.
603 1971. An Olmec stela from San Miguel Amuco, Guerrero.
 American Antiquity 36:95-102. 4 figs.

Stela of standing profile figure with nonhuman attributes represents the northwesternmost extension of large-scale sculpture in the Olmec style. Art objects suggest that Guerrero and central Mexico were colonial Olmec outposts, based on a thriving trade network.

Guillemin, George F.
604 1969. Artefactos de madera en un entierro clásico tardío de Tikal. Proceedings of the 38th International Congress of Americanists 1:175-78. 1 fig. Munich.
 Excavation of Burial 195 revealed a number of wooden objects which are described here. Stuccoed wooden sculpture of a long-lipped god is illustrated.

Guillemin-Tarayre, E.
605 1912. Le grand temple de Mexico. Journal de la Société des Américanistes de Paris n.s. 9:301-5. 1 fig.
 Historic, ethnohistoric, and pictorial evidence for the plan of the Templo Mayor.

Guillén, Ann Cyphers.
606 1982. The implications of dated monumental art from Chalcatzingo, Morelos, Mexico. World Archaeology 13, no. 3:382-93. 9 figs., 12 plates.
 Four in situ stone monuments discovered during excavation help resolve chronological issues. Author dates Chalcatzingo to 700-500 B.C. and relates it to epi-Olmec and early Izapan sculpture.

Gutierrez Solana, Nelly, and Susan K. Hamilton.
607 1977. Las esculturas en terracotta de El Zapotal, Veracruz. Cuadernos de historia del arte, 6. 251 pp., 4 color plates, 77 figs. Mexico: Universidad Nacional Autónoma de Mexico.
 Large, elaborately formed Late Classic figural ceramics from a site near Cerro de las Mesas are well illustrated and well described in a first study of this class of objects.

Gyles, Anna Benson, and Chloë Sayer.
608 1980. Of Gods and Men. 232 pp., profusely illustrated. New York: Harper and Row.
 Survey of ancient Mexican art and culture for the nonspecialist. Based on a series of films made for the BBC. Stresses continuities from ancient to modern Indian groups.

Habel, S.
609 1880. The Sculptors of Santa Lucia Cosumalwhuapa in Guatemala. Smithsonian Contributions to Knowledge, 22. 258 pp., 15 plates.
 An early study of the non-Maya figural sculpture of this Pacific slope area of Guatemala.

Haberland, Wolfgang.
610 n.d. <u>Gold in Alt-Amerika</u> (Eine Einführung in die
 <u>Goldkammer des Hamburgischen Museums für Völkerkunde und</u>
 <u>Vorgeschichte</u>. Wegweiser zur Völkerkunde, 4. 32 pp., no
 illustrations. Hamburg.
 Small pamphlet, discusses metallurgy in pre-Hispanic
 America. Focuses on techniques. Brief discussion of regions,
 including Maya and Mexican areas. Good bibliography.

611 1954. The golden battle disks of Chichen Itza. <u>Ethnos</u> 19,
 nos. 1-4:94-104. Stockholm.
 The author disputes some analyses made by Lothrop (1952)
 of the figures and events portrayed on gold objects from the
 cenote at Chichen Itza.

612 1971. <u>Die Kunst des indianischen Amerika/American Indian</u>
 <u>Art</u>. 408 pp., 173 figs. Zurich: Museum Reitberg.
 Covers the arts of the western hemisphere in the
 Museum's collection. Forty-one plates and catalog entries
 devoted to Mesoamerica. Text in both German and English.

Hagar, Stansbury.
613 1912. The houses of rain and drought in the Codex Vaticanus
 3773. <u>Proceedings of the 18th International Congress of</u>
 <u>Americanists</u>. 137-39. 2 figs. London.
 Draws specious relationship between calendrical
 associations of certain imagery in codices and Western signs of
 the zodiac.

614 1922. The jaguar and serpent mural at Chich'en Itzá.
 <u>Proceedings of the 20th International Congress of</u>
 <u>Americanists</u> 2:75-78. Río de Janeiro.
 Author's explanation of mural in the lower chamber of
 the jaguar temple as representing a ceremony in honor of the
 "Jaguar Sun." Attempt to tie in with Western Zodiac signs.

615 1930. The symbolic plan of Palenque. <u>Proceedings of the</u>
 <u>23rd International Congress of Americanists</u>. 200-220. 2
 figs., 3 plates. New York.
 Building plans and symbolic schemes of Palenque
 architecture seen as similar to that at Uxmal. Complex
 cosmological and calendrical associations posited with little
 proof. Not persuasive.

Hale, Mason E., Jr.
616 1979. Control of the lichens on the monuments of Quirigua.
 <u>Quirigua Reports</u> 1:33-38. 2 figs. Robert J. Sharer,
 general ed., Wendy Ashmore, volume ed. Philadelphia: The
 University Museum, University of Pennsylvania.
 Discussion of mechanical and chemical approaches to
 lichen removal, and report on experimental practice carried out
 at Quirigua.

Hall, Clara Stern.
617 1962. A Chronological Study of the Mural Art of
 Teotihuacan. Ph.D. dissertation, University of California
 at Berkeley.
 Important study focusing on seriation of corpus of
 murals at this Central Mexican site. (See also Clara Millon.)

Hammacher, A. M.
618 1963. Sculpture en pierre de l'ancien Mexique.
 unpaginated, 36 black-and-white plates.
 Catalog of stone sculpture from both the Mexican and
 Maya region.

Hammond, Norman.
619 1972. The planning of a Maya ceremonial center. New World
 Archaeology: Readings from Scientific American. 281-90.
 8 figs. San Francisco.
 Evidence at Lubaantun for Maya site planning.

620 1982. A Late Formative period stela in the Maya lowlands.
 American Antiquity 47, no. 2:396-403. 5 figs.
 A plain stela at Cuello, Belize is 200 years earlier
 than the earliest Initial Series stela known so far from the
 lowlands.

Hammond, Norman, David H. Kelley, and Peter Mathews.
621 1975. A Maya "pocket stela"? Contributions of the
 University of California Archaeological Research Facility
 27, no. 3:17-31. 2 figs., 1 plate. Berkeley.
 Discussion of a mold-made ceramic whistle figurine with
 enthroned figure and glyphic inscription excavated at Lubaantun,
 Belize. Object considered as a folk art adaptation of large-
 scale public monument.

Hamy, E. T.
622 1898. Note sur une figurine Yucatèque de la collection
 Boban-Pinart au Musée d'Ethnographie du Trocadéro. Journal
 de la Société des Américanistes de Paris 2:105-8. 1 fig.
 Paris.
 Brief notes on a "buddha-like" Jaina figurine.

623 1899. Codex Telleriano-Remensis. 47 pp., 51 color plates.
 Paris.
 Facsimile and commentary on an early postconquest Aztec
 manuscript. Commentary in French.

624 1902. Le joyau du vent. Journal de la Société des
 Américanistes de Paris 4:72-81. 15 figs.
 Brief archaeological and ethnohistorical discussion of
 the "wind jewel" insignia of Quetzalcoatl.

625 1906. Note sur une statuette mexicaine en wernerite
 représentant la déesse Ixcuina. <u>Journal de la Société des
 Americanistes de Paris</u> 3:1-5. 1 fig.
 Iconography of a famous Aztec statuette of a female
 deity giving birth, now in the collection of Dumbarton Oaks.

Hardoy, Jorge E.
 626 1964. <u>Pre-Columbian Cities</u>. 602 pp., 87 figs. New York:
 Walker and Company.
 Useful survey of site planning and architectural layout
 in both Mesoamerica and the Andean area.

Harrison, Peter.
 627 1963. A jade pendant from Tikal. <u>Expedition</u> 5, no. 2:13-
 14. 3 figs.
 Portrait-head pendant excavated in Late Classic tomb
 from Structure 5 D-11.

 628 1969. Form and function in a Maya "palace" group.
 <u>Proceedings of the 38th International Congress of
 Americanists</u> 1:165-72. 5 figs. Munich.
 Excavations in the Central Acropolis at Tikal suggest
 combined residential, administrative, and ceremonial functions
 for the structural complex.

Hartung, Horst.
 629 1968. Consideraciones urbanísticas sobre los trazos de las
 centros ceremoniales de Tikal, Copán, Uxmal y Chichén-Itzá.
 <u>Proceedings of the 37th International Congress of
 Americanists</u> 1:121-26. 1 plate. Buenos Aires.
 Basic principles to consider in determining archaeo-
 astronomical configurations and intrasite relationships.

 630 1970. Notes on the Oaxaca tablero. <u>Boletín de Estudios
 Oaxaqueños</u> 27.
 Evolution and importance of Oaxacan style architectural
 profile. Concludes that tablero reached its finalized form
 during Monte Alban IIIb.

 631 1971. <u>Zeremonialzentren der Maya</u>. 137 pp., 36 plates, 7
 maps. Graz, Austria: Akademische Druck- u. Verlagsanstalt.
 Study of the principles of Maya site planning, layout,
 and astronomical interpretation.

 632 1976. El espacio exterior en el centro ceremonial de
 Palenque. <u>Segunda Mesa Redonda de Palenque</u>. Ed. M.G.
 Robertson. 123-35. 11 figs. Pebble Beach, California:
 Robert Louis Stevenson School.
 Consideration of site planning and the interrelationship
 of structures and groups of structures.

633 1977. Ancient Maya architecture and planning:
 possibilities for astronomical studies. Native American
 Astronomy. Ed. Anthony Aveni. 111-29. 8 figs. Austin:
 University of Texas Press.
 Remarks on some aspects of architectural planning and
 alignment, and the later mapping and restoration of these
 features. Particular reference to Tikal and Copan.

634 1977. Maquetas arquitectónicas precolombinas de Oaxaca.
 Baessler-Archiv n.f. 25, no. 2:387-400. 26 figs.
 Small-scale stone and clay temple models and
 architectural details discussed as models or mockups of larger
 buildings.

635 1977. Astronomical signs in the Codices Bodley and Selden.
 Native American Astronomy. Ed. A. F. Aveni. 37-41. 3
 figs. Austin: University of Texas Press.
 Brief analysis of two signs ("crossed sticks" and
 "crossed legs") and their occurrences in these Mixtec codices.

636 1980. Certain visual relations in the palace at Palenque.
 Third Palenque Round Table, 1978. Part 2. Ed. M. G.
 Robertson. 74-80. 12 figs. Austin: University of Texas
 Press.
 Irregular positioning of building and the use of
 diagonals as intentional parts of the building program.

637 1981. Monte Alban in the Valley of Oaxaca. Mesoamerican
 Sites and World-Views. Ed. Elizabeth P. Benson. 40-70. 20
 figs. Washington, D.C.: Dumbarton Oaks.
 Observations on Zapotec site planning and selection, use
 of masses and spaces, and astronomical features of several
 structures.

Haviland, William A.
 638 1974. Occupational specialization at Tikal, Guatemala:
 stoneworking-monument carving. American Antiquity 39, no.
 3:494-96.
 Artifactual evidence found in home workshops suggests
 that monument carving was the occupational specialization of a
 specific family line within a lineage.

Hawley, Henry H.
 639 1961. An Olmec jade head. Bulletin of the Cleveland Museum
 of Art 43:212-15. Cleveland.
 Analysis of three-dimensionally carved head and the
 images incised on its cheeks.

Heikamp, Detlef.
 640 1972. Mexico and the Medici. 107 pp., 61 plates. Florence:
 Editrice Edam.

An examination of Mexican materials that originally formed part of the extensive Medici collections. Some pre-Hispanic pieces, some colonial, and some ethnological. Text in English, with supplementary plate captions and summary in Italian.

641 1976. American objects in Italian collections of the Renaissance and Baroque: a survey. First Images of America: The Impact of the New World on the Old. Ed. Fredi Chiapelli. 455-82. 21 figs. Berkeley: University of California Press.
 Aztec and colonial Aztec objects are featured in this survey article.

Heine-Geldern, Robert.
642 1964. Traces of Indian and southeast Asiatic Hindu-Buddhist influences in Mesoamerica. Proceedings of the 35th International Congress of Americanists 1:47-54, 28 figs. Mexico.
 Artistic motifs such as wheeled figures, lotuses, and zoomorphic representations seen as evidence for trans-Pacific contact.

Heine-Geldern, Robert, and G. F. Ekholm.
643 1951. Significant parallels in the symbolic arts of southern Asia and Middle America. Selected Papers of the 29th International Congress of Americanists. 299-309. 2 figs. Chicago.
 Decorative motifs such as the lotus, central tree, mythological composite animals, and architectural features in the art of two continents used as proof of contact rather than parallel development.

Heizer, Robert F.
644 1959. Specific and generic characteristics of Olmec culture. Proceedings of the 33rd International Congress of Americanists 2:178-82. San José.
 Concise summary of architectural, offertory, and artistic traits specific to the Olmec.

645 1967. Analysis of two relief sculptures from La Venta. Contributions of the University of California Archaeological Research Facility 3, no. 2:25-56. 7 figs., 2 plates. Berkeley.
 The large-scale figural stelae 2 and 3 are compared in style, iconography, and method of construction.

646 1972. An unusual Olmec figurine. The Masterkey 46, no. 2: 71-74, 3 figs.
 Small jade hunchback figure discussed.

Heizer, Robert F., and P. Drucker.
647 1968. The La Venta fluted pyramid. Antiquity 42:52-56. 1
 fig. Cambridge, England.
 New survey at this Olmec site indicates that the pyramid
 is not four-sided, but rather is a fluted or grooved cone,
 perhaps symbolic of volcanic peaks in the Tuxtla mountains.

Heizer, Robert F., and Tillie Smith.
648 1965. Olmec sculpture and stone working: a biliography.
 Contributions of the University of California
 Archaeological Research Facility 1, no. 4:71-87.
 Berkeley.
 Useful but dated bibliography of fewer than 200 entries
 on Olmec stone sculpture.

Heizer, Robert F., Tillie Smith, and H. Williams.
649 1965. Notes on colossal head no. 2 from Tres Zapotes.
 American Antiquity 31, no. 1:102-4. 3 figs.
 A previously unpublished Olmec head now in Santiago
 Tuxtla, Veracruz is described and illustrated. Its distinctive
 characteristics include representations of seven braids of hair
 on the back of the head.

Heizer, Robert F., and Howel Williams.
650 1965. Stones used for colossal sculpture at or near
 Teotihuacan. Contributions of the University of California
 Archaeological Research Facility 1, no. 3:55-70. 11
 plates. Berkeley.
 Unfinished "Idolo de Coatlichán," and large scale "water
 goddess" sculptures discussed in terms of their mineralogical
 composition. Previous discussions of the monuments in the
 literature are reviewed.

Helfrich, Klaus.
651 1973. Menschenopfer und Tötungsrituale im Kult der Maya.
 Monumenta Americana, 9. 212 pp., 80 figs. Berlin.
 Study of human sacrifice and death rituals among the an-
 cient Maya and their iconographic representation. Examples
 drawn from all media. Includes appendix listing archaeological
 evidence for human sacrifice at thirty-four sites and
 iconographic evidence at fifty-nine sites and in codices.

Helfritz, Hans.
652 1968. Mexican Cities of the Gods. 180 pp., 113 figs. New
 York: Praeger Publishers.
 Guidebook to fifteen Mexican and Maya sites. Few
 lowland Maya sites are included. This volume has been
 superseded by C. Bruce Hunter's more recent, thorough, and up-
 to-date volumes.

Hellmuth, Nicholas M.

653 1974. Veracruz-style thin stone heads and ball game yokes
 from Escuintla, Guatemala. Katunob: A Newsletter-Bulletin
 on Mesoamerican Anthropology 8, no. 4:41-46, 5 figs.
 Greeley, Colorado: University of Northern Colorado.
 Report on Veracruz-style ballgame equipment found on the
 Pacific slopes of Guatemala.

654 1975. The Escuintla hoards: Teotihuacan art in Guatamala.
 Foundations for Latin American Anthropological Research,
 Progress Reports 1, no. 2. 70 pp., 51 plates.
 First publication and discussion of Teotihuacan-related
 vessels and incense burners found in southern Guatemala.

655 1975. Pre-Columbian ballgame archaeology and architecture.
 Foundation for Latin American Anthropological Research
 Progress Reports 1, no. 1. 31 pp., 13 figs. Guatemala.
 Pamphlet on ballgame iconography, costume, and architec-
 ture, principally among the Maya.

656 1976. Diplomacy and conquest in pre-Columbian Mesoamerica.
 Américas 26, no. 3:5-12. 11 figs. Washington, D.C.:
 Organization of American States.
 Popular article on Teotihuacan influence on the south
 coast of Guatemala as exhibited in ceramic vessels and incense
 burners.

657 1976. Oaxaca deity in Escuintla, Cocijo in Guatemala.
 Proceedings of the 41st International Congress of
 Americanists 2:263-67.
 Discussion of Zapotec rain-god imagery occurring on
 ceramic vessels found in the highlands and piedmont of
 Guatemala.

658 1978. Teotihuacan art in the Escuintla, Guatemala region.
 Middle Classic Mesoamerica: AD 400-700. Ed. E. Pasztory.
 71-85. 16 figs. New York: Columbia University Press.
 Useful survey of incense burner and cylindrical tripod
 iconography of Teotihuacan-style vessels found on the Pacific
 slopes of Guatemala.

Henderson, John S.

659 1981. The World of the Ancient Maya. 271 pp., 122 figs.,
 10 color plates. Ithaca: Cornell University Press.
 Though a survey of all aspects of Maya culture, most
 useful for its up-to-date discussion of Maya cultural
 interrelationships and history.

Hernández Ayala, Martha Ivon.

660 1976. Una estela olmeca en el area del Usumacinta. Boletín
 (ser. 2) 17:25-28. 3 figs. Mexico: Instituto Nacional de
 Antropología e Historia.

Description and illustration of Stela 6 of Balancán, depicting a seated Olmec style figure with cleft head.

Heyden, Doris.
661　　　1971.　Comentarios sobre la Coatlicue recuperada durante las excavaciones realizadas para la construcción del metro. <u>Anales</u> (ser. 7a) 2:153-70.　5 figs.　Mexico:　Instituto Nacional de Antropología e Historia.
　　　　Iconography of the sculpture of an Aztec goddess discovered during the excavation of the subway.　Because of its many dual features, the author concludes that the sculpture represents an earth deity, possibly representing Ometeotl, the divine creator pair.

662　　　1972.　Autosacrificios prehispánicos con puas y punzones. <u>Boletín</u> (ser. 2) 1:27-30.　3 figs.　Mexico:　Instituto Nacional de Antropología e Historia.
　　　　Ethnohistoric descriptions and pictorial depictions of ritual bloodletting.

663　　　1972.　What is the significance of the Mexica pyramid? <u>Proceedings of the 40th International Congress of Americanists.</u>　109-15.　4 figs.　Rome-Genoa.
　　　　Ethnohistoric and architectural evidence used to support the thesis that pyramidal structures represent heavenly bodies.

664　　　1972. Xiuhtecutli: investidor de soberanos. <u>Boletín</u> (ser. 2) 3:3-10.　11 figs.　Mexico:　Instituto Nacional de Antropología e Historia.
　　　　Study of the fire god, as known from ethnohistory, monumental art, and manuscripts.

665　　　1974.　La diosa madre:　Itzpapalotl.　<u>Boletín</u> 2:3-14.　11 figs.　Mexico:　Instituto Nacional de Antropología e Historia.
　　　　The Aztec goddess "obsidian butterfly" discussed, with reference to her appearance in stone sculpture and codices.

666　　　1975. An interpretation of the cave underneath the Pyramid of the Sun in Teotihuacan, Mexico.　<u>American Antiquity</u> 40:131-47.　12 figs.
　　　　Ethnohistoric and ethnographic accounts of cave deities, rituals, and myths used to interpret the cave at Teotihuacan. Comparison of this cave with the mythic Chicomoztoc, place of creation in Mexican belief.

667　　　1976.　Interpretación de algunas figurillas de Teotihuacán y su posible significado social.　<u>XIV Mesa Redonda.</u>　1-10. 4 figs.　Mexico:　Sociedad Mexicana de Antropología.
　　　　Suggests that further analysis of figurine types would reveal information about pre-Hispanic social organization and hierarchy.

668 1977. The year sign in ancient Mexico: a hypothesis as to
 its origin and meaning. <u>Pre-Columbian Art History:</u>
 <u>Selected Readings.</u> Ed. Alana Cordy-Collins and Jean
 Stern. 213-37. 25 figs. Palo Alto: Peek Publications.
 Survey of trapeze and ray sign in the art of Teotihuacan
 and later cultures. Though the form stays relatively
 consistent, its contextual associations suggest a shift in
 meaning.

669 1979. Flores, creencias y el control social. <u>Proceedings</u>
 <u>of the 42nd International Congress of Americanists</u> 6:85-97.
 10 figs. Paris.
 Manuscripts and ethnohistory allow analysis of the
 central role played by flowers in Mexican ritual.

670 1981. Caves, gods, and myths: world-view and planning in
 Teotihuacan. <u>Mesoamerican Sites and World-Views.</u> Ed.
 Elizabeth P. Benson. 1-39. 32 figs. Washington, D.C.:
 Dumbarton Oaks.
 Discussion of the cave under the Pyramid of the Sun
 leads to an examination of ethnographic and ethnohistoric
 parallels in the veneration of caves and cave deities. Cave
 symbolized as the place of origin of Teotihuacan peoples.

Heyden, Doris, and Paul Gendrop.
 671 1973. <u>Pre-Columbian Architecture of Mesoamerica</u>. 336 pp.,
 numerous text figures, 363 black-and-white plates. New
 York: Harry N. Abrams, Inc.
 Extremely useful survey of the topic. Contains many
 illustrations of plans, elevations, and reconstructions.

Hirtzel, Harry.
 672 1924. Collections d'antiquités guatémaltèques du Musée
 d'Archéologie de l'Université de Gand. <u>Proceedings of the</u>
 <u>21st International Congress of Americanists</u> 2:668-72. 33
 figs. Göteborg.
 Description of a small collection of objects bought at
 Coban in the nineteenth century, now in a Belgian University.
 Mostly ceramic vessels and heads.

673 1926. Statuettes et figurines à turban au Mexique.
 <u>Proceedings of the 22nd International Congress of</u>
 <u>Americanists</u> 1:561-63. 4 figs. Rome.
 Descriptions of the various types of turbanned
 figurines, especially from the Valley of Mexico.

674 1930. Le manteau de plumes dit de "Montezuma" des Musée
 Royaux du Cinquantenaire de Bruxelles. <u>Proceedings of the</u>
 <u>23rd International Congress of Americanists</u>. 649-51. 2
 figs. Paris.

Previously unstudied feather cloak in the Royal Museum since the eighteenth century is said to have belonged to Montezuma.

Holien, Thomas, and Robert B. Pickering.
675 1978. Analogues in Classic period Chalchihuites culture to late Mesoamerican ceremonialism. Middle Classic Mesoamerica: AD 400-700. Ed. E. Pasztory. 145-57. 12 figs. New York: Columbia University Press.
 Well-developed argument for the use of Tezcatlipoca ritual in Classic period Chalchihuites cultures. Suggests more continuity with the outlying regions of Mesoamerica than is usually thought.

Holmes, W. H.
676 1907. On a nephrite statuette from San Andrés Tuxtla, Veracruz, Mexico. American Anthropologist 9:691-701. 8 plates.
 Tuxtla statuette discussed in terms of material, iconography, and glyphs. Cycle 8 date proposed. Good drawing of all glyphs.

677 1914. Masterpieces of aboriginal American art I: stuccowork. Art and Archaeology 1, no. 1:1-12. 10 figs., 1 plate.
 Figural stuccoes at Izamal, Palenque, and Labna.

678 1914. Masterpieces of aboriginal American art II: mosaic work, minor examples. Arts and Archaeology 1, no. 3:91-102. 9 figs., 1 plate.
 Aztec mosaics, principally from the British Museum, are discussed.

679 1914. Masterpieces of aboriginal American art III: mosaic work, major examples. Art and Archaeology 1, no. 6:243-55. 8 figs.
 Architectural mosaics in the Yucatan and at Mitla.

680 1916. Examples of spurious antiquities I: Guatemalan pottery. Art and Archaeology 3, no. 5:286-88.
 Illustration of four poorly made clay figures and tablets. Analysis of the flaws of the modern maker.

681 1916. Masterpieces of aboriginal American art IV: sculpture in the round. Art and Archaeology 3, no. 2:71-85. 16 black-and-white figs.
 Discussion and illustration for the nonspecialist of several of the best-known examples of Aztec, Maya, and Olmec stone sculpture, including the monumental Coatlicue and Maya figure from the hieroglyphic stair at Copan.

682 1916. Masterpieces of aboriginal American art V: the
 great dragon of Quirigua, part 1. Art and Archaeology 4,
 no. 6:269-78. 5 black-and-white figs., 1 color plate.
 Quirigua zoomorph carefully described, illustrated, and
 evaluated.

683 1916. The oldest dated American monument, a nephrite
 figurine from Mexico. Art and Archaeology 3:275-78.
 Essay on the San Andrés Tuxtla figurine in the U.S.
 National Museum and its glyphic inscription.

684 1917. Masterpieces of aboriginal American art V: the
 great dragon of Quirigua, Part 2. Art and Archaeology 5,
 no. 1:38-49. 7 figs.
 Symbolism of a Quirigua zoomorph. Remarks on related
 sculpture at Copan.

Hough, Walter.
685 1912. Censers and incense of Mexico and Central Mexico.
 Proceedings of the U.S. National Museum 42, no. 1887:109-
 37. 12 figs., 10 plates. Washington, D.C.
 Study of figural incense burners from all periods in the
 collection of the U.S. National Museum.

Hunt, Eva.
686 1978. The provenience and contents of the Porfirio Díaz
 and Fernandez Leal Codices: some new data and analyses.
 American Antiquity 43, no. 4:673-90. 1 fig., 5 tables.
 New interpretation of the historical portions of two
 sixteenth century Cuicatec codices. The author faults previous
 writers on the topic for shoddy scholarship and misinformation.

Hunter, C. Bruce.
687 1974. A Guide to Ancient Maya Ruins. 332 pp., numerous
 text illustrations. Norman: University of Oklahoma Press.
 Excellent, informative site-by-site guide to major
 archaeological ruins of the Yucatan, southern lowlands, and Maya
 highlands. Copious illustrations. Architecture well explained.

688 1977. A Guide to the Ancient Mexican Ruins. 261 pp.,
 numerous text illustrations. Norman: University of
 Oklahoma Press.
 First-rate site-by-site guide to major archaeological
 sites in the Valleys of Mexico, Toluca, Morelos, Oaxaca, and the
 Gulf coast. Well illustrated and easy to understand.

Hurtado, Manuel.
689 1966. Yaxchilan. 67 pp., profusely illustrated. Mexico:
 Editorial Orion.
 Nonscholarly account of a modern expedition to this Maya
 site.

Hvidtfeldt, Arild.
690 1958. Teotl and Ixiptlatli: Some Central Conceptions in
 Ancient Mexican Religion, with a General Introduction on
 Cult and Myth. 181 pp. Copenhagen: Munksgaard.
 Important study of Aztec cult, myth, and religion. Puts
 forth conceptual categories for the understanding of Aztec
 ritual based on Aztec terminology.

The Iconography of Middle American Sculpture.
691 1973. 167 pp. New York: The Metropolitan Museum of Art.
 Papers presented at a symposium at the museum in 1970 in
 conjunction with the exhibit "Before Cortés." Essays by M. Coe,
 Bernal, Kubler (2), Ekholm, Thompson, Nicholson, Furst, and
 Willey annotated here.

Indigenous Art of the Americas: Collection of Robert Woods Bliss.
692 1947. 159 pp. Washington: National Gallery of Art.
 Illustration and discussion of a collection of 235
 objects, most of which are illustrated.

Ivanoff, Pierre.
693 1973. Maya. 191 pp., numerous color illustrations. New
 York: Grosset and Dunlap.
 "Coffee table" survey of seventeen major sites in the
 northern and southern lowlands. Good photography.

Jackson, Everett G.
694 1941. The pre-Columbian ceramic figurines from western
 Mexico. Parnassus 13:17-20.
 Figurines from Lake Chapala and the state of Nayarit and
 their morphology.

Jansen, M., and T. Leyenaar (eds.).
695 1982. International Colloquium: The Indians of Mexico in
 Pre-Columbian and Modern Times. 405 pp. Leiden,
 Netherlands: Rijksmuseum voor Volkenkunde.
 Proceedings of a 1981 conference. Essays in English and
 Spanish. Contributions by Langley, van der Loo, Whittaker, and
 Robertson annotated here.

Joesink-Mandeville, L. R. V., and Sylvia Meluzin.
696 1976. Olmec-Maya relationships: Olmec influence in
 Yucatan. Origins of Religious Art and Iconography in
 Preclassic Mesoamerica. Ed. H. B. Nicholson. 87-105. 19
 figs. Los Angeles: UCLA.
 Ceramic and sculptural affinities with Olmec art, of
 objects (both portable and nonportable) found in the Yucatan.

Johnson, Irmgard W.
697 1954. Chiptic cave textiles from Chiapas, Mexico. Journal
 de la Société des Américanistes de Paris n.s. 43:137-48. 4
 figs., 1 plate.

Three textile fragments displaying the rare techniques of hand-painting and batik, not recorded previously in Mesoamerica, recovered from a cave in the Comitan region. Probably of Late Post-Classic date.

698 1958-59. Un antiguo huipil de ofrenda decorado con pintura. Revista Mexicana de Estudios Antropológicos 15:115-22. 1 plate.
 Pre-Hispanic huipil with painted floral decoration found in a cave in the Coahuila region. Technique and material are analyzed.

699 1964. Copper-preserved textiles from Michoacan and Guerrero. Proceedings of the 35th International Congress of Americanists 1:525-36. 3 figs., 5 plates.
 Finds of late preconquest textiles document two previously unrecorded techniques: a unique form of multielement fabrication and an unusual warp-patterned weave.

700 1967. Un huipilli precolombino de Chilapa, Guerrero. Revista Mexicana de Estudios Antropologicos 21:149-72. 8 figs. Mexico: Sociedad Mexicana de Antropología.
 Technical study of a finely woven fragmentary huipil of pre-Hispanic date found in Guerrero. See also Franco (1967) for further comments on the textile.

701 1967. Miniature garments found in Mixteca Alta caves, Mexico. Folk (Dansk Etnografisk Tidsskrift) 8/9:179-90. 7 figs. Copenhagen.
 Technical discussion of four cotton huipils and two cotton quechquemitls found in three caves in the Oaxaca-Puebla border region. It is not possible to determine whether these were of pre- or post-Columbian manufacture, but the offering of quechquemitls in an area where they were worn in ancient times (as seen in the Mixtec codices), but are not in use today, is evidence for their antiquity.

702 1971. Basketry and textiles. Handbook of Middle American Indians 10. Ed. Gordon F. Ekholm and Ignacio Bernal. 297-321. 18 figs., 4 tables. Austin: University of Texas Press.
 Surveys archaeological survivals of these highly perishable materials, listing all major known finds, their dates and contexts. Survey of historical sources on textiles materials and techniques, and lists all known technical variations.

703 1975. Textiles from the Cuevas de Atzcala, Rio Mezcala, Guerrero. Proceedings of the 41st International Congress of Americanists 1:279-91. 12 figs. Mexico.

Brief discussion of several lots of pre-Hispanic textiles recovered by nonarchaeologists, including examples of bark cloth, woven sandals, sacred bundles, and a jacket-like garment.

Jones, Christopher.
704 1975. A painted capstone from the Maya area. <u>Contributions of the University of California Archaeological Research Facility</u> 27, no. 7:83-110. 2 figs., 1 plate, 3 tables. Berkeley.
 Description and illustration of a previously unpublished painted stone from the Puuc or Chenes area. Particular attention paid to glyphic inscription. Date of Terminal Classic proposed.

Jones, Christopher, and Linton Satterthwaite.
705 1982. <u>The Monuments and Inscriptions of Tikal: The Carved Monuments</u>. 138 pp., 112 figs. Tikal Report No. 33, Part A. Philadelphia: The University Museum, University of Pennsylvania.
 Although principally an epigraphic study, useful for its dating of monuments and fine line drawings and photos of all stelae, altars, and lintels.

Jones, Julie.
706 1963. <u>Bibliography for Olmec Sculpture</u>. Primitive Art Bibliographies, 2. 8 pp. New York: Museum of Primitive Art.
 Bibliography of fewer than 200 entries on Olmec art, surveying important contributions through 1963. Not annotated. However, author provides a brief introductory essay.

707 1973. An Early Classic Maya vessel, some questions of style. <u>Acts of the 23rd International Congress of the History of Art</u> 1:145-54. 16 figs. Granada.
 Discussion of yoke-shaped tripod vessel from Maya lowlands and its relation to the Teotihuacan ceramic tradition as well as to the art of central Veracruz.

Joralemon, David.
708 1971. <u>A Study of Olmec Iconography</u>. Dumbarton Oaks Studies in Pre-Columbian Art and Archaeology, 7. 95 pp., 266 figs. Washington, D.C.
 An important first attempt at deciphering the meaning of Olmec art, based on an analysis of hundreds of objects. Includes a "dictionary" of 182 Olmec motifs and symbols, and tentative identification of 10 Olmec gods.

709 1974. Ritual blood sacrifice among the ancient Maya: Part 1. <u>Primera Mesa Redonda de Palenque, Part II</u>. Ed. M.G. Robertson. 59-75. 25 figs. Pebble Beach, California: Robert Louis Stevenson School.

The iconography and implements of ritual self-mutilation as portrayed in stelae, codices, painting, and the minor arts. The author argues that the implement of self-sacrifice was deified, and that the drawing of blood from the male genitals was an important aspect of maintaining the vitality of the natural world.

710 1975. The Night Sun and the Earth Dragon: some thoughts on the jaguar god of the underworld. Jaina Figurines by M. Miller. 63-68. Princeton University.
 Discussion of an unusual Jaina figurine depicting the sun god riding a crocodilian animal.

711 1976. The Olmec dragon: a study in Pre-Columbian iconography. Origins of Religious Art and Iconography in Pre-Classic Mesoamerica. Ed. H. B. Nicholson. 27-71. 25 figs. Los Angeles: UCLA.
 Discussion of the nature of Olmec art and religion, followed by profusely illustrated exploration of two iconographic types: 1) the "dragon" who combines cayman, eagle, jaguar, human, and serpent attributes, and 2) the bird monster. The dragon is seen as the prototype for the Maya god Itzamna, and the Aztec lord of duality.

712 1981. The old woman and the child: themes in the iconography of Pre-Classic Mesoamerica. The Olmec and Their Neighbors. Ed. Elizabeth Benson. 163-80. 27 figs. Washington, D.C.: Dumbarton Oaks.
 Examination of a series of ceramic figures of elderly, wrinkled females, sometimes with children. Discussion of their chronology, geographic distribution, and possible significance as representations of a universal ancestress found in all Mesoamerican religious traditions.

Joralemon, P. D., and Elizabeth Benson.
713 1980. Pre-Columbian Art of Mesoamerica and Ecuador: Selections from Distinguished Private Collections. 32 pp., 67 illustrations. Coral Gables, Florida: The Lowe Art Museum, University of Miami.
 Objects from various collections, principally of small-scale Pre-Classic and Classic period Mesoamerican art.

Joyce, Thomas Athol.
714 1924. An example of cast gold-work discovered at Palenque by de Waldeck, now in the British Museum. Proceedings of the 21st International Congress of Americanists 1:46-47. 2 figs. The Hague.
 Cire-perdue bell in human head form, unlikely to have come from Palenque.

715 1933. The pottery whistle-figurines of Lubaantun. Journal of the Royal Anthropological Institute of Great Britain and Ireland 63:15-25. 10 plates.
 Numerous mold-made whistle figurines from this Maya site in Belize are discussed and illustrated.

716 1938. The Gann Jades. The British Museum Quarterly 12:145. 3 plates.
 Bequest of Maya and Olmec jades to the British Museum is announced. Fourteen pieces illustrated, mostly Classic period.

Joyce, T. A., and H. A. Knox.
717 1931. Sculptured figures from Vera Cruz State, Mexico. Man 31, no. 19:17. 3 figs. London.
 Report on early discovery of Olmec figurines and sculpture near Tonala.

Judd, Neil M.
718 1951. A new-found votive axe from Mexico. American Antiquity 17, no. 2:139-41. 2 figs.
 Description of an Olmec "jaguar-god" votive axe of unknown history given by Georgetown University to the Smithsonian.

Kampen, Michael Edwin.
719 n.d. Classic Maya elements in the iconography of rulership at El Tajin, Veracruz, Mexico. Phoebus 1:93-102. 5 figs.
 Contact between Maya artists and artists at El Tajin proposed based on iconography of several sculptural reliefs in the Temple of the Niches.

720 1972. The Sculptures of El Tajin, Veracruz, Mexico. 195 pp., 39 figs. plus numerous unnumbered text figs. Gainesville: University of Florida Press.
 Figural sculpture discussed in terms of cultural and architectural context, technique, style, and iconography. More than half of the book consists of a catalog of sculptural reliefs, each rendered in a careful line drawing.

721 1974. Ceremonial Centers of the Maya. 152 pp., 169 black-and-white photographs, 24 color plates. Gainesville: University of Florida.
 Popular, well-illustrated survey of fourteen of the best-known Maya sites.

722 1978. The graffiti of Tikal, Guatemala. Estudios de Cultura Maya 11:155-80. 4 charts, 8 figs.
 Art historical analysis of Late Classic graffiti found in architectural context. Discusses technical varieties, sites with reported graffiti, temporal associations, and formal style.

Kan, Michael, Clement Meighan, and H.B. Nicholson.
723 1970. Sculpture of Ancient West Mexico. 116 pp., 206
 plates, some in color. Los Angeles: Los Angeles County
 Museum of Art.
 Important exhibit catalog of ceramic art from Nayarit,
Jalisco, and Colima. Useful text.

Kaplan, Flora.
724 1961. A shell from Mexico. El Mexico Antiguo 9:289-96. 2
 figs.
 Circular perforated shell ornament in Brooklyn Museum
from Huaxtec area discussed briefly.

Kelemen, Pál.
725 1939. Pre-Columbian jades. Parnassus 9, no. 4:4-10. 9
 figs. New York.
 Highlights some fines jades, principally Olmec and Maya.
Remarks focus on style.

726 1943. Medieval American Art. Vol. 1, 212 pp., 168 plates.
 Vol. 2, 418 pp., 308 plates. New York: The Macmillan Co.
 Reprint. Dover Publications, 1969.
 Encyclopedic survey of both Middle and South American
art. As well as architecture, painting, and sculpture, this
work has particularly strong coverage of weaving, metalwork,
jade, and "applied arts."

727 1946. Pre-Columbian art and art history. American
 Antiquity 11, no. 3:145-54.
 Historiographic essay examining the slow acceptance of
pre-Columbian art into the discipline of art history. An
important essay by one of the trailblazers in the discipline.

Kelley, David H.
728 1960. Calendar animals and deities. Southwest Journal of
 Anthropology 16:317-37.
 Eurasian origin of Mesoamerican calendar and day names
based on similarities in sequences of animal and deity names in
Asia and the New World.

729 1965. The birth of the gods at Palenque. Estudios de
 Cultura Maya 5:93-134. 53 figs.
 Uses glyphic and iconographic evidence in support of a
hypothesis that the Cross Group temples at Palenque were
dedicated to the feathered serpent god, an agricultural deity,
and a war god, respectively.

730 1966. A cylinder seal from Tlatilco. American Antiquity
 31, no. 5:744-46.
 Olmec cylinder seal inscribed with what may be the
oldest writing known from Mesoamerica.

Kelly, Joyce.
731 1982. The Complete Visitor's Guide to Mesoamerican Ruins.
527 pp., numerous unnumbered illustrations. Some color
plates. Norman: University of Oklahoma Press.
 Extremely useful and up-to-date guide to archaeological
sites. Includes many lesser-known sites. Remarks on
architecture and related arts, history, and directions to the
sites. Well illustrated.

Kendall, Aubyn.
732 1973. The Art of Pre-Columbian Mexico: An Annotated
Bibliography of Works in English. Institute of Latin
American Studies, Guides and Bibliographies Series, 5. 115
pp., 10 figs. Austin: University of Texas.
 Useful survey of the literature in English. See Kendall
1977 for expanded bibliography.

733 1977. The Art and Archaeology of Pre-Columbian Middle
America: An Annotated Bibliography of Works in English.
324 pp. Boston: G. K. Hall Co.
 Amplification of the author's 1973 work. Annotated
reference manual of 2,147 works prior to 1976. An important
reference tool, but its limitation to English language works
impairs its usefulness for the scholar.

Kidder, A. V.
734 1942. Archaeological specimens from Yucatán and Guatemala.
Notes on Middle American Archaeology and Ethnology 1, no.
9:35-40. 2 figs. Washington, D.C.: Carnegie Institution
of Washington.
 Discussion of thirteen jade and other stone ornaments,
mainly from private collections.

735 1943. Pottery from the Pacific slope of Guatemala. Notes
on Middle American Archaeology and Ethnology 1, no. 15:81-
91. 3 figs. Washington, D.C.: Carnegie Institution of
Washington.
 Vessels and figures of unknown provenience.

736 1944. Certain pottery vessels from Copan. Notes on Middle
American Archaeology and Ethnology 2, no. 36:31-34. 1 fig.
Washington, D.C.: Carnegie Institution of Washington.
 Cylindrical tripod vessels and basal flange bowls and
their relationship to Central Mexican types.

737 1949. Jades from Guatemala. Notes on Middle American
Archaeology and Ethnology 4, no. 91:1-8. Washington, D.C.:
Carnegie Institution of Washington.
 Analysis of a group of jades in private and public col-
lections. Early Classic period date is assigned based on
similarity to jades excavated at Nebaj.

738 1965. Pre-Classic pottery figurines of the Guatemalan
 highlands. Handbook of Middle American Indians 2. Ed.
 Gordon R. Willey. 146-55. 8 figs. Austin: University of
 Texas Press.
 Brief survey. Most data drawn from Kaminaljuyu.

Kidder, A.V., and Carlos Samayoa Chinchilla.
 739 1959. The Art of the Ancient Maya. 124 pp., 99 black-and-
 white figs. New York.
 Examples of Maya art from Proto-Classic to Post-Classic.
 Most objects are from collections in Guatemala and U.S.,
 especially National Museum in Guatemala City and University
 Museum in Pennsylvania.

Kidder, Alfred V., Jesse D. Jennings, and Edwin M. Shook.
 740 1946. Excavations at Kaminaljuyu, Guatemala. Carnegie
 Institution of Washington Publication no. 561. 284 pp.,
 207 figs. Washington, D.C.: Carnegie Institution of
 Washington.
 Although this volume is an excavation report, its wealth
 of illustration and documentation is important for studies of
 highland Maya architecture and Maya-Teotihuacan interaction.

Kidder, A. V., and Anna O. Shepard.
 741 1944. Stucco decoration of early Guatemala pottery. Notes
 on Middle American Archaeology and Ethnology 2, no. 35:23-
 30. 2 figs. Washington, D.C.: Carnegie Institution of
 Washington.
 Miraflores phase Kaminaljuyu vessels exhibit the
 earliest known decorative use of stucco.

Kidder, A. V., and E. M. Shook.
 742 1961. A possibly unique type of formative figurine from
 Guatemala. Essays in Pre-Columbian Art and Archaeology.
 Ed. S. K. Lothrop, et al. 176-81. 3 figs. Cambridge:
 Harvard University Press.
 A small number of anomalous "heavy-eyed" figurines from
 the Guatemalan highlands discussed as possibly the work of a
 single Pre-Classic potter or workshop.

Kingsborough, Lord [Edward King].
 743 1831-48. Antiquities of Mexico, comprising facsimiles of
 ancient Mexican paintings and hieroglyphs. . .the whole
 illustrated by many valuable inedited manuscripts by Lord
 Kingsborough. 9 vols. London.
 Earliest facsimiles of many major Mexican and Mixtec
 manuscripts are included here.

Klein, Cecelia F.
 744 1975. Post-Classic Mexican death imagery as a sign of
 cyclic completion. Death and the Afterlife in Pre--

Columbian America. Ed. E. P. Benson. 69-85. Washington, D.C.: Dumbarton Oaks.
 The author explores the conceptual patterns which recur in en face images, principally among the Aztecs. Themes of death, the completion and renewal of temporal cycles, and imagery of particular deities are considered.

745 1976. The Face of the Earth: Frontality in Two-Dimensional Mesoamerican Art. 293 pp., 83 figs. New York: Garland.
 Publication of the author's 1972 Columbia dissertation in the Department of Art and Archaeology. Discussion of en face images principally in the Post-Classic art of central Mexico. The female earth monster is seen to be most often represented frontally. Also useful for its discussion of many other gods and themes in Aztec art.

746 1976. The identity of the central deity on the Aztec Calendar Stone. Art Bulletin 58, no. 1:1-12. 23 figs. Reprinted in Pre-Columbian Art History Ed. Alana Cordy-Collins and Jean Stern. 167-89. 23 figs. Palo Alto: Peek Publications, 1977.
 Important iconographic study that reinterprets the central image on the calendar stone as Yohualtecuhtli, or the night sun.

747 1980. Who was Tlaloc? Journal of Latin American Lore 6, no. 2:155-204. 11 figs.
 A first-rate iconographic and textual examination of what is known of the Central Mexican rain god from antiquity to the time of the conquest. Discrepancies between colonial document and preconquest visual imagery are discussed.

748 1982. Arte Precolombino y ciencias sociales. Plural 11, no. 4:40-48. Mexico.
 Provocative essay on the relationship of pre-Columbian art history and the social sciences in the United States. The author provides the historical and cultural background to the blossoming of interest in pre-Columbian art in the midtwentieth century.

749 1982. The relation of Mesoamerican art history to archaeology in the United States. Pre-Columbian Art History: Selected Readings. Second edition. Ed. A. Cordy-Collins. 1-6. Palo Alto: Peek Publications.
 Provocative historiographic essay examining the reasons for the estrangement between "new archaeology" and Mesoamerican art history.

750 1982. Woven heaven, tangled earth: a weaver's paradigm of the Mesoamerican cosmos. Ethnoastronomy and

Archaeoastronomy in the American Tropics. Ed. A. Aveni and
G. Urton. Annals of the New York Academy of Sciences 385:
1-36. 17 figs.
 Evidence for the universe as a woven and plaited
structure in Mesoamerican art and ethnohistory.

Knauth, Lothar.
 751 1961. El juego de pelota y el rito de la decapitación.
 Estudios de Cultura Maya 1:183-98. 7 figs.
 Thesis is that the ballcourt, ritual decapitation, and a
cult of vegetation and fertility are intertwined. Supported by
evidence in sculpture, pottery, and codices. The problem is not
considered in depth.

Köhler, Ulrich.
 752 1973. Fledermaus oder Kaiman?--Deutung der Tierdarstellung
 eines Raüchergefässes aus Nebaj, Guatemala. Tribus 22:
 183-86. 3 figs.
 The imagery on a Post-Classic highland Maya tripod
vessel is discussed. The identity of an open-mouthed figure may
be either reptilian or batlike.

 753 1976. Mushrooms, drugs, and potters: a new approach to the
 function of Pre-Columbian Mesoamerican mushroom stones.
 American Antiquity 41, no. 2:145-53. 5 figs.
 A refutation of the commonly held belief that mushroom
stones were used in rituals of drug preparation. An alternative
hypothesis that these convex surfaces were used as potters'
molds is proposed, based on ethnographic analogy.

Kowalewski, S., and M. Truell.
 754 1970. "Tlaloc" in the Valley of Oaxaca. Boletín de
 Estudios Oaxaqueños 31:12-16.
 Study of Central Mexican Tlaloc imagery on ceramic
objects found in Oaxaca.

Kramer, Gerhardt.
 755 1935. Roof combs in the Maya area. Maya Research 2:106-18.
 7 figs.
 Evolution of roof comb as key to architectural
chronology. Concludes that much more field work is necessary
before it is possible to study this carefully.

Krickeberg, Walter.
 756 1950. Bauform und Weltbild im alten Mexico, Mythe, Mensch
 und Umwelt. Paideuma 4:293-335. 10 plates, 7 figs.
 Bamberg.
 An examination of Mexican cosmological beliefs based on
architectural forms. Pyramidal forms and monster mouth doorways
are emphasized.

757 1949-1969. <u>Felsplastik</u> <u>und</u> <u>Felsbilder</u> <u>bei</u> <u>den</u>
<u>Kulturvölkern Altamerikas</u>. Two volumes. Berlin.
 Volume I covers "Die Andenländer" and "Die Felsentempel
in Mexico." Volume II, "Felsbilder Mexicos: Als Historische,
Religiöse und Kunstdenkmäler," was published twenty years later.
It illustrates many unusual Central Mexican rock carvings seldom
seen in other texts. Focuses on Post-Classic Central Mexican
iconographic system.

758 1958. Bemerkungen zu den Skulpturen und Felsbildern von
Cozumalhuapa. <u>Miscellanea Paul Rivet</u> (Selected papers of
the 31st International Congress of Americanists) 1:495-513.
Mexico.
 Principally concerned with the three Cotzumalhuapa
stelae in the Museum für Völkerkunde, Berlin.

759 1960. Altemexikanische Felsbilder. <u>Tribus</u> 9:172-84. 7
figs.
 A survey of figural reliefs on rocks from different
epochs of ancient Mexico. Both freestanding monumental reliefs
and petroglyphic reliefs in situ are considered.

760 1961. Una vasija de barro de la epoca clásica Maya. <u>El</u>
<u>México Antiguo</u> 9:275-88. 4 figs.
 A general discussion of the vases in the Berlin Museum
destroyed during WW II, and discussion of one slate vase from
Campeche decorated with glyphs and figural scenes.

761 1966. El juego de pelota mesoamericano y su simbolismo
religioso. <u>Traducciones Mesoamericanistas</u> 1:191-313. 43
figs. Mexico.
 A thorough look at ballcourts and their iconography,
focusing principally on representations in the codices.

762 1966. <u>Altmexikanische Kulturen</u>. 616 pp., numerous plates
and text figures. Berlin: Safari-Verlag.
 Survey of cultural history, but relies so much on
artistic evidence that it is worthwhile as an introdution to art
as well. Several hundred unnumbered illustrations. Survey
starts with the Aztecs and works backwards to earlier cultures.

Krotser, G. Raymond.
763 1973. El agua ceremonial de los Olmecas. <u>Boletín</u> (ser. 2)
6:43-48. 8 figs. Mexico: Instituto Nacional de
Antropología e Historia.
 Aqueducts for the ritual channeling of water at San
Lorenzo.

Krotser, Paula H., and G. R. Krotser.
764 1973. The life style of El Tajín. <u>American Antiquity</u> 38,
no. 2:199-205.

142

Evidence presented for El Tajin as a Late Classic city with a stratified and diverse population.

Krutt, Michel.
765 1975. Les figurines en terre cuite du Mexique Occidental. 115 pp., 166 figs. Brussels: Université Libre de Bruxelles.
 Typological study of West Mexican figural ceramics in the collection of the Royal Museum of Art and History in Brussels.

Kubler, George.
766 1943. The cycle of life and death in metropolitan Aztec sculpture. Gazette des Beaux-Arts (ser. 6) 23, no. 915:257-68. 15 figs.
 Early essay by Kubler on forms and meanings of Mexica monumental stone sculpture.

767 1944. Remarks upon the history of Latin American art. College Art Journal 3, no. 4:148-52.
 Interesting for its advocacy of the study of Americanist art history at a time when few art historians were involved in the field.

768 1958. The Olsen Collection of Pre-Columbian Art. Yale University Art Gallery Bulletin 24, no. 1:1-18. 12 figs.
 Announcement of a gift of 230 items, mostly from Mesoamerica, from Mr. Fred Olsen to the Yale Art Gallery. Several noteworthy sculptural pieces illustrated.

769 1958. The design of space in Maya architecture. Miscellanea Paul Rivet 1:515-31. Mexico.
 Approach to Mesoamerican architecture as monumental form rather than enclosure. Discussion of roads, platforms, ballcourts, multistoried buildings, and other forms. Some consideration of chronological developments.

770 1961. On the colonial extinction of the motifs of Pre-Columbian art. Essays in Pre-Columbian Art and Archaeology. Ed. S. K. Lothrop, et al. 14-34. 15 figs. Cambridge: Harvard University Press.
 The author's thesis is that survivals of pre-Columbian art into the colonial period are few and scattered. Discusses the modes of extinction of this art, using categories such as juxtaposition, convergence, explant, and so forth. Important theoretical article.

771 1961. Rival approaches to American antiquity. Three Regions of Primitive Art. 61-75, 14 plates. New York: The Museum of Primitive Art.

Examination of art historical versus anthropological approaches to the ancient high cultures of the New World. Brief discussion of diffusion, evolutionary models for culture change, and a "configurationist" approach to the past.

772 1961. Chichén-Itzá y Tula. Estudios de Cultura Maya 1:47-79. 14 figs.
 Comparison of architecture at two cities, concluding that Maya Toltec architecture is actually cosmopolitan and eclectic, rather than drawing strictly from Tulan prototypes, and that some "innovations" at Tula may actually be found later there than at Chichen. See also rejoinder by Alberto Ruz in ECM 2, 1962.

773 1962. The Art and Architecture of Ancient America. Second edition 1975. 421 pp., 192 plates, 124 figs. Middlesex, England: Penguin Books.
 Important survey of pre-Columbian art by the foremost art historian in the field. Covers both Middle America and the Andes. Stronger on architecture than many surveys of the arts.

774 1964. Polygenesis and diffusion: courtyards in Mesoamerican architecture. Proceedings of the 35th International Congress of Americanists 1:345-57. 9 figs.
 Review of courtyard design in Mesoamerican history. Movement from open-corner to closed-corner courtyards. Author points out that his method is instructive to diffusionists who claim relationship merely because of resemblance.

775 1967. The Iconography of the Art of Teotihuacán. Dumbarton Oaks Studies in Pre-Columbian Art and Archaeology, 4. 40 pp., 46 figs. Washington, D.C.
 Important attempt at unlocking the meaning of Teotihuacan art by defining iconographic relationships. Table of ninety-seven themes found in Teotihuacan art and their occurrence at other sites.

776 1967. Pintura mural pre-colombina. Estudios de Cultura Maya 6:45-65. 19 figs.
 Discusses various types of mural painting. Classifies paintings as friezes, scenes, narrative registers, and illustrations.

777 1969. Studies in Classic Maya Iconography. Memoirs of the Connecticut Academy of Arts and Sciences, 18. 111 pp., 99 figs. New Haven.
 Analysis of a number of themes in Maya art, including dynastic and ritual themes, and the triadic sign. Important also for considerations of method.

778 1970. Period, style and meaning in ancient American art. <u>New Literary History</u> 1, no. 2:127-44. Charlottesville, Virginia.

 Significant theoretical article on periodization and regional rates of change in Mesoamerican antiquity. Divergent views of how to demarcate periods effect the historian's way of arranging the evidence. Also considers stylistic and iconographic issues, as well as the problem of disjunction in historical process.

779 1971. Commentary on: early architecture and sculpture in Mesoamerica. <u>Contributions of the University of California Archaeological Research Facility</u> 11:157-68. Berkeley.

 Many insightful remarks on Proskouriakoff's paper in the same volume, covering such topics as proportional studies, frontier and style, Olmec heads, macrotechnics, and writing.

780 1972. La evidencia intrinseca y la analogía etnología en el estudio de las religiones mesoamericanas. <u>Religión en Mesoamérica: XII Mesa Redonda</u>. Ed. Jaime Litvak King and Noemí Castillo Tejero. 1-24. Mexico: Sociedad Mexicana de Antropología.

 Art historical approaches to the study of ideological unity or diversity in ancient Mesoamerica. Holds a pluralist view of a succession of religious systems in the Valley of Mexico based on analysis of Teotihuacan, Toltec, and Aztec art. Remarks on the limitations of analogical thinking, based on examples from both Mesoamerican and Near Eastern scholarship.

781 1972. Jaguars in the Valley of Mexico. <u>The Cult of the Feline</u>. Ed. Elizabeth P. Benson. 19-49. 28 figs. Washington, D.C.: Dumbarton Oaks.

 At Teotihuacan, jaguar imagery occurs principally in conjunction with other life-forms in a jaguar-serpent-bird icon. Later feline imagery in central Mexico is compared, with cautionary notes about the probability of disjunction of form and meaning.

782 1973. Iconographic aspects of architectural profiles at Teotihuacan and in Mesoamerica. <u>The Iconography of Middle American Sculpture</u>. 24-39. New York: Metropolitan Museum of Art. Reprinted in <u>Pre-Columbian Art History</u>. Ed. Alana Cordy-Collins and Jean Stern. Palo Alto: Peek Publications, 1977.

 The talud-tablero architectural profile at Teotihuacan seen as a sign for sacred architecture, the profile itself being the carrier of meaning. The use of architectural profile designs in nonarchitectural media is discussed. Important example of the "contextual method" in pre-Columbian art studies.

783 1973. Science and humanism among Americanists. The
 Iconography of Middle American Sculpture 163-67. New York:
 The Metropolitan Museum of Art.
 Brief but significant statement of the author's
 theoretical position on the supposed ideological unity of
 Mesoamerica.

784 1974. Climate and iconography in Palenque sculpture. Art
 and Environment in Native America. Ed. M. E. King and I. R.
 Traylor, Jr. Special Publications, no. 7:103-13. 3 figs.
 Lubbock: Texas Tech University Museum.
 Three Cross Group temple tablets are examined.
 Differences in costumes of the protagonists, epigraphic
 evidence, and iconographic evidence suggest that the small-scale
 "muffled" figure is a foreigner at Palenque.

785 1975. History--or Anthropology--of Art? Critical Inquiry
 1, no. 4:757-68.
 Remarks on the history of ideas underlying his books The
 Shape of Time (1962) and The Art and Architecture of Ancient
 America (1962). Particular attention paid to the theme of
 disjunction in the history of art, and the divergent views of art
 and anthropology in the study of the archaeological record.
 Important historiographic and theoretical contribution.

786 1976. The double-portrait lintels of Tikal. Actas del 23
 Congreso Internacional de Historia del Arte: España entre
 el Mediterraneo y el Atlántico (Granada, 1974) 1:165-75. 5
 figs. Granada: Universidade de Granada, Departamento de
 Historia del Arte.
 Eighth-century wooden lintels, their iconography and
 historical significance in the rules of "Sky-Rain" and "Sun-Sky-
 Rain."

787 1977. Aspects of Classic Maya Rulership on Two Inscribed
 Vessels. Dumbarton Oaks Studies in Pre-Columbian Art and
 Archaeology, 18. 60 pp., 41 figs. Washington, D.C.
 Epigraphic and iconographic study of an onyx marble bowl
 in the Dumbarton Oaks collection and the famous Initial Series
 Vase excavated at Uaxactun.

788 1977. Renascence and disjunction in the art of
 Mesoamerican antiquity. VIA III: Ornament. Journal of
 the Graduate School of Fine Arts, University of
 Pennsylvania. 31-40, 20 plates.
 A conflation of his 1972 Dumbarton Oaks article and 1973
 Metropolitan Museum symposium article with new remarks on the
 writing of history and the historical process.

789 1977. The style of the Olmec colossal heads. New Mexico
 Studies in the Fine Arts 1:5-9. Albuquerque.

New approach to the stylistic history of colossal heads. Multidimensional scaling suggests that the heads are coeval works of traveling sculptors.

790 1980. Eclecticism at Cacaxtla. Third Palenque Round Table, 1978. Part 2. Ed. M. G. Robertson. 163-72. 12 figs. Austin: University of Texas Press.
 Study of the iconographic program of Maya-style murals in Central Mexico. Eclecticism and syncretistic trends in the paintings are considered.

791 1982. The Mazapan maps of Teotihuacan in 1560. Indiana 7:43-55. 4 figs. Berlin: Ibero-Amerikanisches Institut Preussischer Kulturbesitz.
 Sixteenth-century topography of the ancient site of Teotihuacan according to colonial-period native maps.

Kubler, George, and Charles Gibson.
792 1951. The Tovar Calendar. Memoirs of the Connecticut Academy of Arts and Sciences, 11. 82 pp., 18 figs., 13 plates. New Haven.
 Although a postconquest document, the imagery and text of the Tovar calendar refer to preconquest Aztec festivals and calendrical rituals. This study includes discussion of dating, content, style, historiography, and calendrical correlations.

Kunst aus Mexiko.
793 1974. 272 pp., profusely illustrated. Essen: Villa Hugel.
 Catalog of show of objects from ancient times to present. Concentration on pre-Hispanic art. Brief essays on different aspects of pre-Hispanic art. Illustrations unnumbered.

Kurbjuhn, Kornelia.
794 1977. Fans in Maya art. The Masterkey 51, no. 4:140-46. 6 figs.
 Brief study of mat and feather fans as depicted in figurines, sculpture, and vase painting in the Maya area.

Kurjack, E. B.
795 1976-7. The distribution of vaulted architecture at Dzibilchaltun, Yucatán, Mexico. Estudios de Cultura Maya 10: 91-101, 4 figs., 1 table.
 Compares the distribution of vaulted building construction during two phases at Late Classic Dzibilchaltun. Earlier vaulted architecture found to be less concentrated in space than the later.

Kutscher, Gerdt.
796 1960. Präkolumbische Kunst aus Mexiko und Mittelamerika.
 96 pp., 66 black-and-white figs., 3 color figs. Frankfurt
 am Main: Historisches Museum.
 Catalog of objects drawn from many private and public
 collections, especially from Germany and the U.S. Strongest on
 Mexican objects. Brief introduction written by Kutscher.

797 1971. Wandmalereien des vorkolumbischen Mexiko in Kopien
 Walter Lehmanns. Jahrbuch Preussischer Kulturbesitz 9:71-
 119. 17 figs., 35 plates. Cologne.
 General discussion of mural painting and important early
 copies.

798 1974. El disco azteca de cuero del Linden-Museum de
 Stuttgart. Trans. Wera Zeller. Indiana 2:73-98. 9 figs.,
 2 tables. Berlin: Ibero-Amerikanisches Institut
 Preussischer Kulturbesitz.
 Aztec metal disc with watery scene identical to one in
 Codex Telleriano-Remensis.

Lamb, Weldon.
799 1980. The Sun, Moon and Venus at Uxmal. American Antiquity
 45, no. 1:79-86, 4 figs.
 Archaeoastronomical and ritual information encoded in
 the mosaic facade elements of the nunnery.

Lamp, Frederick.
800 1979. Relief of an Aztec goddess in the Olsen Collection.
 Yale University Art Gallery Bulletin 37, no. 2:25-32. 9
 figs.
 Analysis of the costume attributes and iconography of a
 low-relief female figure in stone. Identification of the image
 as Tlazolteotl.

Langley, James C.
801 1982. Blood, rope, and finery at Cacaxtla. International
 Colloquium: The Indians of Mexico in Pre-Columbian and
 Modern Times. Ed. M. Jansen and T. Leyenaar. 29-49. 11
 figs. Leiden, Netherlands: Rijksmuseum voor Volkenkunde.
 Cacaxtla as recipient of Teotihuacan and Putun-Maya
 influence, as evidenced by iconographic traits in the Maya-style
 frescos there.

Larsen, Helge.
802 1938. The monolithic rock temple of Malinalco. Ethnos 3,
 no. 1:59-63. 8 figs.
 Illustration and description of the Aztec Temple of
 Eagle Knights and Jaguar Knights that had been excavated in
 Central Mexico only two years before.

Lavachery, Henri.
803 n.d. <u>Deux fragments de la statuaire monumentale des Mayas</u>.
 Publication of the Société des Américanistes de Belgique.
 6 pp., 2 plates. Bruxelles.
 Discussion of two stone fragments, probably from Copan,
 in the Musées Royaux d'art et d'histoire, in Brussels.

Lehmann, Heinz.
804 1935. Le fonds maya du Musée d'Ethnographie du Trocadéro
 de Paris. <u>Maya Research</u> 2:345-66. 25 figs.
 The author surveys the small group of Maya specimens in
 the Musée de L'Homme. These are, for the most part, small-scale
 objects of clay and stone.

Lehmann, Henri.
805 1938. Analyse d'un vase mexicain de l'époque
 Précolumbienne. <u>Journal de la Société des Américanistes de
 Paris</u> n.s. 30: 289-98. 5 figs., 1 plate.
 Post-Classic onyx vase from Tlaxlaco, Oaxaca with low
 relief procession of seven figures.

806 1948. Une statue Aztèque en résine. <u>Journal de la Société
 des Américanistes de Paris</u> n.s. 37:269-73. 1 fig., 1
 plate.
 Discussion of a small female statue made of a resinous
 material. Discussion of the Aztec manufacture of perishable or
 edible images.

807 1951. Le personnage couché sur le dos: sujet commun dans
 l'archéologie du Mexique et de l'Equateur. <u>Selected Papers
 of the 29th International Congress of Americanists</u>. 291-
 98. 13 figs. Chicago.
 Figures reclining on beds found in both the art of
 Esmeraldas and of Central and West Mexico. Suggests West Mexico
 as an important influence on the ceramics of the Equatorial
 region.

808 1953. On Noel Morss's cradled infant figurines. <u>American
 Antiquity</u> 19, no. 1:78-80. 2 figs.
 Addenda to Morss's article of 1952. Discusses more
 reclining bed figures, including some from South America. A
 Valley of Mexico origin for this theme is proposed.

Lehmann, Henry.
809 1962. <u>Pre-Columbian Ceramics</u>. 128 pp., 60 figs., 32
 plates, some in color. New York: Viking Press.
 Handbook of figural and utilitarian pottery. Brief dis-
 cussion of forgeries. Outdated.

Lehmann, Walter.
810 1905. Les peintures mixtéco-zapotèques. <u>Journal de la
 Société des Americanistes de Paris</u> n.s. 2:241-80.

An early descriptive classification of pre-Columbian manuscript painting from southern Mexico. No illustrations.

811 1906. Alt mexikanische Mosaiken im KGL Museum für Völkerkunde zu Berlin. Proceedings of the 15th International Congress of Americanists 2:339-49. 2 figs. Québec.
History and thorough description of two Central Mexican mosaic objects in the Berlin Museum.

812 1921. Altmexikanische Kunstgeschichte ein Entwurf in Umrissen. Orbis Pictus/Weltkunst-Bücherei, Band 8. 27 pp., 48 black-and-white plates. Berlin.
Brief introduction to ancient Mexican art. Includes Maya objects.

813 1921. Mexikanische Kunst. 28 pp., 48 plates. Leipzig: Orbis Pictus. Translated as The History of Ancient Mexican Art. New York: Brentano's, 1922.
Despite the book's title, the text deals mainly with ethnic migrations and questions of dating. Artistic aspects of the objects in the photos are not considered.

814 1966. Las cinco mujeres del oeste muertas en el parto y los cinco dioses del sur en la mitología mexicana. Traducciones Mesoamericanistas 1:147-75. 20 figs. Mexico: Sociedad Mexicana de Antropología.
History and explanation of a Mixtec codex fragment in the Bibliothèque Nationale de Paris.

Leigh, Howard.
815 1966. The evolution of the Zapotec glyph C. Ancient Oaxaca. Ed. J. Paddock. 256-69. 101 figs. Stanford: Stanford University Press.
Although a glyphic study, it overlaps onto more general iconographic considerations, for the glyph often appears as a badge on figural urns. Related, nonglyphic stylistic elements are considered as well.

Leon, Nicholas.
816 1933. Codice Sierra. 71 pp., 62 color plates. Mexico: Museo Nacional de Arqueología, Historia y Etnografía.
Color facsimile of an early postconquest document and translation of its accompanying Nahuatl text into Spanish.

Leonard, Jonathan Norton.
817 1967. Ancient America. 192 pp., numerous unnumbered text illustrations. New York: Time, Inc.
Popular introduction to both Middle and South America. Fine quality illustrations.

Leyrer, Dan.
818 1935. New method used in photographing Maya hieroglyphs.
 Maya Research 2:60-63.
 Discusses difficulty of photographing low relief
 sculpture and suggests nighttime photography with portable
 electric powerplant and 500-watt studio reflector.

Linduff, Katheryn M.
819 1974. Ancient Art of Middle America. 124 pp. Huntington,
 West Virginia: The Huntington Galleries.
 Catalog of 151 objects, predominantly sculptural, from
 the collection of Jay C. Leff. Many are illustrated in sepia
 photographs.

Linné, Sigvald.
820 1941. Teotihuacan symbols. Ethnos 3-4:174-86. 6 figs.
 Study of large earthenware slabs with nonfigural decora-
 tion. These and other symbols are associated with Tlaloc.

821 1942. Mexican Highland Cultures. Ethnographic Museum of
 Sweden Publication no. 7. 223 pp., 333 figs., 6 plates.
 Stockholm.
 Excavation report. Important for study of Teotihuacan
 pottery and iconography.

822 1943. Humpbacks in ancient America. Ethnos 8, nos. 1-
 2:161-86. 9 figs.
 Charts the representation of humpbacks in art of the New
 World. Several illustrations of Mesoamerican objects.

823 1951. A wheeled toy from Guerrero, Mexico. Ethnos 16, nos.
 1-2:141-52. 3 figs.
 Additions to Ekholm's 1946 study of wheeled toys.

Lips, Eva, and Helmut Deckert.
824 1962. Maya Handschrift der Sächsischen Landesbibliothek
 Dresden: Codex Dresden. [Introduction by Lips.] 18 pp., 1
 plate. Geschichte und Bibliographie [by Deckert] 86 pp., 1
 plate, 74 separate facsimiles, and "Konkordanztafel," 1 f.
 Berlin: Akademie Verlag.
 Color facsimile of the Maya Dresden Codex. Deckert's
 study is historical, with a comprehensive bibliography.

Littmann, Edwin R.
825 1957. Ancient Mesoamerican mortars, plasters, and
 stuccoes: Comalcalco, Part I. American Antiquity 23, no.
 2:135-40. 1 fig., 1 table.
 First in a series of reports on the use of lime mortar
 and other cementing materials. Site of Comalcalco, Tabasco is
 examined. Technical.

826 1958. Ancient Mesoamerican mortars, plasters, and
 stuccoes: Comalcalco, Part II. American Antiquity 23, no.
 3:292-96. 4 figs.
 A continuation of his 1957 work.

827 1958. Ancient Mesoamerican mortars, plasters, and
 stuccoes: the composition and origin of Sascab. American
 Antiquity 24, no. 2:172-76. 1 fig., 2 tables.
 As well as being used as temper, the Sascab used in the
 preparation of mortar and plaster is shown to be a naturally
 occurring soft limestone powder that is the result of weathering
 and erosion.

828 1980. Maya blue--a new perspective. American Antiquity
 45, no. 1:87-100. 3 figs., 6 tables.
 Technical study of a pigment used by the ancient Maya.
 Author suggests there may be more than one pigment so
 designated. Suggests that indigo was the colorant in at least
 one of these pigments.

Lizardi Ramos, César.
829 1955. ¿Conocian el Xihuitl los teotihuacanos? El México
 Antiguo 8:219-23. 1 fig.
 Mural fragment from Tetitla may represent a calendrical
 glyph.

830 1957. Arquitectura de Huapalcalco, Tulancingo. Revista
 Mexicana de Estudios Antropológicos 14, no. 2:111-15. 1
 fig., 4 plates.
 Notes on excavations. Illustration and discussion of an
 important carved stone yoke found in situ.

831 1961. Estudio de tres piezas arquelógicas. El México
 Antiguo 9:297-324. 13 figs.
 Two plumbate Tlaloc vases, an Olmec statuette in
 Hamburg, and a stela from Xochicalco are discussed.

832 1961. Las estelas 4 y 5 de Balancán-Morales, Tabasco.
 Estudios de Cultura Maya 1:107-30. 4 figs.
 Brief discussion of the inscriptions and relief carvings
 on two Late Classic Maya stelae.

833 1971. Rito previo a la decapitación en el Juego de Pelota.
 Estudios de Cultura Nahuatl 9:21-46. 6 figs. Mexico:
 Universidad Nacional Autónoma de Mexico.
 Draws examples from both Mexican and Maya sources to
 discuss semikneeling figures.

Lombardo de Ruiz, Sonia.
834 1976. Análisis formal de las pinturas de Bonampak.
 Proceedings of the 41st International Congress of
 Americanists 2:365-79. 11 figs. Mexico.

Attributes of pictorial space and form in Bonampak murals.

835 1979. Un método para el análisis formal de la pintura mural Maya del período clásico. Proceedings of the 42nd International Congress of Americanists 7:361-75. 12 figs., 3 tables. Paris.
 A suggestion for the systematization of the study of Maya painting by analyzing formal characteristics of figure, line, volume, texture, color, and so forth.

Long, R. Cary.
836 1849. The Ancient Architecture of America: Its Historical Value and Parallelism of Development with the Architecture of the Old World. 37 pp., 9 plates. New York.
 Comparison of the pyramidal form and its embellishment in ancient Mexico, Egypt, and Asia.

Long, Richard C. E.
837 1926. The Zouche Codex. Journal of the Royal Anthropological Society 51:239-58. London.
 Early study of historical accounts in the obverse of Codex Nuttall.

Longyear, John M.
838 1940. The ethnological significance of Copan pottery. The Maya and Their Neighbors. 268-71. 9 figs. New York: D. Appleton-Century.
 Brief article succinctly states what was known of Copan's relations with Maya highlands, lowlands, and Central Mexico in 1940. Good illustrations.

839 1952. Copan Ceramics: A Study of Southeastern Maya Pottery. Carnegie Instituion of Washington Publication no. 597. 114 pp., 118 figs. Washington, D.C.: Carnegie Institution of Washington.
 Although a ceramic report, it is included here for its coverage of many polychrome painted vessels. Information is also included on jade, shell, flint, and obsidian artifacts.

Lopez, Diana, and Daniel Molina.
840 1976. Los murales de Cacaxtla. Boletín 2, no. 16:3-8. 9 figs. Mexico: Instituto Nacional de Antropología y Historia.
 Brief introduction to the newly discovered murals in Tlaxcala. Several useful line drawings.

Losada Tomé, José (ed.).
841 1971. Murales Pre-hispánicos. Artes de México 18, no. 144. 118 pp., 231 figs., 20 color plates. Mexico.

Particular issue of a Mexican journal devoted to wall painting in ancient Mexico. Excellent illustrations. Commentary in Spanish. Abbreviated summaries in English and French.

Lothrop, Samuel K.
842 1923. Stone yokes from Mexico and Central America. Man 23:97-8. 2 figs. London.
 Description of stone yoke and insights into its use, based on ceramic figurine wearing a yoke at the waist and a Cotzumalhuapa sculpture depicting it being worn in the same fashion.

843 1924. Tulum: An Archaeological Study of the East Coast of Yucatan. Carnegie Institution of Washington Publication no. 335. 179 pp., 186 figs., 27 plates. Washington, D.C.: Carnegie Institution of Washington.
 Important early study of this Maya site. Includes color reproductions of all fresco paintings.

844 1929. Sculptured fragments from Palenque. Journal of the Royal Anthropological Institute 59:53-62. 4 plates. London.
 Report on early exploration at Palenque. Illustration of sculptures taken from Palenque by Del Rio in 1787 and taken to Spain, including the famous "Madrid Stela."

845 1936. Sculptured pottery of the Southern Maya and Pipil. Maya Research 3:140-50. 8 figs.
 Discussion of incised and modeled vessels from various sites.

846 1941. A chronological link between Maya and Olmeca Art. American Anthropologist 43:419-21. 1 fig.
 At a time when Olmec chronology was not understood, this author put forth the thesis that at least one phase of Olmec culture was coeval with Late Classic Maya, based on Olmec-style pendant ornaments worn by personages on Naranjo Stelae.

847 1952. Metals from the Cenote of Sacrifice, Chichen Itza, Yucatan. Memoirs of the Peabody Museum 10, no. 2. 139 pp., 114 figs., 39 tables. Cambridge: Harvard University.
 Study of all metal objects extracted from the sacred well. Considerations of metallurgical process, gold and copper ornaments, their style, iconography, and cultural affiliations.

848 1964. Treasures of Ancient America. 229 pp., profusely illustrated. Geneva: Skira.
 Survey text with numerous fine color plates. Covers Middle and South America.

Lothrop, S. K., W. F. Foshag, and Joy Mahler.
849 1957. Robert Woods Bliss Collection of Pre-Columbian Art.
 295 pp., 31 figs., 162 plates, 2 maps. Washington, D. C.:
 Dumbarton Oaks.
 Catalog of the collection of first-rate objects at Dum-
 barton Oaks. Serves also as an introduction to Mesoamerican
 culture and art styles. Excellent illustrations. Both Middle
 and South America are represented.

Lothrop, Samuel K., et al. (eds.).
850 1961. Essays in Pre-Columbian Art and Archaeology. 507
 pp. Cambridge: Harvard University Press.
 Classic collection of twenty-seven essays by well-known
 scholars. Twelve essays pertain to Mesoamerican topics.
 Contributions by Kubler, D. Easby, Stirling, E. Easby,
 Proskouriakoff, Smith, Borhegyi, Thompson, Kidder and Shook, and
 Dockstader are annotated here.

Lowe, Gareth W.
851 1965. Desarrollo y función de incensario en Izapa.
 Estudios de Cultura Maya 5:53-64. 16 figs.
 Use of incense burners at Izapa from late Pre-Classic to
 Classic periods based on archaeological evidence and pictorial
 evidence in stela sculptures.

Lowy, Bernard.
852 1971. New records of mushroom stones from Guatemala.
 Mycologia 63:983-93. 10 figs.
 Illustration and discussion of several figural and
 zoomorphic mushroom stones. No interpretations presented that
 are not already found in Borhegyi 1953.

853 1972. Mushroom symbolism in Maya codices. Mycologia 64,
 no. 4:816-21. 4 figs.
 Brief discussion of mushroom cults among the Maya based
 on inconclusive evidence in the codices.

Luckert, Karl W.
854 1976. Olmec Religion. 185 pp., 60 figs. Norman:
 University of Oklahoma Press.
 Historian of religion looks at Olmec iconography and
 makes some new hypotheses about the meaning of Olmec forms.
 Serpent seen to be as important as the jaguar in the Olmec belief
 system. New interpretation of the large underground mosaic
 masks of La Venta as representing crotalus snakes.

Lujan Muñoz, Jorge.
855 1966. Dos estelas mayas sustraidas de Guatemala. 28 pp., 5
 figs. Universidad de San Carlos de Guatemala.
 Two Maya stelae in New York museums illustrated and dis-
 cussed as examples of stolen monuments. Legal methods for
 recovery discussed.

Lumholtz, Carl.
856 1909. A remarkable ceremonial vase from Cholula, Mexico.
 American Anthropologist n.s. 11:199-201. 3 figs.
 Vessel in the American Museum of Natural History with
 feathered-serpent imagery is illustrated and described.

MacCurdy, George.
857 1910. An Aztec "calendar stone" in Yale University Museum.
 American Anthropologist 12:481-96. Reprinted in
 Proceedings of the 17th International Congress of
 Americanists 2:382-96. 16 figs. Buenos Aires, 1910.
 Discussion of a small relief-carved monument in the
 Peabody Museum, similar to the famous Aztec calendar stone in
 the Mexican Museum. The Yale version bears no day signs.

Mahler, Joy.
858 1965. Garments and textiles of the Maya lowlands.
 Handbook of Middle American Indians 3. Ed. Gordon R.
 Willey. 581-93. 10 figs. Austin: University of Texas
 Press.
 Evidence drawn from sculpture, painting, and figurines,
 as well as few surviving examples of actual textiles.

Maler, Teobert.
859 1901-3. Researches in the Usumatsintla Valley. Memoirs of
 the Peabody Museum, 2, 216 pp., 68 figs., 80 plates.
 Cambridge: Harvard University.
 Sculpture and architecture at Maya sites. Includes
 important early photos of stone sculpture at Piedras Negras,
 Yaxchilan, and elsewhere.

860 1908. Explorations in the Department of Peten, Guatemala,
 and Adjacent Region. Memoirs of the Peabody Museum 4, no.
 2. 74 pp., 22 figs., 30 plates. Cambridge: Harvard
 University.
 Architecture and figural sculpture at the Maya sites of
 Topoxté, Yaxhá, Benque Viejo, and Naranjo.

861 1908. Explorations of the Upper Usumatsintla and Adjacent
 Regions. Memoirs of the Peabody Museum 4, no. 1. 52 pp., 8
 figs., 13 plates, 1 map. Cambridge: Harvard University.
 Architecture and figural sculpture at the Maya sites of
 Altar de Sacrificios, Seibal, Itsimté-Sacluk, and Cankuen.

862 1910. Explorations in the Department of Peten, Guatemala,
 and Adjacent Region (Continued). Memoirs of the Peabody
 Museum 4, no. 3. 42 pp., 2 plates. Cambridge: Harvard
 University.
 Motul de San José and Peten-Itza are discussed. Only
 one stela from Motul de San José is illustrated.

863 1911. Explorations in the Department of Peten, Guatemala:
 Tikal. Memoirs of the Peabody Museum 5, no. 1. 92 pp., 17
 figs., 28 plates. Cambridge: Harvard University.
 Important early study with useful photos of stelae and
architecture.

864 1971. Bauten der Maya/Edificios Maya. 2 vols. Monumenta
 Americana, 4. Vol. 1: 120 pp., 24 plates. Vol. 2: 40
 fold-out site plans and architectural drawings. Ibero-
 Amerikanischen Institut Preussischer Kulturbesitz.
 Berlin: Gebr. Mann Verlag.
 Bilingual text in Spanish and German of Maler's study of
Maya architecture, based on his fieldwork from 1886-1905. Fine
maps and drawings.

Maler, Teobert, and S. Morley.
 865 1953. El Dintel 42 de Yaxchilan. Yan 2:136-39. 2 figs.
 Lintel 42 in structure 42 at this Maya site is
described. Remarks on its date, inscription, and stylistic
relationship with other works at Yaxchilan and elsewhere.

Manganotti, Donatella.
 866 1966. La triade sacra degli antichi Aztechi. L'Universo.
 46, no. 3:501-36. 23 figures. Florence.
 Psychotropic substances in Aztec art and culture.
Peyote, Oliliuhqui, and mushrooms are considered.

Marcus, Joyce.
 867 1974. The iconography of power among the Classic Maya.
 World Archaeology 6, no. 1:83-94. 3 figs., 9 plates.
 Use of militaristic iconographic motifs and glyphic
texts to establish the power and credentials of the Maya ruling
elite. Examination of pictorial representations of the ruler
and the conquered, including a differential use of realism.
Comparisons with the art of Monte Alban in Oaxaca.

868 1976. The iconography of militarism at Monte Albán and
 neighboring sites in the Valley of Oaxaca. Origins of
 Religious Art and Iconography in Preclassic Mesoamerica.
 Ed. H. B. Nicholson. 123-39. 27 figs. Los Angeles.
 Danzantes, conquest slabs, and later stelae examined for
militaristic themes. Antecedent role of Zapotec civilization in
the use of place signs, bar and dot numeration, political
conquest records and naming rulers by their birth dates is
stressed.

869 1976. Emblem and State in the Classic Maya Lowlands. 203
 pp., numerous text figs. Washington, D.C.: Dumbarton
 Oaks.
 Although principally an epigraphic study, the author
also considers Maya monumental sculpture in her study of Maya
polity and territorial organization.

870 1980. Zapotec writing. <u>Scientific American</u> 242, no. 2:50-
64. 14 figs.
 Important article on Zapotec art, history, and the
inter-relationship and continuities of texts and images in
Zapotec art.

Margain, Carlos R.
871 1971. Pre-Columbian architecture of Central Mexico.
<u>Handbook of Middle American Indians</u> 10. Ed. Gordon F.
Ekholm and Ignacio Bernal. 45-91. 39 figs. Austin:
University of Texas Press.
 Survey of architectural types and the various factors
influencing the building of monumental architecture--geography
and climate, materials, technology, aesthetics, etc.

Marquina, Ignacio
872 1928. <u>Estudio arquitectónico comparativo de los monumentos
arqueológicos de México</u>. 86 pp., numerous unpaginated
plates.
 Important early study of pre-Columbian architecture.
Numerous useful site plans, building plans, and illustrations of
pottery and of other monuments.

873 1960. <u>El Templo Mayor de México</u>. 118 pp., 43 plates, 21
text figures. Mexico: Instituto Nacional de Antropología
e Historia.
 Important study of the principal temple and its precinct
in Tenochtitlan. Architectural, archaeological, and functional
implications are considered.

Marquina, Ignacio, and Luis A. Ruiz.
874 1934. La orientación de las pirámides. <u>Proceedings of the
25th International Congress of Americanists</u> 2:101-6. 1
fig. Buenos Aires.
 An early look at the astronomical orientations of
different Mesoamerican sites. Tenayuca considered in most
detail.

Marti, Samuel.
875 1960. Simbolismo de los colores, deidades, números y
rumbos. <u>Estudios de Cultura Nahuatl</u> 2:93-127. 12 figs.
Mexico: Universidad Autónoma de México.
 Cursory study of iconography of color, deity, number and
directions in pre-Hispanic Mexican and Maya art (especially
codices) as a way of understanding indigenous concepts and their
functions.

Martinez Marin, Carlos.
876 1961. <u>Codice Laud</u>. Serie investigaciones, no. 5. 83 pp.,
including 47 black-and-white facsimile plates of codex.
Mexico: Instituto Nacional de Antropología y Historia.

Text includes a number of brief articles on Codex Laud by Burland, Lehmann, Paso y Troncoso, and others, most of which were previously published elsewhere.

Mascara con mosaico de turquesas: Dictamenes periciales.
877 34 pp., 11 figs. Mexico: Museo Nacional de Arquelogía, Historia, y Etnografía.
Collection of "expert opinions" on the authenticity of famous Teotihucan-style mosaic-encrusted mask.

Mason, J. Alden.
878 1927. Native American jades. Museum Journal 18, no. 1:46-73, 8 figs. Philadelphia.
Technological and stylistic study of Mesoamerican jades in the University Museum. Useful discussion of manufacturing techniques.

879 1929. Turquoise mosaics from Northern Mexico. The Museum Journal 20, no. 2:157-75. Philadelphia.
General discussion of history and method of utilizing turquoise, and description of ancient turquoise ear pendants purchased by author in Azqueltan, Jalisco, where they were being used by modern Indians. Turquoise set in brown resin.

880 1929. Zapotec funerary urns from Mexico. The Museum Journal 20, no. 2:176-201. 11 black-and-white plates. Philadelphia.
Illustration and brief discussion of eleven of the forty Zapotec urns purchased by the museum in 1928. Several look spurious today.

881 1935. Preserving ancient America's finest sculptures. National Geographic 68, no. 5:537-70. 24 black-and-white photos. 8 color plates.
Popular account of excavations at Piedras Negras with particular attention paid to the recovery of stelae and lintels. Color reconstruction drawings of Maya dress and ceremonies.

882 1937. Jade ornaments from Piedras Negras. Museum Bulletin 4, no. 2: 53-56, 1 fig. University of Pennsylvania.
Illustration of half of the objects found in a burial vault at Piedras Negras by a University of Pennsylvania expedition. Jaguar head pendant, ear ornaments, and other items of jewelry.

883 1943. The American Collection of the University Museum, The Ancient Civilizations of Middle America. University Museum Bulletin 10, nos. 1-2. 64 pp., 39 figs. Philadelphia.
Brief survey of the University Museum's collection. Particularly strong in important Maya pieces.

Mastache de Escobar, Alba Guadalupe.
884 1974. Dos fragmentos de tejido decorados con la técnica de
 plangi. <u>Anales</u> (ser. 7a) 4:251-62. 11 figs. Mexico:
 Instituto Nacional de Antropología e Historia.
 Two textile fragments found in a cave near Tehuacán,
 Puebla exhibit an early use of <u>plangi</u> technique. Textiles from
 codices illustrated for comparison.

Matos Moctezuma, Eduardo, and Isabel Kelly.
885 1974. Una vasija que sugiere relaciones entre Teotihuacan
 y Colima. <u>The Archaeology of West Mexico</u>. Ed. Betty Bell.
 202-205. 6 figs. Ajijie, Jalisco. Mexico: West Mexican
 Society for Advanced Study.
 Post-fired painted jar from West Mexico has Teotihuacan-
 style figural and glyphlike designs on it.

Maudslay, Alfred P.
886 1899-1902. <u>Biologia Centrali-Americana: Archaeology</u>. 4
 vols. 353 pp., 392 plates. London: Porter and Dulan.
 Reprint. New York: Milpatron Co., 1974.
 Important early resource for the study of Maya architec-
 ture, stone sculpture, and epigraphy. Superb photos and line
 drawings.

887 1912. A note on the position and extent of the great temple
 enclosure of Tenochtitlán, and the position, structure and
 orientation of the Teocalli of Huitzilopochtli.
 <u>Proceedings of the 18th International Congress of</u>
 <u>Americanists</u>. 173-75, 2 figs. London.
 Abstract of a longer presentation. Reviews all ethno-
 historical and archaeological information on the temple pre-
 cinct. Suggests placement of the Teocalli as northeast of
 present cathedral.

Maurer, Ingeborg.
888 1980. <u>Das Lächeln Mexikos</u>. Rautenstrauch-Joest-Museum.
 Köln. 103 pp., 1 color plate, 33 black-and-white plates.
 Exhibit catalog focusing on smiling face type and other
 ceramic figures of central Veracruz.

Mayer, Karl Herbert.
889 1978. <u>Maya Monuments: Sculptures of Unknown Provenance in</u>
 <u>Europe</u>. 44 pp., 55 figs. Ramona, California: Acoma Books.
 Catalog of major stone sculptures from the Maya lowlands
 in European public and private collections.

890 1980. <u>Maya Monuments: Sculptures of Unknown Provenance in</u>
 <u>the United States</u>. 86 pp., 84 figs. Ramona, California:
 Acoma Books.
 Useful survey of Maya sculptures in U.S. museums and
 private collections, including those of doubtful authenticity.

891 1981. Classic Maya Relief Columns. 33 pp., 16 figs.
 Ramona, California: Acoma Books.
 Documentation of more than ninety examples of this
 unusual style of Maya carving, known principally from the
 Yucatan.

McAfee, Byron, and Robert Barlow.
892 1947. La segunda parte del Códice Aubin. Memorias de la
 Academia Mexicana de la Historia 6, no. 2:156-82. 202
 figs., 1 plate. Mexico.
 Translation of Nahuatl text of this manuscript and dis-
 cussion of corresponding illustrations.

McBride, Harold W.
893 1969. Teotihuacan-style pottery and figurines from Colima.
 Katunob: A Newsletter-Bulletin on Mesoamerican
 Anthropology 7, no. 3:86-91. 17 figs., 2 plates. Greeley,
 Colorado: University of Northern Colorado.
 Jars, figurines, molds, earrings, and incense burners
 found in West Mexico show evidence of Teotihuacan contact.

McDonald, Andrew J.
894 1977. Two Middle Preclassic engraved monuments at
 Tzutzuculi on the Chiapas coast of Mexico. American
 Antiquity 44, no. 4:560-66. 10 figs.
 Olmec were-jaguar and serpent-dragon monuments found in
 direct association with platform building resembling that at La
 Venta.

McDougall, Elsie.
895 1943. A vase from Sanimtaca, Alta Verapaz, Guatemala.
 Notes on Middle American Archaeology and Ethnology 1, no.
 30:194-97. 1 fig. Washington, D.C.: Carnegie Institution
 of Washington.
 Fragmentary Maya style vessel with long-nosed god in low
 relief.

McGowan, Charlotte, and Patricia van Nice.
896 1979. The Identification and Interpretation of Name and
 Place Glyphs of the Xolotl Codex. Katunob: Occasional
 Publications in Mesoamerican Anthropology, 11. 110 pp.,
 numerous figs. Greeley, Colorado: University of Northern
 Colorado.
 Brief essay; most of the work consists of pictures of
 the glyphs in this Aztec postconquest manuscript, accompanied by
 their names in Nahuatl and English.

Medellin Zenil, Alfonso.
897 1963. The Olmec Tradition. unpaginated, 47 figs.
 Houston: Museum of Fine Arts.

Catalog of an exhibit, principally of Olmec art, with the addition of a few later pieces from the Veracruz area. Brief text in both Spanish and English. Checklist of pieces. Documentation and photos of the excavation and shipment of a colossal Olmec head.

Medellin Zenil, A., and Peterson, F. A.
898 1954. A smiling head complex from central Veracruz, Mexico. American Antiquity 20, no. 2: 162-68. 3 figs.
 A large number of mold-made smiling figurines from two partly looted sites in Veracruz discussed and illustrated. Seriation and chronological relationship with other sites provided.

Medioni, Gilbert.
899 1952. L'art tarasque du Mexique Occidental. 8-page text, 93 photos. Paris: P. Hartmann Co.
 Almost all pieces from Diego Rivera collection, focusing especially on ancient art of Colima and Nayarit.

Médioni, Gilbert, and M. T. Pinto.
900 1941. Art in Ancient Mexico. 26-page introduction. 259 black-and-white plates. New York.
 All pieces from the collection of Diego Rivera. Particularly strong on West Mexican pieces; over half the book devoted to West Mexico.

Mena, Ramón.
901 1914. Altares-incensarios a Chalchihuitlicue y a Macuilxochitl. Memorias y Revista de la Sociedad Científica "Antonio Alzate" 33:229-33. 3 figs.
 Teotihuacan-style incense burners excavated at Azcapotzalco said to represent the deities Chalchiutlicue and Macuilxochitl.

902 1926. Piedra ciclográfica de Motecuhzoma Xocoyotzin. Proceedings of the 22nd International Congress of Americanists 1:605-24, 9 plates. Rome.
 Explanatory description, with accompanying photographs of a famous Aztec monument.

903 1927. Catálogo de la Colección de Objetos de Jade. 78 pp., 23 plates. Mexico: Museo Nacional, Departamento de Arqueología.
 Brief discussion of jade-working techniques and catalog of 553 objects in the collection, 23 of which are illustrated.

Mengin, Ernst.
904 1952. Commentaire du Codex Mexicanus nos. 23-24. Journal de la Société des Américanistes n.s. 41:387-498. Paris.

Commentary on Mexican manuscript and photographic facsimile.

905 1958. Codex Moguntiacus. <u>Miscellanea Paul Rivet</u> 1:585-91. Mexico.
Brief look at falsified Mexican codex in private collection in Mainz, in the style of Codex Borgia.

Merwin, R. E., and G. C. Vaillant.
906 1932. <u>The Ruins of Holmul, Guatemala</u>. Memoirs of the Peabody Museum 3, no. 2. 103 pages, 31 figs., 36 black-and-white plates, 1 color plate. Cambridge: Harvard University.
Exploration and excavation at a Maya site in the Peten. Important Tzakol and Tepeu phase pottery illustrated.

Messmacher, Miguel.
907 1966. <u>Colima</u>. 145 pp., 84 plates, some in color. México: Instituto Nacional de Antropolgía e Historia.
Survey of ceramic sculptures from the West Mexican state of Colima.

Metcalf, George, and Kent V. Flannery.
908 1967. An Olmec "were-jaguar" from the Yucatan peninsula. <u>American Antiquity</u> 32, no. 1:109-11. 1 fig.
Small serpentine figure found by Maler in 1887 is illustrated and described.

Meyer, Karl E.
909 1972. <u>The Maya Crisis</u>. 47 pp., 5 figs. Washington, D.C.: privately printed.
Report on the looting of Maya sites and modest proposals for some solutions. Listing of looted sites in the Peten.

910 1977. <u>The Plundered Past</u>. 353 pp. New York: Atheneum.
Although concerned with the general problem of the illegal international trade in art, chapter 1 concerns the illicit trade in pre-Columbian antiquities.

Milbrath, Susan.
911 1979. <u>A Study of Olmec Sculptural Chronology</u>. Dumbarton Oaks Studies in Pre-Columbian Art and Archaeology, 23. 75 pp., 78 figs. Washington, D.C.
New categorization of Olmec sculpture based on formal analysis of three-dimensional seated figures. Evidence from archaeological record is integrated with this to provide a new sculptural chronology.

Miles, S. W.
912 1965. Sculpture of the Guatemala-Chiapas Highlands and Pacific slopes, and associated hieroglyphs. <u>Handbook of</u>

Middle and American Indian 2. Ed. Gordon R. Willey. 237-75. 19 figs., 2 tables. Austin: University of Texas Press.
 Landmark article drawing together much previously unpublished and unillustrated material.

Miller, Arthur G.

913 1967. The birds of Quetzalpapalotl. Ethnos 32:5-17. 2 figs.
 Contextual differences between two bird forms on pillars in the Quetzalpapalotl courtyard at Teotihuacan are explored. Suggestion that owls and quetzal birds are represented, emblematic of nocturnal and diurnal forces of nature.

914 1969. The Mural Painting of Teotihuacan, Mexico, and an Inquiry into the Nature of its Iconography. Unpublished doctoral dissertation, Department of Fine Arts, Harvard University. 173 pp., 190 plates, 47 tables, 11 plans.
 Important study of Teotihuacan mural art and its contexts.

915 1970. Lost Teotihuacan mural. Bolétin Bibliográfico de Antropología Americana 35:261-83. 12 figs. Mexico.
 Discussion of the lost "Ofrendas" mural discovered by Batres in 1889. Illustration of several fragments that may have belonged to this mural program. See also commentary by Clara Millon, 1970.

916 1973. The Mural Painting of Teotihuacan. 193 pp., 367 plates. Washington, D.C.: Dumbarton Oaks.
 Photography and documentation of Teotihuacan murals known as of 1971 and their architectural contexts. Descriptive text, some color plates, some line drawings, some black-and-white plates. Discussion of Teotihuacan painting style.

917 1974. Form and meaning in some Teotihuacan mural paintings: architectural contexts. The Human Mirror. Ed. M. Richardson. 91-133. 18 figs. Baton Rouge: Louisiana State University Press.
 Contextual study of some Teotihuacan murals suggests that the east side of buildings often focuses on human-jaguar imagery.

918 1974. The iconography of the painting in the Temple of the Diving God, Tulum, Quintana Roo: the twisted cords. Mesoamerican Archaeology: New Approaches. Ed. Norman Hammond. 167-86. 7 figs. Austin: University of Texas Press.
 One motif considered and compared to similar representations in codices, Izapan sculpture, and in ethnohistory. Meaning of umbilical cords as related to descending deities and genealogical descents.

919 1974. West and east in Maya thought: death and rebirth at
 Palenque and Tulúm. Primera Mesa Redonda de Palenque, Part
 II. Ed. M.G. Robertson. 45-49. 1 fig. Pebble Beach,
 California: Robert Louis Stevenson School.
 A comparison of two sites on the western and eastern
 margins of the Maya world, expressing opposing cosmological
 associations. Palenque characterized as a necropolis, Tulum as
 a site of birth and renewal.

920 1975. The Codex Nuttall. 18 pp. New York: Dover
 Publications.
 Reprinting of the facsimile of this ancient Mixtec codex
 now in the British Museum, with an introduction by Arthur Miller
 briefly discussing the manuscript, its provenance, style, and
 iconography.

921 1977. The Maya and the sea: trade and cult at Tancah and
 Tulum, Quintana Roo, Mexico. The Sea in the Pre-Columbian
 World. Ed. E. P. Benson. 96-135. 19 figs. Washington,
 D.C.: Dumbarton Oaks.
 Excavations at Tancah, and non-Maya "international
 style" paintings at Tulum and Tancah with marine-related
 iconography support the case for the pivotal role of maritime
 trade on the east coast of the Yucatan during the Post-Classic.
 An important article.

922 1977. Captains of the Itzá: unpublished mural evidence
 from Chichén Itzá. Social Process in Maya Prehistory. Ed.
 Norman Hammond. 197-225. 9 figs. London: Academic Press.
 Analysis of the subject matter of mural paintings from
 Temple A, based on Adela Breton's watercolors done at the turn of
 the century. Links with terminal Classic period events at
 Seibal are suggested, based on ethnohistorical and art
 historical evidence. Translated as Capitanes del Itzá:
 evidencia mural inédita de Chichén Itzá. Estudios de Cultura
 Maya 11:121-54. 9 figs. 1978.

923 1978. A brief outline of the artistic evidence for Classic
 period cultural contact between Maya Lowlands and Central
 Mexican Highlands. Middle Classic Mesoamerica A.D. 400-
 700. Ed. E. Pasztory. 63-70. 5 figs. New York: Columbia
 University Press.
 A brief look at some evidence both at Teotihuacan and in
 the Maya area (principally at Tikal) that suggests contact
 between the two areas.

924 1979. "The little descent": manifest destiny from the
 east. Proceedings of the 42nd International Congress of
 Americanists 8:221-36. 6 figs. Paris.
 Characterizes the Itza as the non-Yucatec immigrants of
 the so-called little descent, based on mural paintings in the

Temple of the Warriors at Chichen Itza and related archaeological data from the east coast.

925 1982. On the Edge of the Sea: Mural Painting at Tancah-Tulum, Quintana Roo, Mexico. 133 pp., 47 color plates, 143 figs. Washington, D.C.: Dumbarton Oaks.
 The mural painting tradition at two Post-Classic sites on the east coast of the Yucatan is examined in terms of its context, chronology, style, and meaning. An important study, much of which concerns previously unpublished material.

926 1983. Image and text in pre-Hispanic art: apples and oranges. Text and Image in Pre-Columbian Art. Ed. J. C. Berlo. 41-54. 2 figs. Oxford: British Archaeological Reports.
 The author suggests that fundamental differences in the mechanisms of visual and written communication impair uncritical parallels between the two systems. In ancient Mesoamerica, visual arts rather than writing carried the major burden of communication.

Miller, Jeffrey H.
927 1974. Notes on a stelae pair probably from Calakmul, Campeche, Mexico. Primera Mesa Redonda de Palenque, Part I. Ed. M.G. Robertson. 149-61. 5 figs. Pebble Beach, California: Robert Louis Stevenson School.
 Maya stelae from the Cleveland Museum and the Kimball Museum in Fort Worth are shown to be a pair, one depicting a male, the other a female, both with the same dedicatory date. Iconographic and epigraphic evidence are cited.

Miller, Mary Ellen, and David S. Stuart.
928 1981. Dumbarton Oaks Relief Panel 4. Estudios de Cultura Maya 8:197-204. Mexico.
 Glyphic and iconographic report on a looted Maya monument probably from the Pomoná region.

Milliken, William M.
929 1942. Jade figurine in the Olmec style. Bulletin of the Cleveland Museum of Art 29:100.
 Description and illustration of small-scale seated figurine purchased for museum collection.

930 1946. Art of the Americas. Cleveland Museum of Art Picture Book no. 2. 58 pp., 5 color plates, 49 black-and-white figs.
 Catalog of a special exhibition at museum in 1945. Pieces from both South and Middle America are included. Sparse text (two pages).

931 1955. Two pre-Columbian sculptures. Bulletin of the
 Cleveland Museum of Art 42:59-61.
 Brief notice of the purchase of a Zapotec ceramic figure
 and an Olmec figural axe.

932 1957. A missing fragment recovered. Bulletin of the
 Cleveland Museum of Art 44:46-48. 1 fig.
 Recounting of how a stone knee and hand combination pur-
 chased in Guerrero was the missing piece to an Olmec figural
 sculpture already in the Cleveland Museum.

Millon, Clara.
933 1970. Commentary about a lost Teotihuacan mural. Bolétin
 Bibliográfico de Antropología Americana 35:284-85.
 Additional remarks on A. Miller's 1970 article on mural
 fragments from Batres's "Ofrendas" mural, and on Miller's
 analysis of them.

934 1973. Painting, writing and polity in Teotihuacan, Mexico.
 American Antiquity 38:294-314. 11 figs.
 Two Teotihuacan mural paintings of unknown provenience
 within the site serve as the basis for discussion of the nature
 of writing and the visual arts at Teotihuacan. The "tassel
 headdress" and its occurrences in the city as well as in the
 Zapotec and Maya areas is discussed. Author assumes it to be a
 symbol of civic authority.

Millon, Clara, and Evelyn Rattray.
935 1972. An extraordinary Teotihuacán mural. Muse 6:46-48.
 3 figs. Columbia, Missouri: University of Missouri.
 Brief discussion of a mural fragment in the museum col-
 lection, noteworthy principally for its use of glyph-like
 elements in stacked vertical format.

Millon, René, and Bruce Drewitt.
936 1961. Earlier structures within the Pyramid of the Sun at
 Teotihuacán. American Antiquity 26, no. 3:371-80. 5
 figs.
 Interior of the pyramid investigated in 1959. Small
 stone-faced structure was the only architectural feature found
 within.

Mirambell, Lorena E.
937 1968. Técnicas lapidarias prehispánicas. Investigaciones,
 14. 115 pp., 43 figs. Mexico: Instituto Nacional de
 Antropología e Historia.
 Study of materials and technique of ancient
 stonecutters, focusing on small-scale pieces.

Moedano Köer, Hugo.
938 1946. Jaina: un cementerio maya. <u>Revista Mexicana de Estudios Antropológicos</u> 8:217-42. 4 figs., 12 plates, 1 map.
 The archaeological context of Jaina pottery and figurines.

939 1947. El friso de los caciques. <u>Anales</u> 2:113-36. 9 figs., 1 color plate, 1 map. Mexico: Instituto Nacional de Antropología e Historia.
 Study of the style, iconography, and context of the painted warrior frieze in Mound B at Tula. Fold-out color reproduction of the frieze.

Moholy-Nagy, Hattula.
940 1962. A Tlaloc stela from Tikal. <u>Expedition</u> 4, no. 2:27. 2 figs.
 Illustration, line drawing, and description of the finding of fragmentary stela 32 at Tikal, depicting a Central Mexican deity.

941 1966. Mosaic figures from Tikal. <u>Archaeology</u> 19, no. 2:84-89. 6 figs.
 Reconstruction of elaborate jade and shell mosaic sculptures excavated at Tikal which represent male figures. Elaborate ear ornaments reconstructed as well.

Molina-Montes, Augusto.
942 1982. Archaeological buildings: restoration or misrepresentation. <u>Falsifications and Misreconstructions of Pre-Columbian Art</u>. Ed. Elizabeth Boone. 125-141. 10 figs. Washington, D.C.: Dumbarton Oaks.
 Historical review of changing fashions in reconstruction and consolidation of ancient buildings. Examples drawn from Tula, Teotihuacan, Uxmal, and Cholula comprise, in the author's opinion, examples of "historical falsification."

Monti, Franco.
943 1966. <u>Precolumbian Terracottas</u>. Trans. Margaret Crosland. 158 pp., 71 figs. London: Hamlyn Publishing Group Ltd.
 Ceramics from both Middle and South America. Most useful for its color plates.

Montolíu, Maria.
944 1976-7. Algunos aspectos del venado en la religión de los Mayas de Yucatan. <u>Estudios de Cultura Maya</u> 10:149-72. 7 figs.
 Deer imagery in vase painting, sculpture, and manuscripts, as well as in ethnographic accounts. Deer associated with rain, fertility, and heart sacrifice.

Moriarty, James Robert, III.
945 1974. Aztec jade. <u>Katunob: A Newsletter-Bulletin on
 Mesoamerican Anthropology</u> 8, no. 4:9-14. Greeley,
 Colorado: University of Northern Colorado.
 Discussion of Aztec jade, using ethnohistorical sources.
 Not illustrated.

Morley, Sylvanus G.
946 1935. <u>Guide Book to the Ruins of Quirigua</u>. 205 pp., 48
 figs. Washington, D.C.: Carnegie Institution of
 Washington.
 Each major sculptural monument in this Maya site
 discussed and illustrated. Useful early work.

947 1946. <u>The Ancient Maya</u>. Third revised edition by George W.
 Brainerd. 1956. 507 pp., 57 figs., 102 plates. Stanford
 University Press.
 Although partly out of date, it still provides a useful
 introduction to Maya art and culture. Profusely illustrated.

948 1970. The stela platform at Uxmal, Yucatan, Mexico.
 <u>Archaeological Studies in Middle America</u>. 153-80. Middle
 American Research Institute Publication no. 26. 23 figs.
 New Orleans: Tulane University.
 Careful discussion of stela platform and associated
 monuments. Photos, drawings and descriptions of 16 stelae.
 Manuscript written in 1940s, published posthumously.

Morley, Sylvanus G., and Frances Morley.
949 1939. The age and provenance of the Leyden Plate.
 <u>Contributions to American Anthropology and History</u> 5, no.
 24. 4 figs. Washington: Carnegie Institution of
 Washington.
 An account of the discovery of this famous Maya jade,
 its calendrical inscription, and its iconographic relationship
 with Early Classic stelae at Tikal.

Morris, Earl H.
950 1931. <u>The Temple of the Warriors</u>. 251 pp., numerous text
 illustrations. New York: Charles Scribner's Sons.
 Popular account of the author's excavations at Chichen
 Itza. More scholarly account is found in a volume of the same
 date and title by Morris, Charlot, and Morris.

Morris, Earl H., Jean Charlot, and Ann Axtell Morris.
951 1931. <u>The Temple of the Warriors at Chichen Itza, Yucatan</u>.
 2 vols. Carnegie Institution of Washington Publication No.
 406. Vol. 1: 485 pp. Vol. 2: 170 plates, some in color.
 Washington, D.C.

Monumental study of one structure at Chichen Itza.
Detailed discussion and illustration of figural reliefs and
murals.

Morss, Noel.
952 1952. Cradled infant figurines from Tennessee and Mexico.
 <u>American Antiquity</u> 18, no. 2:164-66. 2 figs.
 Stylistic and iconographic resemblances between bound
 bed figures from Tennessee and Mexico.

Moser, Christopher L.
953 1969. Matching polychrome sets from Acatlán, Puebla.
 <u>American Antiquity</u> 34, no. 4:480-83. 2 figs.
 Post-Classic slab legged tripod vessels are shown to
 occur in sets: a food preparation bowl and a serving vessel that
 functioned as a lid. Such matched sets were high-status burial
 offerings.

954 1973. <u>Human Decapitation in Ancient Mesoamerica</u>.
 Dumbarton Oaks Studies in Pre-Columbian Art and
 Archaeology, 11. 72 pp., 51 text figs., 16 plates.
 Washington, D.C.
 Iconographic, archaeological, and ethnohistoric
 evidence for the practice of ritual decapitation. The author
 posits that, at least during the Post-Classic period, the stress
 of high population density may have led to mass sacrifice.

955 1977. The head-effigies of the Mixteca Baja. <u>Katunob: A</u>
 <u>Newsletter-Bulletin on Mesoamerican Anthropology</u> 10, no.
 2:1-18. 11 figs. Greeley, Colorado: University of
 Northern Colorado.
 Discussion of "cabecitas colosales" as a key trait of
 Nuiñe culture. Author interprets these hollow heads as
 primarily depicting effigies of decapitated heads. Stylistic
 categories proposed.

956 1977. <u>Nuiñe Writing and Iconography of the Mixteca Baja</u>.
 Publications in Anthropology, no. 19. 246 pp., 76 figs.,
 76 plates. Nashville: Vanderbilt University.
 Study of the glyphic and iconographic content of stone
 sculptures and ceramic urns from the Middle Classic period in
 western Oaxaca. Includes descriptive catalog of all Nuiñe
 glyphs.

Mountjoy, Joseph B.
957 1974. <u>Some Hypotheses Regarding the Petroglyphs of West</u>
 <u>Mexico</u>. Mesoamerican Studies, 9. 36 pp., 11 figs.
 Narayit rock art from 900-1100 A.D. Spiral motif
 indicative of sacred locality.

958 1982. An interpretation of the pictographs at La Peña
 Pintada, Jalisco, Mexico. American Antiquity 47, no.
 1:110-26. 5 figs.
 Archaeoastronomical interpretations for rock art of the
 late Post-Classic.

Muser, Curt.
959 1978. Facts and Artifacts of Ancient Middle America. 212
 pp., 23 plates, and numerous text figures. New York: E. P.
 Dutton.
 Extremely useful glossary of terms, site names, and
 foreign or specialized words used in pre-Columbian archaeology
 of Middle America.

Navarrete, Carlos.
960 1976. Algunas influéncias mexicanas en el area maya
 meridional durante el posclásico tardío. Estudios de
 Cultura Nahuatl 12:345-82. 38 figs.
 Architecture, painting, pottery, sculpture, and burial
 practices of Post-Classic Maya centers (principally in the
 Guatemalan highlands) are compared to Aztec counterparts in
 order to highlight a Central Mexican influence in this period.
 Good survey of the subject.

961 1976. El complejo escultórico del Cerro Bernal, en la
 costa de Chiapas, Mexico. Anales de Antropologia 13:23-45.
 10 figs., 16 plates. Mexico: Universidad Nacional
 Autónoma de México.
 Relief sculptures from Los Horcones and related sites on
 the Chiapas coast which display iconographic motifs similar to
 those used at Teotihuacan and Xochicalco.

Navarrete, Carlos, and D. Heyden.
962 1974. La cara central de la Piedra del Sol : una hipótesis.
 Estudios de Cultura Nahuatl 11:355-76. 13 figs.
 A reinterpretation of the identity of the central head
 on the Aztec calendar stone. Authors present an argument for an
 identification as Tlaltecuhtli rather than Tonatíuh.

Neumann, Frank J.
963 1976. The rattle-stick of Xipe Totec: a shamanic element
 in pre-Hispanic Mesoamerican religion. Proceedings of the
 41st International Congress of Americanists 2:243-51. 6
 figs.
 Focus on Xipe as a shamanic deity, as evidenced by his
 many associated elements. Principal attention paid to his
 rattle-staff, a pan-American and pan-Asian shamanic implement.

Newton, Douglas, and Lee Boltin.
964 1978. The Nelson A. Rockefeller Collection: Masterpieces
 of Primitive Art. 264 pp., profusely illustrated with
 color plates. New York: Knopf.

Highlights of the Rockefeller collection at the Metropolitan Museum. Less than one-quarter of the book is devoted to Mesoamerican art, but these fine objects are illustrated in extraordinary photographs.

Neys, Horace, and Hasso von Winning.
965 1946. The treble scroll symbol in the Teotihuacan and Zapotec cultures. Notes on Middle American Archaeology and Ethnology 3, no. 74:82-89. 2 figs. Washington, D.C.: Carnegie Institution of Washington.
 Study of a tri-lobed symbol for water.

Nicholson, H. B.
966 1954. The birth of the smoking mirror. Archaeology 7, no. 3: 164-70. 13 figs.
 Iconographic examination of two fragmentary stone sculptures, which are shown to be pieces of one Aztec monument. The sculpture represents Tlaltecutli, a toadlike earth monster deity from whom the god Tezcatlipoca is being born.

967 1955. The Temalacatl of Tehuacan. El México Antiguo 8:95-134. 6 figs., 5 plates.
 The author reidentifies a so-called ballgame ring from Tehuacan as an Aztec gladiatorial stone. Discussion of Aztec and Maya celestial band symbolism.

968 1958. An Aztec monument dedicated to Tezcatlipoca. Miscellanea Paul Rivet 1:593-607. Mexico.
 Discussion of cube-shaped cult monument and its iconographic links to the lord of the smoking mirror.

969 1960. The Mesoamerican pictorial manuscripts: research, past and present. Proceedings of the 34th International Congress of Americanists. 199-215. Vienna.
 Outline of major accomplishments of past research on codices and avenues for future inquiry. Origins, spatial distribution, and stylistic types of manuscripts are briefly considered, before discussion of history of the field. Good introduction to manuscript history before 1960.

970 1960. The Mixteca-Puebla concept in Mesoamerican archaeology: a re-examination. Men and Cultures: Selected Papers from the Fifth International Congress of Anthropological and Ethnographical Sciences. Ed. Anthony F. C. Wallace. 612-17. Philadelphia. Reprinted in Ancient Mesoamerica: Selected Readings. Ed. John A. Graham. 258-63. Palo Alto, 1966. Reprinted also in Pre-Columbian Art History. Ed. Alana Cordy-Collins and Jean Stern. 113-19. Palo Alto: Peek Publications, 1977.

Important reevaluation of Vaillant's Mixteca-Puebla
concept, suggesting that it is best understood in stylistic
terms, and may qualify as a true "horizon-style."

971 1961. The use of the term "Mixtec" in Mesoamerican
 archaeology. American Antiquity 26, no. 3:431-33.
 Argues that the term "Mixteca-Puebla" is a more accurate
term than "Mixtec" for the pan-Mesoamerican art style of the
Post-Classic period.

972 1961. An outstanding Aztec sculpture of the water goddess.
 The Masterkey 35, no. 2:44-55. 14 figs.
 Identification of a fragmentary basalt figure of
Chalchihuitlicue is supported through iconographic comparisons,
especially with manuscripts from the Borgia Group.

973 1961. The Chapultepec cliff sculpture of Motecuhzoma
 Xocoyotzin. El México Antiguo 19:379-444. 18 figs., 19
 plates.
 Scholarly study of the portrait reliefs of the Tenochca
rulers, including a look at relevant early historical sources.
Careful discussion of present state of these partly destroyed
sculptures.

974 1963. An Aztec stone image of a fertility goddess.
 Baessler-Archiv 2, no. 1:9-30. Reprinted with an addendum
 in Pre-Columbian Art History. Ed. Alana Cordy-Collins and
 Jean Stern. 145-65. 31 figs. Palo Alto: Peek
 Publications, 1977.
 The fragmentary bust of a maize goddess in a private
Chicago collection is discussed in iconographic terms. It is
compared to other well-known sculptures, as well as to codex
imagery. The shifting nature of deity insignia is discussed.

975 1967. A "royal headband" of the Tlaxcalteca. Revista
 Mexicana de Estudios Antropológicos 21:71-106. 24 figs., 1
 table. Mexico.
 Twisted red and white headband as high-ranking insignia
of the Tlaxcala people. Evidence sought in codices and
ethnohistoric manuscripts.

976 1971. Major sculpture in pre-Hispanic Central Mexico.
 Handbook of Middle American Indians 10. Ed. Gordon F.
 Ekholm and Ignacio Bernal. 92-134. 65 figs. Austin:
 University of Texas Press.
 Important survey from Pre-Classic to Aztec times.

977 1971. The religious-ritual system of late pre-Hispanic
 Central Mexico. Proceedings of the 38th International
 Congress of Americanists 3:223-38. Stuttgart-Munich.

An extremely useful introduction to cosmology, cosmogony, deities, and cult themes of Aztec religion. Digest of later Handbook of Middle American Indians article (Volume 10, 1971).

978 1973. The late pre-Hispanic Central Mexican (Aztec) iconographic system. The Iconography of Middle American Sculpture. 72-97. 15 figs. New York: The Metropolitan Museum of Art.
 Important survey article on Aztec religious imagery and its iconographic variations.

979 1976. Preclassic Mesoamerican iconography from the perspective of the Postclassic: problems in interpretational analysis. Origins of Religious Art and Iconography in Pre-Classic Mesoamerica. Ed. H. B. Nicholson. 159-75. 27 figs. Los Angeles.
 Evaluation of the validity of the direct historical approach ("upstreaming") in pre-Columbian iconographic studies, by means of a number of examples of the apparent continuity of certain deities. Review of some previous literature on the theme of the survival and disjunction of symbols. Important theoretical article.

980 1978. The Deity 9 Wind "Ehecatl-Quetzalcoatl" in the Mixteca pictorials. Journal of Latin American Lore 4, no. 1:61-92. 11 figs. Los Angeles: UCLA.
 Summary of information in various Mixtec codices relevant to this deity. Author suggests numerous similarities between the deity's role in Mixtec and in Toltec civilization.

981 1982. The Mixteca-Puebla concept revisited. The Art and Iconography of Late Post-Classic Central Mexico. Ed. Elizabeth Boone. 227-54. Washington, D.C.: Dumbarton Oaks.
 An update on his 1960 article.

982 1983. Art of Aztec Mexico: Treasures of Tenochtitlan. 188 pp., 86 figs., some in color. Washington, D.C.: National Gallery of Art.
 Catalogue of a major exhibit of Aztec art. Informative entries and essays make it an extremely useful source.

Nicholson, H. B. (ed.).
983 1976. Origins of Religious Art and Iconography in Preclassic Mesoamerica. 181 pp. Los Angeles: UCLA Latin American Center Publications.
 Important conference volume containing eight papers on Olmec, Izapan, Maya, Zapotec, and early Teotihuacan art and iconography, all of which are annotated here. Significant theoretical paper by Nicholson concludes the volume.

Nicholson, H. B., et al.
984 1971. Ancient Art of Veracruz. 92 pp., 150 figs. Los
 Angeles County Museum of Natural History.
 Catalog principally of ceramic art of Veracruz. Brief
 essays by Nicholson, Franco, McBride, von Winning, Heyden, and
 Belt augment the catalog listings.

Nicholson, H.B., and Rainer Berger.
985 1968. Two Aztec Wood Idols: Iconographic and Chronologic
 Analysis. Dumbarton Oaks Studies in Pre-Columbian Art and
 Archaeology, 5. 28 pp., 26 figs. Washington, D.C.
 Female figure of Chalchiuhtlicue in the St. Louis Art
 Museum and male figure in the Leff collection are discussed.
 Figures, radiocarbon dated to the fourteenth century, were
 reportedly found together and may have been carved by the same
 artist.

Nicholson, H.B., and Alana Cordy-Collins.
986 1979. Pre-Columbian Art from the Land Collection. 272
 pp., 218 plates, some in color. San Francisco: California
 Academy of Sciences.
 Profusely illustrated scholarly catalog of one private
 collection. Covers both Middle and South America.

Noel, Bernard.
987 1968. Teotihuacan-Tajin-Monte Alban. 36 pp., 24 figs.
 New York: Tudor Publishing Company.
 Pocket-sized picturebook of the art of these three cul-
 tures. Brief text.

988 1968. Toltecs-Aztecs. 36 pp., 24 figs. New York: Tudor
 Publishing Company.
 Pocket-sized picturebook with extremely brief text.

Noguera, Eduardo.
989 1930. Decorative aspects of certain types of Mexican
 pottery. Proceedings of the 23rd International Congress of
 Americanists. 85-92. New York.
 Classification of pottery designs from various areas of
 Mesoamerica into anthropomorphic, zoomorphic, phytomorphic,
 skeuomorphic, and geometrical categories.

990 1955. Extraordinario hallazgo en Teotihuacan. El México
 Antiguo 8:43-55. 14 figs.
 Burial with marine shells, numerous cylindrical tripods,
 and other fine pottery is described.

991 1967. Representaciones zoomorfas en el arte prehispánico.
 Revista Mexicana de Estudios Antropológicos 21:191-212. 12
 figs.

Wide-ranging but general remarks on animal effigies in Mesoamerican art, principally small-scale ceramic figures.

992 1968. Sports et jeux dans l'art Pre-Columbien du Mexique.
78 black-and-white figs., 1 map, 1 table. Paris: Musée Cernuschi.
Catalog of an exhibit of ballgame players and other "sporting" figures in pre-Columbian art. Predominantly small-scale ceramic objects from all regions.

993 1971. Minor arts in the central valleys. Handbook of Middle American Indians 10. Ed. Gordon F. Ekholm and Ignacio Bernal. 258-69. Austin: University of Texas Press.
Brief survey of mosaic, featherwork, woodwork, and metallurgy. No illustrations.

Norman, V. Garth.
994 1973-76. Izapa Sculpture. 2 vols. Papers of the New World Archaeological Foundation, 30. Vol. 1: 3 pp. 64 plates. Vol. 2: 360 pp., 245 figs. Provo: Brigham Young University.
Detailed discussion and illustration of stone sculpture, its style and iconography at this Late Pre-Classic Pacific coast site.

Nottebohm, Karl-Heinz.
995 1945. A second Tlaloc gold plaque from Guatemala. Notes on Middle American Archaeology and Ethnology 2, no. 51:170-72. 1 fig. Washington, D.C.: Carnegie Institution of Washington.
Repoussé design of Tlaloc on a gold plaque of unknown provenience.

Nowotny, Karl Anton.
996 1948. Erlauterungen zum Codex Vindobonensis (vorderseite). Archiv für Völkerkunde 3:156-200. Vienna.
Obverse of Codex Vienna is described and analyzed.

997 1949. A unique wooden figure from ancient Mexico. American Antiquity 15, no. 1:57-61. 3 figs.
Stylistic and x-ray analysis of a crouching wooden figure in the Vienna Museum für Völkerkunde. Unusual technical features include gold and silver nails, use of wooden pegs, and inlays. Author suggests it represents Xolotl.

998 1957. Der Codex Becker II. Archiv für Völkerkunde 12:172-81. 4 figs. Vienna.
Commentary on Mixtec Codex. Same commentary appears with facsimile in Nowotny 1961.

999 1959. Die Bilderfolge des Codex Vindobonensis und
 verwandter Handschriften. Archiv für Völkerkunde 13:210-
 21. Vienna.
 Ritual scenes in Codex Vienna compared with other manu-
 scripts.

1000 1959. Die Hieroglyphen des Codex Mendoza. Der Bau einer
 mittelamerikanischen Wortschrift. Mitteilungen aus dem
 Museum für Völkerkunde in Hamburg 25:97-113. Hamburg.
 Detailed analysis of toponyms in an Aztec codex.

1001 1961. Codices Becker I/II. Kommentar und Beschreibung.
 28 pp., 4 figs., separate facsimiles of the two
 manuscripts: 16 pp., 4 pp. Graz, Austria: Akademische
 Druck-u. Verlagsanstalt.
 Photo facsimiles of two manuscripts, accompanied by com-
 mentary.

1002 1961. Tlacuilolli: Die mexikanischen Bilderhandschriften
 Stil und Inhalt. Monumenta Americana, 3. 287 pp., 67
 black-and-white plates. Berlin.
 Explication of Mexican codices. Lots of iconographic
 and calendric identification. Identification charts of 67
 different pages of different codices.

1003 1968. Codex Cospi. Calendario messicano 4093. 31 pp. and
 separate screenfold facsimile. Graz, Austria: Akademische
 Druck-u. Verlagsanstalt.
 Photo facsimile of manuscript. Commentary in German
 with English summary.

Nowotny, Karl, and Robert Strebinger.
1004 1958. Der Codex Becker I (Le manuscrit du cacique). Archiv
 für Völkerkunde 13:222-26. Vienna.
 Material and physical properties of codex and technical
 analysis of paint pigments.

Nuñez y Domínguez, José.
1005 1942. La colección de objetos mexicanos antiguos del
 "Museo del Hombre" de Paris. Revista Mexicana de Estudios
 Antropológicos 6, nos. 1-2:5-18. 21 figs.
 Illustration and discussion of some small-scale ceramic
 and stone objects in the Musée de L'Homme in Paris.

Nuttall, Zelia.
1006 1886. Preliminary note of an analysis of the Mexican
 codices and graven inscriptions. Science 8, no. 195:393-
 95.
 Brief but important early announcement of the author's
 findings concerning phonetic glyphs and historical records in
 the codices.

1007 1892. On ancient Mexican shields. <u>Internationales Archiv</u> <u>für Ethnographie</u> 5:34-53. 3 figs. Leiden.
 Important early article on Aztec war shields and ceremonial shields. Thorough discussion of their use, meaning and structure, using sixteenth-century eye-witness descriptions, representations in codices, and analysis of several extant specimens in Mexico and Europe.

1008 1901. Chalchihuitl in ancient Mexico. <u>American</u> <u>Anthropologist</u> n.s. 3:227-38. 4 figs.
 Early study of ethnohistoric references to jade, particularly in the Tribute Roll of Montezuma.

Offner, Jerome A.
1009 1982. Aztec legal process: the case of Texcoco. <u>The Art</u> <u>and Iconography of Late Post-Classic Central Mexico</u>. Ed. Elizabeth Boone. 141-57. 9 figs. Washington, D.C.: Dumbarton Oaks.
 Principles from the comparative anthropology of law used to understand the Aztec legal system. Pictorial evidence from the Mapa Quinatzin used as evidence for Aztec legal practices.

O'Neale, Lila M.
1010 1942. Early textiles from Chiapas, Mexico. <u>Middle</u> <u>American Research Records</u> 1, no. 1:1-6. 3 plates. New Orleans: Tulane University.
 Technical analysis of pre-Hispanic textile fragments from Cieneguilla cave.

1011 1948. Textiles of pre-Columbian Chihuahua. <u>Contributions</u> <u>to American Anthropology and History</u> 9, no. 45:94-161. 30 figs., 8 tables. Washington, D.C.: Carnegie Institution of Washington.
 Detailed analytical study of some 30 specimens of unknown provenience at the University of California at Berkeley. Technique, material, and dyes are considered.

Oppel, A.
1012 1896. Die altmexikanischen Mosaiken. <u>Globus</u> 70:4-13. 15 figs.
 Precise description and analysis of twenty-two mosaic objects from European collections, many of them, like the stone knife with figure mosaic handle in the British Museum, among the best known of ancient Mexican mosaics.

Orellana T., Rafael.
1013 1953. Petroglifos y pinturas rupestres de Sonora. <u>Yan</u> 1: 29-33. 6 figs.
 Introductory report on petroglyph types with hand drawn figures.

Outwater, J. Ogden.
1014 1957. Pre-Columbian stonecutting techniques of the Mexican
 plateau. American Antiquity 22:258-64.
 Comments by a mechanical engineer on time, labor, and
 construction techniques used in stonecutting. Malinalco,
 Xochicalco, and Mitla are discussed in detail.

Paddock, John.
1015 1966. Ancient Oaxaca: Discoveries in Mexican Archaeology
 and History. 416 pp. Stanford: Stanford University
 Press.
 Important survey of Oaxacan archaeology and
 ethnohistory. Contributions by Chadwick, Leigh, Robertson,
 Caso, and Wicke annotated here.

1016 1970. More Nuiñe materials. Boletín de Estudios
 Oaxaqueños 28:2-12. 35 figs.
 Brief discussion of figural ceramics and stone monuments
 from the Mixteca Baja.

1017 1982. Mixteca-Puebla style in the Valley of Oaxaca.
 Aspects of the Mixteca-Puebla Style and Mixtec and Central
 Mexican Culture in Southern Mesoamerica. 3-6. Middle
 American Research Institute Occasional Paper no. 4. New
 Orleans: Tulane University.
 Proposes the Valley of Oaxaca as one of the principle
 centers of Mixteca-Peubla style. Brief.

Pahl, Gary.
1018 1975. The iconography of an engraved Olmec figurine. The
 Masterkey 49, no. 3:85-93. 4 figs. Reprinted in Pre-
 Columbian Art History. Ed. Alana Cordy-Collins and Jean
 Stern. 35-42. 4 figs. Palo Alto: Peek Publications,
 1977.
 A nude male figurine, its restoration, and its original
 engraved design are the subject of this brief essay. The
 engraving depicts a seated figure, hand-held implements, and a
 saurian motif.

1019 1982. A possible Cycle 7 monument from Polol, El Petén,
 Guatemala. Pre-Columbian Art History: Selected Readings.
 Second edition. Ed. A. Cordy-Collins. 23-31. 4 figs.
 Palo Alto: Peek Publications.
 Reevaluation of an early Maya altar from the site of
 Polol. Stylistic and epigraphic evidence considered. An
 important monument in the controversy about the genesis and
 spread of Maya writing.

Palacios, Enrique Juan.
1020 1922. Páginas de la historia de Mexico: La Piedra del
 calendario mexicano. Su simbolismo. unpaginated, 36 figs.
 Mexico.

Early essay on the iconography of one Aztec monument, the so-called Calendar Stone.

1021 1934. La orientación de la pirámide de Tenayuca. Pro-
ceedings of the 25th International Congress of Americanists
2:125-48. 3 figs. Buenos Aires.
Along with Marquina and Ruiz article in the same volume,
another early look at astronomical orientations of structures.
Technical discussion of calendrical matters.

1022 1940. El simbolismo del Chacmool, su interpretación.
Revista Mexicana de Estudios Antropológicos 4:43-56. 4
figs. Mexico.
Brief study of reclining Chac Mool figures and summary
of previous authors' thoughts on them.

Palm, Erwin Walter.
1023 1968. Observaciones sobre el plano de Tenochtitlan.
Proceedings of the 37th International Congress of
Americanists 1:127-32. 3 figs. Buenos Aires.
Maps of Tejupan (Oaxaca), Tecamachaco (Puebla), and
Tenochtitlan compared.

Pang, Hilda.
1024 1975. Archaeological textiles from Chametla, Sinaloa.
Proceedings of the 41st International Congress of
Americanists 1:301-31. 20 figs. Mexico.
Analysis of weaving techniques used in cotton textiles
discovered in a Post-Classic urn burial. Useful discussion of
ethnographic distribution of gauze weaving.

Papa, Sebastiana.
1025 1974. Vita degli Aztechi nel Codice Mendoza. 133 pp., 40
color plates, numerous small black-and-white
illustrations. Milan, Italy: Garzante Editore.
Aztec life as seen in the pages of the Codex Mendoza.
Running commentary on the images. Fine color illustrations.

Paradis, Louise I.
1026 1978. Early dates for Olmec-related artifacts in Guerrero,
Mexico. Journal of Field Archaeology 5:110-16. 5 figs.
Recent archaeological discoveries in the Middle Balsas
River Basin lend support to the hypothesis that Guerrero is the
source of the Olmec art style. Two ceramic figurines in Olmec
style are firmly dated before 1220 B.C.

Parmenter, Ross.
1027 1961. Twentieth-Century Adventures of a Sixteenth-Century
Sheet: The Literature of the Mixtec Lienzo in the Royal
Ontario Museum. Boletín de Estudios Oaxaqueños, 20. 13
pp. Oaxaca.

Lienzo Antonio de León, its history and provenience.

1028 1982. Four Lienzos of the Coixtlahuaca Valley. Dumbarton
Oaks Studies in Pre-Columbian Art and Archaeology, 26. 81
pp., 3 plates, 44 figs. Washington, D.C.
Study of four pictorial manuscripts from Oaxaca, their
discoveries, provenience, and meaning.

Parsons, J. R.
1029 1970. An archaeological evaluation of the Codice Xolotl.
American Antiquity 35:431-40. 10 figs.
Based on recent settlement pattern surveys in Central
Mexico, the author suggests that certain historical data in this
Aztec codex are accurate, others are temporally incorrect. See
Calnek 1973 for opposing viewpoint.

Parsons, Lee A.
1030 1967. An early Maya stela on the Pacific coast of
Guatemala. Estudios de Cultura Maya 6:171-98. 9 figs.
Monument 42 from Bilbao illustrated and discussed. Use-
ful comparative data from elsewhere in the peripheral coastal
lowlands examined as well. Author demonstrates that the
monument dates from the Early Proto-Classic period.

1031 1969. Bilbao, Guatemala, Vol. II. 274 pp., 66 plates, 16
figs. Milwaukee: Milwaukee Public Museum.
Second volume of a field report, important principally
for its ground-breaking chapter, "The Cotzumalhuapa Region and
the Middle American Co-Tradition," wherein the author puts forth
his ideas on a Middle Classic horizon in Mesoamerica based
principally on the diffusion of art styles.

1032 1969. The Pacific coast Cotzumalhuapa region and Middle
American culture history. Proceedings of the 38th
International Congress of Americanists 1:197-201. 2
figs. Munich.
Illustrates monuments 18 and 38 at Bilbao. Discusses
Teotihuacan traits in the Cotzumalhuapa art style.

1033 1973. Iconographic notes on a new Izapan stela from Abaj
Takalik, Guatemala. Proceedings of the 40th International
Congress of Americanists 1:203-12. 4 figs. Rome.
Stela 4 at this Pacific coast site is illustrated and
analyzed. Early Proto-Classic date, and "proto-Maya"
iconography revealed.

1034 1974. Pre-Columbian America: The Art and Archaeology of
South, Central, and Middle America. 193 pp., 201 figs.
Milwaukee: Milwaukee Public Museum.
Handbook for the museum's collection also serves as an
introduction to the field. Strongest in Middle American
materials.

1035 1975. A pseudo pre-Columbian colossal stone head on the Pacific coast of Guatemala. Proceedings of the 41st International Congress of Americanists 1:519-21. 2 figs. Mexico.
The history of an unusual pumice sculpture of recent origin that may be mistaken for an ancient monument.

1036 1980. Pre-Columbian Art: The Morton D. May and the St. Louis Art Museum Collections. 320 pp., 468 figs., some in color. New York: Harper and Row.
Useful and up-to-date survey of pre-Columbian art and culture, illustrated by examples from the permanent collection of the St. Louis Art Museum. Covers Middle and South America. In-depth text plus catalog entries on each of 468 objects.

1037 1981. Post-Olmec stone sculpture: the Olmec-Izapan transition on the Southern Pacific Coast and highlands. The Olmec and their Neighbors. Ed. Elizabeth Benson. 257-88. 44 figs. Washington, D.C.: Dumbarton Oaks.
A selection of forty-four representative examples of sculpture dating from 500-200 B.C. is examined. Four Pre-Classic stone sculpture divisions are suggested and four widely distributed substyles are suggested for the last, post-Olmec period.

1038 1983. Altars 9 and 10, Kaminaljuyu, and the evolution of the Serpent-Wing Deity. Civilization in the Ancient Americas: Essays in Honor of Gordon R. Willey. Ed. R. Leventhal and A. Kolata. 145-56. 3 figs. Albuquerque: University of New Mexico Press.
Study of two cylindrical tetrapod stone monuments as early examples of Maya serpent-bird icon.

Parsons, Lee A., and Peter Jenson.
1039 1965. Boulder sculpture on the Pacific coast of Guatemala. Archaeology 18, no. 2:132-44. 20 figs.
Monte Alto heads and pot-belly sculpture and their relationship to other Pre-Classic monuments.

Paso y Troncoso, Francisco del.
1040 1912. Codice Kingsborough. unpaginated. Madrid: Fototipia de Hauser y Menet.
Black-and-white facsimile of postconquest Codex Kingsborough.

1041 1913. Escritura pictória. Códice Kingsborough, lo que nos enseña. Proceedings of the 18th International Congress of Americanists 2:455-60. 1 plate. London.
Description of Codex Kingsborough.

Pasztory, Esther.
1042 1972. The historical and religious significance of the Middle Classic ball game. <u>XII Mesa Redonda</u>. 441-55. Mexico: Sociedad Mexicana de Antropología.
 Ballgame and its associated cult spread by merchants, reaching its apogee from 450-700 A.D. Aim of the cult was the rejuvenation of agricultural fertility.

1043 1973. The gods of Teotihuacan: a synthetic approach in Teotihuacan iconography. <u>Proceedings of the 40th International Congress of Americanists</u> 1:147-59. Rome. Reprinted in <u>Pre-Columbian Art History</u>. Ed. Alana Cordy-Collins and Jean Stern. 81-95. 16 figs. Palo Alto, 1977.
 Identification of several Post-Classic deities in the art of Teotihuacan. Important discussion of methodology in iconographic research.

1044 1974. <u>The Iconography of the Teotihuacan Tlaloc</u>. Dumbarton Oaks Studies in Pre-Columbian Art and Archaeology, 15. Washington, D.C. 22 pp., 23 figs.
 Elucidation of the multiple yet related meanings of so-called Tlaloc images at Teotihuacan. Division of true rain-god images into two distinct sub-types: a jaguar-Tlaloc and a crocodile-Tlaloc.

1045 1976. <u>Aztec Stone Sculpture</u>. Unpaginated, 27 figs. New York: The Center for Inter-American Relations.
 Catalog of an exhibit of Aztec sculpture selected from the collection of five New York museums. Brief introductory essay and individual catalog entries.

1046 1976. <u>The Murals of Tepantitla, Teotihuacan</u>. 392 pp., 130 figs. New York: Garland Publishing.
 Publication of the author's 1972 doctoral dissertation at Columbia University. In-depth look at the iconographic program in one structure at Teotihuacan.

1047 1976. The Xochicalco stelae and a Middle Classic deity triad in Mesoamerica. <u>Proceedings of the 23rd International Congress of the History of Art</u> 1:185-215. 22 figs. Granada.
 A deity triad dealing with death and rebirth of the sun and maize in the yearly agricultural cycle are shown to occur not only at Xochicalco but at Palenque, El Tajin, and Bilbao. This is seen as indicative of the eclecticism and cosmopolitanism of the Middle Classic Period.

1048 1979. Masterpieces in Pre-Columbian Art. <u>Proceedings of the 42nd International Congress of Americanists</u> 7:377-90. 5 figs. Paris.

Author exhorts scholars to look anew at an "old-fashioned" issue: the question of artistic quality. Using Aztec art as an example, she demonstrates that an examination of "masterpieces" can aid understanding of such culture-specific traits as the nature of artistic limits, innovation, and social status.

1049 1982. Three Aztec masks of the god Xipe. Falsifications and Misreconstructions of Pre-Columbian Art. Ed. Elizabeth Boone. 77-105. 21 figs. Washington, D.C.: Dumbarton Oaks.
 Xipe-Totec masks in the British Museum and Musée de L'Homme shown to have anomalous iconographic features. Author suggests they may be nineteenth-century fakes.

1050 1983. Aztec Art. 335 pp., 319 plates, many in color. New York: Harry N. Abrams, Inc.
 Outstanding survey of Aztec art, including so-called "minor arts." Profuse illustrations and scholarly text make it an important contribution to the field.

Pasztory, Esther (ed.).
1051 1978. Middle Classic Mesoamerica: AD 400-700. 190 pp. New York: Columbia University Press.
 Important collection of essays examining interrelationships of Mesoamerican cultures during one time period. The editor provides a synthetic view of issues in two essays, "Historical Synthesis of the Middle Classic Period," and "Artistic Traditions of the Middle Classic Period." Contributions that deal most directly with art, by Miller, Hellmuth, Cohodas, Holien and Pickering, and Sharp are annotated here.

Paul, Anne.
1052 1976. History on a Maya vase? Archaeology 29, no. 2:118-26. 10 figs.
 Late Classic Maya polychrome vase in the Art Institute of Chicago is discussed. The scene of arraignment is similar to that found in Bonampak murals, and the author argues for history as well as myth on Maya ceramics.

Pavon Abreu, Raul.
1053 1962. Bonampak en la escultura. unpaginated. Mexico: Instituto Nacional de Antropología e Historia.
 Picturebook of black-and-white photos of details of Bonampak stelae. Slightly grainy photos, but still useful.

Payne, W. O.
1054 1970. A potter's analysis of the pottery from Lambityeco Tomb 1. Boletín de Estudios Oaxaqueños, no. 29.
 A potter reconstructs ancient procedures in ceramic manufacture.

184

Pendergast, David M.
1055 1966. The Actun Balam vase. Archaeology 19, no. 3:154-61.
 8 figs.
 Maya polychrome vessel with scene of deer hunt
 discovered in a cave in Belize. Unusual tapered vessel form and
 clothing.

1056 1968. Four Maya pottery vessels from British Honduras.
 American Antiquity 33:379-82. 6 figs.
 Vessels from Pre-Classic to Late Classic date are com-
 pared with specimens known from Tikal and elsewhere in Maya
 area. Two have figural painting of Late Classic Maya type. One
 polychrome vessel is of interest because of its apparent
 depiction of a priestess sacrificing a bound victim.

1057 1969. An inscribed jade plaque from Altun Ha. Archaeology
 22, no. 2:85-92. 6 figs.
 Jade pendant found in a seventh-century burial at this
 Maya site in Belize discussed in terms of style, iconography,
 and glyphic inscription. Date of 584 A.D. is suggested.

Peterson, Fredrick A.
1058 1951. Stone masks of Mexico. Illinois State
 Archaeological Society 1:4.
 Presents a series of false masks.

1059 1952. Falsificaciones arqueológicas en el estado de
 Guerrero, México. Tlàtoani 1, no. 3-4:15-19. 12 figs.
 Use of stylistic analysis to determine inauthentic stone
 objects. Brief discussion of "fake" workshops in Tasco, Iguala
 and Teloloapan, Guerrero.

1060 1953. Faces that are really false. Natural History 62
 (April):176-80. 6 figs.
 Report of falsified jade masks, plagues, and statuette
 made in Guerrero. Discussion of the means by which forgers make
 the works look aged.

1061 1953. Falsificaciones de Chupícuaro. Yan 2:150-56. 11
 black-and-white photos.
 Comparison of genuine Chupicuaro figurines, pipes, and
 other ceremonial objects with those of a recent fake factory.

1062 1954. Smiling heads from Veracruz. Ethnos 19:80-93. 12
 figs. Stockholm.
 Comparative study of the various types of smiling
 ceramic figurines based on private collections and Mexican
 excavations.

1063 1955. "Doughnut-shaped" vessels and bird bowls of
 Chupicuaro, Mexico. Ethnos 20, nos. 2-3:137-45. 13 figs.
 Stockholm.

Five rare Pre-Classic circular effigy containers and
several zoomorphic effigy containers are discussed.

1064 1956. Anthropomorphic effigy vessel from Chupicuaro,
Mexico. Ethnos 21, nos. 3-4:161-179. 5 figs. Stockholm.
Brief typology of human effigy vessels from one Pre-
Classic style area.

Pickands, Martin.
1065 1980. The "first father" legend in Maya mythology and
iconography. Third Palenque Round Table, 1978. Part 2.
Ed. M. G. Robertson. 124-37. 2 figs. Austin:
University of Texas Press.
Primordial male ancestor in Maya codices and vase
painting.

Pijoan, José.
1066 1946. Historia del arte precolombino. Summa Artis, 10.
610 pp., 926 figs., 23 plates. Madrid: Espasa-Calpe, S. A.
Important early survey volume of Mesoamerican art.
Still useful. Profusely illustrated.

Piña Chan, Román.
1067 1960. Algunos sitios arqueológicos de Oaxaca y Guerrero.
Revista Mexicana de Estudios Antropológicos 16:65-76. 18
figs.
Listing of some relatively little-known sites in these
two states. Useful for illustrations of previously little-known
stone sculptures.

1068 1968. Jaina: La casa en el agua. 137 pp., 77 figs., 22
plates. Mexico: Instituto Nacional de Antropología e
Historia.
Archaeological study of Jaina Island, focusing princi-
pally on its ceramic figurines.

1069 1971. Pre-Classic or Formative pottery and minor arts of
the Valley of Mexico. Handbook of Middle American Indians
10. Ed. Gordon F. Ekholm and Ignacio Bernal. 157-78. 21
figs., 2 charts. Austin: University of Texas Press.
Survey of the literature on figurines and other pottery.

Piña Chan, Román, and Luis Covarrubias.
1070 1964. El pueblo del Jaguar. 68 pp., 34 plates, 62 figs.
Mexico: Museo Nacional de Antropología.
Survey of Olmec art and culture published in conjunction
with the opening of the Olmec hall in Mexico's National Museum.
Drawings by Miguel Covarrubias.

Pirazzini, Robert Thomas.
1071 1982. The cult of death at El Zapotal, Veracruz. Pre-
 Columbian Art History: Selected Readings. Second edition.
 Ed. A. Cordy-Collins. 101-8. 7 figs. Palo Alto: Peek
 Publications.
 Brief discussion of large-scale ceramic Cihuateteo
 figures found in situ at the site of El Zapotal, a Classic period
 Gulf coast center. Comment on the paucity of controlled
 excavation in this area and plea for more research.

Pleasants, Frederick R.
1072 1940. Pre-Columbian art at the Fogg. Magazine of Art 33,
 no. 2:84-91. 9 figs.
 Review of exhibit of sculpture at Harvard's Fogg Museum.
 Fine quality illustrations of several important pieces.

Pohl, Mary.
1073 1981. Ritual continuity and transformation in Mesoamerica:
 reconstructing the ancient Maya cuch ritual. American
 Antiquity 46, no. 1:513-29. 6 figs.
 Polychrome pottery, incised bones, and Maya codices used
 in conjunction with ethnography and ethnohistory to illuminate
 fertility and accession ceremonies. Deer iconography in
 particular is considered.

Pohorilenko, Anatole.
1074 1975. New elements of Olmec iconography: ceremonial
 markings. XIII Mesa Redonda, Sociedad Mexicana de
 Antropología. 265-81. 11 figs. Xalapa, Mexico.
 Striations and cuppings on colossal heads and other
 sculptures are discussed as deliberate ceremonial marks rather
 than mutilations.

1075 1977. On the question of Olmec deities. Journal of New
 World Archaeology 2, no. 1:1-16. 8 figs.
 Disagreement with the methodological premises of
 Joralemon's classifications of Olmec gods. A thought-provoking
 essay.

1076 1981. The Olmec style and Costa Rican archaeology. The
 Olmec and Their Neighbors. Ed. Elizabeth Benson. 309-27.
 11 figs. Washington, D.C.: Dumbarton Oaks.
 Systematic analysis of Olmec-related objects from Costa
 Rica suggests a late temporal placement of their objects, and a
 stylistic affinity with other provincial rather than
 metropolitan Olmec works.

Pollock, H. E. D.
1077 1936. Round Structures of Aboriginal Middle America.
 Carnegie Institution of Washington Publication no. 471.

182 pp., 44 figs. Washington, D.C.: Carnegie Institution of Washington.
 A comparative analysis of this unusual architectural form, using both ethnohistoric and archaeological data. A very useful survey.

1078 1940. Sources and methods in the study of Maya architecture. The Maya and Their Neighbors. Ed. Clarence L. Hay, et al. 179-201. D. Appleton-Century Company. Reprint. New York: Dover Publications, 1977.
 Useful but brief discussion of commentaries on Maya architecture from the sixteenth century to 1940.

1079 1965. Architecture of the Maya Lowlands. Handbook of Middle American Indians 2. Ed. Gordon R. Willey. 378-440. 48 figs. Austin: University of Texas Press.
 Survey considers major trends in site planning, technical achievements, formal types, and style.

1080 1970. Architectural notes on some Chenes ruins. Peabody Museum Papers 61:1-87. 107 figs. Cambridge: Harvard University.
 Building plans and photos of facade sculpture at numerous northern Maya sites, including Hocob, El Tabasqueño, Dzibilnocac, Nohcacab, and seven other sites.

Porter de Moedano, Muriel, and Elma Estrada Balmori.
1081 1945. Estudio preliminar de la ceramica de Chupicuaro, Guanajuato. Revista Mexicana de Estudios Antropológicos 7:89-112. 33 figs.
 Stratigraphic placement of this Pre-Classic pottery tradition and numerous photos of ceramic types.

Potter, David F.
1082 1976. Prehispanic architecture and sculpture in central Yucatán. American Antiquity 41, no. 4:430-48. 13 figs.
 Architecture and sculpture in Rio Bec and Chenes styles seen as a unified phenomenon marking the first phase of the Florescent period in the Yucatan (coeval with Late Classic in Peten). Important article on some little-known sites like Becan and Chicanna. Important article for reevaluation of this region.

1083 1977. Maya Architecture of the Central Yucatan Peninsula, Mexico. Middle American Research Institute Publications, 44. 119 pp., 79 figs., 2 tables. New Orleans: Tulane University.
 Survey of architectural sites and styles in the Rio Bec and Chenes regions. Author unites these two substyles into one "Central Yucatan style." Becan and Chicanna discussed in most depth.

Powell, Jane P.
1084 1959. Ancient Art of the Americas. 68 pp., 37 plates. New
 York: The Brooklyn Museum.
 Introduction to ancient arts of the western hemisphere.
 Fifteen of the illustrations are Mesoamerican. Many of them are
 important objects. Almost half the book is devoted to general
 discussion of Mesoamerica.

Pre-Columbian Sculpture.
1085 1956. Unpaginated, 49 figs. La Jolla Art Center.
 Catalog of exhibit, principally of Mesoamerican pieces.
 A few from lower Central America. Little text.

Prem, Hans.
1086 1969. Die Mapa Monclova--eine unveröffentlichte Kopie des
 Codex Boturini. Tribus 18:135-38. 1 fig. Linden-Museum
 für Völkerkunde.
 Based on chemical analysis, an assessment of the
 "Monclova Map" as a nineteenth-century falsified manuscript.

Proskouriakoff, Tatiana.
1087 1944. An inscription on a jade probably carved at Piedras
 Negras. Notes on Middle American Archaeology and Ethnology
 2, no. 47:142-47. 1 fig. Washington, D.C.: Carnegie
 Institution of Washington.
 It is demonstrated through glyphic evidence that a jade
 head with an incised glyphic inscription found in the cenote at
 Chichen Itza came from Piedras Negras and was carved circa 700
 A.D. The evidence argues for long-distance trade of valued
 heirlooms.

1088 1946. An Album of Maya Architecture. 142 pp. Washington
 D.C.: Carnegie Institution of Washington. Reprint.
 Norman: University of Oklahoma Press, 1963.
 Architectural reconstruction of buildings at Uaxactun,
 Tikal, Palenque, Piedras Negras, Copan, Xpujil, Sayil, Labná,
 Kabah, Uxmal, and Chichen Itza.

1089 1950. A Study of Classic Maya Sculpture. Carnegie
 Institution of Washington Publication no. 593. 209 pp.,
 110 figs. Washington, D.C.: Carnegie Institution of
 Washington.
 Important study of Maya figural sculpture and its
 changes through time. Valuable for its many charts of
 individual costume traits and for its many plates of
 infrequently published Maya sculpture from lesser sites.

1090 1951. Some non-Classic traits in the sculpture of Yucatan.
 Selected Papers of the 29th International Congress of
 Americanists. 108-18. 6 figs.

Important article drawing attention to pre-Toltec
costume and figural styles in the Yucatan that do not share in
the Classic Maya lowland tradition. Suggests that outside
influences in the Yucatan were not confined to one period or one
source.

1091 1953. Scroll patterns (entrelaces) of Veracruz. Revista
Mexicana de Estudios Antropológicos 13, no. 2-3:389-401. 9
figs.
 The author suggests the term "Classic Veracruz style"
for the sculptural tradition that had heretofore been called
Totonac or Tajin. Scroll styles on stone yokes, palmas, and
hachas are differentiated with yoke styles subdivided into
several distinct varieties.

1092 1958. Studies on Middle American art. Social Science
Monographs 5:29-35. Washington, D.C.: Pan American Union.
Reprinted in Anthropology and Art. Ed. C. M. Otten. 1971.
129-40. Garden City, New York: The Natural History Press.
 Historiographic remarks and comments on the need for
certain types of research in the future.

1093 1960. Varieties of Classic Central Veracruz sculpture.
Contributions to American Anthropology and History 12, no.
58:61-94. 13 figs. Washington, D.C.: Carnegie Institu-
tion of Washington.
 First detailed stylistic study of Gulf coast sculptural
art. Yokes, hachas, palmas, and monumental sculpture are
considered an important contribution.

1094 1961. Portraits of women in Maya art. Essays in Pre-
Columbian Art and Archaeology. Ed. S. K. Lothrop, et al.
81-99. 10 figs. Cambridge: Harvard University Press.
 Costume and attributes of female figures in Classic Maya
sculpture and clay figurines. Discussion of glyphic material
pertaining to women. Groundbreaking essay; one of the author's
early articles that suggested a historic approach to Maya
monumental art.

1095 1961. The lords of the Maya realm. Expedition 4, no. 1:
14-21. Reprinted in Ancient Mesoamerica: Selected
Readings. Ed. John A. Graham. 168-75. 9 figs. Palo Alto,
1966.
 Important article, easily understood by nonspecialists,
explaining Proskouriakoff's "dynastic hypothesis" about the
subject matter of Maya stelae.

1096 1964. El arte maya y el model genético de cultura.
Desarrollo Cultural de los Mayas. Ed. E. Z. Vogt and A.
Ruz. 187-202. Mexico: Universidad Nacional Autónoma de
México.

Some thoughts on the origin and development of the Maya art style from the Late Pre-Classic to the Post Classic. General remarks, but worthwhile.

1097 1965. Sculpture and major arts of the Maya Lowlands. Handbook of Middle American Indians 2. Ed. Gordon R. Willey. 469-97. 16 figs. Austin: University of Texas Press.
Chronological review of sculptural style.

1098 1968. Olmec and Maya art: problems of their stylistic relation. Dumbarton Oaks Conference on the Olmec. Ed. E. P. Benson. 119-34. 7 figs. Washington, D.C.: Dumbarton Oaks.
Discussion of the relationship of early sculpture on the Pacific slope of Guatemala to Olmec art. Possible outside influence suggested in the art of La Venta. No monolinear scheme of stylistic development is found from Olmec to Maya art.

1099 1971. Classic art of central Veracruz. Handbook of Middle American Indians 11. Ed. Gordon F. Ekholm and Ignacio Bernal. 558-72. 15 figs. Austin: University of Texas Press.
Survey focuses on sculptural art in stone, which is categorized according to functional type.

1100 1971. Early architecture and sculpture in Mesoamerica. Contributions of the University of California Archaeological Research Facility 11:141-56. Berkeley, California.
Brief but important survey of the development of the monumental arts from Olmec to early Maya times. See also Kubler's commentary on this paper in the same volume.

1101 1974. Jades from the Cenote of Sacrifice, Chichen Itza, Yucatan. Memoirs of the Peabody Museum 10, no. 1. 217 pp., 86 figs., 4 color plates. Cambridge: Harvard University.
Important in-depth study of numerous jades and greenstone fragments excavated from the cenote. Typological classifications and stylistic discussions.

1102 1978. Olmec gods and Maya god-glyphs. Codex Wauchope: A Tribute Roll. Ed. M. Giardino, et al. 113-17. 2 figs. New Orleans: Tulane University.
Provocative comments on glyphs and sculptural imagery suggesting that our preoccupation with classifying Olmec and Maya "deities" may not fit the evidence.

Quirarte, Jacinto.
1103 1973. Izapan-Style Art: A Study of Its Form and Meaning. Dumbarton Oaks Studies in Pre-Columbian Art and Archaeology, 10. 47 pp., 13 figs., 10 plates. Washington, D.C.: Dumbarton Oaks.

An examination of formal and thematic programs in relief sculptures from Izapa, El Baul, Abaj Takalik, Chiapa de Corzo, and Kaminaljuyu.

1104 1973. El estilo artístico de Izapa. Cuadernos de historia del arte, 3. 77 pp., 13 figs., 13 plates. Mexico: Universidad Nacional Autónoma de Mexico.
 Stylistic study of Izapan sculpture and its relation to other Mesoamerican cultures.

1105 1973. Izapan and Mayan traits in Teotihuacan III pottery. Contributions of the University of California Archaeological Research Facility 18, no. 2:11-29. 3 figs., 1 plate. Berkeley.
 Study of long-lipped compound zoomorphic creature on cylindrical tripod vessel excavated at Teotihuacan reveals it to be a Maya motif. Proportional study of the vessel wall reveals it to be of non-Teotihuacan format.

1106 1974. Terrestrial/celestial polymorphs as narrative frames in the art of Izapa and Palenque. Primera Mesa Redonda de Palenque, Part I. Ed. M.G. Robertson. 129-35. 3 figs. Pebble Beach, California: Robert Louis Stevenson School. Reprinted in Pre-Columbian Art History. Ed. Alana Cordy-Collins and Jean Stern. 53-62. 3 figs. Palo Alto, 1977.
 Several compound ("polymorphic") motifs of Izapan derivation that reappear in the later art of Palenque are discussed. The differing functions of polymorphs as framing devices in these two art styles are contrasted.

1107 1975. Wall paintings of Santa Rita, Corozal. National Studies 3, no. 4:5-29. 6 figs. Belize.
 Analysis of forms, motifs, and themes in the now-lost murals of Santa Rita, based on a study of Gann's facsimiles.

1108 1976. The relationship of Izapan-style art to Olmec and Maya art: a review. Origins of Religious Art and Iconography in Preclassic Mesoamerica. Ed. H. B. Nicholson. 73-86. 5 figs. Los Angeles.
 Discussion of thematic and formal continuities in the arts of these three related traditions.

1109 1977. The ballcourt in Mesoamerica: its architectural development. Pre-Columbian Art History. Ed. Alana Cordy-Collins and Jean Stern. 191-212. 9 figs. and appendix. Palo Alto: Peek Publications.
 Useful survey article of ballcourt types, with particular attention paid to dimension, proportion, and configuration of the court itself.

1110 1977. Early art styles of Mesoamerica and Early Classic
 Maya art. The Origins of Maya Civilization. Ed. Richard E.
 W. Adams. 249-283. 7 figs. Albuquerque: University of
 New Mexico Press.
 Discussion of recurring elements in Olmec and Izapan art
 and themes that develop from Izapan to Mayan art. Analysis is
 principally concerned with motif, style, and format.

1111 1977. The underworld jaguar in Maya vase painting: an
 iconographic study. New Mexico Studies in the Fine Arts
 1:20-25. Albuquerque.
 Contexts and themes concerning the water-lily jaguar on
 five Maya vases suggest underworld, supernatural, and death
 associations.

1112 1978. Methodology in the study of pre-Columbian art.
 Research Center for the Arts Review 1, no. 1:1-4. 2 figs.
 San Antonio: University of Texas.
 Discussion of the means by which pre-Columbian art
 history differs from European art history, principally because
 of the paucity of texts. Differences in the use of space are
 considered too.

1113 1979. Maya and Teotihuacán traits in Classic Maya vase
 painting of the Petén. The Visual Arts. Ed. J. Cordwell.
 595-608. 6 plates, 1 table. The Hague: Mouton.
 Morphological considerations such as vessel wall propor-
 tion and thematic structure used to determine Mexican versus
 Maya art styles.

1114 1979. The representation of place, location, and direction
 on a Classic Maya vase. Tercera Mesa Redonda de Palenque.
 Ed. M. G. Robertson and D. C. Jeffers. 99-110. 5 figs.
 Monterey, California.
 Discussion of the iconography of a polychrome vessel de-
 picting bicephalic creatures who support the sun deity on his
 journey through the underworld.

1115 1979. The representation of underworld processions in Maya
 vase painting: an iconographic study. Maya Archaeology
 and Ethnohistory. Ed. N. Hammond and G. Willey. 116-48.
 12 figs. Austin: University of Texas Press.
 Iconographic and glyphic analysis of procession scenes
 and characters on ten vessels. A portion of this essay published
 as his 1976 article.

1116 1979. Sculptural documents on the origins of Maya
 civilization. Proceedings of the 42nd International
 Congress of Americanists 8:189-96. Paris.

Discussion of Izapa sculpture in terms of style, format, pictorial conventions, etc. Several monuments from Abaj Takalik, El Baul, and Kaminaljuyu considered in this category.

1117 1981. Tricephalic units in Olmec, Izapan-style, and Maya art. The Olmec and Their Neighbors. Ed. Elizabeth Benson. 287-308. 7 figs. Washington, D.C.: Dumbarton Oaks.
 A review of three-headed imagery that suggests thematic connections among these three art styles. The heads demonstrate opposing characteristics having to do with feline-serpent and serpent-saurian traits.

1118 1982. The Santa Rita murals: a review. Aspects of the Mixteca-Puebla Style and Mixtec and Central Mexican Culture in Southern Mesoamerica. 43-60. Middle American Research Institute Occasional Paper no. 4. 11 figs. New Orleans: Tulane University.
 Stylistic study of the Post-Classic murals in Belize of combined Maya and Mixtec parentage.

Rabin, Emily.
1119 1970. The Lambityeco Friezes. Boletín de Estudios Oaxaqueños 33.
 Discussion of figural friezes made of plaster, dating from around 700 A.D.

1120 1979. The war of heaven in codices Zouche-Nuttall and Bodley: a preliminary study. Proceedings of the 42nd International Congress of Americanists 7:173-82. 2 tables. Paris.
 Preliminary study of two sections of the front of Codex Nuttall that deal with description and analysis of the protagonists in one long war in Mixtec history.

Ramsey, James R.
1121 1982. An examination of Mixtec iconography. Aspects of the Mixteca-Puebla Style and Mixtec and Central Mexican Culture in Southern Mesoamerica. 33-42. Middle American Research Institute Occasional Paper no. 4. 9 figs., 2 tables. New Orleans: Tulane University.
 Mixtec iconography from the vantage point of the minor arts, which often can be more readily dated and their origins located than can the manuscripts.

Rands, Robert L.
1122 1952. Some Evidences of Warfare in Classic Maya Art. Unpublished Ph.D. dissertation, Department of Anthropology, Columbia University.
 Iconographic study supplemented with ethnohistorical evidence.

1123 1953. The water lily in Maya art: a complex of alleged Asiatic origin. Bureau of American Ethnology Bulletin 151:75-153. 6 figs. Washington, D.C.: Smithsonian Institution.
 Examination of the religious symbolism of the water lily and the iconographic connections between Maya sites in the use and context of this motif. Author does not find convincing evidence for trans-Pacific importation of this theme.

1124 1954. Artistic connections between the Chichen Itza Toltec and the Classic Maya. American Antiquity 19, no. 3:281-82.
 Closer temporal connections suggested between the Toltec of Northern Yucatan and the Classic Maya of the southern lowlands, based on artistic evidence assembled by Lothrop (1952), Proskouriakoff (1950, 1951) and Rands (1953).

1125 1955. Some manifestations of water in Mesoamerican art. Bureau of American Ethnology Bulletin 157:265-393. 23 figs., 5 plates. Washington, D.C.: Smithsonian Institution.
 Useful study of water iconography and related deities in all media.

1126 1957. Comparative notes on the hand-eye and related motifs. American Antiquity 22, no. 3:247-57. 10 figs.
 Iconographic motifs held in common by Mesoamerican civilizations and Indian groups of North America (northwest coast, southeast archaeological cultures) suggest diffusion from Mesoamerica.

1127 1965. Classic and Postclassic pottery figurines of the Guatemalan highlands. Handbook of Middle American Indians 2. Ed. Gordon R. Willey. 156-62. 11 figs. Austin: University of Texas Press.
 Brief survey stresses that few conclusions can be drawn.

1128 1965. Jades of the Maya lowlands. Handbook of Middle American Indians 3. Ed. Gordon R. Willey. 561-80. 48 figs. Austin: University of Texas Press.
 Useful introduction to forms, techniques, functions, styles, and their geographic interrelationships.

1129 1969. Relationship of monumental stone sculpture of Copan with the Maya lowlands. Proceedings of the 38th International Congress of Americanists 1:517-29. 5 figs. Stuttgart-München.
 Combined epigraphic-stylistic approach to intersite relationships in the arts. Copan-Palenque and Copan-Piedras Negras resemblances are noted.

Rands, Robert, and Barbara C. Rands.
1130 1959. The incensario complex of Palenque, Chiapas.
 American Antiquity 25:225-36. 11 figs.
 Both plain and ornate incense burners are discussed,
with emphasis on the fancy flanged cylindrical censer stands
characteristic of Palenque. Local manufacture is indicated,
although there are correpondences to southern Tabasco and Alta
Verapaz in particular.

1131 1965. Pottery figurines of the Maya lowlands. Handbook of
 Middle American Indians 2. Ed. Gordon R. Willey. 535-60.
 51 figs. Austin: University of Texas Press.
 Surveys Pre-Classic through Post-Classic, although
major focus is on Classic period figurines from various sites.

Rands, Robert, Ronald L. Bishop, and Garman Harbottle.
1132 1979. Thematic and compositional variation in Palenque-
 region incensarios. Tercera Mesa Redonda de Palenque. Ed.
 M. G. Robertson and D. C. Jeffers. 19-30. 13 figs.
 Monterey, California.
 A study of the interrelationship of style and regional
production in Late Classic tubular incense burners. Results of
neutron activation analysis of censer paste as well as
iconographic analysis of the imagery are considered.

Rands, Robert L., and Robert E. Smith.
1133 1965. Pottery of the Guatemalan highlands. Handbook of
 Middle American Indians 2. Ed. Gordon R. Willey. 95-145.
 21 figs. Austin: University of Texas Press.
 Useful survey of types. Focuses on both plain and fancy
wares.

Ranney, Edward.
1134 1974. Stonework of the Maya. 117 pp., 76 black-and-white
 plates. Albuquerque: University of New Mexico Press.
 Covers architecture and figural sculpture at twelve
major cities in a site-by-site progression.

Rattray, Evelyn C.
1135 1977. Seración de cerámica teotihuacana. Anales de Antro-
 pología 14:37-48. 1 fig., 2 tables. Mexico: Universidad
 Nacional Autónoma de Mexico.
 Refining of Teotihuacan ceramic sequence based on stra-
tigraphic excavations.

Rau, Charles.
1136 1879. The Palenque Tablet in the United States National
 Museum. Contributions to Knowledge, 331. 77 pp., 17
 figs., 2 plates. Washington, D.C.: Smithsonian
 Institution.

Panel in the Temple of the Cross at Palenque is discussed in terms of its iconography and what was known at the time about "aboriginal writing." Discussion of history of exploration at Palenque.

Reina, B.
1137 1924-27. Algunas observaciones acerca del Códice Vaticano 3738 o Códice Ríos. El México Antiguo 2:212-19. Mexico.
 Comparisons between codices Telleriano-Remensis and Ríos.

Rickards, Constantine G.
1138 1913. Notes on the "Codex Rickards." Journal de la Société des Américanistes de Paris n.s. 10:47-57. 13 figs., 3 plates.
 Description of this Mixtec painting done on cotton. Hand-drawn and photographic illustrations.

1139 1938. Monograph on ornaments on Zapotec funerary urns. Journal de la Société des Américanistes de Paris n.s. 30: 147-65. 23 figs., 5 plates.
 Cursory study of headdresses, earplugs, necklaces, and face ornaments on a group of Zapotec urns. Not very satisfactory. Some possible fakes included.

Ricketson, Edith Bayles.
1140 1927. Sixteen carved panels from Chichen Itza. Art and Archeology 23, no. 1:11-15. 6 figs.
 Illustrates and discusses low-relief figural columns of the northeast colonnade of the Court of the Thousand Columns. Dress and adornment of the figures are discussed.

1141 1935. Pictographs at Lake Ayarza, Guatemala. Maya Research 2:244-50. 3 figs.
 Preliminary report on Mexican-style pictographs painted on a cliff above a lake in the department of Santa Rosa.

Ricketson, Oliver.
1142 1935. Four pottery molds from Guatemala. Maya Research 2: 253-56.
 Discussion of coarse-ware bowls with interior nonfigural designs in low relief. Author suggests these were used to impress designs on balls of copal.

Ries, Maurice.
1143 1942. Ancient American Art 500 B.C.-A.D. 1500. unpaginated, 14 black-and-white illustrations. Santa Barbara: Santa Barbara Museum of Art.
 Listing of 221 objects in exhibit. Only 14 illustrated. Brief essay. Important for its date.

Ritzenthaler, Robert.
1144 1963. Recent Monument Worship in Lowland Guatemala. 107-
 116. Middle American Research Institute Publication 28,
 no. 2. 7 figs. New Orleans: Tulane University.
 Cotzumalhuapa monuments are still the focus of Maya
 Indian veneration today.

Rivard, Jean-Jacques.
1145 1971. Pictures Can Be Glyphs. Miscellaneous Series, 26.
 unpaginated, 10 figs. Greeley: University of N. Colorado
 Museum of Anthropology.
 The author posits that images in the Maya codices serve
 as elaborate glyphic images, rather than as illustrations for
 the accompanying glyphic text. Provocative, but hypothesis is
 neither well developed nor proven.

Rivet, Paul.
1146 1960. Maya Cities. London. Translation of the French
 Cités maya 1954, Paris. 234 pp., 10 color plates, 136
 figs., and numerous text figs.
 General introduction to ancient Maya peoples. A lot of
 attention paid to architecture and arts.

Rivet, Paul, and H. Arsandaux.
1147 1946. La métallurgie en Amérique précolumbienne.
 Université de Paris. Travaux et mémoires de l'institut
 d'ethnologie, 39. 251 pp., 8 figs. Paris.
 Study principally of objects at the Musée de l'Homme
 from South and Middle America.

Robertson, Donald.
1148 1959. Mexican Manuscript Painting of the Early Colonial
 Period. 222 pp., 88 ill. New Haven.
 Landmark study of pictorial style of pre- and
 postconquest Mixtec and Mexican codices and other documents.
 Format, style, composition, line, and color are among the many
 criteria for discussing individual manuscripts.

1149 1963. Pre-Columbian Architecture. 128 pp., 122 figs. New
 York: George Braziller.
 Useful shorter synthesis of architectural traditions in
 both Middle and South America.

1150 1963. The style of the Borgia Group of Mexican pre-
 conquest manuscripts. 20th International Congress of the
 History of Art 3:148-64. 8 figs. Princeton.
 Author discusses Mixtec origins of Borgia and Vaticanus
 B manuscripts. Remarks on stylistic considerations.

1151 1966. The Mixtec religious manuscripts. Ancient Oaxaca.
 Ed. J. Paddock. 298-312. 7 figs. Stanford.

Borgia-group manuscripts analyzed through the formal study of graphic style. Formal analysis seen as preferable to an iconographic approach for solving problems of provenience. Useful introduction to stylistic affinities and differences within the Borgia Group.

1152 1966. The sixteenth-century Mexican encyclopedia of Fray Bernadino de Sahagún. Journal of World History 9, no. 3:617-27. Neuchatel.
 Useful survey article on the encyclopedia and its contents.

1153 1968. Paste-over illustrations in the Duran Codex of Madrid. Tlalocan 5, no. 4:340-48. Mexico: Universidad Nacional Autónoma de Mexico.
 Author notes some peculiarities in the original postconquest manuscript that are not apparent in reproductions, principally that illustrations from an older manuscript have been cut out and pasted over. Additional notes on the style of the illustrations.

1154 1970. The Tulúm murals: the international style of the late Post-Classic. Proceedings of the 38th International Congress of Americanists 2:77-88. 8 figs. Stuttgart-Münich.
 Stylistic analysis of the Tulum frescoes reveals their lack of connection to other paintings in the Maya tradition. Connection with the murals of Santa Rita, Belize is demonstrated. A south-central Mexican origin for the style is suggested. An important article.

1155 1974. The treatment of architecture in the Florentine Codex of Sahagún. Sixteenth Century Mexico: The Work of Sahagún. Ed. Monro S. Edmonson. 151-64. 7 plates. Albuquerque: University of New Mexico Press.
 Discussions of the relationship of text and illustration in the Florentine Codex. Suggests that architectural illustrations show a great deal of acculturation and that text must be examined for similar nonnative bias.

1156 1974. Some remarks on stone relief sculpture at Palenque. Primera Mesa Redonda de Palenque, Part. II. Ed. M.G. Robertson. 103-24. 29 figs. Pebble Beach, California: Robert Louis Stevenson School.
 Formal analysis of low-relief sculpture in architectural contexts, with particular attention to the nine figures in the east court of the palace. The author calls his approach "an antidote to the single-minded attention to iconography."

1157 1976. Mexican Indian art and the Atlantic filter: sixteenth to eighteenth centuries. First Images of America:

The Impact of the New World on the Old. Ed. Fredi
Chiapelli. 483-94. 19 figs. Berkeley: University of
California Press.
Discussion of the influence and impact of New World dis-
coveries on art in Europe. Focus on Mexican images.

1158 1977. Domestic architecture of the Aztec period: "Mapa de
Quinatzin." Del arte: Homenaje a Justino Fernandez. 11-
18. 8 black-and-white figs. Mexico: Universidad Nacional
Autónoma de Mexico.
Looks at domestic architecture at Teotihuacan and Tula
as well as architectural representations in pre-Hispanic Mexican
manuscripts, especialy the Quinatzin map. Suggests a functional
analysis of architectural form and space.

1159 1978. Anthropology, archaeology, and the history of art.
Codex Wauchope: A Tribute Roll. Ed. M. Giardino, et al.
73-80. New Orleans: Tulane University.
Remarks on the interrelationships of disciplines, espe-
cially as they pertain to the study of pre-Columbian art.

1160 1982. A preliminary note on the Codex Tulane. Interna-
tional Colloquium: The Indians of Mexico in Pre-Columbian
and Modern Times. Ed. M. Jansen and T. Leyenaar. 223-31.
4 figs. Leiden, Netherlands: Rijksmuseum voor
Volkenkunde.
Discussion of early colonial Mixtec document painted in
a "Europeanized native style." Genealogical and stylistic
content considered.

1161 1982. Some comments on Mixtec historical manuscripts.
Aspects of the Mixteca-Puebla Style and Mixtec and Central
Mexican Culture in Southern Mesoamerica. 15-26. Middle
American Research Institute Occasional Paper no. 4. 5
figs., 1 table. New Orleans: Tulane University.
Discussion of natural and man-made changes in the Mixtec
Codices Bodley and Selden and Nuttall. Lengthy appendix on
pagination and pentimenti in Codex Nuttall.

Robertson, Merle Greene.
1162 1972. Monument thievery in Mesoamerica. American
Antiquity 37, no. 2:147-55. 8 figs.
Report by field-worker on the dramatic increase in the
looting of Maya stelae in the 1960s and 1970s. Specific sites
and monuments are discussed.

1163 1972. Notes on the ruins of Ixtutz, Southeastern Peten.
Contributions of the University of California
Archaeological Research Facility 16, no. 7: 89-94.
Berkeley.

Remarks on the architecture and stelae of this Maya site. Rubbings of the carved stelae are included.

1164 1974. The quadripartite badge--a badge of rulership. Primera Mesa Redonda de Palenque, Part I. Ed. M.G. Robertson. 77-93. 32 figs. Pebble Beach, California: Robert Louis Stevenson School.
A four-part emblem occurring often in the iconography of Palenque is presented as a badge of kingship, proclaiming by its component parts terrestrial and celestial affinities.

1165 1975. Stucco techniques employed by ancient sculptors of the Palenque Piers. Proceedings of the 41st International Congress of Americanists 1:449-79. 20 figs. Mexico.
Significant article on the probable methods used by artists and their workshops at this Classic Maya site. Use of patterns, armatures, and the buildup of layers from nude to clothed figures is discussed.

1166 1976. Correction of the Maudslay drawings of the stucco piers at Palenque. Proceedings of the 41st International Congress of Americanists 2:358-64. 4 figs. Mexico.
Recent photography and drawings made of figural stuccos on the Temple of Inscriptions and Palace House A reveal major omissions in Maudslay drawings. One of the most significant is the failure to notice that the royal baby held in several scenes has one human foot and one serpent foot. Another is the failure to accurately record the six fingers clearly depicted on one individual in Palace House A.

1167 1977. Painting practices and their change through time of the Palenque stucco sculptors. Social Process in Maya Prehistory. Ed. Norman Hammond. 297-326. 6 figs., 6 color plates. London: Academic Press.
Important, detailed discussion of technique and method used by Palencano artists during the Classic period. Color and build-up of the layered stucco images are considered in depth.

1168 1979. Methods used in recording sculptural art at Palenque. Proceedings of the 42nd International Congress of Americanists 7:439-60. 14 figs. Paris.
The author describes her ground-breaking methods of recording sculpture by means of rubbings, photos, reconstruction sculpture, technical illustration, reconstruction drawing, and research into colors and pigments. Each method is described in detail.

1169 1979. A sequence for Palenque painting techniques. Maya Archaeology and Ethnohistory. Ed. N. Hammond and G. Willey. 149-71. 9 tables, 10 figs., 5 color plates. Austin: University of Texas Press.

Historical development in painting practices from 615-830 A.D. ranges from early monochromatic plain painted walls to late painted stucco sculpture on the exterior.

1170 1979. An iconographic approach to the identity of the figures on the piers of the Temple of the Inscriptions, Palenque. <u>Tercera Mesa Redonda de Palenque</u>. Ed. M. G. Robertson and D. C. Jeffers. 129-38. 16 figs. Monterey, California.

The author presents evidence that the children held in the arms of the stucco figures on the piers had God K heads rather than human heads, and that they represent the child Chan-Bahlum at age six at a ceremony identifying him both with God K and with the right to the Palenque throne.

Robertson, Merle Greene (ed.).
1171 1974. <u>Primera Mesa Redonda de Palenque, Parts I and II</u>. Part I: 173 pp., numerous text illustrations. Part II: 142 pp., numerous text illustrations. Pebble Beach, California: Robert Louis Stevenson School.

A two-volume collection of essays based on lectures given at a conference at Palenque, Chiapas, Mexico in 1973. Many of the contributions dealing with art rather than epigraphy are individually annotated.

1172 1976. <u>Segunda Mesa Redonda de Palenque</u>. 230 pp., numerous text illustrations. Pebble Beach, California: Robert Louis Stevenson School.

A collection of essays based on lectures given at a conference at Palenque, Chiapas, Mexico in 1974. Many of the contributions dealing with art rather than epigraphy are individually annotated.

1173 1980. <u>Third Palenque Roundtable, 1978. Part 2</u>. 226 pp. Austin: University of Texas Press.

Proceedings of the 1978 conference. Contributions by Adams and Aldrich, Hartung, Barthel, Goldstein, Pickands, Gendrop, Schávelzon, Kubler, Barrera Rubio, and Foncerrada de Molina are annotated here.

Robertson, Merle Greene, Marjorie S. Rosenblum Scandizzo, M.D., and John R. Scandizzo, M.D.
1174 1976. Deformities in the ruling lineage of Palenque and the dynastic implications. <u>Segunda Mesa Redonda de Palenque</u>. Ed. M.G. Robertson. 59-86. 33 figs., 3 tables. Pebble Beach, California: Robert Louis Stevenson School.

The physical deformities of acromegaly, clubfoot, and polydactyly are suggested by irregularities in the artistic depictions of several rulers at Palenque.

Robicsek, Francis.
1175 1972. <u>Copán: Home of the Mayan Gods</u>. 166 pp., 123 figs.,
 297 plates, many in color. New York: Museum of the
 American Indian, Heye Foundation.
 Wide-ranging survey of the art, archaeology,
 iconography, and architecture of the one Maya site with
 supplementary material on the Maya in general. Many first-rate
 photos and line drawings.

1176 1975. <u>A Study in Maya Art and History: The Mat Symbol</u>.
 Museum of the American Indian. 358 pp., 307 figs., 88 color
 plates. New York: Heye Foundation.
 Wide-ranging study of interwoven wicker-like motif in
 Maya art and its relationship to Maya dynastic power. All media
 considered.

1177 1978. <u>The Smoking Gods: Tobacco in Maya Art, History, and
 Religion</u>. 233 pp. 265 color plates, 234 figs. Norman:
 University of Oklahoma Press.
 Exhaustive ethnological and archaeological survey of
 tobacco and smoking rituals. Focused principally on polychrome
 ceramics.

1178 1979. The mythological identity of God K. <u>Tercera Mesa
 Redonda de Palenque</u>. Ed. M. G. Robertson and D. C.
 Jeffers. 111-28. 23 figs. Monterey, California.
 Iconographic features associated with the Maya God K are
 considered. Thorough analysis based principally on a study of
 vase painting and figural sculpture.

1179 1979. Representation of smoking in ancient Maya art. <u>Pro-
 ceedings of the 42nd International Congress of Americanists</u>
 7:399-406. Paris.
 Cursory survey of smoking figures in Maya painting and
 sculpture. Not illustrated. Superseded by the author's
 extensive work on the subject, <u>The Smoking Gods</u> (1978).

1180 1981. <u>The Maya Book of the Dead: The Ceramic Codex</u>. 257
 pp., 186 plates, 90 figs., 27 photographic tables.
 Charlottesville: University of Virginia Art Museum.
 Profusely illustrated study of one particular style of
 Maya vase painting, the "codex style." Author argues that
 ceramic vessels functioned "textually" as pages of a codex, and
 that Maya mythology can be reconstructed by studying these
 "pages."

Robicsek, Francis, and Donald Hales.
1181 1982. <u>Maya Ceramic Vases from the Classic Period: The
 November Collection of Maya Ceramics</u>. 63 pp. 22 plates,
 some in color. Charlottesville: University Museum of
 Virginia.

Catalog of a private collection of twenty-two pieces of figural painted pottery in the University Museum of Virginia. Fine roll-out photos by Justin Kerr and commentaries on the imagery and text.

Röck, Fritz.
1182 1924. Der altmexikanische Prunkfederschild des Naturhistorischen Museums in Wien. Proceedings of the 21st International Congress of Americanists 2:185-89. Göteborg.
 Description and provenance of the Aztec feathered shield in the Vienna Museum. The object is not illustrated.

Romero, Emilia.
1183 1951. ¿Existe alguna relación entre "Los Danzantes" de Monte Albán en México y los monolitos de Cerro Sechín en el Peru? Selected Papers of the 29th International Congress of Americanists. 285-90. 4 figs. Chicago.
 Brief comparison of stylistic and iconographic features of danzante sculptures in Oaxaca with Chavin low-relief carvings in Peru. Suggestion of a historical connection based on superficial similarities.

Ross, Kurt.
1184 1978. Codex Mendoza. 124 pp., numerous text illustrations. Fribourg: Productions Liber S. A.
 Color reproductions of many pages in an important Aztec codex. Brief remarks on the manuscript pages. Most useful for being an inexpensive facsimile. Some photos blurred.

Rozaire, Charles E.
1185 1966. Ancient Civilizations of Latin America. 72 pp., numerous unnumbered figs. Los Angeles: Los Angeles County Museum of Natural History.
 Catalog of the hall of pre-Columbian cultures in the Los Angeles Museum.

Rubín de la Borbolla, Daniel F.
1186 1962. El personaje de las tres caras. Revista Mexicana de Estudios Antropológicos 18:45-48. 4 figs.
 Brief discussion and illustration of an unusual ceramic sculpture in which a death's head and a wrinkled head are parted to reveal a youthful visage.

Ruppert, Karl.
1187 1931. Temple of the Wall panels, Chichen Itza. Contributions of American Archaeology 1, nos. 1-4:117-40. 2 figs. 18 plates. Washington, D.C.: Carnegie Institution of Washington.
 Archaeological and architectural study of one structure.

1188 1935. <u>The Caracol at Chichen Itza, Yucatan, Mexico</u>. Carnegie Institution of Washington Publication no. 454. 294 pp., 350 figs. Washington, D.C.: Carnegie Institution of Washington.
 Comprehensive study of the observatory at Chichen Itza and its underlying platforms. Many detailed fold-out figures and architectural plans.

1189 1940. A special assemblage of Maya structures. <u>The Maya and Their Neighbors</u>. 222-31. 6 figs. New York: D. Appleton-Century Company. Reprint. New York: Dover Publications, 1977.
 An early discussion of astronomical orientation of Maya architecture with particular reference to sites in Peten.

1190 1943. The Mercado, Chichen Itza, Yucatan. <u>Contributions to American Anthropology and History</u> 8, no. 43:223-60. 35 figs. Washington, D.C.: Carnegie Institution of Washington.
 Archaeological study of a gallery-patio type building on the south side of the court of a thousand columns. Unusual structure in length and in alternation of rectangular and round columns. Figural relief sculpture.

1191 1952. <u>Chichen Itza: Architectural Notes and Plans</u>. Carnegie Institution of Washington Publication no. 595. 146 pp., 150 figs. Washington, D.C.: Carnegie Institution of Washington.
 Plans, some elevations, and descriptive notes on numerous minor structures not covered in other publications.

Ruppert, Karl, J. Eric S. Thompson, and Tatiana Proskouriakoff.
1192 1955. <u>Bonampak, Chiapas, Mexico</u>. Carnegie Institution of Washington Publication no. 602. 71 pp., 29 figs., 10 graphs. Washington, D.C.: Carnegie Institution of Washington.
 Study of a Maya site and commentary on the mural paintings there. Copies of the murals by Antonio Tejeda are included.

Ruz Lhuiller, Alberto.
1193 1952. Cámara secreta del Templo de las Inscriptiones. <u>Tlatoani</u> 1, no. 3-4:2-5. 6 figs.
 Brief recounting by the discoverer of the famous tomb at Palenque.

1194 1952. Estudio de la cripta del Templo de las Inscripciones en Palenque. <u>Tlatoani</u> 1, no. 5-6:2-27. 20 figs., 5 plates and charts.
 First overview of the tomb and its contents including stonework, stucco, tomb plan, and epigraphy.

1195 1958. El juego de pelota de Uxmal. <u>Miscellanea Paul Rivet</u> 1:635-67. 7 figs.

 Thorough discussion of ballcourt based on 1948 excavations, including epigraphic information on the rings, and ceramic associations. Excellent plans and elevations.

1196 1959. Comentarios sobre un falso codice maya. <u>Revista Mexicana de Estudios Antropológicos</u> 15:71-88. 10 figs.

 Study of the iconographic sources of the imagery of the so-called Manuscrito Porrua, a poorly falsified Maya codex.

1197 1962. Chichen-Itza y Tula: comentarios a un ensayo. <u>Estudios de Cultura Maya</u> 2:205-20.

 Reply to Kubler's article of 1961 on Chichen and Tula that takes issue with some of Kubler's unconventional hypotheses about the donor-receptor relationship of Tula and Chichen.

1198 1964. Influencias mexicanas sobre los Mayas. <u>Desarrollo cultural de los Mayas.</u> Ed. E. Z. Vogt and A. Ruz. 203-41. Mexico: Universidad Nacional Autónoma de Mexico. Second edition 1971.

 Analysis of central Mexican traits found in the Maya area from Pre-Classic to Post-Classic times. Good bibliography. Marred by lack of illustrations.

1199 1973. <u>El Templo de las Inscripciones, Palenque.</u> Coleccion Científica Arqueología, 7. 269 pp., 266 figs. Mexico: Instituto Nacional de Antropología e Historia.

 Discussion of fieldwork, architecture, stucco and stone sculpture, inscriptions, and minor arts of this important Maya monument.

Sabloff, Jeremy A., and William L. Rathje.
1200 1975. The rise of a Maya merchant class. <u>Scientific American</u> 233, no. 4:72-82. 9 figs.

 Although not focused exclusively on artistic evidence, this article suggests that, when viewed in its historical context, the different standards in the art of the Post-Classic Maya of Yucatan can be understood not as "decadent" but as reflecting a reordering of social priorities.

Sáenz, Cesar.
1201 1961. Tres estelas en Xochicalco. <u>Revista Mexicana de Estudios Antropológicos</u> 17:39-65. 25 figs., 3 plates. Mexico.

 Report on the excavation of these three stelae and their associated offerings. Discussion of glyphic inscriptions.

1202 1968. Cuatro piedras con inscripciones en Xochicalco, México. <u>Anales de Antropología</u> 5:181-99. 6 figs., 7 plates. Mexico.

Primarily a glyphic study, although several of the monuments under consideration have figural reliefs as well.

Salazar O., Ponciano.
1203 1952. El Tzompantli de Chichen Itza, Yucatan. <u>Tlatoani</u> 1:5-6. 5 figs., 1 plate, and fold-out reconstruction drawings.
Brief article by one of the archaeologists responsible for the reconstruction of the skull rack area.

1204 1966. Interpretación del altar central de Tetitla, Teotihuacán. <u>Boletín</u> 24:41-47. 1 fig. Mexico: Instituto Nacional de Antropología e Historia.
Description of the reconstruction of a small talud-tablero-style altar in the central patio of a residential compound at Teotihuacan.

Sanchez Ventura, Rafael.
1205 1943. Flores y jardines del México antiguo y del moderno. <u>Cuadernos Americanos</u> 7, no. 1:127-48. 6 plates, 8 figs.
Especially interesting for its discussion of plant forms in the sixteenth-century codices, but not a scholarly article.

Sanders, William T.
1206 1977. Ethnographic analogy and the Teotihuacan horizon style. <u>Teotihuacan and Kaminaljuyu</u>. Ed. W. T. Sanders and J. W. Michels. 397-410. Philadelphia: Pennsylvania State University Press.
Teotihuacan's "mercantile imperialism" explained by analogy with the Aztec pochteca.

Sanders, William T., and J. W. Michels (eds.).
1207 1977. <u>Teotihuacan and Kaminaljuyu: A Study in Prehistoric Culture Contact</u>. 467 pp. Philadelphia: Pennsylvania State University Press.
Collection of essays, principally of archaeological interest, on the interaction of these two sites. The contribution by Sanders is annotated here.

Satterthwaite, Linton, Jr.
1208 1936. An unusual type of building in the Maya old empire. <u>Maya Research</u> 3, no. 1:62-73. 2 figs.
Possible sweat-baths at Piedras Negras and other Maya sites.

1209 1937. Thrones at Piedras Negras. <u>University Museum Bulletin</u> 7, no. 1:18-23. 3 figs., 1 plate. Philadelphia: University of Pennsylvania.
Uses of benches, tablelike platforms, and thrones revealed by excavation at this Maya site and by sculptural reliefs on the lintels.

1210 1939. Evolution of a Maya temple, part I. <u>University Museum Bulletin</u> 7, no. 4:3-14. 3 figs. 4 plates.
Excavation and reconstruction of temple K-5 at Piedras Negras.

1211 1940. Evolution of a Maya temple, part II. <u>University Museum Bulletin</u> 8, no. 2-3:18-24. 2 figs.
Further notes on aesthetic and structural changes to structure K-5 at Piedras Negras. See Satterthwaite 1939.

1212 1940. Another Piedras Negras stela. <u>University Museum Bulletin</u> 8, no. 2-3:24-27. 1 fig. Philadelphia: University of Pennsylvania.
Two fragments of stela 16 that were excavated during two different field seasons at this Maya site are discussed.

1213 1943. Notes on sculpture and architecture at Tonala, Chiapas. <u>Notes on Middle Americn Archaeology and Ethnology</u> 1, no. 21:127-36. 1 fig. Washington, D.C.: Carnegie Institution of Washington.
Fragmentary stelae and some comments on architecture are recorded for this little-known site.

1214 1946-7. A stratified sequence of Maya temples. <u>Journal of the Society of Architectural Historians</u> 5:15-21. 6 figs.
Construction and enlargement sequence in structure K5 at Piedras Negras. Some changes seen as innovations borrowed from central Peten. One in-depth example of the complex factors involved in a study of Maya architectural development.

1215 1954. Sculptured monuments from Caracol, British Honduras. <u>Bulletin of the University Museum</u> 18, no. 1-2:3-45. 42 figs. Philadelphia: University of Pennsylvania.
Important introductory article on the monumental art of this Maya site. Both the figural designs and inscriptions are considered.

1216 1958. Five newly discovered carved monuments at Tikal and new data on four others. <u>Tikal Report</u> 4:85-150. 25 figs. Philadelphia: The University Museum.
Photos, line drawings, epigraphic and stylistic analysis of several stelae.

1217 1958. The problem of abnormal stela placements at Tikal and elsewhere. <u>Tikal Reports</u> 3:61-83. Philadelphia: The University Museum.
Examination of reuse, fragmentation, and modification of monuments in antiquity, with particular reference to seven Tikal stelae.

1218 1961. The mounds and monuments at Xutilha, Peten, Guatemala. Tikal Reports 9:171-211. 73 figs. Philadelphia: The University Museum.
 Introductory remarks on a new site in the southeastern Peten. Architectural plans and drawings of several stelae and altars.

Saville, Marshall.
1219 1894. The plumed serpent in northern Mexico. The Archaeologist 2, no. 10:291-93. 2 figs.
 Brief remarks on plumed serpent imagery from Casa Grandes, Chihuahua. Relationship of this imagery to both Pueblo and Mesoamerican belief.

1220 1901. Mexican codices: a list of recent reproductions. American Anthropologist n.s. 3, no. 3:532-41.
 Covers period from 1885 to 1901.

1221 1909. The cruciform structures of Mitla and vicinity. Putnam Anniversary Volume. 151-90. 13 figs., 13 plates. New York.
 Discussion of architectural style and greca mosaic wall treatment in a group of cruciform tombs at Mitla, site of Xaaga, Guiaroo. Includes ground plan and sections. Comparison with greca mosaic in Yucatan. Part of this had been published under title "Cruciform Structures Near Mitla," Bulletin of the American Museum of Natural History XII, article XVII, 208-18. 10 plates, 8 text figs. (New York, 1900.)

1222 1922. Turquoise Mosaic Art in Ancient Mexico. 110 pp., 19 figs., 39 black-and-white plates, 1 color plate. New York: Museum of the American Indian, Heye Foundation.
 Important early study of existing specimens and early ethnohistorical accounts of the lapidary arts.

1223 1925. The Wood-Carver's Art in Ancient Mexico. 123 pp., 52 plates. New York: Museum of the American Indian, Heye Foundation.
 Important early investigation of wooden objects from various pre-Columbian cultures. Discusses utilitarian use of wood, weapons, musical instruments, mirrors, lintels, figures, and other categories.

1224 1928. Bibliographic Notes on Palenque, Chiapas. Indian Notes and Monographs 6, no. 5. 180 pp., 11 figs. New York: Museum of the American Indian, Heye Foundation.
 Chronological listing and annotation of works about or mentioning Palenque from 1784 to 1928. Brief notes on architecture and a few sculptural reliefs.

1225 1928. <u>Bibliographic Notes on Xochicalco, Mexico</u>. 185-207.
Indian Notes and Monographs 6, no. 6. 5 figs. New York:
Museum of the American Indian, Heye Foundation.
 Brief historiographic study of early writing on this
Mexican site. Works from 1791 to 1928 are included.

1226 1928. <u>Ceremonial Axes from Western Mexico</u>. 280-93.
Indian Notes and Monographs 5. 7 figs. New York: Museum
of the American Indian, Heye Foundation.
 Animal-head votive axes from Jalisco.

Sawyer, Alan R.
1227 1957. <u>Animal Sculpture in Pre-Columbian Art</u>. 48 pp., 73
black-and-white figs. The Art Institute of Chicago.
 Both Middle and South America represented. In Middle
America, concentration on West Mexican arts. Brief introductory
statement.

Schávelzon, Daniel.
1228 1980. Temples, caves, or monsters? Notes on zoomorphic
facades in pre-Hispanic architecture. <u>Third Palenque Round
Table, 1978. Part 2</u>. Ed. M. G. Robertson. 151-62. 23
figs. Austin: University of Texas Press.
 Impressionistic survey of zoomorph-mouth facades from
Formative to Post-Classic times in Mesoamerica and South
America.

Schele, Linda.
1229 1974. Observations on the cross motif at Palenque.
<u>Primera Mesa Redonda de Palenque, Part I</u>. Ed. M.G.
Robertson. 41-61. 21 figs. Pebble Beach, California:
Robert Louis Stevenson School.
 Thematic interrelationships of sculpture and architec-
ture of the Cross Group and the Temple of the Inscriptions.
Three major roles of the ruler stressed in his public icono-
graphy.

1230 1976. Accession iconography of Chan-Bahlum in the Group of
the Cross at Palenque. <u>Segunda Mesa Redonda de Palenque</u>.
Ed. M.G. Robertson. 9-34. 18 figs. Pebble Beach,
California: Robert Louis Stevenson School.
 Cross Group pictorially depicts the transfer of dynastic
power from Pacal to Chan-Bahlum. Complex iconographic program
is explained.

1231 1977. Palenque: the house of the dying sun. <u>Native Ameri-
can Astronomy</u>. Ed. Anthony Aveni. 43-56. Austin: Univer-
sity of Texas Press.
 Discussion of iconography of the Temple of the Inscrip-
tions sarcophagus lid and the Temple of the Cross tablet, as well
as the siting of those two buildings to form a graphic pictorial

display linking the "dying sun" at winter solstice with the dead ruler. Epigraphic material used as supporting evidence. Palenque defined as the western portal of the underworld.

1232 1979. Genealogical documentation on the tri-figure panels at Palenque. <u>Tercera Mesa Redonda de Palenque</u>. Ed. M. G. Robertson and D. C. Jeffers. 41-69. 22 figs. Monterey, California.
 Analysis of costume, offertory objects, gesture and glyphs on the Palace Tablet, Dumbarton Oaks Tablet, Slaves Tablet, and other fragmentary monuments. It is demonstrated that highly standardized imagery documents the genealogical claims of rulers ascending to the throne at Palenque.

1233 1979. The Palenque triad: a visual and glyphic approach. <u>Proceedings of the 42nd International Congress of Americanists</u> 7:407-23. 8 figs. Paris.
 Discussion of the methodologies employed in conducting iconographic and hieroglyphic research. Focus on three related deity images known from Palenque and elsewhere in the Maya area.

1234 1981. Sacred site and world-view at Palenque. <u>Mesoamerican Sites and World-Views</u>. Ed. E. P. Benson. 87-117. 10 figs. Washington, D.C.: Dumbarton Oaks.
 Topographical configurations and site layout at Palenque favor western and sunset phenomena. Events of death and accession are associated with the sun's western descent into the underworld. Emblem glyph of the site alludes to this death imagery.

Schele, Linda, and Peter Mathews.
1235 1979. <u>The Bodega of Palenque, Chiapas, Mexico</u>. Washington, D.C.: Dumbarton Oaks.
 Unpaginated catalog of 908 objects and fragments in the museum storeroom at this Maya site. Line drawings of many glyphic stucco fragments.

Schellhas, Paul.
1236 1890. Vergleichende Studien auf dem Felde der Maya-Alterthümer. <u>Internationales Archiv für Ethnographie</u> 3: 209-31. 1 plate, 155 figs. Leiden.
 Early study of costume attributes in Maya art. Line drawings of jewelry, sandals, headgear, and so forth, drawn from figurines and codices.

1237 1904. Representation of deities of the Maya manuscripts. <u>Papers of the Peabody Museum of American Archaeology and Ethnology</u> 4, no. 1:1-47. 1 plate, 65 figs. Cambridge: Harvard University.
 Early iconographic study of fifteen gods and six mythological animals appearing in three Maya codices.

Tabulations of number of times and in what contexts these figures appear. First to designate the gods by letters of the alphabet.

Schleu, K.
1238 1961. Miniatures en barro del Mexico antiguo. El México Antiguo 9: 525-38, 7 figs.
 Small-scale ceramic objects from diverse sources are briefly discussed.

Schuler-Schömig, Immina.
1239 1970. Figurengefässe aus Oaxaca, Mexico. 155 pp., 4 color plates, 233 black-and-white plates. Berlin: Museums Für Völkerkunde.
 Scholarly catalog of Oaxacan urns and braziers in the museum's collection, many of which were collected by Seler early in the century. Introductory essay and catalog entry on each piece.

Schwerin, Karl H.
1240 1966. On the arch in pre-Columbian Mesoamerica. Current Anthropology 7, no. 1:89.
 Brief remarks on the use of a true arch at Oztuma in Guerrero and La Muñeca in Campeche.

Scott, John F.
1241 1976. Post-Olmec Mesoamerica as revealed in its art. Proceedings of the 41st International Congress of Americanists 2:380-86. Mexico.
 Late Pre-Classic art styles deriving from Olmec sources are shown to vary by region. Discussion focuses on Monte Alban, Oaxaca and Monte Alto, Guatemala.

1242 1977. El Mesón, Veracruz, and its monolithic reliefs. Baessler-Archiv n.f. 25, no. 1:83-138. 24 figs.
 Stylistic and contextual study of two large-scale stone monuments and their relationship to sculptural styles elsewhere in Mesoamerica. A Late Pre-Classic or Proto-Classic date is suggested for them.

1243 1977. Masters and followers: pre-classic Oaxacan clay sculptors. Del arte: Homenaje a Justino Fernandez. 19-26. 6 figs. Mexico: Universidad Nacional Autónoma de Mexico.
 Interesting discussion of possible workshops and individual artists' work in a study of Monte Alban I braseros.

1244 1978. The Danzantes of Monte Alban. 2 Vols. Dumbarton Oaks Studies in Pre-Columbian Art and Archaeology, 19. 79 pp., 29 text figs., 370 unnumbered figures in the catalog. Washington, D.C.

A thorough study of the relief figures from Periods 1 and 2 at the Zapotec capital. Stylistic and iconographic characteristics, meaning, stylistic evolution, and archaeological relationships are all considered.

Sejourné, Laurette.
1245 1958. Las figurillas de Zacuala y los textos Nahuas. Estudios de Cultura Nahuatl 1:43-57. 8 figs. Mexico: Universidad Nacional Autónoma de Mexico.
Looks to Sahagun's texts for explication of ceramic figurines excavated at the Zacuala palace, Teotihuacan. Finds evidence for existence of Xochiquetzal and other Mexica deities in Teotihuacan culture.

1246 1961. El culto de Xochipilli y los braseros teotihuacanos. El México Antiguo 9:111-24. 8 figs.
Teotihuacan incensarios seen as offerings to the god Xochipilli based on imagery used in the attached plaques.

1247 1966. Arqueología de Teotihuacán: La cerámica. 262 pp., 222 figs., 64 plates. Mexico: Fondo de Cultura Económica.
Study of Teotihuacan ceramic types, useful especially for its numerous line drawings and photographs.

1248 1966. Arquitectura y pintura en Teotihuacan. 334 pp., 185 figs., 118 plates. Mexico: Siglo Veintiuno Editores.
Study of Teotihuacan residential architecture and mural painting. Especially useful for its profuse illustrations of architectural reconstructions, murals, figurines, and pottery.

1249 1966. El lenguaje de las formas en Teotihuacan. 318 pp., 194 figs., 72 plates. Mexico.
One in a series of books by this author on Teotihuacan. Here the primary focus is on ceramic figurines, their stylistic and iconographic variety.

1250 1969. Teotihuacan, métropole de l'Amérique. 318 pp., 81 figs., 72 photos, 95 color plates. Paris: François Maspero.
Survey of Teotihuacan arts, useful principally for its profuse illustrations of architecture, ceramics, figurines, and mural paintings.

Seler, Eduard.
1251 1887. Der Codex Borgia und die verwandten aztekischen Bilderschriften. Zeitschrift für Ethnologie 19:105-14. Berlin. Reprinted in Gesammelte Abhandlungen 1:133-44. 21 figs.
Important early study defining the Borgia group of manuscripts.

1252 1894. Der Fledermausgott der Maya-Stämme. <u>Zeitschrift für</u>
 <u>Ethnologie</u> 26:577-85. 5 figs. Translated as "The bat god
 of the Maya race." <u>Bureau of American Ethnology Bulletin</u>
 28:233-41. 5 figs. 1904.
 Representations of bats in codices and pottery discussed
 with reference to glyphs and ethnohistory.

1253 1895. Das Gefass von Chama. <u>Zeitschrift für Ethnologie</u>
 27:307-20. 4 figs. Translated as "The vase of Chama."
 <u>Bureau of American Ethnology Bulletin</u> 28:651-64. 4 figs.
 1904.
 Further remarks on the vase published by Diesseldorf
 (1894:372-77). Seler discusses costume and weaponry in
 reference to Aztec and other ethnohistoric accounts.

1254 1900-01. <u>The Tonalamatl of the Aubin Collection</u>. 146 pp.,
 20 plates, and facsimile. Berlin and London.
 Important early commentary on this Aztec manuscript with
 explanatory tables for each sheet in the manuscript and a drawn
 and colored facsimile.

1255 1902. <u>Codex Féjerváry-Mayer</u>. 211 pp., 219 figs., 44
 plates. Berlin and London.
 Important early study of a Mixtec manuscript. Text in
 English. Useful pictorial tables in which gods and their
 attributes are labeled.

1256 1902. <u>Codex Vaticanus 3773</u>. 356 p., 585 figs., 96 plates.
 Berlin.
 Important early study of Codex Vaticanus B. Text in
 German. Useful drawings of codex pages with gods and their
 attributes labeled in Nahuatl and German.

1257 1902. Die Altertümer von Castillo de Teayo. <u>Proceedings</u>
 <u>of the 14th International Congress of Americanists</u> 1:263-
 305. 69 figs., 18 plates. Stuttgart.
 One of Seler's far-ranging essays drawing on manuscript
 sources and ethnohistory for a discussion of the sculpture and
 architecture at one site.

1258 1902-23. <u>Gesammelte Abhandlungen zur amerikanischen</u>
 <u>Sprach-und Altertums-kunde</u>. Vols. 1-5. Berlin. Reprint.
 Graz, Austria:Akademische Druck- U. Verlagsanstalt, 1961.
 Collected works of the great ethnohistorian, linguist,
 and art scholar of the turn of the century. Only a few of the
 most important and lengthy contributions are annotated
 separately here.

1259 1904. Ancient Mexican feather ornaments. <u>Bureau of Ameri-</u>
 <u>can Ethnology Bulletin</u> 28:59-74. 7 figs.

Argues with Nuttall's analysis of famous Vienna feather shield as headdress. Uses codex illustrations to prove that it is a shield.

1260 1904. Das Grünsteinidol des Stuttgarter Museums. Proceedings of the 14th International Congress of Americanists 1:241-61. 25 figs., 7 plates. Stuttgart.
Identification of Aztec skeletal figure based on iconographic and ethnohistoric clues.

1261 1904. Wall paintings of Mitla. Bureau of American Ethnology Bulletin 28:247-324. 28 figs., 17 plates.
Thorough discussion of these fragmentary paintings and their relationship to codex paintings. Modern Zapotec beliefs and deities discussed as well.

1262 1904-9. Codex Borgia: Eine altmexikanische Bilderschrift der Bibliothek der Congregatio de Propaganda Fide. 3 vols., numerous plates. Berlin. Reprinted in Spanish edition as Comentarios al Códice Borgia. 1963. Mexico: Fondo de Cultura Económica.
Seler's monumental work on one Mixtec codex. Landmark study in Mesoamerican iconography, providing many useful remarks on related manuscripts.

1263 1906. Die monumente von Huilocintla im Canton Tuxpan, des staates Vera Cruz. Proceedings of the 15th International Congress of Americanists 2:381-89. 3 figs. Québec.
Two Huilocintla reliefs and their imagery discussed in relation to Aztec gods and rituals.

1264 1906. Einige fein bemalte alte thongefasse der Dr Sologuren' schen Sammlung aus Nochistlan und Cuicatlan. Proceedings of the 15th International Congress of Ameri-canists 2:391-403. 6 figs. Québec.
Narrative scenes painted on Mixtec vessels from a private collection are discussed.

1265 1906. Die Wandskulpturen im Tempel des Pulquegottes von Tepoztlan. Proceedings of the 15th International Congress of Americanists 2:351-79. 15 figs. Québec.
Study of the relief sculpture of an Aztec temple, using comparative material from the codices.

1266 1908. Die ruinen von Chich'en Itzá in Yucatan. Proceedings of the 16th International Congress of Americanists. 151-239. 117 figs. Vienna.
Lengthy erudite article on architecture, sculpture, and iconography at this Toltec Maya site.

1267 1912. Similarity of design of some Teotihuacan frescoes
 and certain Mexican pottery objects. Proceedings of the
 18th International Congress of Americanists. 194-202. 9
 figs., 3 plates. London.
 Illustrates a large number of clay heads. Discusses the
 relationship of figurines to figural and symbolic designs in
 mural painting.

1268 1912. Ueber einige ältere Systeme in den Ruinen von Uxmal.
 Proceedings of the 18th International Congress of Ameri-
 canists. 220-35. 14 figs., 4 plates. London.
 An explication of architectural principles at Uxmal.
 Ground plans, construction technique, and stone facade designs
 are considered.

1269 1915. Die Ruinen von Chichen Itzá in Yucatan. Gesammelte
 Abhandlungen 5:197-388. 257 figs. 46 plates.
 Important and lengthy early study of architecture,
 figural sculpture, and painting at Chichen Itza.

1270 1915. Die Stuckfassade von Acanceh in Yucatan. Gesammelte
 Abhandlungen 5:389-404. 9 figs. 11 plates. Berlin.
 Early study of the non-Maya figural stuccos on the
 pyramid at Acanceh.

1271 1923. Die Tierbilder der mexikanischen und der Maya-
 Handschriften. Gesammelte Abhandlungen 4:455-758. 1005
 figs. Berlin.
 Exhaustive study of animal imagery in codices, including
 mammals, birds, reptiles and amphibians, fish and insects.

Seler-Sachs, Caecilie.
1272 1912. Die Reliefscherben von Cuicatlan und Teotitlan del
 Camino. Proceedings of the 18th International Congress of
 Americanists. 206-15. 17 figs. London.
 Survey of stamped patterns on bowls from Oaxaca.

1273 1922. Altertümer des Kanton Tuxtla im Staate Veracruz.
 Festschrift Eduard Seler. Ed. W. Lehmann. 543-56. 7
 plates. Stuttgart.
 Descriptive essay on collection of small clay and stone
 artifacts from Veracruz, most of which are in the Berlin Museum.
 Each plate depicts multiple ceramic artifacts.

Seligman, Thomas K., and Kathleen Berrin.
1274 1982. The Bay Area Collects: Art from Africa, Oceania, and
 the Americas. 112 pp., 115 figs. San Francisco: The Fine
 Arts Museums.
 Catalog of an exhibit at the de Young Museum. Twenty-
 eight objects from Mesoamerica are illustrated and discussed.

Seufert, Andy.
1275 1974. El "Templo B" redescubierto en la zona de Rio Bec.
 Boletín (ser. 2) 8:3-18. 13 photos. Mexico: Instituto
 Nacional de Antropología e Historia.
 Recounts the 1973 rediscovery of Temple B by several
 Americans. Notes on the condition of the architecture.

Shao, Paul.
1276 1976. Asiatic Influences in Pre-Columbian American Art.
 195 pp., 305 black-and-white figs. Ames, Iowa: Iowa State
 University Press.
 Stylistic and iconographic correspondences between the
 arts of Asia and Mesoamerica. Unpersuasive.

Sharer, Robert J., and David W. Sedat.
1277 1973. Monument 1, El Porton, Guatemala and the development
 of Maya calendrical and writing systems. Contributions of
 the University of California Archaeological Research
 Facility 18, no. 12:177-94. 6 figs. Berkeley.
 First Pre-Classic sculpture known from the northern Maya
 highlands is analyzed for its style and epigraphic content. A
 fragmentary monument.

Sharp, Rosemary.
1278 1970. Early architectural grecas in the Valley of Oaxaca.
 Boletín de Estudios Oaxaqueños 32.
 Analysis of geometric fretwork decoration principally at
 Atzompa, Lambityeco, Monte Alban and Teotitlán del Valle.

1279 1975. A fine-orange vessel from the Olsen Collection.
 Yale University Art Gallery Bulletin 35, no. 2:8-23. 12
 figs. New Haven.
 The iconography and cultural relationships of an X-fine
 orange vase.

1280 1978. Architecture as interelite communication in precon-
 quest Oaxaca, Veracruz, and Yucatan. Middle Classic Meso-
 america: AD 400-700. Ed. E. Pasztory. 158-71. 15 figs.
 New York: Columbia University Press.
 Greca-style architecture as a common denominator in
 three different regions of Mesoamerica. Technology, style, and
 dating are considered.

1281 1978. Trading chiefs to warring kings. Codex Wauchope: A
 Tribute Roll. Ed. M. Giardino, et al. 89-100. 6 figs.
 New Orleans: Tulane University.
 Art and architectural motifs in the service of ideology
 during the Puuc phase in Northern Yucatan.

1282 1981. Chacs and Chiefs: The Iconography of Mosaic
 Stone Sculpture in Pre-Conquest Yucatan, Mexico.

Dumbarton Oaks Studies in Pre-Columbian Art and Archaeology, 24. 48 pp., 41 figs. Washington, D.C.

Relationship of mosaic architectural decoration to ideological and political systems. Analysis of Epi-Classic period as a time of transition and transformation, when old symbols were imbued with new meanings.

Shepard, Anna O.
1283 1948. Plumbate--A Mesoamerican Trade Ware. Carnegie Institution of Washington Publication no. 573. 176 pp., 44 figs. Washington, D.C.: Carnegie Institution of Washington.

A pioneering study that includes stylistic, iconographic and technological analysis of this widely distributed Post-Classic ware.

1284 1962. Maya blue: alternative hypotheses. American Antiquity 27, no. 4:565-66.

A response to Gettens's 1962 article on the same topic, stressing that organic as well as inorganic materials make up the colorant compound.

1285 1964. Ceramic development of the Lowland and Highland Maya. Proceedings of the 35th International Congress of Americanists 1:249-62.

Focuses on technological issues, materials, functional specializations, and decorative techniques.

Shepard, Anna O., and Harry E. D. Pollock.
1286 1971. Maya Blue: An Updated Record. Notes from a Ceramic Laboratory, 4. 32 pp. Washington, D.C.: Carnegie Institution of Washington.

Technological study of a Maya pigment with special reference to its use in contemporary Maya ceramics in the Yucatan and its mention in ethnological records.

Shimbunsha, Yomiuri.
1287 1974. Tesoros maya de Guatemala. unpaginated, numerous plates. Guatemala City.

Catalog of an exhibit of Maya art held in Japan. Most objects from the Guatemala National Museum. Text in Spanish and Japanese. Useful principally for its fine color plates.

Shook, Edwin M.
1288 1940. Explorations in the ruins of Oxkintok, Yucatan. Revista Mexicana de Estudios Antropologicos 4, no. 3:165-71. 9 figs., 1 map.

Useful for site plan, architectural notes, and photographs of lintels, stelae, and doorway columns with figural reliefs.

1289 1954. A round temple at Mayapan, Yucatan. <u>Current Reports</u>
 2, no. 16:15-23. 2 figs. Washington, D.C.: Carnegie
 Institution of Washington.
 Report on an excavation. No features associate this
 structure with Quetzalcoatl.

1290 1954. The Temple of Kukulcan at Mayapan. <u>Current Reports</u>
 2, no. 20:89-103. 5 figs. Washington, D.C.: Carnegie
 Institution of Washington.
 Report on the excavation of a structure, also known as
 the Castillo, at this late Yucatan site.

1291 1956. An Olmec sculpture from Guatemala. <u>Archaeology</u>
 9:260-62. 5 figs.
 Small sculptural fragment of Olmec human-jaguar head
 with tight-fitting cap alleged to have come from El Baul area.

Shook, Edwin M., and Robert F. Heizer.
1292 1976. An Olmec sculpture from the south (Pacific) coast of
 Guatemala. <u>Journal of New World Archaeology</u> 1, no. 3:1-8.
 6 figs.
 Important Olmec low-relief round sculpture from an
 unknown area of the Pacific Piedmont is discussed and
 illustrated.

Shook, Edwin M., and William N. Irving.
1293 1955. Colonnaded buildings at Mayapan. <u>Current Reports</u> 2,
 no. 22:127-67. 7 figs. Washington, D.C.: Carnegie
 Institution of Washington.
 In-depth study of one architectural type and its mani-
 festations at this Late Post-Classic site in the Yucatan.
 Associated artifacts suggest ritual function for this
 architectural type.

Shook, Edwin M., and Alfred Kidder II.
1294 1961. The painted tomb at Tikal. <u>Expedition</u> 4, no. 1:2-7.
 8 figs.
 Early Classic burial 48 at Tikal is described and
 illustrated. Unique because of walls painted with large-scale
 glyphic inscription and the inclusion of Teotihuacan-related
 ceramics among the burial offerings.

Simpson, Jon Erik.
1295 1976. The New York relief panel--and some associations
 with reliefs at Palenque and elsewhere, Part I. <u>Segunda</u>
 <u>Mesa Redonda de Palenque</u>. Ed. M.G. Robertson. 95-105. 4
 figs. Pebble Beach, California: Robert Louis Stevenson
 School.
 Limestone lintel in the Metropolitan Museum is discussed
 in terms of iconography and epigraphy. The site of La Pasadita
 is suggested as its provenience.

Smith, A. Ledyard.
1296 1932. Two recent ceramic finds at Uaxactun. Contributions
 to American Archaeology 2, no. 5. 9 figs., 5 plates.
 Washington, D.C.: Carnegie Institution of Washington.
 Discussion of nine polychrome vessels.

1297 1934. Two recent ceramic finds at Uaxactun. Contributions
 to American Archaeology 2, no. 5:1-25. 9 figs., 5 plates.
 Washington. D.C.: Carnegie Institution of Washington.
 Report on finds from Classic Maya mortuary vaults at
 Uaxactun. Finds include several important polychrome plates and
 vases. Full color reproductions of several vessels.

1298 1937. Structure A-XVIII, Uaxactun. Contributions to
 American Archaeology 20:1-27. 24 plates. Washington, D.C.:
 Carnegie Institution of Washington.
 Archaeological study of a multichambered vaulted
 building at the Maya site of Uaxactun, Guatemala.

1299 1940. The corbelled arch in the New World. The Maya and
 Their Neighbors. Ed. Clarence L. Hay, et al. 202-21. 3
 figs. New York: D. Appleton-Century Company, Inc.
 Reprint. New York: Dover Publications, 1977.
 Origin and development, spread and distribution of the
 corbelled arch in Middle America. Other types of roofs
 considered briefly.

1300 1961. Types of ball courts in the highlands of Guatemala.
 Essays in Pre-Columbian Art and Archaeology. Ed. S. K.
 Lothrop, et al. 100-125. 9 figs. Cambridge: Harvard
 University Press.
 Typology of ballcourt architecture refined, with clear
 explanations of several different types. Useful table listing
 all known highland sites with courts.

1301 1965. Architecture of the Guatemalan highlands. Handbook
 of Middle American Indians 2. Ed. Gordon R. Willey. 76-94.
 8 figs. Austin: University of Texas Press.
 Survey of major architectural types focusing on the
 Post-Classic.

Smith, Harvey P.
1302 1975. A ballplayer from Mexico's past. The Masterkey 49,
 no. 1:30-33. 2 figs.
 Pre-Classic figurine with elaborate yoke and harness
 from West Mexico.

Smith, Mary Elizabeth.
1303 1963. The Codex Colombino: a document of the south coast
 of Oaxaca. Tlalocan 4, no. 3:276-88. 2 figs. Mexico:
 Universidad Nacional Autónoma de Mexico.

Discussion of a Mixtec codex. Based on internal evidence, the author suggests that it comes from the south coast of Oaxaca and is the south-coast version of a dynastic history also known from the Mixteca Alta in Codex Nuttall.

1304 1973. Picture Writing from Ancient Southern Mexico: Mixtec Place Signs and Maps. 348 pp., 164 figs. Norman: University of Oklahoma Press.
 Comprehensive study of Mixtec manuscripts, both pre-Hispanic and early colonial. Decipherment of numerous place signs. Helpful chapter on pictorial conventions of the Mixtec histories.

1305 1973. The relationship between Mixtec manuscript painting and the Mixtec language: a study of some personal names in Codices Muro and Sánchez Solís. Mesoamerican Writing Systems. Ed. E. P. Benson. 47-75. 12 figs., 11 plates. Washington, D.C.: Dumbarton Oaks.
 Specific pictorial motifs (principally name glyphs) in two Mixtec historical manuscripts are related to Mixtec words in the Alvarado and other dictionaries. Drawing styles, dating, and iconographic features are also considered.

1306 1979. Codex Becker II: a manuscript of the Mixteca Baja? Archiv für Völkerkunde 33:29-43. Vienna.
 Toponymic evidence for a northern Oaxaca/southern Puebla provenience for this manuscript.

Smith, Robert E.
1307 1955. Ceramic Sequence at Uaxactun, Guatemala. 2 Vols. Middle American Research Institute Publication no. 20. 214 pp., 86 figs. New Orleans: Tulane University.
 Important early sequence of excavated ceramics of the Maya. Excellent illustrations.

1308 1957. The Marquez collection of X fine orange and fine orange polychrome vessels. Notes on Middle American Archaeology and Ethnology 5, no. 131:135-81. 17 figs.
 A large Yucatecan collection of vessels, principally from Jaina and Huaymil is discussed and illustrated. Useful line drawings of design motifs.

1309 1957. Tohil plumbate and Classic Maya polychrome vessels in the Marquez collection. Notes on Middle American Archaeology and Ethnology 5, no. 129:117-30. 7 figs. Washington, D.C.: Carnegie Institute of Washington.
 A large Yucatecan collection of Post-Classic and Classic period Maya vessels is illustrated and discussed.

Smith, Robert E., and James C. Gifford.
1310 1965. Pottery of the Maya Lowlands. Handbook of Middle
 American Indians 2. Ed. Gordon R. Willey. 498-534. 16
 figs. Austin: University of Texas Press.
 Considers ceramic complexes of various subregions.
 Technical.

Smith, Tillie.
1311 1963. The main themes of "Olmec" art tradition. The
 Kroeber Anthropological Society Papers 28:121-213. 416
 hand-drawn figs. Berkeley.
 Descriptive study of the stylistic elements comprising
 the Olmec art style. Brief text; poorly drawn illustrations.

Solana, Nellie Gutierrez and Susan K. Hamilton.
1312 1977. Las esculturas en terracota de El Zapotal, Veracruz.
 251 pp., 77 black-and-white plates, 4 color plates.
 Mexico: Universidad Nacional Autónoma de Mexico.
 Study and catalog of Late Classic figural ceramics (many
 of exceedingly large scale) from El Zapotal in the Museo de
 Antropología de la Universidad Veracruzana in Xalapa.

Solís Olguín, Felipe R.
1313 1975. Estudio de los anillos del juego de pelota: el
 origen de este elemento. Proceedings of the 41st Interna-
 tional Congress of Americanists 1:252-61. 15 figs.
 Mexico.
 Discussion of ballcourt markers and rings from various
 sites and periods.

1314 1982. The formal pattern of anthropomorphic sculpture and
 the ideology of the Aztec state. The Art and Iconography of
 Late Post-Classic Central Mexico. Ed. Elizabeth Boone.
 73-110. 41 figs. Washington, D.C.: Dumbarton Oaks.
 More than three hundred Aztec anthropomorphic stone
 sculptures analyzed to determine the "formal constants."
 Figures divided into subgroups according to sex, apparel,
 accessories, and formal symmetry.

Sotomayor, Alfredo, and Noemí Castillo Tejero.
1315 1963. Estudio petrográfico de la cerámica "anaranjado
 delgado." Departamento de Prehistoria publicaciones, 12.
 21 pp., 10 plates. Mexico: Instituto Nacional de
 Antropología e Historia.
 In-depth scientific study of one type of pre-Columbian
 pottery, its petrochemical makeup, and the sites at which it is
 found.

Soustelle, Jacques.
1316 1966. Terrestrial and celestial gods in Mexican antiquity.
 Diogenes 56:20-50.

Survey of religions in Central Mexico from Pre-Classic to the conquest, with some remarks on the ethnographic present. Maya religion is briefly contrasted with that of Central Mexico. No illustrations.

1317 1967. <u>Mexico</u>. 285 pp., 79 color figs., 105 black-and-white figs. Cleveland: The World Publishing Co.
Survey of Mexican art and culture. Many fine plates.

1318 1967. <u>Arts of Ancient Mexico</u>. 160 pp., 42 figs., 206 plates, some in color. London: Thames and Hudson.
Focuses more closely on art than his other 1967 volume.

Spence, Lewis.
1319 1923. <u>The Gods of Mexico</u>. 388 pp., profusely illustrated. London: T. F. Unwin.
Detailed study of ancient Mexican gods, using all artistic media for evidence of their characteristics.

Spinden, Herbert J.
1320 1910. The chronological sequence of the principal monuments of Copan (Honduras). <u>Proceedings of the 17th International Congress of Americanists</u> 2:357-63. 1 fig., 7 plates. Buenos Aires.
Stelae were arranged in groups according to their figural proportion and other formal attributes. A progressive distortion of the human figure over time was found. Includes useful table of dated monuments and their formal characteristics. This material incorporated into his 1913 study.

1321 1913. The picture writing of the Aztecs. <u>American Museum Journal</u> 13:31-37. New York: American Museum of Natural History.
A popular account.

1322 1913. <u>A Study of Maya Art</u>. Memoirs of the Peabody Museum 6. 285 pp., 286 figs., 29 plates. Harvard University. Reprint. New York: Dover Publications, 1975.
Important early study of Classic Maya art, architecture, and iconography. Chronology is outdated, but much of the work is still useful.

1323 1915. Recent progress in the study of Maya art. <u>Proceedings of the 19th International Congress of Americanists</u>. 165-77. 13 figs., 2 plates. Washington, D.C..
Explains that the sequence of "natural artistic development" seen in Maya monuments is often correlated by the dates inscribed on the monuments. Analyzes dragon motifs and ceremonial bars on sculpture at Quirigua, Copan, and elsewhere.

Architectural proportion at Yaxchilan briefly considered as well.

1324 1935. Indian manuscripts of southern Mexico. <u>Annual Report of the Smithsonian Institution for 1933</u>. 429-51. 14 figs., 3 plates. Washington.

 Discusses chronology and historical nature of Bodley, Nuttall, Selden, and Vienna codices from the Mixtec area.

1325 1937. Huaxtec sculptures and the cult of apotheosis. <u>Brooklyn Museum Quarterly</u> 24, no. 4:178-88. 7 figs.

 Discussion of provenience and meaning of two Huaxtec stone sculptures, one male and one female, owned by the Brooklyn Museum. Spinden suggests that they represent the deification of mortals.

1326 1957. <u>Maya Art and Civilization</u>. 432 pp., 372 figs., 94 plates, numerous tables. Indian Hills, Colorado: The Falcon's Wing Press.

 Survey of Maya art and culture. First part of the book is a reprinting of the author's Harvard dissertation (1913). The second part is a survey of Maya and related cultures, and a discussion of the Maya calendar.

Spranz, Bodo.

1327 1964. <u>Göttergestalten in den mexikanischen Bilderhandschriften der Codex Borgia-Gruppe (eine ikonographische untersuchung)</u>. 32 plates, 1791 figs. Wiesbaden: Franz Steiner Verlag. Translated as <u>Los dioses en los códices mexicanos del grupo Borgia</u>. Mexico: Fondo de Cultura Económica, 1973.

 Thorough study of gods and the distinctive features of their dress, hairdo, emblems, etc. in codices of the Borgia Group. Iconographic units and insignia that define each deity are itemized.

1328 1973. Late Classic figurines from Tlaxcala, Mexico, and their possible relation to the Codex Borgia-Group. <u>Meso-american Writing Systems</u>. Ed. E. P. Benson. 217-26. 21 figs. Washington, D.C.: Dumbarton Oaks.

 Pottery figures from a mound at Xochitecatl, Tlaxcala, were found to be of Metepec-phase Teotihuacan style. Figurines thought to represent goddesses known from later codices, principally Xochiquetzal and Tlazolteotl. Xochitecatl site as early stratum of Mixteca-Puebla culture.

1329 1982. Archaeology and the art of Mexican picture writing. <u>The Art and Iconography of Late Post-Classic Central Mexico</u>. Ed. Elizabeth Boone. 159-173. 5 figs. Washington, D.C.: Dumbarton Oaks.

Deities and implements pictured in the codices are iden-
tified in ceramic figurines and objects found in archaeological
contexts. Author suggests that further inquiry in this
direction will better pinpoint the dates and places of origin of
certain manuscripts.

Spranz, Bodo, D. E. Dumond, and P. P. Hilbert.
1330 1974. Die Pyramiden vom Cerro Xochitecatl, Tlaxcala
 (Mexico). 109 pp., 37 plates, 13 figs. Wiesbaden.
 Essays by the three authors focus on ceramics of Pre-
 Classic and Late Classic type, and Teotihuacan-style figurines
 found at one site in Tlaxcala. Text partly in English, partly
 German, summaries in Spanish.

Starr, Frederick.
1331 1897. Stone images from Tarascan territory, Mexico.
 American Anthropologist o.s. 10, no. 1:45-47. 2 plates.
 Brief notes on crude figural monuments from Michoacan
 and Jalisco.

Stern, Jean.
1332 1973. Feathered serpent motif on ceramics from Nayarit.
 Pre-Columbian Art History. Ed. Alana Cordy-Collins and
 Jean Stern. 139-44. 6 figs. Palo Alto: Peek
 Publications, 1977.
 Stylistic and iconographic identification of one motif
 on Amapa pottery.

1333 1973. A carved spindle whorl from Nayarit. The Masterkey
 47, no. 4:143-48. 4 figs. Reprinted in Pre-Columbian Art
 History. Eds. Alana Cordy-Collins and Jean Stern. 135-
 38. 4 figs. Palo Alto: Peek Publications, 1977.
 Serpentine spindle whorl said to be from Sentispac,
 Nayarit is discussed. Low-relief carving of stylized feathered
 serpent resembles designs found on Amapa pottery.

Stirling, Matthew W.
1334 1940. Great stone faces of the Mexican jungle. National
 Geographic Magazine 78, no. 3:309-34. 27 figs.
 Popular account of finds of monumental Olmec sculpture
 at Tres Zapotes and La Venta.

1335 1941. Expedition unearths buried masterpieces of carved
 jade. National Geographic 80, no. 3:277-302. 15 black-
 and-white figs., 8 color plates.
 Popular account of excavations at Cerro de las Mesas,
 Veracruz. Focuses on the discovery of stone monuments and a
 cache of 787 pieces of jade.

1336 1943. La Venta's green stone tigers. National Geographic
 Magazine 84, no. 3:321-28. 4 figs.

Popular account of unearthing the greenstone mosaic masks at La Venta. Dating now is inaccurate, but details of the finds are interesting.

1337 1943. Stone Monuments of Southern Mexico. Bureau of American Ethnology Bulletin no. 138. 84 pp., 14 figs., 62 plates. Washington, D.C.: Smithsonian Institution.
Illustration and discussion of stelae and monuments at Tres Zapotes, Cerro de las Mesas, La Venta, and Izapa.

1338 1955. Stone Monuments of the Rio Chiquito, Veracruz, Mexico. 1-23. Bureau of American Ethnology Bulletin no. 157. 1 fig., 26 plates. Washington, D.C.: Smithsonian Institution.
Olmec-style monumental sculpture, principally from San Lorenzo and Portrero Nuevo.

1339 1961. The Olmecs, artists in jade. Essays in Pre-Columbian Art and Archaeology. Ed. S. K. Lothrop, et al. 43-59. 10 figs. Cambridge: Harvard University Press.
Fine review of the basics of Olmec jade styles. Discussion of techniques by an Olmec scholar who excavated many of the pieces.

1340 1965. Monumental sculpture of Southern Veracruz and Tabasco. Handbook of Middle American Indians 3. Ed. Gordon R. Willey. 716-38. 29 figs. Austin: University of Texas Press.
Focuses principally on the Olmec period with some discussion of the Classic period.

1341 1968. Early history of the Olmec problem. Dumbarton Oaks Conference on the Olmec. Ed. E. P. Benson. 1-8. Washington, D.C.: Dumbarton Oaks.
Brief historiography of Olmec archaeology and art scholarship from 1862 to 1950. Only late in this period were the Olmec seen as a separate culture.

1342 1968. Three sandstone monuments from La Venta Island. Contributions of the University of California Archaeological Research Facility 5, no. 2:35-36. 3 plates. Berkeley.
Announcement of the excavation of sandstone monuments A, B, and C on the periphery of the La Venta site.

Stirling, Matthew W., and Marion Sterling.
1343 1942. Finding jewels of jade in the Mexican swamp. National Geographic Magazine 82, no. 5: 635-61. 29 plates.
Popular discussion of excavations at La Venta, with notes on ethnography and the Maya site of Palenque.

Stocker, Terry, Sarah Meltzoff, and Steve Armsey.
1344 1980. Crocodilians and Olmecs: further interpretations in
 formative period iconography. American Antiquity 45, no.
 4:740-58. 5 figs.
 An ecological approach to religious iconography suggests
 the meaning of reptilian forms in Olmec and later art.

Stocker, Terrance L., and Michael S. Spence.
1345 1973. Trilobal eccentrics at Teotihuacán and Tula.
 American Antiquity 38, no. 2:195-99. 1 fig.
 M-shaped eccentric chipped stones found both at
 Teotihuacan and Tula. Same symbol appears in murals and low
 reliefs at these sites. Authors argue for continuity of
 tradition between the two central Mexican sites.

Stone, Doris.
1346 1970. An interpretation of Ulua polychrome ware.
 Proceedings of the 38th International Congress of
 Americanists 2:67-76. 7 figs. Münich.
 Salient characteristics of this ware from northwestern
 Honduras. Remarks on subject matter and style. Fusion of
 Nahuatl and Maya traits.

1347 1982. Cultural radiations from the central and southern
 highlands of Mexico into Costa Rica. Aspects of the
 Mixteca-Puebla Style and Mixtec and Central Mexican Culture
 in Southern Mesoamerica. 61-70. Middle American Research
 Institute Occasional Paper no. 4:. 15 figs. New Orleans:
 Tulane University.
 Fundamental traits shared by Post-Classic Mexico and
 Costa Rica are discussed. Focus on pottery and metal objects.

Strebel, Hermann.
1348 1885. Alt-Mexico. Archäologische Beiträge zur Kultur-
 geschichte Seiner Bewohner. 144 pp., 19 plates, 1 table.
 Hamburg and Leipzig: Leopold Voss.
 Early study of archaeological material from diverse
 parts of Mexico. Focus on small-scale ceramic and stone
 objects.

1349 1890. Studien über Steinjoche aus Mexico und Mittel
 Amerika. Internationales Archiv für Ethnographie 3:49-61.
 4 plates, 2 figs. Leiden.
 Fine illustration and description of a large number of
 stone yokes principally from European museums. Classification
 by formal properties.

Stresser-Péan Guy, Alain Ichon, and Yves Guidon.
1350 1963. La première statue antique en bois découverte dans
 la Huaxteca. Journal de la Société des Américanistes de
 Paris n.s. 52:315-18. 1 fig. Paris.

Discussion of an 85-cm. badly eroded wooden statue of a nude male figure with pronounced sexual organs. Provenience unknown, Post-Classic date proposed.

Stromsvik, Gustav.
1351 1952. The ballcourts at Copan. Contributions to American Anthropology and History 11, no. 55:183-214. 23 figs. Washington, D.C.: Carnegie Institution of Washington.

Discussions and detailed section drawings of three courts at this Maya site. Related sculpture and courts and markers at four other sites in the region are included. (La Union, Quirigua, San Pedro Pinula and Asuncion Mita.)

Sturdevant, William D.
1352 1973. The world of Aztec sculpture. Archaeology 26, no. 1:10-15. 8 figs.

Short survey article discussing several familiar monuments. The role of the artist is briefly considered.

Sullivan, Thelma.
1353 1976. The mask of Itztlacol-iuhqui. Proceedings of the 41st International Congress of Americanists 2:252-62. 10 figs.

Iconographic and textual examination of the many facets of the god "Curved Obsidian Knife" who wears a thigh-skin mask and conical curved headpiece.

1354 1982. Tlazolteotl-Ixcuina: the great spinner and weaver. The Art and Iconography of Late Post-Classic Central Mexico. Ed. Elizabeth Boone. 7-35. 21 figs. Washington, D.C.: Dumbarton Oaks.

Based on linguistic and codical evidence, the author discusses one Aztec goddess from her Huaxtec genesis through her numerous variant aspects.

Taladoire, Eric.
1355 1979. Ball-game scenes and ballcourts in West Mexican archaeology. Indiana 5:33-43. 2 tables. Berlin: Ibero-Amerikanisches Institut Preussischer Kulturbesitz.

Typology and chronology of ballcourts in West Mexico and their relationship to ballcourts in the American southwest.

Tapia, Rafael Orellana.
1356 1955. Nueva lapida Olmecoide de Izapa, Chiapas. El México Antiguo 8:157-68. 7 figs.

The iconography of Izapa stela 21 is analyzed. Similarities with Toltec monuments depicting decapitation are discussed.

Tate, Carolyn.
1357 1982. The Maya Cauac monster's formal development and
 dynastic contexts. Pre-Columbian Art History: Selected
 Readings. Second edition. Ed. A. Cordy-Collins. 33-54.
 9 figs. Palo Alto: Peek Publications.
 Iconographic study of a common monster-mask theme in
 Maya art. Author shows the image to present multiple referents
 to cyclic phenomena, earth, rain, fertility, and dynastic links
 to God K.

Taylor, Dicey.
1358 1979. The Cauac Monster. Tercera Mesa Redonda de
 Palenque. Eds. M. G. Robertson and D. C. Jeffers. 79-90.
 10 figs. Monterey, California.
 A study of the dragonlike creature associated with rain,
 lightning, and vegetation as it appears in Maya art of the
 Classic period. Particular attention is paid to vase painting.
 The roots of this imagery in the Pre-Classic period and the
 function of the Cauac monster as both support and enclosure is
 considered.

1359 1982. Problems in the study of narrative scenes on Classic
 Maya vases. Falsifications and Misreconstructions of Pre-
 Columbian Art. Ed. Elizabeth Boone. 107-24. 14 figs.
 Washington, D.C.: Dumbarton Oaks.
 Issues in the restoration of Maya polychrome ceramics.
 Study of repainted vases presents problems in accurate analysis
 of style, iconography, and epigraphy.

Taylor, Walter
1360 1941. The ceremonial bar and associated features of Maya
 ornamental art. American Antiquity 7, no. 1:48-63. 8
 figs.
 The ceremonial bar, bar pendant, and architectural
 frieze mask are seen as three aspects of a single symbolic
 complex. Geographic and cultural development and shift of these
 forms are noted.

Tejeda, Antonio.
1361 1947. Drawings of Tajumulco sculptures. Notes on Middle
 American Archaeology and Ethnology 3, no. 77:107-21. 14
 figs. Washington, D.C.: Carnegie Institution of
 Washington.
 Pencil drawing of sculptures from a site in San Marcos,
 Guatemala.

1362 1955. Ancient Maya Paintings of Bonampak, Mexico.
 Carnegie Institution of Washington Supplementary
 Publication no. 46. 36 pp., 3 fold-out color plates.
 Washington, D.C.: Carnegie Institution of Washington.

Useful color reproducions of the frescos at Bonampak and a brief pamphlet describing their content.

Tellenbach, Michael.
1363 1977. Algunas consideraciones sobre la "Estela C" y su complemento, la "Estela Covarrubias," de Tres Zapotes, Veracruz. <u>Indiana</u> 4:63-74. 7 figs. Berlin: Ibero-Amerikanisches Institut Preussischer Kulturbesitz.
 Author contends that two Olmec sculptures are actually the broken pieces of one monument. Discussion of calendrical data.

<u>Tenayuca: Estudio arqueológico de la Pirámide de este lugar.</u>
1364 1935. 351 pp., profusely illustrated. Mexico: Talleres gráficos del Museo Nacional de Arqueología, Historia y Etnografia.
 Excavation report for this Aztec site. Useful for its voluminous illustrations, architectural plans, and maps.

Tentori, Tullio.
1365 1961. <u>La pittura Precolombiana</u>. 287 pp., numerous black-and-white text figures, 26 color plates. Milan: Societa Editrice Libraria.
 Useful survey of the painting traditions of North, Middle, and South America. Wall painting, vase painting, manuscripts, and cloth are considered.

Termer, Franz.
1366 1973. <u>Palo Gordo: Ein Beitrag zur Archäologie des pazifischen Guatemala</u>. Monographien zur Völkerkunde, 8. 251 pp., 144 figs., 24 plates. Munich: Hamburgischen Museum für Völkerkunde.
 Monograph on the site, structures, stone monuments, and ceramics of this site in the piedmont of southern Guatemala.

Thomas, Cyrus.
1367 1884. Notes on certain Maya and Mexican manuscripts. <u>Bureau of American Ethnology, Third Annual Report, 1881-1882</u>. 3-65. Washington, D.C.: Smithsonian Institution.
 Observations on several codices. Mostly calendrical in nature.

1368 1888. Aids to the study of the Maya codices. <u>Bureau of American Ethnology, Sixth Annual Report, 1884-1885</u>. 253-371. Washington, D.C.: Smithsonian Institution.
 Comments on Dresden and Madrid manuscripts. Mainly concerned with numbers and dates.

Thompson, Edward H.
1369 1897. <u>Explorations of the Cave of Loltun, Yucatan</u>. Memoirs of the Peabody Museum 1, no. 2. 22 pp., 8 plates. Cambridge: Harvard University.

Maya pottery and pre-Maya stone reliefs in a Yucatec cave.

1370 1902. The mural paintings of Yucatán. <u>Proceedings of the 13th International Congress of Americanists</u>. 189-92. New York.
 Brief description of coloration and state of preservation of some Maya murals.

1371 1904. <u>Archaeological Researches in Yucatan</u>. Memoirs of the Peabody Museum 3, no. 1. 20 pp., 11 figs., 6 black-and-white plates, 3 color plates. Cambridge: Harvard University.
 A number of Maya sites in the Uxmal area are surveyed. Color plates of murals at Chacmultan and Tzulá.

1372 1911. The genesis of the Maya arch. <u>American Anthropologist</u> n.s. 13:501-16. 16 figs., 1 plate.
 Indigenous developmental process from native palm. Thatched house to complex stone structures. Discusses the building process of Maya thatched structure.

Thompson, J. Eric S.
1373 1934. Sky bearers, colors, and directions in Maya and Mexican religion. <u>Contributions to American Archaeology</u> 2, no. 10:209-42. 5 plates. Washington, D.C: Carnegie Institution of Washington.
 Ethnohistoric texts and prehistoric imagery, especially in the codices, used to eludicate the interrelationships of directional gods and directional colors.

1374 1939. The Moon Goddess in Middle America. <u>Contributions to American Anthropology and History</u> 5, no. 29:121-73. 5 figs. Washington, D.C.: Carnegie Institution of Washington.
 A thorough iconographic, ethnohistoric, and hieroglyphic study of the moon goddess, her symbols, and related deities in both the Mexican and Maya traditions.

1375 1941. The missing illustrations of the Pomar Relación. <u>Notes on Middle American Archaeology and Ethnology</u> 1, no. 4:15-21. 4 figs. Washington, D.C.: Carnegie Institution of Washington.
 Analysis of illustrations to a document of 1582 in which Aztec gods and customs are discussed.

1376 1941. The prototype of the Mexican codices Talleriano-Remensis and Vaticanus A. <u>Notes on Middle American Archaeology and Ethnology</u> 1, no. 6:24-26. Washington, D.C.: Carnegie Institution of Washington.

Argues that both manuscripts derive independently from an earlier lost prototype.

1377 1941. Yokes or ball game belts? American Antiquity 6, no. 4:320-26. 1 fig.
Depictions on carved monuments of figures wearing stone "yokes" more likely depict a type of lighter weight belt that was part of ballgame attire.

1378 1942. Representations of Tezcatlipoca at Chichen Itza. Notes on Middle American Archaeology and Ethnology 1, no. 12:48-50. Washington, D.C.: Carnegie Institution of Washington.
Depictions of five figures with amputated legs at this Yucatan site are said to be warriors wearing the insignia of the Central Mexican god Smoking Mirror.

1379 1943. An Archaeological Reconnaissance in the Cotzumalhuapa Region, Escuintla, Guatemala. 1-56. Carnegie Institution of Washington Publication no. 44. 63 figs. Washington, D.C.: Carnegie Institution of Washington.
Archaeology, sculpture, architecture, and ceramics of non-Maya style in southern Guatemala. Mexican domination of this region suggested. Important early discussion of this region.

1380 1943. A figurine whistle representing a ball-game player. Notes on Middle American Archaeology and Ethnology 1, no. 25:160-62. 1 fig. Washington, D.C.: Carnegie Institution of Washington.
Unusual figurine discovered in Quintana Roo.

1381 1943. Representations of Tlalchitonatiuh at Chichen Itza, Yucatan, and at Baul, Escuintla. Notes on Middle American Archaeology and Ethnology 1, no. 19:117-21. Washington, D.C.: Carnegie Institution of Washington.
Iconographic connections between warriors and the sun god in sculptural art of two sites.

1382 1943. Some sculptures from southeastern Quezaltenango, Guatemala. Notes on Middle American Archaeology and Ethnology 1, no. 17:100-112. 3 figs. Washington, D.C.: Carnegie Institution of Washington.
Cotzumalhuapa-type and earlier Izapa-type sculpture is recorded.

1383 1945. A survey of the Northern Maya Area. American Antiquity 11, no. 1:2-24, 2 figs. 4 plates.
Important survey article on the sites, pottery, dates, architecture, and monuments of the various style regions (Puuc, Chenes, Rio Bec, etc.) of the Yucatan peninsula. Succinct summary of defining features.

1384 1952. Aquatic symbols common to various centers of the
 Classic period in Meso-America. <u>Proceedings of the 29th</u>
 <u>International Congress of Americanists</u> 2:31-36, 1 fig.
 The aquatic references of turquoise, owl, and jaguar
 symbols occuring at different sites emphasis the underlying
 unity of Classic period cultures.

1385 1957. Deities portrayed on censers at Mayapan. <u>Current</u>
 <u>Reports</u> 2, no. 40:599-632. 4 figs. Washington, D.C.:
 Carnegie Institution of Washington.
 Useful study of extremely ornate ceramic figural incense
 burners excavated at a Late Post-Classic Yucatan site.

1386 1961. A blood-drawing ceremony painted on a Maya vase.
 <u>Estudios de Cultura Maya</u> 1:13-20. 1 fig.
 Maya cylindrical vase at the University Museum, Pennsyl-
 vania, in which a row of crouching men draw blood from their
 penises and blood drops onto paper. Brief survey of
 ethnohistorical literature on such practices.

1387 1961. Notes on a plumbate vessel with shell inlay and on
 Chiclero's ulcer. <u>Essays in Pre-Columbian Art and Archae-</u>
 <u>ology</u>. Ed. S. K. Lothrop, <u>et al</u>. 171-75. 1 fig.
 Cambridge: Harvard University Press.
 Brief note on dog-shaped plumbate vessel acquired by the
 Cambridge University Museum. Vessel has inlaid eyes and one
 lacerated ear tip--a common Central American type of ulcer
 depicted in art.

1388 1963. Pictorial synonyms and homonyms in the Maya Dresden
 Codex. <u>Tlalocan</u> 4, no. 2:148-56. Mexico: Universidad
 Nacional Autónoma de Mexico.
 Discussion of "rebus pictures" or pictorial synonyms for
 textual references in one Maya manuscript.

1389 1964. Ayopechtli, an aspect of the Nahua goddess of the
 Maguey. <u>Proceedings of the 36th International Congress of</u>
 <u>Americanists</u> 2:103-6. 4 plates.
 Ayopechtli and Atlacoaya discussed as aspects of
 Mayauel. Variant iconographic features of these maguey-related
 goddesses are mentioned.

1390 1965. A copper ornament and stone mask from Middle
 America. <u>American Antiquity</u> 30, no. 3:343-45. 1 fig.
 Evidence that the Maya cast copper is found in a small
 metal mask that has been in the British Museum since the
 nineteenth century. The authenticity of an Olmecoid stone mask
 also from the British Museum is supported.

1391 1966. Merchant gods of Middle America. <u>Summa</u>
 <u>antropológica en homenaje a Roberto J. Weitlaner</u>. 159-72.

2 figs. Mexico City: Instituto Nacional de Antropología y Historia.

Both Maya and Mexican sources considered for a study of gods associated with commerce and travel.

1392 1969. An Olmec mask from the Maya Lowlands. American Antiquity 34, no. 4:478-80. 3 figs.

Small greenstone mask in the Gann collection at the British Museum is described. It is said to have come from the Peten.

1393 1970. The Bacabs: their portraits and their glyphs. Peabody Museum Papers 61:469-85. 19 figs. Cambridge: Harvard University.

Sky-bearer gods and their iconography in Maya sculpture, pottery, and manuscripts.

1394 1972. A Commentary on the Dresden Codex. 156 pp., 45 color plates. Philadelphia: The American Philosophical Society.

Scholarly study of all aspects of this Maya manuscript. Especially detailed discussion of glyphic passages. Useful for its color plates of the manuscript. So far, the definitive study.

1395 1973. Maya rulers of the Classic period and the divine right of kings. The Iconography of Middle American Sculpture. 52-71. 10 figs. New York: The Metropolitan Museum of Art.

Ethnohistory, archaeology, and art suggest that the Classic Maya deified the founders of royal lineages. Itzam Na as patron deity of the ruling class.

1396 1973. The painted capstone at Sacnicte, Yucatan, and two others at Uxmal. Indiana 1:59-64. 2 black-and-white figs., 1 color fig. Berlin: Ibero-Amerikanisches Institut Preussischer Kulturbesitz.

Male figure and dwarf on Maya painted capstone. Author reviews evidence for painted capstones at other Maya sites.

1397 1975. The Grolier Codex. Contributions of the University of California Archaeological Research Facility 27, no. 1:1-9. Berkeley.

Thompson's remarks on the new Maya codex, which he believes to be a forgery.

1398 1977. Hallucinatory drugs and hobgoblins in the Maya lowlands. Tlalocan 7:295-308. Mexico: Universidad Nacional Autónoma de Mexico.

Evidence for mushroom cult among the ancient Maya based on archaeological and ethnological sources. Evidence for ghostlike figures in Cotzumalhuapan art and Maya ethnography.

Thompson, J. Eric S., Harry E. D. Pollock, and Jean Charlot.
1399 1932. <u>A Preliminary Study of the Ruins of Cobá</u>. 213 pp.,
 70 figs., 18 plates, 5 maps. Carnegie Institution of
 Washington Publication no. 424. Washington, D.C.:
 Carnegie Institution of Washington.
 Important early study of the architecture and carved mo-
 numents at this Maya site.

Thomsen, Erich G., and Harriette H. Thomsen.
1400 1970. Pre-Columbian obsidian ear-spools: an investigation
 of possible manufacturing methods. <u>Contributions of the
 University of California Archaeological Research Facility</u>
 8, no. 4:41-53. 3 figs., 1 plate. Berkeley.
 Techniques of working with such fragile, brittle
 material.

Thomson, Charlotte.
1401 1971. <u>Ancient Art of the Americas from New England
 Collections</u>. 140 pp., 145 figs. Boston: Museum of Fine
 Arts.
 Exhibit catalog, principally of small-scale objects in
 clay of both Middle and South America.

Tobriner, Stephen.
1402 1972. The fertile mountain: an investigation of Cerro
 Gordo's importance to the town plan and iconography of Teo-
 tihuacán. <u>Teotihuacán, Onceava Mesa Redonda</u> 2:103-15.
 Mexico: Sociedad Mexicana de Antropología.
 Water and mountain imagery in the art of Teotihuacan and
 its relationshp to the mountain with springs that rises behind
 the Pyramid of the Moon.

Tompkins, J. B.
1403 1942. Codex Fernandez Leal. <u>Pacific Art Review</u> 2:39-59.
 12 black-and-white plates.
 Illustration and description of Mixtec codex in the col-
 lection of the Bancroft Library, University of California.
 According to the author, this codex seems to tell same story as
 Codex Diaz in Mexico City. Leal was first published by Peñafiel
 in 1895.

Tompkins, Peter.
1404 1976. <u>Mysteries of the Mexican Pyramids</u>. 427 pp.,
 profusely illustrated. New York: Harper and Row.
 Interesting history of the exploration of Mesoamerican
 sites, from ancient explorers to recent archaeological projects.
 Author stresses importance of architectural layout and
 archaeoastronomy. Author also gives some weight to fanciful
 theories about the origins of New World societies.

Torre, Ernesto de la.
1405 1960. El arte prehispánico y sus primeros críticos
 europeos. Homenaje a Rafael Garcia Granados. 259-318.
 Mexico.
 Extended discussion of Dürer's response to the pre-
 Hispanic objects he saw in Europe in the sixteenth-century.
 Quotes from many sixteenth-century Europeans who discussed the
 arts of their New World colony and detailed lists of art objects
 and textiles sent as tribute to Europe and offered to particular
 churches and individuals in New Spain.

Toscano, Salvador.
1406 1943. Los Codices Tlapanecas de Azoyu. Cuadernos
 Americanos 10, no. 4:127-41. 5 figs.
 Post-conquest genealogical lienzos from Guerrero are
 illustrated and discussed.

1407 1944. Arte precolombino de México y de la América Central.
 Institute de Investigaciones Estéticas. México:
 Universidad Nacional de México. (Third edition, 1970,
 updated by Beatriz de la Fuente.) 286 pp., 293 black-and-
 white illustrations, 21 color plates.
 Important early survey of the field. Chapters organized
 by artistic media.

1408 1945. Informe sobre la existencia de jugadores de pelota
 mayas en la cerámica escultórica de Jaina. Notes on Middle
 American Archaeology and Ethnology 2, no. 54:182-84. 1
 fig. Washington, D.C.: Carnegie Institution of
 Washington.
 Ballplayer costumes on Jaina figurines.

1409 1947. Los murales de Bonampak. Revista Mexicana de
 Estudios Antropológicos 9:5-9. 7 plates.
 Brief discussion of these Maya paintings soon after
 their discovery. Useful for several watercolor reproductions of
 the murals though these reproductions have simplified some
 details.

1410 1948. Pirámides de Mexico. Colección anahuac de arte
 mexicano, 10. 68 pp., 60 black-and-white figs. Mexico.
 Brief guide to the varieties of pyramids found at
 Mexican archaeological sites. Text in English, Spanish, French,
 Italian.

Totten, George O.
1411 1926. Maya Architecture. 250 p., 204 figs. Washington,
 D.C.: The Maya Press.
 Important early survey of the varieties of Maya
 architecture. Strongest on sites in the Yucatan.

Townsend, Richard.
1412 1979. State and Cosmos in the Art of Tenochtitlan.
 Dumbarton Oaks Studies in Pre-Columbian Art and
 Archaeology, 20. 78 pp., 33 figs. Washington, D.C.
 A valuable essay on some major themes in the art and
 politico-religious ideology of the Aztecs. Important sections
 on "the meaning and function of cult effigies" and "cosmic
 symbols and commemorative monuments."

1413 1982. Malinalco and the lords of Tenochtitlan. The Art and
 Iconography of Late Post-Classic Central Mexico. Ed.
 Elizabeth Boone. 111-40. 16 figs. Washington, D.C.: Dum-
 barton Oaks.
 Rock cut temple at Malinalco interpreted as an
 "architectural ideogram" of Mexica ideas about imperial
 rulership and authority. Malinalco as a site of communion with
 chthonic forces.

1414 1982. Pyramid and sacred mountain. Ethnoastronomy and
 Archaeoastronomy in the American Tropics. Ed. A. Aveni and
 G. Urton. Annals of the New York Academy of Sciences
 385:37-62. 12 figs.
 Form and symbolism of the pyramid of Tenochtitlan and
 the sacred hill of Tetzcotzingo as clues to the cultural and
 religious values of the Aztec empire.

Tozzer, Alfred. M.
1415 1911. A Preliminary Study of the Prehistoric Ruins of
 Tikal, Guatemala. Memoirs of the Peabody Museum 5, no. 2.
 42 pp., 30 figs., 2 plates. Cambridge: Harvard
 University.
 Supplements Maler's 1911 work in the same volume.
 Focuses on architecture.

1416 1913. A Preliminary Study of the Prehistoric Ruins of
 Nakum, Guatemala. Memoirs of the Peabody Museum 5, no. 3.
 60 pp., 54 figs., 23 plates. Cambridge: Harvard
 University.
 Important early study of this Maya site. Focus on
 architecture.

1417 1930. Maya and Toltec figures at Chichen-Itzá.
 Proceedings of the 23rd International Congress of
 Americanists. 155-64. 9 figs. New York.
 Early discussion of the historical character of the
 frescoes and sculptures of Chichen Itza. Much of this
 information was incorporated into his 1957 encyclopedic volume.

1418 1957. Chichen Itza and Its Cenote of Sacrifice. Memoirs of
 the Peabody Museum, 11 and 12. 230 pp., 709 figs.
 Cambridge: Harvard University Press.

Important and wide-ranging study of art at Chichen Itza, encompassing Maya and Toltec history, religion, and cult practice.

Tozzer, Alfred M., and Glover M. Allen.
1419 1910. Animal figures in the Maya Codices. Papers of the Peabody Museum of American Archaeology and Ethnology 4, no. 3:275-372. 39 plates, 24 figs. Harvard University.
 Zoological identification and ethnological information of all animal forms appearing in the three Maya manuscripts. Much comparative material from Central Mexico is included.

Treasures of Pre-Columbian Art: Collection of Janos Szekeres.
1420 1980. Utica, New York, 64 pp., 25 black-and-white, 12 color illustrations.
 Small-scale stone objects, many of Olmec manufacture. Some Maya vases and figurines. Brief essay by P. D. Joralemon.

Trebbi del Trevigiano, Romolo.
1422 1957. Premesse per una storia dell'arte precolombiana. Critica d'Arte 19:22-31. 10 figs.
 General remarks on the notion of art and pre-Hispanic art objects with reference to many media.

1423 1958. Personalitá e scuole di architetti e scultori maya a Palenque. Critica d'Arte 28:246-85. 53 black-and-white plates.
 Attempt to delineate individuality of hands in the sculpture and architecture of sixth- to eighth-century Palenque. Makes a case for the hands of individual masters, such as "maestro della croce," "maestro dei volti," "maestro dei rilievi tardi."

Trik, Aubrey S.
1424 1939. Temple XXII at Copan. Contributions to American Anthropology and History 5 no. 27:83-103. 15 plates, 11 figs. Washington, D.C.: Carnegie Institution of Washington.
 Archaeological study of one Maya temple at Copan, Honduras, its architecture and architectural sculpture (built before 9.17.0.0.0.).

Troike, Nancy.
1425 1969. Observations on the physical form of the Codex Becker I. Archiv für Völkerkunde 23:177-82. Vienna.
 Series of measurements made on this manuscript and remarks on its physical conditions.

1426 1970. Observations on some material aspects of the Codex Colombino. Tlalocan 6, no. 3:240-52. 1 table. Mexico: Universidad Nacional Autónoma de Mexico.

Precise measurements and notes on the physical condition
of this Mixtec codex. Based on physical observation, author
asserts that no pages have been lost between fragments II and
III.

1427 1970. A study of some stylistic elements in the Codex
 Colombino-Becker. Proceedings of the 38th International
 Congress of Americanists 2:167-71. Stuttgart-Munich.
 Three artistic styles in the depiction of human figures
in one Mixtec manuscript are provisionally identified.

1428 1971. The structure of the Codex Colombino-Becker. Anales
 (ser. 7a) 2:181-205. 10 figs. Mexico: Instituto Nacional
 de Antropología e Historia.
 Aspects of the physical structure of one Mixtec manu-
script seen as important to the reading of the manuscript.
Detailed discussion of page patterns and pictorial continuity.

1429 1978. Fundmental changes in the interpretations of the
 Mixtec Codices. American Antiquity 43, no. 4:553-68.
 Important article that surveys current manuscript
research. Suggests new chronology, clarification of mythic
versus human history, nature of deities, linguistic
affiliations, place signs, names, etc. Cautions that much
previous research is outdated and inaccurate.

1430 1979. Preliminary notes on stylistic patterns in the Codex
 Bodley. Proceedings of the 42nd International Congress of
 Americanists 7:182-92. Paris.
 Utility of stylistic analysis for determining the
pictorial nuances of form and content. Useful survey of the
conventions of this one Mixtec manuscript, especially for the
nonspecialist.

1431 1982. The interpretation of postures and gestures in the
 Mixtec codices. The Art and Iconography of Late Post-
 Classic Central Mexico. Ed. Elizabeth Boone. 175-206. 14
 figs. Washington, D.C.: Dumbarton Oaks.
 Postural and gestural poses as pictorial abridgements
standing for certain conventions. Codices Bodley, Selden, and
Columbino-Becker are utilized in the study of poses.

1432 1982. Studying style in the Mixtec Codices: an analysis of
 variations in the Codex Colombino-Becker. Pre-Columbian
 Art History: Selected Readings. Second edition. Ed. A.
 Cordy-Collins. 119-51. 16 figs. Palo Alto: Peek
 Publications.
 An introduction to Mixtec manuscripts, focusing
principally on style as a means of illuminating the various
"style areas" and the range of artistic and informational
license allowed each Mixtec scribe.

Tudela de la Orden, José.
1433 1960. Las primera figuras de indios pintadas por
 españoles. Homenaje a Rafael García Granados. 319-29. 7
 figs. Mexico: Instituto Nacional de Antropología e
 Historia.
 Brief report on a postconquest Aztec codex in Madrid
 that illustrates Indians from various parts of Mesoamerica. The
 author describes it as an important early ethnographic document.

Tuggle, H. D.
1434 1968. A panel from El Tajin. The Masterkey 42, no. 3:113-
 16. 1 fig.
 Brief discussion of a previously unpublished fragmentary
 panel, possibly from Pyramid of the Niches, depicting a seated
 human figure within a ring enclosed by two serpents.

1435 1968. The columns of El Tajin, Veracruz, Mexico. Ethnos
 33, no. 1-4:40-70. 9 figs.
 The low-relief scenes on large "drums" that were stacked
 to form columns are examined. Mythico-religious scenes and
 ballgame imagery are depicted.

Ubbelonde-Doering, H.
1436 1959. Alt-mexikanische und peruanische Malerei. 52 pp.,
 22 plates. Berlin.
 Brief look at examples of painting, from small scale
 pottery to architectural murals. The Middle American examples
 are mostly Maya and Teotihuacan.

Valentini, Ph. J. J.
1437 1880. Mexican Paper: An Article of Tribute; Its
 Manufacture, Varieties, Employment, and Uses. Proceedings
 of the American Antiquarian Society, Oct. 21, 1880.
 Privately printed, Worcester, Mass. 26 pp., 13 figs.
 Uses of paper as depicted in Mexican manuscripts.

Valliant, George C.
1438 1939. Tiger masks and platyrrhine bearded figures from
 Middle America. Proceedings of the 27th Internatioal
 Congress of Americanists 2:131-35. Mexico.
 Remarks on distinctive physical types in Olmec art.

van der Loo, Peter L.
1439 1982. Rituales con manojos contados en el grupo Borgia y
 entre los Tlapanecos de hoy dia. International Colloquium:
 The Indians of Mexico in Pre-Columbian and Modern Times.
 Ed. M. Jansen and T. Leyenaar. 232-43. 9 figs. Leiden,
 Netherlands: Rijksmuseum voor Volkenkunde.
 Several Borgia Group codex illustrations compared with
 modern day ritual practice of the inhabitants of Guerrero.

van Zantwijk, Rudolf.
1440 1967. La organización de once guarniciones aztecas: una
 nueva interpretación de los folios 17v y 18r del Códice
 Mendocino. Journal de la Société des Américanistes 56, no.
 1:149-58. 2 plates. Paris.
 Original remarks on two pages of Codex Mendoza.

1441 1981. The Great Temple of Tenochtitlan: model of Aztec
 cosmovision. Mesoamerican Sites and World-Views. Ed. E.
 P. Benson. 71-86. 3 figs. Washington, D.C.: Dumbarton
 Oaks.
 Symbolism of the component parts of the Templo Mayor
 related to celestial and terrestrial orderings.

Villacorta, J. Antonio, and Carlos A. Villacorta.
1442 1930. Codices mayas: Reproducidos y desarrollado. 450
 pp. Guatemala City: Tipografía Nacional. Second edition
 published in 1976.
 Hand-drawn illustrations of all pages in Paris, Dresden,
 and Madrid codices accompanied by commentary and glyphic
 translation where possible.

Villagra Caleti, Agustin.
1443 1939. Los danzantes: piedras grabadas del Monticulo L,
 Monte Alban, Oaxaca. Proceedings of th 27th International
 Congress of Americanists 2:143-58. 17 figs. Mexico.
 Discussion of recent excavations at Monte Alban and the
 comments and drawings of the danzante figures by earlier
 explorers.

1444 1951. Las pinturas de Atetelco en Teotihuacán. Cuadernos
 Americanos 10:153-62. 12 figs.
 Techniques of consolidation, restoration, and copying of
 Teotihuacan murals in one residence compound, discussed by the
 leading authority on mural reproductions.

1445 1952. Teotihuacan, sus pinturas murales. Anales 5:67-74.
 4 figs., 10 plates. Mexico: Instituto Nacional de
 Antropología e Historia.
 Documentation of the author's work on mural paintings in
 several residence compounds at Teotihuacan. Useful color
 reproductions and architectural plans included.

1446 1965. La conservación de los murales prehispánicos.
 Anales 17:109-15. 3 figs., 1 black-and-white plate, 1
 color plate. Mexico: Instituto Nacional de Antropología e
 Historia.
 Brief discussion of the author's techniques for
 recording, reconstructing, and reproducing pre-Hispanic murals.

1447 1971. Mural painting in Central Mexico. Handbook of
 Middle American Indians 10. Ed. Gordon F. Ekholm and
 Ignacio Bernal. 135-56. 34 figs. Austin: University of
 Texas Press.
 Focuses on wall painting at Teotihuacan, but other sites
 covered also. Many illustrations of Teotihuacan frescoes.

Vokes, Emily H.
1448 1963. A possible Hindu influence at Teotihuacán. American
 Antiquity 29, no. 1:94-98. 2 figs.
 Identification of conch-shell motifs on the temple of
 Quetzalcoatl as the "Sacred Chank" shell of Hindu tradition.
 The author finds this to be another piece of evidence for Asiatic
 influence in the New World. Weak.

Vollmer, Günter.
1449 1981. Geschichte der Azteken: Codex Aubin und verwandte
 Dokumente. 354 pp., 108 plates. Berlin: Gebr. Mann
 Verlag.
 Study of early postconquest Codex Aubin. Focuses on
 translation of Nahuatl text into German.

von Euw, Eric.
1450 1974. Las ruinas de Itzimte. Boletín (Ser. 2) 10:19-26.
 11 figs. Mexico: Instituto Nacional de Antropología e
 Historia.
 A Maya site in Campeche is mapped and its carved monu-
 ments illustrated.

von Hagen, Victor Wolfgang.
1451 1944. The Aztec and Maya Papermakers. 120 pp., 39 plates.
 New York: J. J. Augustin.
 Survey of the indigenous manufacture and use of bark
 paper in ancient Mesoamerica, with reference to modern survival
 of the practice.

von Sydow, Eckart.
1452 1941 Studien zur Form und Form-Geschichte der
 mexikanischen Bilderschriften. Zeitschrift für Ethnologie
 72, nos. 4-6:197-234. 18 figs. Berlin.
 Discussion of pictorial and compositional elements in
 both preconquest and postconquest codices.

von Winning, Hasso.
1453 1947. Certain types of stamped decoration on pottery from
 the Valley of Mexico. Notes on Middle American Archaeology
 and Ethnology 3, no. 86:202-13, 16 figs. Washington, D.
 C.: Carnegie Institution of Washington.
 Maya long-lipped heads on late Teotihuacan-style vessel
 fragments.

1454 1947. Representations of temple buildings as decorative patterns on Teotihuacan pottery and figurines. Notes on Middle American Archaeology and Ethnology 3, no. 83:170-77. 4 figs. Washington, D.C.: Carnegie Institution of Washington.
Patterns of temple facades and their components parts on Teotihuacan ceramics. Useful line drawings.

1455 1947. A symbol for dripping water in the Teotihuacan culture. El Mexico Antiguo 6:334-41. 3 figs.
Lobe-like symbols pending from flowers, and other objects are interpreted as dripping water. Examples drawn from mural painting and pottery.

1456 1948. The Teotihuacan owl-and-weapon symbol and its association with "serpent head X" at Kaminaljuyu. American Antiquity 14, no. 2:129-32. 6 figs.
Painted and modeled designs on Kaminaljuyu pottery compared to Teotihuacan iconography. Conflation of two symbol systems seen to have taken place.

1457 1949. Incised archaic clay disks from the Valley of Mexico. Ethnos 14, nos. 2-4:89-100. 70 figs. Stockholm.
The varieties of simple disks with concave edges and incised geometric decoration characteristic of the Ticoman culture complex are cataloged.

1458 1949. Spindle-whorl from Culhuacan, Mexico, showing deity emerging from conch shell. The Masterkey 23, no. 5:149-52.
Examination of a mold-impressed relief-decorated spindle-whorl. The iconography of the conch shell is discussed and stylistic affiliation of the object with coeval Huaxtec spindle-whorls is suggested.

1459 1949. Teotihuacan figurine heads with one eye intentionally patched. The Masterkey 23, no. 5:133-34. 2 figs.
Brief report on unusual figurine fragments purchased at Santiago Ahuixotla.

1460 1950. Animal figurines on wheels from ancient Mexico. The Masterkey 44, no. 5:154-60. 10 figs.
Terracotta figurines unearthed at Santiago Ahuixotla and Culhuacan in the Stendahl collection are shown to be of late Teotihuacan type, though no wheeled figures are known from Teotihuacan itself.

1461 1951. Another wheeled animal figurine from Mexico. The Masterkey 25, no. 3:88-89. 1 fig.
Addendum to his 1950 article on the same topic.

1462 1953. A decorated vessel support from Acapulco, Mexico.
 <u>Notes on Middle American Archaeology and Ethnology</u> 4, no.
 113:220-22. 1 fig. Washington, D. C.: Carnegie
 Institution of Washington.
 Stamped vessel foot with plano-relief decoration
 reminiscent of Teotihuacan imagery is discussed.

1463 1955. A two-part effigy from the Valley of Mexico. <u>El</u>
 <u>Mexico Antiguo</u> 8:66-75. 4 figs. Mexico.
 Figural "cookie-jar" effigy in late Teotihuacan style
 from Santiago Ahuizotla and comparative material from
 Kaminaljuyu and Uaxactun.

1464 1957. Wind God on a Mexican stone relief. <u>The Masterkey</u>
 31, no. 4:112-15. 3 figs.
 Description of a Late Post-Classic columnar relief of
 Ehecatl in the Earl Stendahl collection.

1465 1958. An unusual incense burner from Colima, Mexico. <u>The</u>
 <u>Masterkey</u> 32, no. 2:40-42. 1 fig.
 A two-part censer representing the god of fire is
 unusual in its depiction of male genital organs. In some
 respects it seems to be a provincial variant of Teotihuacan
 Huehueteotl stone censers.

1466 1958. Figurines with movable limbs from ancient Mexico.
 <u>Ethnos</u> 23:1-60. 39 figs. Stockholm.
 Thorough typological study of jointed figurines from all
 areas.

1467 1958. Notes on Mexican spear throwers. <u>The Masterkey</u> 32,
 no. 3:93-98. 5 figs.
 Pre-Hispanic representation of atlatls in codices and
 pottery as well as more recent ethnohistoric examples in wood
 and iron.

1468 1959. An incised bone artifact from Cholula, Mexico. <u>The</u>
 <u>Masterkey</u> 33, no. 2:67-70. 1 fig.
 Unusual tubular deer bone fragment depicting four
 figures in Codex Borgia Group style.

1469 1959. Eine Keramische Dorfgruppe aus dem alten Nayarit im
 westlichen Mexico. <u>Mitteilungen aus dem Museum für Völker-</u>
 <u>kunde</u> 25:138-43. 7 figs. Hamburg.
 Analysis of one complex Nayarit house group with four
 houses and several dozen figures.

1470 1960. A Chac Mool sculpture from Tlascala, Mexico. <u>The</u>
 <u>Masterkey</u> 34, no. 2:50-55. 3 figs.

Analysis of angular Chac Mool figure less than a meter long whose tenoned head is missing. The Toltec-style figure has low relief symbols carved on side and bottom.

1471 1961. A relief-decorated Aztec stone block. El México Antiguo 9:461-72. 11 figs.
Quetzalcoatl imagery on small volcanic rock sculpture.

1472 1961. Teotihuacan symbols: the reptile's eye glyph. Ethnos 26:121-66. 14 figs.
One Teotihuacan glyph-like symbol is examined for its occurrences in all media. Glyph interpreted as a symbol for earth, fertility, and abundance. Many useful drawings in each figure.

1473 1961. Two figurines with moveable limbs from Veracruz, Mexico. The Masterkey 35, no. 4:140-46. 6 figs.
Late Classic jointed Nopiloa figurines which conjoin Maya and Totonac traits in the relief decoration on the torso.

1474 1961. Stone sculpture of an Aztec deity. The Masterkey 35, no. 1:4-12. 14 figs.
Identification of small gray andesite statue as representing one of the ciuapipiltin, or deified women who died in childbirth. Iconographic and calendrical evidence used in support of the thesis.

1475 1962. Two pottery molds in Maya-Toltec style. The Masterkey 36, no. 3:87-96. 6 figs.
Molds with figural designs, dating from twelfth to thirteenth centuries, are illustrated and discussed. Both came from Tultitlan, south of Tula, Hidalgo.

1476 1963. Una vasija de alabastro con decoracion en relieve. Estudios de Cultura Maya 3:113-18. 4 figs.
Analysis of a Classic Maya alabaster vase found in Burial 48 at Tikal, Guatemala.

1477 1963. A Maya "Old God" effigy bowl. The Masterkey 37, no. 2:59-65. 5 figs.
Effigy vessel depicting an aged deity with a snail shell body is modeled on a bowl from Uaymil, Campeche. A panel on the back of the bowl depicts three figures in low relief. Comparison is made with a group of bowls found at Kaminaljuyu.

1478 1965. Dual pottery molds from Mexico. The Masterkey 39, no. 2:60-65. 7 figs.
Teotihuacan and Aztec molds for figurines and incense burner adornos are illustrated and discussed.

1479 1965. Relief-decorated pottery from central Veracruz,
 Mexico. Ethnos 30:105-35. 13 figs.
 First study of the formal and iconographic aspects of
 this particular category of pottery vessels, said to be from the
 Rio Blanco area of Veracruz.

1480 1967. Semejanzas entre las figurillas de Jaina y de
 Teotihuacan. Revista de Estudios Antropológicos 21:41-69.
 17 plates, 26 figs. Mexico.
 A listing of iconographic traits and costume elements
 found both in Teotihuacan and Maya figurines of Jaina style.

1481 1968. Process of head deformation shown by Mesoamerican
 figurines. The Masterkey 42, no. 2:53-58. 3 figs.
 Jaina and Tlatilco figurines suggest the process by
 which infants' heads were flattened.

1482 1968. Der Netzjaguar in Teotihuacan, Mexico: eine
 ikonographische Untersuchung. Baessler-Archiv n.f. 16, no.
 1:31-46. 13 figs.
 Essay on the iconography of the net-jaguar in
 Teotihuacan painting and pottery. Relates the Teotihuacan net
 jaguar to later Tlaloc and Tepeyollotl imagery in the Valley of
 Mexico.

1483 1969. A toad effigy vessel from Nayarit. The Masterkey 43,
 no. 1:29-32. 1 fig.
 Ethnographic analogy with Cora Indians suggests that
 ancient Nayarit potters had beliefs about toads as divine
 messengers, associated with rain.

1484 1969. Ceramic house models and figurine groups from
 Nayarit. Proceedings of the 38th International Congress of
 Americanists 1:129-32. 2 figs. Stuttgart-Münich.
 Summary of a study of thirty-six house groups from tombs
 in southern Nayarit. Five architectural types are
 distinguished. Comparisons between Chinese and Nayarit house
 groups.

1485 1970. Two-headed figurines from Mexico. The Masterkey 44,
 no. 2:45-52. 8 figs.
 Brief survey of the sporadic distribution of two-headed
 terracotta figurines in Mexico. Early Tlatilco examples are
 female, later figures are Janus-like, with more widespread
 distribution.

1486 1971. Relief-decorated pottery from central Veracruz,
 Mexico: addenda. Ethnos 36:38-51. 5 figs.
 An update of his 1965 article, discussing five
 additional relief-decorated bowls from the same area.

1487 1971. Shell pendants from Jalisco, Mexico. <u>The Masterkey</u> 45, no. 1:20-26. 4 figs., 1 plate.

Twenty zoomorphic and anthropomorphic carved shell ornaments reputed to be from one cache west of Lake Chapala are described and illustrated.

1488 1974. A duck hunter from West Mexico. <u>The Masterkey</u> 48, no. 2:72-73. 1 fig.

Brief description of a Colima figure whose head is covered by a duck effigy.

1489 1975. A victim of the planet Venus? <u>The Masterkey</u> 49, no. 4:124-29. 3 figs.

Post-Classic Central Mexican spindle-whorls, cast from same mold, depict a wounded warrior. Based on analogy with Mexican manuscripts, the author suggests the image is a metaphor for the effect of Venus at heliacal rising, foreboding ill.

1490 1976. Late and Terminal Preclassic: the emergence of Teotihuacán. <u>Origins of Religious Art and Iconography in Preclassic Mesoamerica</u>. Ed. H. B. Nicholson. 141-56. 6 figs. Los Angeles: UCLA.

Cultural development during the incipient stages of Teotihuacan culture is explored, with particular attention to earliest architectural and artistic manifestations.

1491 1976. Escenas rituales en la cerámica policroma de Nayarit. <u>Proceedings of the 41st International Congress of Americanists</u> 1:387-400. 11 figs. Mexico. Translated as "Rituals depicted on polychrome ceramics from Nayarit." <u>Pre-Columbian Art History</u>. Ed. Alana Cordy-Collins and Jean Stern. 121-34. 11 figs. Palo Alto: Peek Publications, 1977.

Three Early Post-Classic polychrome vessels in Mixteca-Puebla style from the Amapa-Peñitas region of Nayarit discussed. The author suggests Borgia-group manuscripts as stylistic and iconographic source.

1492 1977. The Old Fire God and his symbolism at Teotihuacan. <u>Indiana</u> 4:7-61. 29 figs. Berlin.

Existence of a Fire God cult postulated by means of an analysis of conventional designs in Teotihuacan iconography. Numerous useful drawings of Teotihuacan signs, definitions of their forms and occurrences, and interpretation of their meaning, often based on analogy with later Mexican art.

1493 1978. A Zapotec Rain God carved in stone. <u>The Masterkey</u> 52, no. 4:147-50. 2 figs.

A small basaltic rock head of Cocijo with stylistic resemblance to Zapotec pottery urns is discussed. Only one other similar specimen is known in stone.

1494 1978. Human-mask pectorals on Teotihuacan figurines. <u>The</u>
<u>Masterkey</u> 52, no. 1:11-16. 4 figs.
 A rare class of figurines depicts warriors in quilted
armor wearing ring-eyed human face pectoral masks. Their use as
grave offerings for dead warriors is suggested.

1495 1978. Betrachtungen zu einem gefälschten polychromen Maya-
Gefäss. <u>Baessler-Archiv</u> n.f. 26, no. 2:233-40. 2 plates.
 Iconographic analysis of a Maya polychrome pot leads the
author to conclude that the vessel is a modern falsification
based on an authentic vase found in Tomb 116 at Tikal.

1496 1979. The binding of the years and the new fire at
Teotihuacan. <u>Indiana</u> 5:15-32. 5 figs. Berlin.
 Building on his 1977 article on the Fire God, the author
discusses firewood bundle imagery which he believes to have
calendric significance, based on analogy with Aztec practice.

1497 1980. Los decapitados en la cerámica moldeada de Veracruz.
<u>Indiana</u> 6: 23-36. 6 figs. Berlin: Ibero-Amerikanisches
Institut Preussischer Kulturbesitz.
 Iconographic programs on Classic Period pottery of the
Rio Blanco region are discussed. Mold-impressed reliefs are
well illustrated by roll-out drawings.

1498 1980. Ritual cloth and Teotihuacan warriors. <u>The</u>
<u>Masterkey</u> 54, no. 1:17-23. 6 figs.
 Ritual use of cloth to hold spears in Teotihuacan
warrior murals is compared with the use of cloth in presentation
scenes at Palenque.

1499 1981. Dos estelas en la Mixteca Baja del Sur de Puebla.
<u>Anales del Instituto de Investigaciones Estéticas</u> 49:13-22.
2 figs. Mexico.
 Iconographic and glyphic discussion of two stone stelae
found in the Nuiñe region. Their affinities with Xochicalco
stelae are discussed, and an Epi-Classic date is proposed.

1500 1982. A procession of god-bearers: notes on the icono-
graphy of classic Veracruz mold-impressed pottery. <u>Pre-</u>
<u>Columbian Art History: Selected Readings</u>. Second edition.
Ed. A. Cordy-Collins. 109-18. 3 figs. Palo Alto: Peek
Publications.
 A further addition to his previous studies of the themes
on Rio Blanco ceramics of the Late Classic period. Post-
conquest pictorials used to illuminate the concept of "god-
bearer" as revealed in this earlier pottery.

von Winning, Hasso, and Olga Hammer.
1501 1972. <u>Anecdotal Sculpture of Ancient West Mexico</u>. 96 pp.,
205 figs., 8 color plates. Los Angeles: Los Angeles County
Natural History Museum.

Useful survey of figural groups in West Mexican mortuary ceramics. Particular attention paid to house models, figurine groups, and ritual bed figures.

von Winning, Hasso, and Alfred Stendahl.
1502 1968. Pre-Columbian Art of Mexico and Central America.
 388 pp., 594 photos, many in color.
 Brief text, but impressive pictorial survey of the arts.
Concise catalog entry for each photo. Focus is on small- to middle-scale ceramic, stone, and metal objects.

Wallace, Anthony F. L.
1503 1971. A possible technique for recognizing psychological
 characteristics of the ancient Maya. Art and Aesthetics in
 Primitive Societies. Ed. Carol F. Jopling. 11-29. 1 fig.
 New York.
 Dubious test case, judging ancient Maya personality
based on evidence in pictorial codices. Cross-checked with
Landa's accounts.

Wardle, H. Newell.
1504 1902. Certain clay figures of Teotihuacán. Proceedings of
 the 13th International Congress of Americanists 213-16. 1
 fig. New York.
 Ethnohistoric accounts used to elucidate Classic period
jointed figurines. Author calls them small representations of
goddess Cinteotl, to be hung in planting fields.

1505 1910. Miniature clay temples of ancient Mexico.
 Proceedings of the 17th International Congress of
 Americanists 2:375-81. 2 plates. Buenos Aires.
 Description of a number of small-scale temple models.
The deity's emblems found on roofcombs are like those on
headgear.

Wassen, S. Henry.
1506 1942. A forged Maya codex on parchment: a warning.
 Ethnologiska Studier 12-13:293-304. 8 figs. Göteborg.
 Discussion of a fake pictorial manuscript in the
Göteborg museum in Sweden.

1507 1962. Three Mesoamerican effigy incense burners
 representing the god of fire. Ethnos 27:150-66. 12 figs.
 Similarities in Huehueteotl or "old god of fire" sym-
bolism on pottery from different regions.

1508 1966. An Olmec stone figurine from Ahuachapán, El
 Salvador. Ethnos 31:84-89. 3 figs.
 Notes on a stone object in the Götenborg Museum
depicting a seated male figure. Provenience of western El
Salvador.

Wasson, R. Gordon.
1509 1973. The role of "flowers" in Nahuatl culture: a
 suggested interpretation. Harvard University Botanical
 Museum Leaflets 23, no. 8:305-24. 11 figs.
 The botanical emblems on the Aztec statue of Xochipilli
 identified as psychotropic plants. Textual, iconographic, and
 ethnographic evidence used to support this thesis.

1510 1980. The Wondrous Mushroom: Mycolatry in Mesoamerica.
 248 pp., 139 figs. New York: McGraw Hill.
 Ethnographic, ethnohistoric, and archaeological study
 of drug use. Chapters on Maya mushroom stones, imagery in
 Teotihuacan murals, codices and Xochipilli iconography are of
 interest here. Parts of the book appeared previously, in
 slightly altered format, as journal articles.

Waterman, T. T.
1511 1916. The delineation of the day-signs in the Aztec
 manuscripts. University of California Publications in
 American Archaeology and Ethnology 11, no. 6. 101 pp., 38
 figs. Berkeley: University of California Press.
 Calendar system of the Aztecs as known from the codices.
 Useful comparative charts of conventions for day signs in
 different manuscripts.

1512 1929. Is the Baul stela an Aztec imitation? Art and
 Archaeology 28, no. 5:183-87.
 Calls the cycle 7 El Baul monument 1 an Aztec imitation
 or reproduction of an ancient work. Disputes the cycle 7 date,
 and the "un-Maya-like" crudity of the work.

Wauchope, Robert.
1513 1940. Domestic architecture of the Maya. The Maya and
 Their Neighbors. Ed. Clarence L. Hay, et al. 232-41, 2
 figs. New York: D. Appleton-Century Company. Reprint.
 New York: Dover Publications, 1977.
 Discussion of contemporary Maya houses and their rela-
 tionship to archaeological ones.

1514 1942. Notes on the age of the Cieneguilla Cave textiles
 from Chiapas. Middle American Research Records 1, no.
 2:7-11. 1 fig. New Orleans: Tulane University.
 Ceramic associations of textile fragments date them Late
 Post-Classic or immediate postconquest period. Companion study
 to L. O'Neale's report in the same volume.

Weaver, Muriel Porter.
1515 1967. Tlapacoya Pottery in the Museum Collection.
 Miscellaneous Series, 56. 48 pp., 41 plates. New York:
 Museum of the American Indian, Heye Foundation.

Museum's collection of pottery (both vessel forms and figural types) from this Formative period site in central Mexico is discussed and illustrated.

1516 1981. The Aztecs, Maya, and Their Predecessors. Second edition. 597 pp. 16 plates, 35 figs., 75 photos. New York: Academic Press.
 Encyclopedic introduction to pre-Columbian archaeology of Mesoamerica. Included here for its strength in placing objects in cultural context.

Weber, Gertrud.
1517 1973. Felsbilder von Las Palmas. Tribus 22:167-82. 18 plates.
 Survey and documentation of petroglyphs found at Finca Las Palmas, Chiapas. Designs include geometric and figural patterns; a Late Classic date is suggested.

1518 1978. Das Thema von Leben und Tod in Bezug auf die Petroglyphen von Las Palmas/Chiapas, Mexiko. Tribus 27:143-57. 14 figs.
 Cross-cultural comparison of skeletal imagery in rock art from Chiapas with that in other parts of the world. Emphasis on duality of life and death.

Westheim, Paul.
1519 1950. Arte antiguo de México. Mexico: Fondo de Cultura Económica. 348 pp. 151 figs., 5 color plates.
 Survey of themes and forms in ancient Mesoamerican art. The work is not organized temporally but rather by themes.

1520 1963. The Sculpture of Ancient Mexico. 69 pp., 94 black-and-white figs. Garden City, N.Y.: Doubleday and Co., Inc.
 General remarks on sculpture in all media.

Weyerstall, Albert.
1521 1932. Some observations on Indian mounds, idols, and pottery in the Lower Papaloapan Basin, State of Veracruz, Mexico. Middle American Research Series Publications 4:21-69. New Orleans: Tulane University.
 Useful for its illustrations of ceramic figures from Veracruz.

Whittaker, Gordon.
1522 1982. The tablets of mound J at Monte Alban. International Colloquium: The Indians of Mexico in Pre-Columbian and Modern Times. Ed. M. Jansen and T. Leyenaar. 50-86. 75 figs. Leiden, Netherlands: Rijksmuseum voor Volkenkunde.

Place signs and emblem glyphs in the art and inscriptions of Monte Alban. Author disputes readings made by Marcus (1980).

Wicke, Charles R.
1523 1966. Tomb 30 at Yagul and the Zaachila tombs. Ancient Oaxaca. Ed. J. Paddock. 336-44. 11 figs. Stanford: Stanford University Press.
 Most architecturally elaborate tomb at Yagul, but discovered after having been robbed. T-shaped tomb with greca mosaic. Architectural and archaeological features held in common with Zaachila tombs lead to the conclusion that it is a Mixtec tomb.

1524 1971. Olmec: An Early Art Style of Pre-Columbian Mexico. 188 pp., 38 illustrations, 9 tables. Tucson: University of Arizona Press.
 Useful survey of Olmec art and archaeology and the problems of interpretation of archaeological materials.

1525 1976. Once more around the Tizoc stone: a reconsideration. Proceedings of the 41st International Congress of Americanist 2:209-22. 7 figs.
 The Tizoc stone records not that ruler's individual conquests, but all wars that the Aztecs had waged up to that time. Discussion of place glyphs supports this argument. Figures encircling the stone are shown to represent the deities of the tribes that the Aztecs conquered.

Willcox, H.
1526 1954. Removal and restoration of the monuments of Caracol. University Museum Bulletin 18:46-72. 24 figs. Philadelphia: University of Pennsylvania.
 Discussion of the logistics and problems involved in removing monuments from their jungle settings, transporting them to Philadelphia, repairing, and reerecting them.

Willey, Gordon R.
1527 1971. The early great styles and the rise of the pre-Columbian civilization. Anthropology and Art. Ed. C. M. Otten. 282-97. 2 plates. Garden City, N. Y.: The Natural History Press.
 Olmec and Chavin arts and cultures as the precursors to the later great civilizations in Mesoamerica and the Andes.

1528 1973. Mesoamerican art and iconography and the integrity of the Mesoamerican ideological system. The Iconography of Middle American Sculpture. 153-62. New York: The Metropolitan Museum of Art.

Commentary on other volume papers, yet outlines succinctly the standard methodological practice of Mesoamerican archaeologists vis-à-vis the conceptual unity of Middle America.

Willey, Gordon R., and A. Ledyard Smith.
1529 1967. A temple at Seibal, Guatemala. Archaeology 20, no. 4:290-98.
 Discussion of the excavation of structure A-3, with particular attention paid to the fragmentary figural stucco work adhering to the building. Ninth-century date suggested.

Williams, Howel, and Robert F. Heizer.
1530 1965. Sources of rocks used in Olmec monuments. Contributions of the University of California Archaeological Research Facility 1, no. 1:1-39. 4 figs., 4 plates, Berkeley.
 Petrographic character of lithic materials used in Olmec monuments and notes on the nature and distribution of volcanic and metamorphic rocks in the Olmec area.

Winters, Howard D.
1531 1955. Three serpent column temples and associated platforms at Mayapan. Current Reports 2, no. 32:397-423. 6 figs. Washington, D. C.: Carnegie Institution of Washington.
 Report on one architectural type at this Late Post-Classic Yucatan site.

1532 1955. A vaulted temple at Mayapan. Current Reports 2, no. 30:363-79. 4 figs. Washington, D.C.: Carnegie Institution of Washington.
 Excavation of a structure with remains of mural paintings at Late Post-Classic Yucatan site.

Wray, D. E.
1533 1945. The historical significance of the murals in the Temple of the Warriors. American Antiquity 11, no. 1:24-27.
 An interpretation of the action in four scenes in the Temple of the Warriors at Chichen Itza. The imagery is seen to record the political and military subjugation of the Maya by the Toltec in a location near the coast.

Index